THE PRINCETON SERIES IN

NINETEENTH-CENTURY ART,

CULTURE, AND SOCIETY

12 Views of Manet's *Bar*

12 Views
of Manet's *Bar*

Edited by Bradford R. Collins

PRINCETON UNIVERSITY PRESS

Library of Congress Cataloging-in-Publication Data

12 Views of Manet's Bar / edited by Bradford R. Collins.

p. cm. — (The Princeton series in nineteenth-century art,
culture, and society)

Includes bibliographical references.

ISBN 0-691-03690-X (cl : alk. paper). — ISBN 0-691-03691-8 (pb : alk. paper)

1. Manet, Edouard, 1832–1883. Bar at the Folies-Bergère.
2. Manet, Edouard, 1832–1883—Criticism and interpretation.
3. Painting—Historiography. I. Collins, Bradford R., 1942– .
II. Series.

ND553.M3A63 1996

759.4—dc20 95-38924

This book has been composed in Utopia Regular Typeface

Princeton University Press books are
printed on acid-free paper and meet the guidelines
for permanence and durability of the Committee
on Production Guidelines for Book Longevity
of the Council on Library Resources

Printed in the United States of America
by Princeton Academic Press

1 3 5 7 9 10 8 6 4 2
1 3 5 7 9 10 8 6 4 2
(Pbk.)

THIS BOOK IS DEDICATED

TO MY MENTOR AT

WASHINGTON UNIVERSITY,

NORRIS KELLY SMITH,

TO MY LOVELY DAUGHTERS

(MAIDA, ALI AND ZOLA),

AND, MOST IMPORTANTLY, TO

STACEY

(FOR SO MANY REASONS).

Contents

List of Illustrations xi

Notes on Contributors xv

Preface xix

Introduction: Ascribing to Manet, Declaring the Author
 Richard Shiff 1

Counter, Mirror, Maid: Some Infra-thin Notes on
A Bar at the Folies-Bergère
 Carol Armstrong 25

Manet's *A Bar at the Folies-Bergère* as an Allegory
of Nostaligia
 Albert Boime 47

Art History in the Mirror Stage: Interpreting *A Bar at the
Folies-Bergère*
 David Carrier 71

Le Chef d'Oeuvre (bien connu)
 Kermit S. Champa 91

The Dialectics of Desire, the Narcissism of Authorship:
A Male Interpretation of the Psychological Origins
of Manet's *Bar*
 Bradford R. Collins 115

On Manet's Binarism: Virgin and / or Whore
at the Folies-Bergère
 Michael Paul Driskel 142

Looking into the Abyss: The Poetics of Manet's
A Bar at the Folies-Bergère
 Jack Flam 164

CONTENTS

Dumbshows: A Carefully Staged Indifference
 Tag Gronberg 189

Privilege and the Illusion of the Real
 James D. Herbert 214

In Front of Manet's *Bar:* Subverting the "Natural"
 John House 233

Manet's Man Meets the Gleam of Her Gaze:
A Psychoanalytic Novel
 Steven Z. Levine 250

The "View from Elsewhere": Extracts from a Semi-public
Correspondence about the Visibility of Desire
 Griselda Pollock 278

A Select Bibliography for Methodological Issues in Art History 315

List of Illustrations

The medium is oil on canvas, unless otherwise stated. All dimensions are in centimeters.

Frontispiece

Edouard Manet, *A Bar at the Folies-Bergère*, 1881–82. 96 × 130. Courtauld Institute Galleries, Home House Trustees, London.

Figures

1. Edouard Manet, *A Bar at the Folies-Bergère*, c. 1881. 47 × 56. Private Collection.

2. Edouard Manet, *The Asparagus*, 1880. 16 × 21. Musée d'Orsay, Paris. © PHOTO R.M.N.

3. Edouard Manet, *The Lemon*, c. 1880. 14 × 21. Musée d'Orsay, Paris. © PHOTO R.M.N.

4. Edouard Manet, *Before the Mirror*, 1876–77. 92.1 × 71.4. Solomon R. Guggenheim Museum, New York, Thannhauser Collection, Gift, Justin K. Thannhauser, 1978. Photograph by David Heald. © The Solomon R. Guggenheim Foundation, New York.

5. Edouard Manet, *Woman Reading*, 1878–79. 61.2 × 50.7. The Art Institute of Chicago, Mr. and Mrs. Lewis Larned Coburn Memorial Collection. Photograph © 1994, The Art Institute of Chicago. All Rights Reserved.

6. Charles Fichot, *The Great Stairway of the Bon Marché Department Store*. Wood engraving. *L'Illustration*, 30 March 1872.

7. Louis-Henry Dupray, *Self Portrait*, n.d. Wash drawing. Published in A.M. de Belina, *Nos peintres dessinés par eux-mêmes* (Paris, 1883).

8. Stop, *A Merchant of Consolation at the Folies-Bergère*. Wood engraving. *Le Journal Amusant*, 27 May 1882.

9. Anonymous, *At the Anglo-American Bar*. Wood engraving. Published in G. A. Sala, *Paris Herself Again in 1878–79* (London, 1882).

10. Jules Chéret, *At the Folies-Bergère*, 1875. Color Lithograph. Private Collection.

11. Theater of the Folies-Bergère: The Act of Miss Leona Dare. Wood engraving. *L'Illustration*, 16 December 1876.

12. Edouard Manet, *At the Cafe*, 1878. 78 × 84. Oskar Reinhart Collection "Am Romerholz," Winterthur.

13. Edouard Manet, *At the Folies-Bergère,* c. 1881. Wash over hard pencil. 15.5 × 20. Collection unknown.

14. Edouard Manet, *Study for A Bar at the Folies-Bergère,* c. 1881. Wash drawing. 22.4 × 24.8. Collection unknown.

15. X-Ray photograph of Edouard Manet, *A Bar at the Folies-Bergère,* 1881–82. Courtesy of the Courtauld Institute Galleries, Home House Trustees, London.

16. James Tissot, *Quiet,* c. 1881. 68.9 × 91.4. Private collection.

17. Jean Auguste Dominique Ingres, *The Virgin with the Host,* 1854. Diameter 113.5. Musée du Louvre, Paris. © PHOTO R.M.N.

18. Hippolyte Flandrin, *Mother of Sorrow,* 1845. Lithograph after the painting by Jules Laurens. Bibliothèque Nationale, Cabinet des estampes, Paris.

19. Anonymous, *The Miraculous Medal,* c. 1838. Engraving. Photograph by Michael Paul Driskel.

20. Jean-Paul Laurens, *Studio Visits, Le Philosophe,* 26 Oct. 1867. Lithograph. Bibliothèque Nationale, Department des imprimés, Paris.

21. Pepin, cover for Léo Taxil, *Vie de Veuillot immaculé* (Paris, 1884). Bibliothèque Nationale, Department des imprimés, Paris.

22. Frid'rick, *The New Virgin.* Published in Léo Taxil, *Calotte et Calotins,* volume 2 (Paris, 1879). Cornell University Library. Photograph by Michael Paul Driskel.

23. Edouard Manet, *Model for the Barmaid of "A Bar at the Folies-Bergère,"* 1881. Pastel. 54 × 34. Musée des Beaux-Arts, Dijon.

24. G. Lafosse, *At the Folies-Bergere.* Lithograph. *Le Journal Amusant,* 14 Dec. 1878.

25. G. Lafosse, *At the Folies-Bergere.* Lithograph. *Le Journal Amusant,* 24 Nov. 1877.

26. Diagramatic reconstruction of Edouard Manet's *Reichshoffen* project prepared from *At the Cafe,* 1878 (Oskar Reinhardt Collection, Winterthur), an X-ray of *Corner in a Cafe-Concert,* 1878–79 (National Gallery, London), and the first drawing for the project (Museée du Louvre, Paris). Reconstruction courtesy of *The Burlington Magazine.*

27. Anonymous, *Les Hanlon-Volta, Aerial Gymnasts.* Published in G. Strehly, *L'Acrobatie et les Acrobates* (Paris, 1904).

28. Anonymous, *Les Alex, Trapeze Artists.* Published in G. Strehly, *L'Acrobatie et les Acrobates* (Paris, 1904).

29. Edgar Degas, *The Rehearsal of the Ballet on the Stage,* 1874.

54.3 × 73. Metropolitan Museum of Art, New York, Gift of Horace Havemeyer, 1929. The H. O. Havemayer Collection.

30. Pierre August Renoir, *The First Outing*, 1875–76. 64.8 × 50.2. Reproduced by courtesy of the Trustees, The National Gallery, London.

31. Alfred Roll, *14 July 1880*, Salon of 1882. 650 × 980. Musée du Petit Palais, Paris.

32. Ernest Duez, *In the Restaurant Le Doyen*, 1878. 88 × 114. Collection unknown.

33. Léon Lhermitte, *The Wages of the Harvesters*, Salon of 1882. 215 × 275. Musée d'Orsay, Paris. © PHOTO R.M.N.

34. Edouard Manet, *Portraits of M. and Mme Auguste Manet*, 1860. 110 × 90. Musée d'Orsay, Paris. © PHOTO R.M.N.

35. Edouard Manet, *Portrait of Mme Manet*, 1866. 60 × 50. Norton Simon Art Foundation, Pasadena, California.

36. Diego Valázquez, *Portrait of the Infanta Maria Margarita*, 1654. 70 × 59. Musée du Louvre, Paris. © PHOTO R.M.N.

37. Edouard Manet, *Portrait of Mme Michel-Lévy*, 1882. Pastel and oil. 74.4 × 51. Chester Dale Collection, © 1994 National Gallery of Art, Washington.

38. Mary Cassatt, *At the Opera*, 1879. 80 × 64.8. The Hayden Collection, Courtesy, Museum of Fine Arts, Boston.

39. Edouard Manet, *Spring: Jeanne*, 1881. 73 × 51. Private Collection.

40. Henri di Toulouse-Lautrec, *The Laundress*, 1889. 93 × 75. Private Collection.

41. Edouard Manet, *Luncheon in the Studio*, 1868. 118.3 × 153.9. Neue Pinakothek, Munich.

Notes on Contributors

Richard Shiff is Effie Marie Cains Regents Chair in Art at the University of Texas at Austin. He is author of *Cézanne and the End of Impressionism* (1984), as well as essays on modernist art and on issues of history and theory.

Carol Armstrong teaches at the Graduate Center of the City of New York. Her publications include *Odd Man Out: Readings of the Work and Reputation of Edgar Degas* (1991) and articles on Degas, Manet, and 20th-century photography. She is currently working on two books: one on photographic illustration in 19th-century England and one on Manet.

Albert Boime, Professor of Art History at the University of California, Los Angeles, is currently completing volume three of his Social History of Modern Art, *Art in an Age of Counter-Reformation.* His most recent book is *Art and the French Commune* (The Princeton Series in Nineteenth-Century Art, Culture, and Society).

David Carrier; Professor of Philosophy at Carnegie Mellon University, writes art criticism. His books include: *Artwriting* (1987), *Principles of Art History Writing* (1991), *Poussin's Paintings* (1993), and *The Aesthete in the City: The Philosophy and Practice of American Abstract Painting in the 1980s* (1994). He is at work on a study of Baudelaire's art criticism.

Kermit S. Champa has been a professor of the history of art at Brown University since 1969. His most important books and exhibition catalogues include: *German Painting of the Nineteenth Century* (1970), *Studies in Early Impressionism* (1972), *Mondrian Studies* (1985), *The Rise of Landscape Painting in France* (1990), and *"Masterpiece" Studies* (1994).

Bradford R. Collins teaches contemporary art history and theory at the University of South Carolina. He has written articles on Manet,

Greenberg, Motherwell, Warhol, and the Abstract Expressionists. Recently, he edited an *Art Journal* issue dedicated to rethinking the introductory survey (fall 1995) and authored three chapters of *Art History* (Harry N. Abrams, 1995).

Michael Paul Driskel, author of *Representing Belief: Religion, Art, and Society in Nineteenth-Century France* (1992) and *As Befits a Legend: Building a Tomb for Napoleon, 1840–1861* (1993), has published numerous articles on French art and culture in the nineteenth century. He lives in Washington, D.C.

Jack Flam is Distinguished Professor of Art History at Brooklyn College and at the Graduate Center of the City University of New York. He is author of numerous articles, exhibition catalogues, and books on modern art, including *Matisse: the Man and his Art, 1869–1918* (1986), which won the College Art Association's Charles Rufus Morey Award.

Tag Gronberg, a member of *The Oxford Art Journal* Editorial Board, teaches the history of art and design at Birbeck College, University of London. She is author of "Femmes de Brasserie" (*Art History,* 1984) and *Manet: A Retrospective* (1988). She recently completed a study of the 1925 Paris Exhibition.

James D. Herbert is Associate Professor of Art History at the University of California, Irvine. His *Fauve Painting: The Making of Cultural Politics* (1992) received the 1993 Hans Rosenhaupt Memorial Book Award, granted by the Woodrow Wilson National Fellowship Foundation. He is currently examining such French cultural practices as Surrealist art, the Musée de L'Homme, and the Exposition Internationale of 1937 in a manuscript entitled *Global Speculations: Exhibitions of Commerce, Ethnography, and Art in Paris, 1937–38.*

John House is professor in the history of art at the Courtauld Institute of Art, University of London. He was co-organizer of the *Post-Impressionism* exhibition at the Royal Academy of Arts, 1979–80, and of the *Renoir* exhibition, Hayward Gallery, London, 1985. He is author

of *Monet: Nature into Art* (1986) and of many articles on French 19th-century painting.

Steven Z. Levine is chair of the history of art department and Leslie Clark Professor in the Humanities at Bryn Mawr College. He is author of *Monet and His Critics* (1976), *Claude Monet* (1994), and *Monet, Narcissus, and Self-Reflection: The Modernist Myth of the Self* (1994). His next book is on self-portraiture.

Griselda Pollock is Director of the Center for Cultural Studies at the University of Leeds. She is co-author, or author, of numerous books, including *Old Mistresses: Women, Art and Ideology* (1981), *Framing Feminism* (1987), and *Vision and Difference* (1988). Her *Sexuality and Surveillance* and *Differencing the Canon: Feminist Desire and the Writing of Art's Histories* are forthcoming.

Preface

precise/orderliness

THIS ANTHOLOGY grew out of a discussion with a colleague about the methodological approaches now loosely grouped under the label of "the New Art History." My colleague—trained in the period before 1970 in methods of research and analysis that he and his mentors trusted essentially without question—was both distressed by the vehemence of recent attacks on so-called "standard" art history and puzzled by them. He wanted to know of a book or article he might consult that would provide him with some handle, at least, on the various approaches constantly referred to in contemporary art historical discourse: Marxist, psychoanalytic, structuralist, poststructuralist, and feminist, most notably. In short, he was curious to know how the methodologies coming to the discipline from fields such as anthropology, philosophy, and literary studies compared with the iconographical, stylistic, and contextual methods of analysis he had always found quite adequate. I told him that I could recommend articles that discussed the theoretical bases of the New Art History and books by the better-known practitioners associated with them (see Bibliography), but that the kind of document he sought was simply not available. We agreed that perhaps the profession needed a book that would provide both more conventional historians, such as himself, and our students, graduate and undergraduate, with a good, solid introduction to the new methodologies. — Task

My first thought for this volume was to commission a series of theoretical essays. In turning this idea over in my mind I realized that such a book would not, in fact, properly reflect the present state of the "newer" art historical research. Although everyone I know— whether "newer" or not—is working under some label or other, these rubrics rarely do justice to the complexity of their individual approaches. While many of my friends are called "Marxists" or "feminists" or "standard practitioners," those terms are essentially a matter of convenience, a quick and convenient way to *refer* to them, not a way to understand what it is they actually *do*. In my own case, for example, while it would be accurate to say that I attempt to do psychoanalytic readings of art works, this would hardly be sufficient. In the first place, there is no psychoanalytic approach per se, but merely many individuals such as myself whose understanding of art and art-

studying & teaching

xix

ists is *informed* by some of the insights into human nature pioneered by Freud and elaborated by his followers. Moreover, the aspects of the psychoanalytic discourse I choose—or feel compelled to choose—to utilize in a particular instance is shaped by a variety of other theoretical, practical, and personal materials too numerous and complex to begin to enumerate or analyze. I therefore decided it would be more useful, because more accurate, to put together a collection of essays that *demonstrated* the way a sampling of "new" art historians actually work. I decided, too, that it would be even more informative if the book also included essays by those identified with more traditional methodologies. The purpose of this anthology, then, is to look behind the rhetoric of the current methodology wars to examine the actual praxes of art history today. To see, in short, what kinds of questions specific historians bring to their task; what kinds of evidence seem meaningful to them; what they ignore; and how they marshal their *chosen* evidence, including that of the painting itself, to form their conclusions.

Finally, I decided the most interesting and informative format for such an examination would be one wherein all the participants were focused on the same object and had access to the same written materials. Observing a group of art historians working on different objects seemed a much less revealing exercise in contemporary historiography. Although I considered a number of possible works, I decided on Manet's *A Bar at the Folies-Bergère* (frontispiece) not only because it was a painting that had long interested me but because I knew that it could bear up well under such concentrated scrutiny.

All the essays except two were commissioned specifically for this anthology. Carrier's offering is based on one that appeared several years ago in a literary magazine and Boime's is from a recent German art-historical journal. Because both were much changed and because neither of these important writings was easily accessible to a general audience, their inclusion here seemed warranted. Kermit Champa's essay was commissioned for this volume but has since appeared in a collection of his writings. It appears here unaltered. The two important recent writings on Manet's *Bar* not included are Novelene Ross' *Manet's Bar at the Folies-Bergère and the Myths of Popular Illustration* (1982) and T. J. Clark's "A Bar at the Folies-Bergère," chapter four of his book, *The Painting of Modern Life* (1984). The latter, in particular, continues to occupy a central place in the scholarly debate on the painting, as you will see. The length and general availability of each

argued against their inclusion. I mention these two writings partly to remind the reader that this anthology represents merely the latest chapters in a long and ongoing process of investigation in both Manet studies and art history.

Although Manet's *Bar* is the subject of all these essays, the painting is merely the vehicle for a controlled experiment in current methodology, or methods. While I have tried to be as inclusive as possible with regard to current practices, I make no claim to completeness. The collection is merely a sampling, a representative one I believe, but no more than that. It cannot be said to be complete not only because of the fundamentally individualistic nature of contemporary methods but because many art historians now eschew so-called "masterpiece studies," preferring to focus their attention on visual imagery and material artifacts from the domain of ordinary culture. Their voices, obviously, are not to be found here.

I have also commissioned one of the leading historiographers in the field of modern art, Richard Shiff, to write an introduction to the volume. That introduction, like the essays themselves, is not meant to close discussion, but to open it. Hopefully, my colleague will find this collection more than useful.

Bradford R. Collins

12 Views of Manet's *Bar*

Ascribing to Manet, Declaring the Author

RICHARD SHIFF

> Imagine that someone unconscious (anesthetized, perhaps)
> were to say "I am conscious"—should we respond "He
> ought to know"?[1]

NINETEENTH-CENTURY Paris was the chief testing ground for modernity and the central location for modernity's art. Manet was quintessentially Parisian. Born in 1832, he spent his childhood (prophetically, it seems) just across the Seine from the Louvre and down the street from the Ecole des Beaux-Arts. As an adult and until his death in 1883, he maintained residences and studios in the city, figuring prominently in its social and cultural life.[2] In his capacity as painter of modernity, he was in the right position to know what he was doing. But how do *we* know what Manet did or intended to do? What do his representations communicate—and to whom?

During his half century in Paris Manet witnessed a transformation of the urban environment: it was the period of regional industrialization, of railroads and commuter transport, of Baron Haussmann's grand boulevards, of commercial enterprise and display on a massive scale, of the café and the *flâneur,* of what has come to be called "spectacle"— Paris as image of capitalist success, perpetually regenerating the very desires that the city's offerings were designed to satisfy.[3] It is often argued that the process of modernization as it occurred in nineteenth-century Paris anticipated typical economic and social developments across Europe and America. Early modern Paris was the present Western world in embryo. Hence, one reason art historians and others, including the authors represented in this volume, attend to Manet and his immediate environment: nineteenth-century Paris is quite relevant to a twentieth-century understanding of Euro-American culture.

Manet's visual art preserves the traces of his Paris. So do related literary documents such as Charles Baudelaire's poems and essays,

1

Emile Zola's novels, and the subsequent account of the culture of arcades and department stores (the culture of commodities) offered by Walter Benjamin, one of Baudelaire's most astute readers.[4] Like Baudelaire, Zola, or Benjamin, Manet was both consumer and creative critic of the Parisian experience. Sophisticated and well-to-do, he coursed the boulevards, strolled the parks, patronized shops, theatres, and cafés, and journeyed by rail to suburban gardens and still further to coastal resorts. Indeed, Manet's early biographers portray him as belonging to a privileged class, enjoying its prerogatives and cognizant of the signs of class in both material things and other people: "He loved elegance, took an active part in society, charmed everyone with his distinguished manners and refinements of speech."[5]

Over more than a century of interpretation, Manet's consciousness of class has been often acknowledged, yet rarely used productively, especially not by those aiming to set his painting into a general history of modernist style. T. J. Clark's work in the social history of art established a different course. His book of 1985, *The Painting of Modern Life: Paris in the Art of Manet and His Followers,* investigated Manet's imagery in specific relation to the cultural construction of Parisian class identities. Although the issue of class might at first seem to belong to histories of political, economic, and institutional development, it is by no means untouched by the history of art. Because art constitutes a major source of imagery (pictorial discourse), it is intimately linked to class as a cultural product. Indeed, according to Clark, class distinction does not arise from any "natural" social evolution but is a discursive production that serves a certain structure of power and privilege. Such a structure, whether we think of it as representation or reality, works to sustain and reproduce itself; yet it is also affected by forces altering its configuration. Collective ideology prevents the individual (the subject in discourse) from recognizing this inherent potential for change: "Ideologies naturalize representation. . . . Ideology is a set of limits to discourse [and] closes speech against consciousness of itself as production."[6] In other words, while ideological representations (both literary and pictorial) purport merely to describe or reflect existing social conditions, they actually "produce" those very structures and relationships, which, as a result, become the "reality" recognized in everyday life. Alternatively, it can be argued, ideology generates the knowledge that leads an individual to accept one set of social relations as true to

2

reality while regarding others as false or illusory. In effect, representations tell the members of a society who they are and where they belong. Yet given this state of affairs, representation can also function as a kind of counter-production; for no hierarchy or order that excludes all others can be "natural" to the play of representation itself. Although representation fixes the image of a particular thing within a determined context, it also introduces a fundamental indeterminacy, a flux in the meaning of all things; representations shift whenever the understanding of their contexts and environments does. Perhaps the only thing "natural" to representation is that its meaning is neither singular nor predictable, but forever contested.

Clark's analysis of the production and reception of Manet's last major painting, *A Bar at the Folies-Bergère* (1881–1882), follows his extensive discussion of the Parisian café-concert, a social and cultural institution that operated across class divisions, tested ideological limits, and threatened to destabilize any normative representation of class relations. Clark's influential view of Manet's *Bar* constitutes much of the common ground for the twelve essayists in this volume; developing their own interpretations, they often either differ with Clark's details or dispute the validity of his purpose and methods. Some essayists extend Clark's historical analysis of the café-concert and its entertainments: John House attends to the fortune of such establishments with regard to particulars of political life during the 1870s; Tag Gronberg discovers problematic aspects of modern masculinity in representations of acrobats (Manet's *Bar* includes one). Several contributors develop psychoanalytic insights: in different ways, Bradford Collins and Steven Levine probe forms of psychological recognition associated with Manet's art as well as historians' writings; Albert Boime attends to specifics of the painter's fantasy life and psychological needs. Still other scholars pursue matters of theory: David Carrier analyzes ideology as a "shared neurosis"; he relates this concept to the fact that Clark saw fit to publish two interpretations of Manet's *Bar* and claimed rather cryptically that the second disputed the first.[7] I will briefly allude to each of the twelve contributors in the course of this introduction, setting their present efforts into a historical and methodological context, but without attempting to indicate the full scope and significance of any individual statement.

On at least one point all scholars seem to agree: Manet took great pleasure in the novelty, diversity, and experiential richness of life in

Paris. His artistic concern was to capture in paint that life's particular character and interests, and the very act of doing so identified him as modern. In contrast, traditional or classical painters—even when their images evoked current events and politics—led viewers into a realm of "timeless" value and "generic" beauty (such designations being used during Manet's era). This kind of beauty could be seen in the Louvre's collection of antique statuary, but not on the walls of a portrait photographer's studio; it was the antithesis of individual character and of the character-types who populated urban society, those personages who best represented the various social classes, professions, and codes of moral conduct.[8] When academically trained artists failed to idealize or beautify their live models in the expected, conventional ways, critics accused them of "copying" nature slavishly, with the implication that they lacked sufficient inventive skill and imagination to convert banal reality into a higher form. Curiously, unexpected or irregular features in painting were often regarded as signs of creative and technical limitation, not freedom.

Yet what is slavish for one, is liberating for the other. Once the positive value of individual experience and independent judgment became an issue in political life, painters had cause to doubt the ultimate merits of the academic hierarchy. It seemed fitting to associate unrestricted individual action and expression with democracy and republicanism, as well as with romanticism and realism in the arts; whereas respect for classical hierarchy connoted the old authorities of aristocracy and the Roman Church. Given the choices, painters agonized over the extent they might allow a figure drawn from life to retain the peculiarities of its appearance, those very aspects that seemed "ugly" to eyes trained in the artistic norm. Baudelaire's criticism became a persuasive, if complicating, force in the debate. Encountering an exhilarating diversity at the Universal Exhibition of 1855—objects ranging from Chinese handcrafted decorative arts to photographs suggestive of industrial or mechanical process—Baudelaire offered a guide, not only to casual tourists but to artists of his era: he reversed the expected formulation, announcing that beauty would not be found in regularity but in strangeness.[9] This meant that no matter how unfamiliar its effects might be, the modern (like the exotic, which in Baudelaire's example was the Chinese) would hold its own peculiar aesthetic charm, as valuable as any effusion of classical culture. The observer need merely be open to this

beauty and accept it. In 1876 such was precisely the advice of Edmond Duranty, "realist" writer and critic, who ridiculed contemporary painters for depriving themselves in pictures of what they appreciated in everyday life: "Perhaps some day the living French woman with her turned-up nose will [finally] dislodge the Greek woman in marble, with her straight nose."[10]

To resist the authority of tradition and discover the beauty of modernity—a taste already savored in the streets, yet unacknowledged in art—a painter could simply depict, naively and directly, what was already there to be observed in Paris or, indeed, anywhere else. Thus Zola, recalling the time Manet painted his portrait, complimented the artist for the fidelity of his "copying" and for his proud acceptance of (as Manet himself supposedly put it) "not know[ing] how to invent," that is, either failing or refusing to elaborate, edit, idealize, or (as Duranty might metaphorize it) convert the model into something worthy of classical marble.[11] To the contrary, Manet "copied." Yet no one can deny that he arranged and composed his works. Manet's *Portrait of Zola* (1868) itself cleverly displays a pamphlet the writer published to accompany the painter's private exhibition of the previous year.

We can only conclude that the meaning—indeed the good faith—of a given painter's acceptance or denial of his own imaginative and willful composition cannot be determined without engaging some specific cultural discourse. The artist's statements require an interpretive context (which might belong more to the interpreter's era than to the artist's). For who can say with any finality what counts as copying the "real" or inventing the "ideal"? Or, for that matter, as conscious or unconscious expression? In any exchange between painter-subject and model-object, the precise terms of the exchange, the abstract concepts and material things denoted—even the actual physical actions associated with the painter's act of representation—all these can assume multiple meanings within plays of difference to which different people, or cultures, or societies are sensitized at different moments. Copying can signify either slavishness (dependence on the live model) or liberation (from conventional practices), while invention can signify either liberation (from the live model) or slavishness (obligation to aestheticize and compose). When the twelve interpretive essays in this volume differ, it is usually not because of a dispute regarding factual data, but more often because of disagreement as to how the nature of the artistic and historical discourses

should be construed. Who is positioned to be the judge of whom? One matter to be decided is the extent to which today's interpreters conceive of themselves as identifying with, and their writing as implicated in, the nineteenth-century issues they study, as if there could be no "objective" distance (more on this matter follows).[12]

What do we know, factually, of Manet and his art? A great deal—and yet Manet remains a somewhat shadowy figure because he protected his privacy. When he died in 1883 of a long, debilitating illness, he was a relatively young man.[13] Most of his friends outlived him; Baudelaire, a decade older, was the exception, having died in 1867. Manet's friends disseminated a number of anecdotes, chosen, it seems, to solidify the painter's quasi-mythical position as both revolutionary leader of the avant-garde, and refined, witty, eminently dignified member of *haute bourgeoisie*. A story told by Antonin Proust concerning Manet's years in Thomas Couture's studio (the early 1850s) serves particularly well to establish the painter's irreverent "modern" attitude. Proust recalls how his fellow student Manet irritated Couture's illustrious model, the very professional Dubosc, by repeatedly demanding more natural, less "academic" poses. Exasperated, Dubosc finally reminded the importunate Manet that owing to his excellence as a model, "more than one" student had "gone to Rome." By "Rome" Dubosc meant the Rome Prize and the French Academy in Rome—that is, success in the institution of art, which required a proper understanding of tradition, how to make a figure look Roman and classical. Manet's retort returned Dubosc from the ancient world to the modern: "We're not in Rome and we don't want to go there. We're in Paris: let's stay here."[14] The distinction between classical and modern could not have been rendered more graphic.

Manet's subjects demonstrated the immediate presence of modernity—its environmental presence as well as the pressure it put upon the viability of classical modes of representation, which seemed unsuited to images of urban movement, transience, and the flux that shaped modern society. Manet depicted change not only in the physical nature of the city (*The Rue Mosnier with Pavers*, 1878) but also in the social identities of its residents, their patterns of work and leisure, and habits of vision (all of which can be derived from *A Bar at the Folies-Bergère*). As a cultivated intellectual as well as fashion enthusiast, Manet may have expected his ideal viewer to be able to connect the world of the museum, library, and conservatory to that of the café and the street, as his friend Baudelaire did famously. In his early work

particularly, Manet combined observations of modern life with references to traditional pictorial themes, intentionally confusing old categories of learning with new topics of observation: he would convert the classical goddess or concubine into an urban prostitute (*Olympia*, 1863), or elide the cultivated man's knowledge of personifications of Victory with the fashionable man's interest in costumed bullfighters (*Mlle V. in the Costume of an Espada*, 1862).

Thematically, Manet's art directed viewers from the general and timeless (comprehensive allegories and mythologies) to the specific and momentary (encounters with a changing daily life); his work often corrupted classical concepts by evoking them through the appearance of the modern. Manet's application of paint featured—in fact, it constructed—the look of a corresponding abruptness and spontaneity, a quality of the here and now. His paint calls viewers, especially nineteenth-century viewers, to attention. Manet neglected conventional compositional order for the sake of suggesting directness of vision, hence truth to appearances and sincerity of emotional response. With its idiosyncratic immediacy—the bold, summary brushwork, the spread of blond tonalities, the radical simplification of perspective effects—Manet's painting interrupted the continuity of conventional pictorial space and, by extension, the coherence of systematic academic practice and every cultural value it connoted. Many who observed the technique recognized, or chose to assert, a connection between painting Parisian life and a kind of generalized rupture, not only pictorial but social. Here, for example, is the commentary of Ernest Chesneau in 1880: "To representatives of diverse social conditions, the types we encounter each day in Paris, [Manet] has wanted to give the importance that the academies reserve exclusively for mythological or historical figures. . . . [With his] summary technique, [he] appears entirely preoccupied with expressing modern life in its precise reality and divorcing his art from the professional studio conventions transmitted from school to school."[15] Chesneau's phrase "from school to school (*d'école en école*)" can also be translated as "from fashion to fashion" (or "from one fashionable clique to another"). If the tradition of painting forged links across social space and time, establishing a common ground even among passing fashions, Manet's involvement with modernity moved beyond—or perhaps to the side of—the spaces charted by *either* tradition *or* fashion. Manet's painting was both, and it was neither. Where, then, was a viewer to locate this art?

The situation had an obvious political dimension, at least in the minds of critics adept at drawing analogies: if Manet's work lacked the conventional sense of hierarchy in both subject matter and formal composition, this compound failing, for better or worse, signalled the demise of the old aristocratic order and the political ascendancy of the new urban bourgeoisie, a social class, or set of related economic and professional classes, that had the distinction of *lacking* tradition. The argument of Louis Courajod, a conservative educator, was characteristic: "The danger of art in France lies in . . . contempt for authority, the hatred of a hierarchical system . . . and a witless intellectual democracy which degrades the highest minds to the level of the lowest."[16] Yet, when he spoke on his own behalf in 1867, Manet could hardly be judged a social or political upstart. Although he complained of intolerant academic juries, he also insisted (perhaps disingenuously) that he had no interest in attacking the values of others. Referring to himself, he emphasized, as Baudelaire or Duranty might, the need of an artist to express an individual's world and values: "Monsieur Manet has always recognized talent wherever it is found and has never pretended to overthrow an old manner of painting or create a new one. He has simply sought to be himself and not another."[17] Here we can substitute "tradition" for what Manet calls the "old manner of painting," and substitute tradition's antithesis, "fashion," for the "new" manner he would not presume to invent. Manet opposed his art to both.

Like Duranty's real Parisian woman with the decidedly noncanonical nose—that is to say, like the irregular reality of the modern world—Manet's art could claim neither perfection nor a related completeness. "Today's artist," he stated, "does not say 'Come see works without faults,' but 'Come see works that are sincere.'"[18] Sincerity, a theme among romantic critics of the earlier nineteenth century, was a particularly intangible quality, quite open as to what might signify it and not easily formulated in pictorial terms. There may have been conventional postures, facial expressions, and allegorical attributes to represent nobility, or courage, or temperance, but none to signify the modern value of sincerity or the related quality of naiveté. If the painting of modern life found its standard of excellence in the sincerity of the artist, then art became a matter of morality, sensibility, and inner psychological state, rather than rational judgment and technical expertise—in other words, not something that could be transmitted as a verbalized aesthetic principle or a skill of trained eye

and hand, not something for the academic studios or even the fashion cliques. Aware of this level of distinction, Zola defended Manet by insisting that the painter would never commit the error of entertaining "ideas" in the practice of his art.[19] "Ideas" were a matter of philosophies and precepts, not living sensations and emotions. Yet Manet's position by no means excluded the development of techniques suited to its own representation; he may not have professed an explicit verbal theory, but his art nevertheless had a visual rhetoric. Given a critical discourse that recognized sketchlike effects as signs of an artist's commitment to both "sincerity" and republican politics, Manet could cultivate his technical abbreviations: bold juxtapositions of darks and lights, heavily worked surfaces seen against thinly painted ones. These were the visible discontinuities that marked his modernity.

Perhaps Manet's public stance was best encapsulated when Zola evaluated his career not long after his death, claiming that "in beginning a picture, [the painter] could never say how it would come out."[20] Modernist artists reiterated this formulation as they emphasized that their images derived not from rules or formulas, but rather from a set of unpredictable responses, drives, and feelings—whether stimulated by the model (as in naturalistic portrait painting) or by the composition itself emerging on the canvas at the moment (as in certain kinds of expressive abstraction). What had been said of Manet's combination of intellectual and emotional liberation would be said also of Jackson Pollock seventy years later: "He does not know beforehand how a particular work of his will end."[21]

By now it seems especially evident that (from before Manet, to after Pollock) such declarations are ideological; such accounts, mythological. This is "evident" not because art historians have collectively become better critics, but because the configuration of critical discourses has shifted. We appear to have passed into another era—one less committed to, or less convinced of, the value, the efficacy, and even the very possibility of genuinely individual action, spontaneity, "sincere" expression, "naive" observation. Today's assurance, however, requires an immediate caution (hence the quotation marks accompanying my word "evident"). Perhaps our evidence comes too easily. We tend to exaggerate the differences between our own beliefs and those of the recent past. We join our counterparts in the nineteenth century in making the recent past—both theirs and ours—seem more univocal, fixed, and extreme than it might. We must recall

9

that even those who championed "sincerity" during the nineteenth century recognized it as a pose as much as a worthy value; as a principle, sincerity was questioned by many of its adherents, even as they sought to act upon it. Consistent with this modernist tradition of multiplicity and self-doubt, the questioning of the writer's own ideological premises is a feature of many of the essays in this volume. The matter is especially developed with James Herbert: he calls upon readers to challenge his own purchase on reality, just as he is challenging Clark's; Herbert then engages the reader in a particularly active investigation of social ranking, provocatively suggesting that Manet's *Bar* might work to reconfigure its privileged viewer as female, not male.

Herbert's interpretive concerns are both historiographical and political. His politics are feminist; he recognizes and chooses to resist prevailing forces of patriarchy. Indeed, if the ideological nature of accounts of Manet and other modernists has become "evident," a second cause of this unmasking is widespread belief that the lineage extending from Manet forward (to Cézanne, to Picasso, to Pollock) operates as a patriarchy, a system constructed to privilege the contributions of men. The predominance of patriarchal conceptualizations and institutions necessitates special efforts on the part of historians who would resist the traditions that make patriarchy seem so natural. To question one's own gendered responses to images, as either man or woman, is consistent with such resistance (compare the essays by Bradford Collins and Griselda Pollock).

It might be argued that a scholar's mythology (faith in the possibility of rational explanation) conflicts with an artist's mythology (faith in the possibility of liberated emotional expression). Although scholars have their own blindnesses, it is their business to gainsay mythologies. Yet not all historical study pits the scholar against the self-declared face value of the evidence. Certain modes of analysis suit the surface characteristics of the works or artists to which they are applied, appearing to mirror without much distortion. For example, historians using an analysis of market economics to understand why artists chose certain projects at certain moments may actually work in consonance with the attitudes of a Monet or a Pissarro, both of whom openly cared about sales; but they meet resistance in a figure such as Cézanne, who did not, openly or otherwise. With regard to Manet (or Degas, who is comparable), the painter's own interest in representing women in specifically modern situations, as well as his

10

sensitivity to the markings of class and profession, make him a natural target for discussions of the politics of class and gender.

Despite possible points of sympathy, partnerships between artists as historical figures and art historians as their belated critics nearly always become uneasy. In Manet's case there is an obvious sense in which the customary methods of the art historian cannot square with the painter's self-representation: in statements designed for public consumption (as opposed to private opinions passed on to friends and acquaintances), Manet insisted he did not plan his works; whereas art historians assume that every work of art has a plan, order, procedure, or motivation to be uncovered, described, and analyzed—whether an individual's willful intention (conscious) or a society's ideological construction (unconscious). Of course, if the "plan" is ideological, the historian's effort must reveal an order of representation that the artist may well have created (or reproduced), but only unwittingly. To put meaning and order into art—to operate beyond merely finding what is already clearly there—constitutes the art historian's task, what he or she has been trained to do. While scholars debunk mythologies of the past and work to give past representations what they regard as an accurate interpretive viewing, they participate in creating (or reproducing) the mythologies of the present. This is another way of saying that art historical interpretation is itself motivated or interested. As such, it is productive in an ideological sense. Yet the authors in this volume take steps to make evident that very principle, otherwise so often hidden. They unmask many of their motivations, interests, and assumptions, which become acknowledged features of their interpretations.

Can the matter be pushed further? Are today's authors in a better position to know their own motivations than to speculate on those of others? Why study the past? Should past representations be investigated only as a means of self-criticism?[22] The question relates to a fundamental problem addressed by theories of language and by psychoanalysis, of which Manet's famous mirror is emblematic. It not only reflects, but also splits his *Bar* into alternative zones of reality and illusion (a point made by James Herbert, Jack Flam, Bradford Collins, Albert Boime, Carol Armstrong, and others).[23] This difference generates the two images of Manet's barmaid—one woman who is emotionally opaque, the central figure appearing to address the viewer, perhaps even mirroring him/her, and another woman who represents the ready satisfaction of male desire, the mirrored

11

figure who engages a depicted man's attention. Does this split reflect a difference in Manet (and, presumably, in other men of his class), one he demonstrates for us, as if he were saying "Here is my conscious world, and here is my unconscious; here is my reality, and here is my dream"?[24] Perhaps recognition of the split in Manet's pictorial construction indicates a universal condition: any representation, visual or verbal, divides subject from object, facilitating the understanding that subjectivity is contingent upon an individual's existence as an object for others. The perceiving subject is split off from everything it sees. Without this alienating divide, there is no subject.

If Manet's *Bar* addresses this general condition of human subjectivity, the matter does not rest. For if we realize our social condition in relation to others only through the mediation of representation, then words and pictures create the reality we live. Representations are what we see, and they both disclose and mask. This is tantamount to saying that words and pictures place the subject within some specific ideological framework, ideology becoming its (our) reality. The "truth" of representation is partial at best; representation separates the subject from any integrated knowledge or fulfilled desire. When we state, for example, that a set of representations (a discourse) is gendered masculine and figures its subjects as either possessing or lacking an essential masculinity, we are alluding to such an ideological split, an arbitrary investment of truth and value in judgments of masculinity.

Many scholars have explored such issues through the psychoanalytic theory of Jacques Lacan for whom the experience of mirroring is basic to self-consciousness (in this volume, see, among others, Carrier and Collins). Lacan discusses painting as a prime example of representations that fix the "look" or "gaze" (*le regard*). We must think of the Lacanian gaze not so much as a view directed outward, but as a look returned, or as a pictorial field in which subject and object meet in a play of vision and mutual desire. (The gaze is not embodied or personalized; *it* embodies *you,* lending you an identity; it envelopes you in its field.) Because any given picture fixes the view or the look of something, it causes the individual subject to misperceive that its true desire is satisfied in this one view, which seems to reflect and return the gaze, remaining ever available, as if now and forever the gaze were personalized and possessed. For the moment, the subject feels itself completed in the image it sees; and the desire of the subject becomes identified with the desire of the object, which

is the desire of and for another subject. In this sense, a picture, like an ideological representation, gives a false but desirable accounting of real conditions. There is no "true" accounting. The subject must eventually experience the image slipping away from it, signifying much more than what the subject can fix or possess, generating desire rather than its satisfaction.[25]

Art historians persist nevertheless in collecting facts and documentation, as if to provide, at the very least, a kind of true and satisfying inventory of the "picture." Manet's *Bar at the Folies-Bergère* is a distinguished painting within the European tradition as well as a "picture" in the very general Lacanian sense. According to its interpreters, it depicts an exchange of relatively personalized gazes. What scene is actually illustrated? With regard to the architecture of the Folies-Bergère itself, Manet appears to locate his viewer in front of one of the bars along a promenade in the balcony above the establishment's main room, a horseshoe-shaped theatre.[26] Since the viewer's position is directed toward one of the side ends of the balcony, the mirror behind the bar reflects the distant crowd at the opposite end of the same curving structure.[27] The crowd itself is well dressed and either affluent or acting so; indeed, the Folies was a relatively expensive place of entertainment.[28]

In 1986 Juliet Wilson Bareau interpreted the results of an X-radiographic analysis.[29] She concluded that Manet twice shifted to the right the reflection of the barmaid; he also reconceived the male figure who addresses her and who appears only as mirror image (for further discussion, see the essays by John House and Jack Flam). The X-rays indicate that Manet's composition of the reflected barmaid and patron only gradually assumed its optically illogical relationship to the central figure of the "real" barmaid. Although T. J. Clark in 1985 did not have the benefit of Juliet Wilson Bareau's study, he regarded the *Bar*'s final composition as calculated to convey a precise meaning. Clark assumes that some consistency motivated Manet's inconsistency: "Inconsistencies so carefully contrived must have been felt to be somehow appropriate to the social forms the painter had chosen to show."[30] Despite the confusing result, Manet's changes in composition are, of course, consistent with the production of a studio work, for which live models may be posed in various orders or may have their images adjusted arbitrarily by the painter. Can studio work that results in what cannot be observed in nature (an illogical optics) nevertheless be "sincere"? Can such composition, as

Clark might ponder, accord with a "metaphysic of plainness and immediacy"?[31]

One actual witness to Manet's studio work on the *Bar*, the artist Georges Jeanniot, insisted that "Manet, although painting his pictures from the model, was in no way copying nature."[32] It is as if Jeanniot were responding to critics who had complained of a lack of imagination, idealization, and inventiveness. His verb "copying" is particularly marked in this context. Even as Jeanniot speaks of Manet's inventive construction, he notices in Manet's style precisely those "summary" qualities that Zola had taken as the sign of a welcome naiveté and, indeed, a practice of direct "copying," a way for the artist to express the particularity of his vision (painting "as he sees").[33] Apparently, a given set of pictorial features can plausibly suit contrasting positions and attitudes: the very same visual effects are regarded by Zola as adherence to the direct sensation of nature, and by Jeanniot as departure from it. In Jeanniot's words, "Everything was abbreviated; the tones were brighter, the colors livelier [than in nature]."[34]

The difference between Zola and Jeanniot, which seems quite unstable, is not a matter of a viewer's isolated judgment. Instead it speaks to the specific discursive context and the motivation behind each statement. Zola witnessed and discussed Manet's "copying" in 1868; Jeanniot wrote in 1907, recollecting Manet's practice as of 1882. Between the two accounts, in 1902, Manet's old friend Théodore Duret solidified the prevailing artistic mythology as he featured its two essential terms, *sincérité* and *naïveté:* "Never has anyone painted with more sincerity and, for that matter, more naiveté than Manet; never has anyone, with brush in hand, absorbed by the subject, sought to render it more faithfully."[35] Is Jeanniot's 1907 description of what Manet was doing in 1882 being triggered by Zola's and Duret's language, based as it well may be on Manet's verbal self-representations? Barring further information, it remains uncertain whether Jeanniot intended his remarks to confirm or deny the position of his predecessors.

Such matters quickly become complicated for historians, because they are the most likely to understand that Manet's use of the live model could evoke either a practice of determined "copying" (the artist's faithfulness and sincerity) or a practice of "invention" and "idealization" (the artist's expression of will and desire, which can also be associated with sincerity).[36] The matter had been prob-

lematized by Baudelaire in a way that seems to encompass statements issuing later from Manet, Zola, Duret, and finally Jeanniot: "The introduction of the portrait—that is to say, of the idealized [living] model—into historical, religious, or imaginative subjects necessitates at the outset an exquisite choice of model [that is, one that exemplifies the beauty to be discovered in modernity], and is certainly capable of rejuvenating and revitalizing modern painting."[37] Baudelaire conflates portraiture as a naive "copying" of unique particulars, with portraiture as imaginative portrayal, characterization, and idealization.[38]

We have become so accustomed to regarding painting as a Baudelairean exercise in subjectivity (in contrast to the use of standardized, and therefore "objective," imagery) that it is natural—ideological?—for us to confuse two seemingly opposed sets of conditions, which might be described as those of "art" and those of "life." On the one hand, we have the particular conditions within the studio, a controlled environment arranged at the painter's will (this is "art"). On the other hand, we have the worldly conditions the painter attempts to represent (this is "life"). Recall how many artists of the earlier twentieth century, including Matisse and Picasso, thematized the studio in their work, as if to obviate any distinction between a "real" life-world and a fictive, pictorial world—to eliminate, as it were, the tension in Manet's mirror. If "art" in the enclosed or framed environment of the painter's studio seems to become the only "reality," then studio work and pictorial construction (a *making* of "nature," not its finding or disclosure) assumes a very special meaning, indeed a kind of truth value. And this is the truth so many of us, including both artists and historians, now hold dear: discourse and representation construct the only reality we know. If there is some other reality affecting us, we cannot discern it.

A woman known as Suzon, who tended bar at the Folies-Bergère and who became the specific character Manet eventually featured in his pictorial *Bar,* was hired as a model for the painting as it progressed in the studio. One interpretive account recognizes her problematic status as both "reality" and "representation" by making two observations potentially so independent of each other that it is as if they were penned by different hands—one hand writing of the *barmaid* Suzon whose "professional attentiveness barely hides exhaustion," the other writing of the *model* Suzon whose "tired and rather bored expression may be largely a result of posing for long hours in

15

Manet's studio."[39] There is a logic to this dual observation: although she would have been more expert at one role than the other, bartending and modeling were both tasks for the historical Suzon, and both were performances of self-representation. As performances they were perhaps strained in the way that professional activity of any kind is likely to be (whether gendered male or female), because a pose of equanimity must be maintained under all conditions. The "real" Suzon, with all her "real" emotions, if ever "she" existed, was and will remain invisible.

Nevertheless, Jeanniot witnessed a very visible Suzon as a model in Manet's studio. Although his observations may appear to be innocent, empirical, and diaristic, they follow the dissemination of Baudelaire's views, are in some respect marked by them, and lead inexorably, if the interpreter attends to the discursive traces, to some of the most massively debated issues of cultural and moral value in the nineteenth century. Questions centering on the exercise of originality and invention or on the expression of one's view (whether in the more literal sense of "painting what one sees" or in the more metaphorical sense of rendering a judgment) were related to arguments over what level of personal satisfaction individuals might be entitled to in a modern society. Such issues were contended in the form of philosophical and aesthetic abstractions, as well as in connection with specific matters of social policy, religious doctrine, and legislative control.

Jeanniot's account of Manet's *Bar* demonstrates the capacity of a critical term—in this instance, "copying"—to resume or focus debate, with the effect of turning the direction of a general understanding. It is instructive to compare Jeanniot's case to the essays in this volume, which often involve an expansion or shifting of the prevailing pattern, because the authors either introduce new references, considerations, and interests or give old ones unexpected emphasis. Interpretations often hinge on a single highlighted word or an obscure pictorial feature which suddenly becomes meaningful. For example, Michael Driskel observes in Manet's *Bar* a particular detail of the posture Suzon assumes, the fact that her hands turn outward toward the viewer, a feature to be seen in nineteenth-century depictions of the Virgin Mary. Driskel surmises that Manet may have been playing on popularized forms of Marian religious imagery; in turn, this would link Manet's art to debate over the role of religion and the Church in his modern society. To be sure, others have noticed a gen-

eral resemblance between the modern Suzon and the traditional Mary (and in some instances, the figure of Christ).[40] Robert Rosenblum, for example, remarks on a "Raphaelesque compositional Madonna."[41] Yet the import of Driskel's account is very different from Rosenblum's. Rosenblum likens Manet's composition to Raphael's, restricting his observation to the formal and typological; it is but one of a number of disparate visual comparisons, all presented as of similar interest, in effect an expression of authorial disinterest. Driskel instead connects one kind of scholarly investigation (pictorial style, its narrative content, its dualistic structure) with another (the politics of religion during Manet's era), asserting the latter as *his* interest.

Like Driskel, Griselda Pollock notices something about Suzon's posture and the way she shows her hands—in particular, the fact that Manet's view attends to something less than the entire hand, "the bulging mounds of Venus, as the fleshy parts below the thumb are named." In addition, Suzon's hands are ungloved, simply naked; and Pollock relates this to nineteenth-century typologies of women. Building on such details, she also scrutinizes a figure in the background of the *Bar* (the "metaphorical female spectator"), raising the possibility that Manet made oblique allusions to Mary Cassatt and to nineteenth-century attempts to reconceive the structuring of gender, *her* interest.[42] In varying ways it is also the interest of Boime, Collins, Flam, Gronberg, Herbert, House, and Levine, several of whom ponder gender reversals or transferences. For example, with the aid of biographical considerations, Boime reasonably concludes that in Suzon "Manet create[d] the female equivalent of himself."

To return to backgrounds and viewings: When the actual architectural setting for Manet's *Bar* is considered, the gaze of the Cassatt-like figure (in Pollock's words, the "young bourgeois woman from the respectable opera") is directed not only "elsewhere" (in Pollock's feminist sense of the figure's disengagement from a masculine order of representation), but also specifically toward the theatrical stage at the Folies, as opposed to the promenade and gallery spaces. So a divide or split opens. When viewers—their gender not necessarily being at issue—consider Manet's *Bar* as an independent material object (compare Armstrong, Flam, or House), they first see a painted surface facing them, as if the picture itself, not its represented figures, were structuring the gaze. For a feminist, the Cassatt-like figure is anomalous in that its depicted gaze fails to engage the (masculine) viewer. Yet, for a social historian, this figure seems logical enough in

17

that its bourgeois character-type acts properly, looking toward the stage of the Folies-Bergère, which is to be located in the "real" space of the world imagined beyond the left-hand frame of the picture. Given the indeterminacies, it is useful to consider David Carrier's argument that ambitious interpretation, necessarily contextualized and hardly disinterested, just as necessarily leads to ambiguity.

Having different interests, Driskel and Pollock move in different directions from similar observations. The fact of their divergence is emblematic of a general reorientation occurring over the past two or three decades. Previously, it was typical of art historians to research all conceivable links between images within the history of art, which they regarded as a single, cohesive discourse; its elements were the objects of Western art and of those non-Western arts collected by Westerners. Historians recorded all possible similarities as a set of objective data; if they pursued interpretive directions motivated by contingent interests, they were not particularly open about such "subjectivity." Scholars acted as if a comprehensive knowledge of the vicissitudes of visual motifs within the history of the culture (a kind of panoramic vision of Western art) would yield a fundamental understanding, independent of the politics of the moment. Recently, researchers have chosen—or have felt themselves increasingly obligated—to pursue matters otherwise, however much they might still rely on typological classifications and documentation supplied by their predecessors. If the older questions concerned attribution, stylistic innovation, grand schemes of evolution, and identification of pictorial sources and iconographic themes, the newer questions concern the relation of art and artist to society: Which aspects of culture and society do works of art actually represent, either directly or indirectly? Is it conceivable, for instance, that Manet somehow pictured the structuring of class? Who is authorized to produce art? What is the social status of the artist? And how is the artist gendered? How should we conceive of the industry and business of art? How are artworks actually made and displayed? Who sponsors them? And who views them? What meanings do works of art generate? What meanings otherwise adhere to them, seemingly generated by outside forces? How does art affect the form of its society?

Each of these issues can be investigated as specific to a given category or class of people, because a society or polity is itself heterogeneous. Questions of this sort therefore open themselves to introspective accounts of the viewing process, since the art historian can

18

reflect on his or her own experience of the work and relate it to his or her own social identity. Indeed, the present collection of essays—representing a specific place and moment in art-historical scholarship, itself not necessarily stable—might be characterized by its encouragement, or tolerance, of the assertive authorial voice. Most of the contributors frankly declare their interests and commitments, and several assume an autobiographical stance; this is especially marked in Kermit Champa, as well as in Levine and Pollock.[43] On the evidence of this collection and other recent publications, it appears that many art historians are shifting from an archival or biographical method (reconstructing Manet's experience) to a more emphatically subjectivized, autobiographical method (reflecting on what the experience of Manet and his work means to the author). I say "more" subjectivized because the selection of an archive or set of documents, even by the most empirically oriented scholar, must already reflect a certain interest or bias.

Art historians' increasingly explicit recognition of their contextual limitations—the author's own situation in discourse and inability to assume a universalizing stance—might be linked to a postmodernist carnival of language and denial of authorial control. If our art history has indeed become "new," is it not likely to parallel a chronologically "late" postmodernism? Postmodernists stress the capacity of representations to associate freely with other representations, generating new meanings at each and every instant in a limitless play of both metaphor (association by resemblance or form) and metonymy (association by position or function). In a postmodern world, the author's position must keep changing as it negotiates a field of signs. Yet, ironically, the subjectivism that marks recent art history also accords with a familiar modernism. Modernists anchor representation in the expressive individual. Since such representation derives from a unique moment in a unique life, one author cannot adequately translate his or her perspective into another's. Multiplicity rules either way, whether one follows a modernist or postmodernist logic.

Modern or postmodern, the contemporary historian's critical method seems to mimic the problematic of modernity as it was once addressed by Manet's art. You approach modernity by probing your vision, your own perspective, the moment that belongs to you. The writing we call "history" therefore becomes artistic, like Manet's *Bar*—a matter of historically contingent, self-reflective expression. Has it not always been?

19

NOTES

1. Ludwig Wittgenstein, *Zettel,* ed. G. E. M. Anscombe and G. H. von Wright, trans. G. E. M. Anscombe (Berkeley, 1970), 71 (translation modified).

2. For the Parisian locations important to Manet's career, see the map in Françoise Cachin and Charles S. Moffett, *Manet 1832–1883,* exh. cat. (New York, 1983), 502–503.

3. On "spectacle" in relation to Paris, see T. J. Clark, *The Painting of Modern Life* (New York, 1985), 9–10, 36; and Clark's inspiration for use of the term, Guy Debord, *La Société du spectacle* (Paris, 1967). Understanding of both Clark and Debord on spectacle can be expanded by consulting various writings by Walter Benjamin, Jacques Lacan, and Louis Althusser. Concerning spectacle as a social product of technologies that induce a distracted or fragmented consciousness, see Walter Benjamin, "On Some Motifs in Baudelaire," *Illuminations,* ed. Hannah Arendt, trans. Harry Zohn (New York, 1969), 155–200. Concerning the capacity of images to deflect any final satisfaction of desire, which is also a kind of distraction, see Jacques Lacan, *The Four Fundamental Concepts of Psycho-Analysis,* ed. Jacques-Alain Miller, trans. Alan Sheridan (New York, 1978 [1973]), 67–119. Concerning the problematic desire to perceive the "real" structure, mode of production, or social formation in or through its specular effects, see Louis Althusser and Etienne Balibar, *Reading Capital,* trans. Ben Brewster (London, 1970 [1968]), esp. 188. In a passage on the interaction of the singer Thérésa with her café-concert audience, Clark (224) evokes the language of both Benjamin ("inattentiveness," "shock") and Althusser ("interpellation").

Much of the debate around Manet's *Bar* has centered on whether the barmaid might also be a prostitute, a notion entertained by Clark. In the literature on modernity, the concept of prostitution—etymologically, a setting-before, a (visible) displaying or offering of oneself—has traditionally been linked to commodification; hence, to "spectacle" and the production of desire through representation. So prostitution becomes relevant to the study of ideology (as discussed below) in addition to being a topic for social history and gender studies.

4. See, for example, Charles Baudelaire, "The Painter of Modern Life" (1859–60), *The Painter of Modern Life and Other Essays,* ed. and trans. Jonathan Mayne (London, 1964), 1–40; Emile Zola, *Au Bonheur des Dames [The Ladies' Paradise]* (Paris, 1883); Walter Benjamin, *Das Passagen-Werk,* in *Gesammelte Schriften,* ed. Rolf Tiedemann and Herman Schweppenhauser, 7 vols. (Frankfurt am Main, 1972–1989), vol. 5; Benjamin (as in n. 3), 155–200.

5. Edmond Bazire, *Manet* (Paris, 1884), 25. (Here and elsewhere, author's translations unless otherwise noted.)

6. Clark (as in n. 3), 8.

7. The earlier version is Timothy J. Clark, "The Bar at the Folies-Bergère," in Jacques Beauroy, Marc Bertrand, and Edward T. Gargan, eds., *The Wolf and the Lamb: Popular Culture in France, from the Old Regime to the Twentieth Century* (Sarasota, 1977), 233–251.

8. On the opposition of "generic beauty" (associated with the arts of ancient Greece and Renaissance Italy) to particularized "character," see Charles Blanc, "Salon de 1866," *Gazette des beaux-arts* 21 (1 July 1866), 31.

9. Charles Baudelaire, "The Exposition Universelle 1855" (1855), *Art in Paris 1845–1862*, ed. and trans. Jonathan Mayne (Oxford, 1965), 124. Photography in the exhibition was not grouped with the "fine arts" of painting and printmaking, but with the industrial arts and commercial printing.

10. Louis Emile Edmond Duranty, "La Nouvelle Peinture" (1876), reprinted in Charles S. Moffett, *The New Painting: Impressionism 1874–1886*, exh. cat. (San Francisco, 1986), 478–479.

11. Emile Zola, "Mon Salon" (1868), *Mon Salon, Manet, Ecrits sur l'art*, ed. Antoinette Ehrard (Paris, 1970), 141–42. Zola uses the verb *copier* in its idiomatic sense to refer to portrait painting, but also to connote the unprejudiced directness with which Manet would conduct his rendering: "He copied me as he would have copied any human animal whatever." Such practice led another sympathetic critic to advise Manet, "Consult the model, don't copy it"; Ernest Chesneau, *L'Education de l'artiste* (Paris, 1880), 339.

12. A familiar scholarly parallel is the case of modern ethnographers—"self-reflexive writers occupy[ing] ironic positions within the general project of ethnographic subjectivity and cultural description" (James Clifford, *The Predicament of Culture* [Cambridge, Mass., 1988], 113).

13. Manet died of complications following the amputation of a gangrenous leg. The recorded symptom of his long-term illness was a degenerative locomotor ataxia, involving loss of ability to coordinate, and eventual paralysis of, the voluntary muscles. From the time of Manet's illness to the present, many commentators have assumed his affliction was tertiary syphilis; for a convincing argument that he suffered instead from multiple sclerosis or a closely related disease (not definitively diagnosed at the time), see Mary Mathews Gedo, *Looking at Art from the Inside Out: The Psychoiconographic Approach to Modern Art* (Cambridge, 1994), 6–9. It appears, however, that Manet's father suffered and died from syphilis (although this, too, is debated); see Nancy Locke, "New Documentary Information on Manet's 'Portrait of the Artist's Parents,'" *Burlington Magazine* 133 (April 1991), 249–252.

14. Antonin Proust, *Edouard Manet, souvenirs* (Paris, 1913), 21. Manet's complaint over the artificiality of the model's poses has a history, beginning at least with Denis Diderot, who made the same argument; Denis Diderot, "Essai sur la peinture" (1766), *Oeuvres esthétiques,* ed. Paul Vernière (Paris, 1965), 669. In 1876 Duranty (as in n. 10, 481) approvingly cited a related passage from Diderot's treatise (666–668). Tag Gronberg (in this volume) re-

sumes Georges Bataille's discussion of Manet's attitude toward models as a silencing of authoritative rhetoric—"the effect Manet deliberately aimed at [was] not a carefully arranged pose, but a natural disorder arrived at by chance" (Georges Bataille, *Manet*, trans. Austryn Wainhouse and James Emmons [New York, 1955], 38). On Bataille's *Manet*, see Youssef Ishaghpour, *Aux origines de l'art moderne: Le Manet de Bataille* (Paris, 1989).

15. Chesneau (as in n. 11), 337–338. I have reversed the order of Chesneau's two sentences.

16. Louis Courajod, *L'Ecole royale des élèves protégés* (Paris, 1874), ciii, as quoted and translated in Albert Boime, "Political Signification and Ambiguity in the Oil Sketch," *Arts Magazine* 62/1 (September 1987), 44. Much has been published on the political context for, and connotations of, Manet's style and subject matter. See, for example, Marilyn R. Brown, "Art, the Commune and Modernism: The Example of Manet," *Arts Magazine* 58/4 (December 1983), 101–107; Stephen F. Eisenman, "The Intransigent Artist *or* How the Impressionists Got Their Name," in Moffett (as in n. 10), 51–59; Jane Mayo Roos, "Within the 'Zone of Silence': Monet and Manet in 1878," *Art History* 11/3 (September 1988), 374–407; Philip Nord, "Manet and Radical Politics," *The Journal of Interdisciplinary History* 19/3 (Winter 1989), 447–480; John House, "Manet's Maximilian: History Painting, Censorship and Ambiguity," in Juliet Wilson-Bareau, *Manet: "The Execution of Maximilian": Painting, Politics and Censorship* (London, 1992), 87–111.

17. Edouard Manet and Emile Zola (?), "Motifs d'une exposition particulière" (1867), reprinted in Etienne Moreau-Nélaton, *Manet raconté par lui-même*, 2 vols. (Paris, 1926), 1:87.

18. Manet and Zola (as in n. 17), 1:87.

19. Emile Zola, "Une Nouvelle Manière en peinture: Edouard Manet" (1867), in Zola (as in n. 11), 101.

20. Emile Zola, "Préface du catalogue de l'exposition Edouard Manet" (1884), in Zola (as in n. 11), 362.

21. Robert Goodnough, "Pollock Paints a Picture," *Art News* 50/5 (May 1951), 60.

22. One possible critique of Clark would stress his tendency to configure the café-concert and other institutions and conditions in Paris during Manet's lifetime on the model of the conditions of May 1968, with the result that past events for which no *soixante-huitard* analogy comes forth remain unconsidered. One dynamic political era, the 1860s (in which Clark concentrates his study of the café-concert), is figured through another dynamic political era, the 1960s—and vice versa.

23. Mirrors were customary equipment for painters' studios, used not only in making self-portraits, but for observing models from odd angles and constructing variations and reversals of given poses.

24. On fantasy and the play of reality and illusion, see also Gedo (as in

n. 13), 1–55; and James H. Rubin, *Manet's Silence and the Poetics of Bouquets* (Cambridge, Mass., 1994), 86–90.

25. Lacan (as in n. 3), 106–107, 116.

26. Some scholars have misidentified the location as the balcony of the adjoining winter garden, which also contained bars. Novelene Ross, *Manet's Bar at the Folies-Bergère and the Myths of Popular Illustration* (Ann Arbor, 1982), 4, 76, suggests a third possibility, that Manet's mirror view combines aspects of both theatre and winter garden.

27. The best descriptions and illustrations of the organization of the Folies-Bergère are found in Juliet Wilson Bareau, *The Hidden Face of Manet*, exh. cat. (London, 1986), 79, 96; Robert L. Herbert, *Impressionism: Art, Leisure, and Parisian Society* (New Haven, 1988), 79; and Gedo (as in n. 13), 24–39.

28. A point stressed by Herbert ([as in n. 27], 80), to distinguish the Folies from the typical café-concert of the 1860s on which Clark grounds his analysis. See also Adrian Rifkin, "Marx' Clarkism," *Art History* 8/4 (December 1985), 492.

29. Wilson Bareau (as in n. 27), 78–82.

30. Clark (as in n. 3), 252.

31. Clark (as in n. 3), 253.

32. Georges Jeanniot, "En souvenir de Manet," *La Grande Revue* 46 (10 August 1907), 853. Clark does not cite Jeanniot's account, whereas several authors in this volume refer to it. Jeanniot's text—which, to my knowledge, has never been discussed in its entirety—includes many statements in the following spirit, in which Manet's paintings are characterized as "without theatrical composition, economical, lucid, where figures are rendered solely to receive the light and to create an ensemble of colored surfaces" (848). Jeanniot's attitude toward painting, at least in 1907, was consistent with the formalistic expressionism of many of his better-known contemporaries, such as Henri Matisse, who, like Jeanniot, published in *La Grande Revue* and enjoyed the support of its painter-editor George Desvallières. On details of the context, see Roger Benjamin, *Matisse's "Notes of a Painter": Criticism, Theory, and Context, 1891–1908* (Ann Arbor, 1987), 133–149.

33. Zola, "Une Nouvelle Manière en peinture: Edouard Manet" (1867), in Zola (as in n. 11), 102.

34. Jeanniot (as in n. 32), 854. Jeanniot continues by reporting that Manet advised painters to be "concise," as if to affirm what he had just observed regarding Manet's actual practice.

35. Théodore Duret, *Histoire de Edouard Manet et de son oeuvre* (Paris, 1926 [1902]), 63–64. Jeanniot (as in n. 32, 856) himself attributes to Manet the "naiveté of a child." On Manet's naiveté and sincerity, see John House, "Manet's *Naïveté*," in Wilson Bareau (as in n. 27), 1–19; and Richard Shiff, *Cézanne and the End of Impressionism* (Chicago, 1984), 27–38, 92–98.

36. Jeanniot (as in n. 32, 854) referred to the blond tones of Manet's paintings as had many others before him, implicitly distinguishing his studio work from that of academics for whom conditions of studio lighting entailed a more pronounced use of dark shadows. The difference is analogous to that between "faithfulness" (Manet's blondness) and "idealization" (academics' dramatic illumination). Viewers of the time were particularly sensitive to such distinctions; cf. Albert Wolff, "Edouard Manet" (1883), *La Capitale de l'art* (Paris, 1886), 225–226.

37. Charles Baudelaire, "Salon of 1846," in Baudelaire (as in n. 9), 81.

38. Baudelaire's position differs from conventional academic teaching in that the element of portrayal derives from the artist's imagination as initially activated by the live model itself rather than by the recollection of ideal artistic prototypes. On this point, Baudelaire can be contrasted with Gustave Planche, "L'Art grec et la sculpture réaliste," *Revue des deux mondes,* 2 per., 5 (1 October 1856), 552.

39. Pierre Schneider and the Editors of *Time-Life* Books, *The World of Manet 1832–1883* (New York, 1968), 173, 176. Given the degree of editorial collaboration in this *Time-Life* series, it remains possible that the two statements have independent origins; cf. Steven Levine, in this volume. On scholars' involvement with proper names—Suzon's in particular—cf. Levine and Jack Flam.

40. See, for example, Christopher Lloyd, "Manet and Fra Angelico," *Source* 7/2 (Winter 1988), 20–24; or, on related Marian imagery in Manet, Harry Rand, *Manet's Contemplation at the Gare Saint-Lazare* (Berkeley, 1987), 41–45.

41. Robert Rosenblum and H. W. Janson, *19th-Century Art* (New York, 1984), 370.

42. On the identification of the figure in question, see also Ross (as in n. 26), 6–7. On female spectatorship at the time of Manet's *Bar,* cf. Ruth E. Iskin, "Selling, Seduction and Manet's *A Bar at the Folies-Bergère:* Soliciting the Eye in the Age of Mass Consumption," *Art Bulletin* 77/1 (March 1995), 25–44.

43. Like Driskel, Champa notes that Manet's Suzon strikes a "hieratic" pose within a pictorial environment that suggests an altar. But he wishes to interpret with a minimum of contextualization. He therefore views the "religion" in Manet's art not through nineteenth-century French history, but as something he personally—as it were, autobiographically—perceives as the character of the painting. Addressing his own experience, Champa writes: "I'm starting to sense more or less conventional religious vibrations."

Counter, Mirror, Maid: Some Infra-thin Notes on *A Bar at the Folies-Bergère*

CAROL ARMSTRONG

infrathin separation—better than screen, because it
indicates interval (taken in one sense) and screen
(taken in another sense)—separation has
the two senses male and female
—*Marcel Duchamp[1]*

Manet's last great work, *A Bar at the Folies-Bergère*, has, in late twentieth-century writing on it, become a sort of epicenter for variations on the practice of the social history of art.[2] As such, discussion has centered on two of the painting's aspects: its site at the Folies-Bergère, on the one hand, and the famous disjunction, which appears to have been intended, between the space in front of and the space within its represented mirror, on the other. These two questions would seem to belong to different orders of argument, the one having to do with the picture's social context, its external referent in the real, historical world of nineteenth-century Paris, the other with its internal structure, its pictorial construction of space. In fact, the most interesting work on the *Bar* has sought to bring those two orders of argument together; indeed, it has sought to force two misaligned spaces—the space beyond and the space within the frame of the *Bar*—into close alignment with one another, in order that the *Bar*, with its mirror, should stand as a mirror-image of the social field and ideological structure of nineteenth-century Paris as condensed and embodied in the real space of the Folies-Bergère. The reflection behind the barmaid, then, is, in different ways, held to be a reflection, not only of the barmaid and of the pictured spaces, both near and far, beyond her—not only of the *depicted* Folies-Bergère, that is, but also of the *real* Folies-Bergère (and beyond it Paris at large)

25

and many of the things that it represented: from the particularities of its night life, its entertainments, its menu of food and drink, and its mix of classes; to the invention of the *populaire* and the self-definition of a new urban class, that of the *calicot;* to the flourishing discourse on clandestine prostitution; to the fixed gendering of public space.

Arguably, much of this is actually *painted* into *A Bar at the Folies-Bergère* in the form of fragments, such as the reflected balcony audience, the trapeze artist's feet in the upper left-hand corner, the blank stare and sartorial spendour of the barmaid, and, of course, the reflected gentleman to the right. But in the existing accounts of it the picture is not really addressed as a painting per se—as a painted construction whose outward references are made by way of a collection of differently painted fragments. Rather, in different ways and to different degrees, the world beyond the picture's edges is imported into its field, shoving aside what is actually painted there. And curiously, it is what is in the forefront of the painting that is most shoved aside and most forgotten in the recycling of social accounts of its mirror image: not just the canvas' obvious paintedness, and with it the fact that it is patently *not* the "real" Folies-Bergère, but also the thickly painted representation of the marble-topped bar and its luscious offerings of fruit, flowers, and labelled bottles.

It is that, the foremost space of the painting, the domain of the still-life—which is also, here, the zone of the counter and of the commodity, of painted *comestibles* and *consommations*—that I wish to address first. Following that, I would like to look again at the mirror and have, in my turn, my say about it—this time as a piece of painting, and as one whose disjunction with the first, still-life zone of the picture might be understood in two ways that are different from the current socio-historical understandings of it: as announcing the paintedness of the space it represents and hence its *difference* from the reality to which it refers, and as opening up in front of the painting a differentiated, many-positioned space of viewing, which is precisely *not* the same as, *not* equivalent or reducible to that of the fictively mirrored male customer. Finally, I will want to return to the barmaid herself, as a kind of ultra-flat, infra-thin hinge between the two painted worlds of the countertop and the mirror surface—again, precisely *not* as a real classed and sexed individual who has her reasons for not exactly returning our gaze, and who either does or doesn't offer herself to us and serve us in more ways than one, but

26

rather, as a sort of screen, an interval, a "separation [that] has the two senses male and female."

THE STILL-LIFE ON THE COUNTER

The foreground of *A Bar at the Folies-Bergère* is occupied by a partic-ular kind of still-life—a kind that in one sense Manet had never painted before. Made up of items for sale—principally bottles of alcohol—the still-life on the countertop belongs to the public, rather than the private realm of consumption. So in that sense it departs from Manet's kitchen and dining room still-lives of the sixties and seventies, in which the domestic moments of meal preparation and consumption, as well as flower arrangement, are celebrated, just as they had been in their Dutch and Chardinesque prototypes.[3] The labels on the bottles, unreadable though they are (with one notable exception, to which I will return, and that is the date and signature wittily inscribed by Manet on the label of the left-most bottle), clearly advertise the commodity status of the bottles, while their existence as mass-produced, interchangeable multiples—another defining fea-ture of the commodity—is announced in the duplication of bottles across the counter: the bottle of red aperitif on which Manet has signed his name is repeated again, on the right (though it is turned around, so that its label is no longer visible), as is the brown bottle of beer with its red triangular logo, and the bottles of champagne with their gold-foiled necks are multiplied several times over. (The only bottle that is not duplicated is the green bottle of cognac—it is as if it is there to signal some sort of play between the single unit and the multiple.) The illegibility of the labels notwithstanding, the shapes of the bottles, the colors of the glass out of which they are made, and the bits of paper and foil with which they are decorated, all serve clearly signifying functions—reproducing the advertising strategies of product design, they identify the kind of liquor that is being sold, differentiating their wares and their markets of potential customers.

This is, in one way, markedly different from Manet's earlier preoc-cupation with consumables: even his attention to different kinds of surface effects, ranging from the transparency and translucency of different kinds of glass—the thick colored glass of the bottles, the thin clear glass in which two blossoms float, and the heavily worked glass of the *compotier* with its oranges—to the reflective sheen of

marble, the matte white of paper, and the glitter of metallic foil, is extricated from its traditional context of enumerating and celebrating the material comforts of the prosperous bourgeois home, and is re-inserted into the commercial context of the open, brilliant, desire-inciting, gaze-confusing space of the shop and its countertop dis-plays. Which is to say that Manet's earlier engagement with the confined, at-home shelf space of the Chardinesque still-life, in which the effect of narrow perpendicularity was repeatedly announced in the illusionistically shallow abutment of the horizontal plane of the table top directly against the vertical plane of the canvas, is here, for the first time, converted into the equally shallow, but now open-to-the-world shelf space of the self-advertising, illusion-supported com-modity display. Again, that shelf space abuts illusionistically against the literal vertical plane of the *Bar*'s canvas, but now its playful con-fession of the illusion of perpendicularity pertains to the world of commercial exchange.

In another way, however, the *Bar*'s commercial still-life was not entirely new to Manet. The year before he began *A Bar at the Folies-Bergère,* he painted a few small still-lives with which the *Bar*'s con-cerns were continuous, and which had some bearing on its themat-ization of the commodity, of exchange and consumption. These were the *Bundle of Asparagus* and its companion, the single *Asparagus* (fig. 2), both painted in 1880, as well as the single *Lemon* (fig. 3), begun in 1880 and finished the following year, just as Manet was starting work on the *Bar.*

The two *Asparagus* companions were made famous by the part they played in a joke of Manet's concerning the question of value. Upon sending the *Bundle of Asparagus* to Charles Ephrussi, Manet received from Ephrussi 200 francs more than the originally agreed upon price of 800 francs. Whereupon Manet painted and sent to Ephrussi the image of the single *Asparagus,* noting that there had been one missing from the original bundle—implying that this little painting made up the difference, and that Ephrussi now had his money's worth in asparagus.[4] Not unlike Manet's earlier 1872 still-life of a bunch of violets sent to Berthe Morisot in lieu of the violets themselves (which included a painted note that substituted for a real hand-written note), the *Asparagus* opens wittily onto the question of illusionistic substitution—this time as it relates to exchange value. For, of course, in suggesting that real and painted asparagus were worth the same amount, and begging the question of whether the

Bundle of Asparagus represents a single painted item or a plural bundle of countable, weighable, edible items, Manet was making a joke that had to do with much more than the relative price of vegetables and paintings. He was also gently mocking the valuation of the referent in illusionistic painting (particularly acute in the tradition of still-life painting, with its frequent equation of the value of fine painting with that of finely worked luxury objects, and its staging of the painted surface's dialectic of fictive transparency and literal opacity), and mounting a tongue-in-cheek demonstration of the interdependence of exchange value and painterly illusionism, and the system of equivalences and substitutions of which they both partake. It is important, however, that the single *Asparagus* was a joke—obviously, in no way was Manet serious about his claim that the painting could stand in for the asparagus, or that asparagus and paintings were equivalent in value. Quite the contrary. "This is not an Asparagus": *that* is the claim of this still-life.

For the *Asparagus* declares its own paintedness. By tipping up the illusionistic marble surface on which the asparagus rests until it is virtually equivalent with the plane of the canvas and the illusion of perpendicularity is almost entirely negated (that illusion is at one and the same time strained against and marginally held on to by means of the dark lower right-hand corner and its establishment of slight obliquity, which is doubled in the opposing direction of the asparagus' equally slight oblique angle, its minimal shadow, and its just-barely broaching of the counter's edge, only to be cut short by the picture's right-hand edge); by showing that the means of creating an asparagus out of paint are not substantially different from those of painting a marble surface, and by suggesting that it is creamy white, brown, pink, and green paint, rather than an asparagus per se, which is delectable here, Manet interferes with the transparency of illusionism and the operations of substitution that underly its valuation, declaring that the object of consumption, here, is *not* actually a vegetable, but a piece of illusionistic painting instead. Thus the *Asparagus* stands on its head the equation between a painting and an asparagus; it returns us to the worked ground of painterly value, and with it to the moment of painterly production, and it short-circuits the system of substitution, equivalence, and exchange that structures the valuation of illusionistic painting, not to mention consumer culture at large. It is after all *painting*—or better, painterly illusionism—or better still, the particular brand of painterly illusionism that is

signed Manet—that is the commodity: so the *Asparagus* reminds us.[5]

As for the *Lemon*, it is like the single *Asparagus* both in its singleness and its lack of defining context. Just as the single *Asparagus* is unadulterated by the grocer's greenery lying under the *Bundle of Asparagus* (which might signal the latter's marketplace context), so the *Lemon* on its pewter plate, which appears to rest, again, on some sort of marble surface, provides no clues at to whether its context is to be imagined as kitchen, dining room, café, or restaurant. But the *Lemon* is no joke about exchange value. Rather, it is a remark about closure. It looks back through a still-life tradition in which the lemon figured repeatedly, and almost always to signal use and consumption—the preparation, garnishing, and eating of meals.[6] While in the beginning its status as a privileged item in still-life painting was conferred by the luxury value of real lemons, by the time Manet himself would display it and other citrus in his own still-life and figural paintings, the lemon had become more commonplace: one of the things that this downsized painting of a single lemon announces is that the lemon is now a small affair. (Significantly, like the *Asparagus*, the lemon in the 14 × 21 cm *Lemon* is a close approximation of the size of the real article.) But most of all, in its contextlessness and hence uselessness, and in its emphatically unopened, and hence unused state, the *Lemon* puts a period to a still-life tradition which was all about fictive consumption. This lemon is emphatically *not* for consumption. By literally closing the lemon, the *Lemon* also closes itself off to still-life painting's illusion of corporeal consumption and announces its own opacity as a piece of painting closed to any other uses but the optical. Thus the *Asparagus* and the *Lemon* are related— the lemon's closure is analogous to the *Asparagus'* slightly different interference with the operations of illusionistic transparency, substitution, and exchange. For the *Lemon* also announces that still-life *painting* is the commodity, and that eyeing a painting and opening, squeezing, or eating a lemon are not equivalent or simultaneous activities and cannot be supported by the same object. And by further extension, the implication of the *Lemon*'s closure is, after all, to distinguish between the bodiliness of use value and the disembodiedness of exchange value—between the physical consumption of material reality and the circulation of equivalences and reality effects that define the ephemera of both illusionism and capital.[7]

Both the *Asparagus* and the *Lemon* share something with the front-

plane commodity zone of *A Bar at the Folies-Bergère.* The marble surface of the *Asparagus,* for instance, and its confounding of the illusion of perpendicularity, is not unlike the countertop of the *Bar,* while the closed surface of the *Lemon* is not unlike the series of un-opened items arranged on the marble surface of that countertop. In-deed, it is in the *Bar* that the questions of illusionism, commodity value and closure raised by the two small still-lives are brought fully and problematically together. For the bottles on the *Bar's* countertop all appear to be full, their seals unbroken, while the oranges (or are they tangerines?) are all as unbroached as the *Lemon*—indeed, the white highlights upon them could almost be taken as suggesting some sort of transparent outer wrapping, so glossy and finished are those orange optical shapes, so doubly touch resistant are they (as fruit at least, if not as paint). The rather insistently unopened state of the *Bar's* still-life items pertains, of course, to their status as com-modities for sale—for the appearance of permanently virginal, un-used perfection is one of the prime self-advertising features of the commodity. So in one way the emphasis upon unopenedness simply functions to announce that this still-life belongs to the public world of commerce rather than the private one of the domicile, and thus to possession—to ownership and physical consumption—ever in the future rather than in the past or present tense. (The same may be said of the barmaid, of course, in so far as she is one of the things she sells—in so far, that is, as she belongs with the things on the counter.)

In another way, however, the still-life of unopened objects does what the *Lemon* does, and does it multiply: it demonstrates the closed opacity of its own painted surface. By the still-life's placement in the front plane of the picture, it forces an acknowledgment of its identity with the literal vertical plane of the canvas, which refuses to dissolve away into fictive transparency. Thus the equivalence the still-life zone asserts is an inversion of the referential equivalences of illusionism—for it suggests a kind of backwards, boomerang effect equation between the depicted commodities and the literal, opaque objecthood of the painting, rather than the other way around, be-tween the putatively transparent depiction and the commodities to which it outwardly refers. And since the still-life's identity with the literal plane of the canvas, reinforced by the tendency of the depicted marble countertop surface to tip up, like that of the *Asparagus,* and proclaim its factured verticality, also announces that it is again the *painting* which is really the object of the consumer's gaze, another

dimension is added to the closed quality of the still-life: namely, that the state of being ever new, of being unbroached and unused, not-yet owned and not-yet consumed, is a kind of self-advertising definition of painting per se—painting as a purer kind of commodity than others, one that is specifically aesthetic, and that can be consumed only optically and economically, never physically.

As if to reinforce the attention to the painting as a self-advertising luxury commodity, Manet signs his name and dates the painting in miniature at the bottom of the label of the bottle of aperitif at the left edge of the *Bar.* Manet's signature often migrated around—so the discovery of the signature at the left rather than the right edge of the painting is not unusual. But its miniaturization, its placement on the bottle label, and its mimicking of the printed logo all conspire to suggest another joke of the kind made by the *Asparagus* (where, by the way, Manet's scribbled "M" in the upper right corner of the image mimics the black marks used to render marble, and thus equates itself quite overtly with a signature style of illusion painting). And the joke, compounded now, is this: Manet's name is a trademark, the logo for a product. And the product is what?—the bottle of aperitif? Well no, for the bottle of aperitif, in its turn, is simply a kind of logo for the rest: a concentrated demonstration of the character of Manet's painting—namely, its characteristic identification with still-life illusionism, the characteristically overt paintedness of that illusionism, and the equally characteristic equation of that overtly painted illusionism with the frontality, flatness, and literal object-hood of the painted canvas. This illusionism, which identifies itself with painting as a material fact, is the ware that Manet has to offer to his customers, the ware that he advertises here. This is what you see when you come to see a Manet. And this is what you buy if you come to buy a Manet. (For, in the world that Manet paints, seeing and buying are twinned like Siamese twins.) So, get your vintage Manet here!—1882 was a very good year.

THE MIRROR

If we look next to the mirror, we will find, I think, that it reiterates and compounds what occurs in the still-life zone, now in mirrorly terms. Specifically, it doubles the already-multiplied objects in the front-plane, confounds the distinction between one kind of duplication

and another, and states the attachment of the still-life effects to a framed flat plane and to the material apparatus of illusionism. Where the bottles are duplicated and, already like mirror images of one another, turned front to back across the lateral expanse of the first plane of the picture, so are they duplicated and turned front to back in the illusionistic movement back from the front plane into the mirror's "depths" (which of course reflects an imagined movement the other direction, outward to the space in front of the canvas)— witness, for example, the reflections of that bottle of red aperitif and of the beer bottle next to it. And, as if to announce not only the desire-inciting function of scintillation and of optical confusion,[8] but also the way multiplicity is an effect as much as a reality—an *illusion* of numerousness, plenty, and surplus, supply that underwrites the commodity and helps to sell it to the consumer—the mirror's duplicates are deliberately confusing. Note the bit of red and white of the fragment of reflection caught between the barmaid's bangled right arm and torso, a left-in pentimento, perhaps, suggesting a bottle that is nowhere to be found on the countertop. Note as well the way the right-most champagne bottle appears interpenetrated by the gilt edge of the mirror "behind" it, such that it suggests an impossible reflection right there at the near edge of the mirror, and makes it fundamentally difficult to tell what's to be taken as in front of, and what within, the confines of that mirror. Finally, returning to the left side of the painting, it is worth noticing the way that same bottle of red aperitif with which we began appears to have another impossible reflection just the other side of the mirror—namely, the bit of oval white atop a vertical strip of reddish brown which mimics the shape and color of the bottle, only to turn out to be a little sconce on a distant pillar beneath the reflected balcony, and thus another mirror mirage. So the discrepancy between the bar and its reflection, classically encountered in the skewed relationship of the barmaid's front to her mirrored back, and in the impossible inclusion of the male customer in the reflection, is multiplied into a series of confusions when we look to the still-life and its mirror image. And at the level of the mirrored still-life at least, those multiplied confusions have more to do with the mutual imbrication of illusionism and commodity culture than with considerations of class or the specific commodification of women in the business of prostitution. But more on that in a moment.

The mirror is declared as such not only in the inclusion of the gilt

frame at its lower edge, parallel to the horizontal of the countertop, but also in the white scumbling everywhere marking its surface. That scumbling is to be found particularly across the top of the painting, where the lights and chandeliers are shown reflected. But it is also streaked across the balcony at the left, between the bottles and the barmaid's right arm, and over the reflected interchange between her back and the male customer. In addition to signalling glassiness and glare—the opticality of the mirror plane—that scumbling also draws attention to the paintedness of the mirror zone, as if to announce the identity of painting and opticality, as well as the paintedness *of* opticality. So in addition to being the illusionistic space of the mirror, this brushmarked surface is also the flat plane of painting—and its depicted gilt edge serves the double function of insinuating that we are looking at a reflection in a mirror, and signalling that we are also, simultaneously, looking at a framed painting within a framed painting. And the painting within the painting marks itself as such by being rather differently painted from the front, still-life zone of the *Bar*. For the zone of the mirror image is painted rather more sketchily than the front area of the painting, with its harder, more opaque thing-ness.

Of course, the looser rendering of the mirror image serves the illusionistic function of creating the optical impression of reflected distance, of rendering the rustle of a crowd and the glitter of lights, and of distinguishing between reflected and "real" spaces. But more than the simple pragmatics of illusionism is involved here. For there is a kind of deliberation involved in the contrast between "thingy" front-plane and brushy background is to be found, and is identified with a contrast between alternative styles of painting that is by no means new to the *Bar*—Manet had engaged in such contrasts before, when no such mirror image was in question. Here I am thinking, for instance, of the famous *Luncheon on the Grass* of 1863, in which just such a contrast between alternative views of woman—one hard, frontal, outward, and still-life associated, the other soft, recessive, and inward, and associated more with the process of painting than with its products. The *Luncheon on the Grass* is, I believe, a not-very-veiled evocation of the painter's world of the studio, replete with the model and her discarded clothes, a still-life arrangement, accoutrements and sets, and family visitors, together with a demonstration of painterly quotations and manners, and of the workings of illusionism.[9] The *Bar*, on the other hand, very defi-

nitely represents a movement out into the trafficky world beyond the private, producerly confines of the studio. But the two paintings share a concern that is not isolated to them and to which I will return, and that is a fascination with the splitting of the image of woman, indeed an identification with femininity represented as indeterminate, double, and divided.[10]

The one other time Manet had been concerned with rendering a mirror image, he had done so without any engagement in the mirror's opticality. In *Before the Mirror* of 1876–77 (fig. 4) Manet had rendered the mirror as a gilt-edged zone, just as spatially discrepant as the mirror in the *Bar*, in which one hardly sees anything at all, and which is characterized by being only slightly more painterly than the front zone of the image, with its brushy, rococo-inspired depiction of the back of a woman in her corset. That image was a kind of alternative to Manet's contemporaneous picture of *Nana* the courtesan, with its overt prostitutional thematics: indeed, in a way *Before the Mirror* simply represents *Nana* from behind—swivelled around so that we get the view that Count Muffat is to be imagined as having, past Nana's back and over her shoulder to her mirror image. But in *Before the Mirror*, we don't really see more of the woman in the mirror, for all we see in the mirror is a lot of paint. Thus, just a few years before the *Bar*, Manet's other rare encounter with a mirror image was on the order of a kind of meta-painting, a piece of painting about itself, declaring its own paintedness, and thereby refuting the possessability of its illusionistic referent, the figure of the woman. She can be possessed as a piece of painting, but as a woman she dissolves, like Balzac's Catherine Lescaut, into a painterly mirage.[11]

All of which is to suggest three things about the mirror image in the *Bar at the Folies-Bergère*, and its complex identification of opticality with painterliness. First, the zone of the mirror represents a very specific fascination with opticality which was by no means Manet's only specular option, not the only way to represent the optical space of the mirror, but which also cannot be reduced to explanation according to the social and sexual circumstances of the place represented, the Folies-Bergère; rather, I'm inclined to think that Manet chose the Folies-Bergère because it offered him something illusionistically complex to paint. Second, the *Bar*'s mirror image, with its alternatively painted alternate view of the barmaid, opens on to some concerns about the doubling of femininity which were continuous with earlier paintings. And third, the differently painted rendering of

the mirror zone is a way of announcing its lack of identity—or more strongly, its refusal of identity—with what it represents, its difference from the world this side of the painting. That is one other kind of sense that one can make, not only of the difference between the barmaid and her reflection, but also of the spatial inconsistency of the reflection of the countertop, floating illogically, suspended like the balcony beyond it without apparent support or relation to the ground, doubling up, together with the flat horizontal strip of the balcony, on the countertop's play on the illusion of perpendicularity and its dialectic of the horizontal and the vertical. That discrepancy, together with its play on the vertical plane of the painting, also helps to establish the painted difference between the picture and the world it depicts.

It should be said that the difference between the two zones of the painting is not absolute. For the white scumbling and the loose manner of painting attached most dramatically to the rendering of the reflection, are also echoed in parts of the front zone of the *Bar*. Both are found in the rendering of bottle surfaces, as if to establish an illusionistic kinship between two kinds of glass, between different zones of optical confusion, and between the surfaces of two kinds of commodity—the bottles and the illusionistic devices of the painting itself. The comparison between kinds of painting is perhaps most overt in the comparison between the bottles and their looser reflections; yet that comparison also reveals how very slight, ultimately, the distinction really is. It is also matched to further specular confusions—found for instance in the relationship between the twinned aperitif and beer bottles and their reflections: it is not at all clear which is behind which on the countertop—it looks as if they are simply lined flush up against one another, next to one another rather than before or behind—but the mirror image more emphatically—and impossibly—lines ones up behind the other. Thus Manet's indeterminate distinctions between the painterly styles of mirror and countertop are matched to their spatial inconsistencies. And there is the countertop itself, with its loosely painted suggestions of reflectivity—found in the green beneath the cognac bottle, in the touches suggesting the beginning of a reflection of the barmaid herself, and in the flesh-toned marks beneath the champagne bottles. So the vertical surface of the mirror and the horizontal surface of the countertop turn out to be more alike than different. Finally, there is the light-handed rendering of the lace edging of the barmaid's decol-

36

letage, which frames her flesh and face just as the gilt edge, which her body interrupts, frames the mirror, and just as the countertop, which in turn interrupts and cuts off the barmaid's body at the thighs, frames her corset-shaped hourglass torso. And there are the brushily rendered blossoms tucked into her bodice, linking her both to the flowers in front of her on the countertop, one rendered more loosely than the other, and to the loosely painted zone behind and around her. In the end, the painting is all of a piece—it declares itself what it is, a single, painted plane-surface, whose differences in painterly manner are scattered laterally across that surface, rather than read through the separate planes of the *Bar*'s fictively mirrored depths. So like the still-life items on the countertop, the different kinds of painting in which Manet specialized are here presented as multiple offerings displayed on a single surface.

The Barmaid

A couple of other things need to be said about the mirror—as a way of arriving, at last, at the barmaid. First, if what the mirror with its many discrepancies suggests is the painting's difference from the world it represents, then that embraces the reflected male customer too, as the most dramatic discrepancy of the mirror zone. For the reflected male customer is shown precisely where we cannot be, and from an oblique angle that dislodges the mirrored space from the straight-on world of the counter, so that the painting becomes so deeply fissured between the illusion of obliquity and that of parallel planes of representation that we end up having no idea where to imagine ourselves standing in front of it. Or, at any rate, the inclusion of the reflection of the male customer dramatizes what we already know, which is that standing in front of *A Bar at the Folies-Bergère* is not the same as standing in front of the bar at the Folies-Bergère—standing in front of the flat plane of the *Bar*, that is, is not the same as standing in front of the open space of the eating, drinking, and entertainment establishment.

And anyway, in this painting that establishment is pictured as a place in which spectatorship is defined by dislocation—the reflected male customer, fixed at the right side of the painting, but opening up the series of spatial discrepancies that he does, dramatizes this imagining of the space of the Folies-Bérgère as one in which spectatorial

37

fixture is converted, by a series of dislocations, into spectatorial mo-
bility. Which brings me to the second of my last comments about the
space of the mirror. Within it is represented a plurality of gazes and a
multiplicity of vantage points. Moving from right to left, we move
from the already estranging vantage point of the male customer
past the barmaid, who intrudes in our scansion of the picture to sug-
gest a head-on confrontation of gazes (just as estranging as the de-
stabilizing side-line encounter with the oblique glance of the male
customer), to the reflected distance on the other side of the canvas,
where we find a series of gazers, one with opera glasses, peering off to
the side, finally moving to the upper corner, from which dangle the
famous legs of the trapeze artist, bringing us up short against the
edge of the canvas, at the same time suggesting another, detached,
differently directed act of glancing, and indicating, contradictorily, an
elision between different objects and worlds of the glance—namely,
those of the spectacle and of the painting of the Folies-Bergère. The
difficulty of defining and fixing the place of the spectator which is
broached on the right by the reflected male customer is multiplied ad
infinitum as we move to the mirrored distance of the left-hand side of
the canvas and scan all its instances of floating, hovering disloca-
tion, of optical confusion and spectatorial flotsam and jetsam. In
short, the job of the mirror in this painting is specifically to unfix the
gaze, to make both the position and the identity of the spectator
undecidable.[12]

The job of the mirror in the *Bar* is also to show how the unfixing of
the gaze is part of the solicitation and functioning of consumerly de-
sire. For in the *Bar* the domain of the mirror is also the domain of the
consumer—as opposed to the commodity zone of the front-plane
countertop. Indeed, various kinds of consumption are alluded to in
the space of the mirror—from the overt buying of drinks, and yes,
perhaps the covert buying of sex as well, at the right edge of the
picture, to the gazing at the paid-for spectacle at the left edge of the
picture (it is here that buying and seeing, economic and optical con-
sumption, are most equated), not to mention the gazing at other
spectators and perhaps at their clothing (and in tandem, the gazing
back at us—note the left-most male spectator in his tophat) which is
sketchily suggested in the small distant figures at the same left edge,
which is inevitably part of the decoration of such spectacle con-
sumption, and which in turn is fairly directly suggested in our appre-
hension of the barmaid's store-bought finery, itself the product of her

acts of optical and economic consumption as she is now the object of ours. Which brings us, finally, to the barmaid.

In one way, the barmaid simply belongs to another fairly long-standing preoccupation of Manet's, and that is with women and their clothes. From his depictions of Victorine Meurent in the sixties, robed in a variety of dresses and different apparel, to his seventies and early eighties fascination with fashion-plate garb, fashion fetishes like corsets, hats, and gloves, and fashionable women like Méry Laurent and others (Méry Laurent is supposed to be one of the sketchily indicated spectators in the reflected distance of the *Bar*— the one who, in spite of her quick, diminutive notation, can be singled out by a pair of yellow gloves similar to those that crop up repeatedly throughout Manet's painting career), Manet's oeuvre is marked by its obsession with the complexities of women's clothing, with the equally complex feminine fashioning of identity through clothing, and with female consumerism—it is distinguished by its repeated, and I believe sympathetic, attention to the acts, objects, and processes by which women both attain the commodity of femininity for themselves, and transform themselves into that same commodity for others. The barmaid of *A Bar at the Folies-Bergère* appears before us more as a commodity similar in shape and objective appearance to the bottles on the counter than as a consumer—in that she is, for instance, unlike the loosely rendered behatted, beruffed, and yellow-gloved woman in *Woman Reading* (fig. 5), who is one of the best examples of Manet's interest in women as consumers. (The woman is a consumer of clothing, of an illustrated journal which probably advertises clothing, and of beer at a café—and it has been suggested, though I'm not sure I find it convincing, that she, like the barmaid, is backed by a mirror.) Nonetheless the barmaid belongs to Manet's fascination with female fashion—and as such, she forms a kind of bridge, not to mention a sort of separation, between the worlds of commodities and consumers found on the countertop and in the mirror.

It has been remarked that the barmaid appears quite radically different from her own reflection—and that difference has been attached to questions of class, as well as of sexual equivocation.[13] I would like to take another look at the difference between the barmaid and her reflection now, and consider it somewhat differently: under the double heading of the questions of illusionism, the self-advertising commodity and painting, and of the unfixed, plural gaze.

To begin, one might expect the difference between the barmaid and her reflection to follow an illusionistic logic whereby the barmaid would look more "real"—more three-dimensional and lively—than her reflection. But that is not the case: for not only does her gaze absent her, she is also rendered more flatly than her reflection. Her harder contours, her upright, frontal pose, and her closed, finished appearance succeed in likening her to the closed objects in front of her—a likeness that is furthered by such details as the different views of her two lace cuffs, similar to the views of bottles with labels half showing, fully shown or shown not at all; the comparison between one white-painted cuff and the working of the *compotier* in white paint; the linking of the blossoms on the counter and those at her bodice; the mimicking of her highlit buttons by the highlights on the glass in which the blossoms on the counter float; the triangulation of a series of blond and gold accents, ranging from her bangs to her locket and her bangle, to the gilt mirror frame and the gold-foiled bottle-necks between which she is sandwiched; and so on. Indeed, she appears before us not only as a kind of signboard advertisement for the *Bar* and its wares, but also as a sort of cut-out, pop-up figure, an insert between the two domains of counter and mirror—an interruption, flatter than anything else before, behind or around her.

Thus the barmaid is a piece of meta-painting, too: she is inserted between the painting's two domains of illusionism in order to advertise their paintedness. She stands between those domains in order to separate and to connect their different kinds of paintedness, and to join the illusory horizontality of the still-life zone to the equally illusory verticality of the mirror zone, and both to the literal plane of the framed canvas. And she is part of a series of interruptions, each of which advertises the flatness and paintedness of the whole: the bottles interrupt each other and the mirror frame; the counter, the flowers in the glass, and the *compotier* interrupt the barmaid; the barmaid interrupts the frame of the mirror as well as the reflection of herself and of the countertop. And the barmaid interrupts our gaze—for she stands where we should be mirrored, if we were standing directly in front of the painted counter and the painted mirror mirrored us correctly.

All of which suggests two questions, I think. First, there is a question about the painted nature of all those interruptions and what it is that they interrupt: less the singleness of the painted plane of the canvas, than the plurality of its illusionistic planes. Which is to say

that with each successive interruption the spatial reading of the canvas is confounded and the separate planes of its illusion are complexly and inextricably woven together, so that they are shown to be indivisible into separate planes. Their layers of illusionistic depth are shown to be collapsed and paper thin—like a series of flat collage elements glued on top of each other on a flat surface, thickening that surface into a slightly thicker thin-ness, declaring its two-dimensionality to be a very thin three-dimensionality that belongs both here in the world of real objects and there in the world of representations. The barmaid, emphatically thin and closed, insistently flat and objective, interrupts that layering simply to punctuate it parenthetically—to mark the middle of the illusionistic sentence with a flattening slash/period.

The second question the interruptive barmaid poses is a question about sameness and difference, identity and otherness, the subject and object of the painting, and the world of the gaze it opens up—a question about the structure of (narrative) identification and (fetishistic) objectification that describes the "male gaze," in other words.[14] So far the readings of the barmaid that bring gender into the field of vision, do so to fix it in place—either to illustrate the masculinity of public space, or to show how the optical ambiguities of the painting are really sexual ambiguities, which in turn mask and naturalize the certainties of a mysogynistic gender ideology.[15] Both readings reiterate the assumption that the subject position is necessarily male, and the object position female. That assumption is not wrong as far as late nineteenth-century prostitutional discourse, public space, and gender ideology are concerned. But as far as this painted object is concerned, which is self-declaredly *not* exactly equivalent to any of those things, that is another question. And while *A Bar at the Folies-Bergère* begins by laying out the equation: spectator = male, object of vision = female, it ends by so complicating its own equation that it nearly defeats it.

The barmaid's flatly interruptive figure is very much part of the complication. Though she is depicted as an object among objects, and very much the object of our gaze, at the same time she is just another of those pieces of painting that announce their paintedness and their status as mirages. Also, her closure, like the closure of the commodities around her, makes her quite emphatically unavailable to us—if she is an object of consumption, again she is another of those objects that announces that it can be consumed only optically,

never bodily. That means if she can be bought in any way—and certainly she, like the painting of which she is a part, is presented as an object of economic consumption—the buying of her is equated with a cycle of looking that can never be rolled over into one of sexual possession and incorporation. That latter equation is cancelled out by the barmaid's obstinate, painted closure.[16] And if the reflected interaction between the barmaid and the male customer opens onto a narrative reading of the painting predicated on a scenario of identification with the customer, the barmaid cuts that narrative reading short with the flattening of her own fetishistic appearance, and flatly refutes it. Finally, the barmaid's interruptive quality is conducive to the feeling that she is not exactly what we expected the object of our vision to be—it is as if she is not only the object, but also the occlusion of our vision.

And what was it that we were waiting to see, exactly? Well, not only the painting's dissolve into its illusionistic referent (a dissolve that does not happen), not only a narrative meeting of human gazes (which also does not happen), but perhaps some version of ourselves as well. That, too, we do not get: though spectatorial sublimation is denied us, and though our spectatorial collusion in the spectacle is characteristically announced, we are also made to feel, rather uncannily, that we are not there, that as subjects we are as absent and as much a blind spot as the barmaid is herself and as her gaze, failing to connect, makes us. Instead of ourselves we find the barmaid, as flat and frontal as the mirror itself, woven with its edge, so that she becomes, quite literally, a stand-in for us, not quite our mirror image, but as much our objective alter ego, as her mirror image is hers, as much our simultaneous counterpart and other as the reflected male customer is simultaneously *her* (and our) counterpart and other. Both purveyor and object of optical consumption, she folds out twice—to become first her twin and then her mate, her opposite number, so that her difference from and her kinship to the subject of vision, the spectator-consumer, are so linked and elided together as to be indivisible and unopposable. Which is to say that the consumer and the commodity, the subject and object of vision, the spectacle's male and female cases, are sewn together to form a Janus figure.

It is also to say that the barmaid is a sort of *doppelganger* for us. She is both a psychic double and a figuration of commodity culture's doubling of consumer and commodity, its structuring of the two as mirror images of one another. The barmaid's insertion between counter

and mirror places her in an intersticial no-man's-land between the zone of vision's objects and the visual plane on which identity is mapped in both a psychic and a consumer sense. So not only does she both divide and bridge the twinned zones of the commodity and the consumer, showing how interpenetrated and interlinked they are, she also both divides and bridges the gendered worlds of the subject and object, the self and the other, demonstrating how joined—rather than opposed—they are, how twinned they are, too.[17] How, then, can we determine that the barmaid is simply a fixture of gender ideology, of its gendering of the public and private spaces of vision, and of its one-way traffic in gender commodities? For isn't she, rather, Manet's painted imagining of what a subject looks like as an object? Mightn't we just as well consider her a complexly painted image of the fissure—and the elision—between those two aspects of our gendered selves, and of our positioning within the culture of the commodity? Both a "screen" onto which anything can be projected and an "interval" that interrupts that projection? An "infra-thin," a "separation [that] has the two senses male and female," in other words.[18]

NOTES

1. *Marcel Duchamp Notes,* ed. Paul Matisse; trans. Anne d'Harnancourt (Boston, 1983), 9.

2. See T. J. Clark, *The Painting of Modern Life: Paris in the Art of Manet and his Followers* (New York, 1985), 205–258; Robert Herbert, *Impressionism: Art, Leisure and Parisian Society* (New Haven, 1988), 79–81; Griselda Pollock, *Vision and Difference: Femininity, Feminism and Histories of Art* (London, 1988), 51–55; and Hollis Clayson, *Painted Love: Prostitution in French Art of the Impressionist Era* (New Haven, 1991), 151–152.

3. I am indebted to Jeannene Pryzlbyski, "Le Parti Pris des Choses: French Still Life and Modern Painting, 1848–1876" (Ph.D. diss., University of California, Berkeley, 1995): many of my ideas about the still-life zone of the *Bar at the Folies-Bergère* were developed and expanded in the discussions and consultation that surrounded the genesis of this dissertation. See also James Rubin, *Manet's Silence and the Poetics of Bouquets* (London & Cambridge, Mass., 1994); Norman Bryson, *Looking at the Overlooked: Four Essays on Still-life Painting* (Cambridge, Mass., 1990); and Gabriel Weisberg, *Chardin and the Still-life Tradition in France* (Cleveland Museum of Art, 1979).

4. A. Tabarant, *Manet, histoire catalographique* (Paris, 1931), 381. Cited in Françoise Cachin, *Manet 1832–1883* (Paris, 1983), 450–451.

5. It is my view, contrary to the usual argument about modernist flatness, that illusionism and the literal objecthood of painting in Manet's work are not so much opposed and mutually exclusive as they are equated and mutually imbricated. For a more extended version of this argument, see my "Manet/Manette: Encoloring the I/Eye," *Encoding the Eye, Stanford Humanities Review* 2:2–3 (Spring 1992), 1–46.

6. See Roland Barthes, "World as Object," *Critical Essays,* trans. Richard Howard (Evanston, Ill., 1972), 3–12.

7. See Karl Marx, "Commodities and Money," *Capital* I, in *The Marx-Engels Reader,* ed. Robert C. Tucker (New York, 1978), 302–329. See also Walter Benn Michaels, *The Gold Standard and the Logic of Naturalism* (Berkeley, Cal., 1987), 139–180.

8. See Siegfried Giedion, *Space, Time and Architecture,* 5th ed. (Cambridge, Mass., 1967), 234–243, for a relevant account of the open, interpenetrated spatiality of the department store and its functioning in the display of commodities. See also Michael Miller, *The Bon Marché: Bourgeois Culture and the Department Store, 1869–1920* (Princeton, 1981); and David Van Zanten, "Architectural Composition at the Ecole des Beaux-Arts from Charles Percier to Charles Garnier," *The Architecture of the Ecole des Beaux-Arts,* ed. Arthur Drexler (Museum of Modern Art, New York, 1977), 254–273—on Charles Garnier's theorization of such spatiality in *Le Théâtre* (Paris, 1871). The terms of that discussion are remarkably resonant for Manet's *A Bar at the Folies-Bergère.*

9. See my "Manet/Manette" (as in n. 5). This reading of the *Luncheon on the Grass* is further elaborated in my paper, "To Paint, To Point, To Pose: Manet's *Déjeuner sur l'herbe,*" given at the C.A.A. conference in February 1994 (session: "Manet's *Déjeuner sur l'herbe,*" Paul Tucker, chair).

10. This is the main argument of "Manet/Manette," as it concerns Manet's 1860's depictions of his model Victorine Meurent. According to the Freudian logic followed in a lot of feminist writing, such identification with the feminine would be possible on the part of a male subject only in pre-Oedipal terms—only when the feminine is equated with the maternal. I simply do not share the conviction that this is the only possible scenario of masculine identification with the feminine. In the case of Manet's early paintings of Victorine, the scenario of identification is that of the studio—and Victorine is a figure who stands for Manet's internal world of painting and Manet's construction of a painterly identity. Though Manet's later paintings of women shed the trappings of the studio and no longer chart the changes that can be worked on a single model's features, I believe the traces of the identificatory logic of the studio are still to be found in them—transformed now into the terms and scenarios of commodity culture.

11. Honoré de Balzac, *Le chef-d'oeuvre inconnu* (1837), in *Le chef-d'oeuvre inconnu/Gambara/Massimilla Doni* (Paris, 1981).

12. A Marxist reading of this spectatorial mobility would see it as a reflection of the ideology of capital. For the classic version of this, see Meyer Schapiro, "The Nature of Abstract Art," *Modern Art: 19th and 20th Centuries, Selected Papers* (New York, 1978), 192–193. See also Clark (as in n. 2), 1–22. My disagreement with this pertains to the view of painting as a metonymic mirroring of a larger cultural construct: in such accounts, the mirror model of the relationship between paintings and their context still stands, even when paintings and the world they represent are both held to be complex constructions. In contrast, I believe that the spectatorial mobility posited in the *Bar* is one that is quite specific to the painting's *difference* from its world, as paradoxically proposed by its mirror.

13. See Clark (as in n. 2), 249–252; Clayson (as in n. 2), 251–252.

14. These, of course, are the terms provided by Laura Mulvey's classic essay, "Visual Pleasure and Narrative Cinema," *Visual and Other Pleasures* (Bloomington, Ind., 1989), 14–26. The structure of the filmic gaze as described by Mulvey appears to be illustrated almost verbatim in the *Bar;* at the same time, I believe that one of the things the *Bar* does is to show how the very terms of that structure can exceed and disturb it—how, for instance, the fetishistic object of the gaze is potentially also a disturbance of the field of the gaze, one that may be mastered by an identificatory narrative or not. In the *Bar* I believe it is quite emphatically not.

15. See Pollock (as in n. 2), and Clayson (as in n. 2).

16. It is not as if Manet, in his *Nymph Surprised* and his *Olympia,* hadn't tinkered with precisely these gender and spectator-consumer equations before, with de-sublimating, stating and negating them. See Rosalind Krauss, "Manet's 'Nymph Surprised,'" *Burlington Magazine* 109 (Nov. 1967), 622–627; and Clark (as in n. 2), 79–146.

17. In this, the barmaid opens up aspects of the gaze and the mirror, and onto questions of identification that are not specifically gendered—see Jacques Lacan, "The Mirror Stage as Formative of the Function of the I as Revealed in Psychoanalytic Experience," *Ecrits,* trans. Alan Sheridan (New York, 1977), 1–8. For an account of Manet's work that raises some related questions about spectators, the gaze, and identity, but does so, rather curiously, by fantasizing about the invisible, rather than the visible—see Richard Wollheim, *Painting as an Art* (Princeton, 1987), 141–164.

18. Several times I have coupled Manet's name with the name of Duchamp. But of course, in spite of the fact that he seems to have had an inclination for pictorial jokes and self-referential mischief, and that he quoted from the museum with an eclectic, flattening, proto-post-modernist zeal, Manet was no Duchamp. He was a painter's painter, whose thinking was visual, not verbal—he had not folded the moment of verbal criticism into the of act of material making, in the way that his dada, and later his post-modernist, descendants would.

It has been my intention to elucidate some of the conceptual implications of the visuality of *A Bar at the Folies-Bergère*. Naturally I have done so in the medium in which I work, which is verbal. But the picture's visuality and my critical elucidation of its conceptuality occupy different dimensions and take place at different moments. Thus, the Duchampian notion of the "infra-thin" belongs to my critical moment—and not, obviously, to the historical moment of the production and reception of Manet's painting. As such, it has served me as a critical tool—a way of getting at something that was not provided for in the discourse of Manet's day. So the application of the "infra-thin" to the case of *A Bar of the Folies-Bergère* is opportunistic and limited. (*Not* of interest, for example, was the "infra-thin"'s derivation in and reference to the n-dimensional domain of Poincaré et al.)

First, my use of the "infra-thin" was simply descriptive—it seemed a particularly good term for the thin-ness, flatness and between-ness of the barmaid. And then, the "infra-thin" provided a means of opening up the question of the relationship between the two-dimensional plane of representation and the three-dimensional world flattened onto that plane, which is so much at issue in the *Bar*. And since one of the "infra-thin" planes of representation frequently mentioned by Duchamp was the mirror, the term came to seem particularly apt. Also, the "infra-thin" refers precisely to the doubling of juncture and separation that is one of the principle estranging effects of the *Bar*. The "infra-thin" concerns as well the kind of industrial duplication that Manet seems to thematize in his address to the bottles on the counter. Finally, the "infra-thin" conceptualizes gender, as Duchamp was wont to do, as a field of projection, of doubling and of figurative reversibility. So the "infra-thin" usefully brought together the various concerns of the *Bar*, and helped me to see how they were interwoven there: the commodity, the mirror, the plane of painting, and gender. Thus the "infra-thin" was a kind of conceptual pry for *A Bar at the Folies-Begère*. If I have not been faithful to its functioning in a historically specific discourse, that is why. I did not mean to be.

Manet's *A Bar at the Folies-Bergère* as an Allegory of Nostalgia

ALBERT BOIME

> Paris is the City of Mirrors.
> *Walter Benjamin,* Das Passagen-Werk

MODERNIST AND POSTMODERNIST critics have enshrined Manet's *A Bar at the Folies-Bergère* as one of their heroic and exalted monuments (frontispiece).[1] The canonization of this naturalist painting is paradoxically based more on its unrealistic visual contradictions and ambiguities than on the clarity of its content—an almost casual scene of an encounter between a fashionably attired male client at the Folies-Bergère and a barmaid serving tempting refreshments behind a marble counter. Yet even here the striking instance of the impersonalized expression of the distribution of food and drink in a public site has been overlooked as part of the social meaning of the picture.[2] This is owing perhaps to the intense presence of the scene that resonates so startlingly with our own experience of modernity.

Directly behind the barmaid, a gilt-framed mirror extending the breadth of the picture reflects the theater gallery filled with spectators witnessing a trapeze performer whose dangling legs we glimpse perched above the luminous electric lights and glittering chandeliers. One of the most eccentric features of the work is the reflection in the mirror of the two protagonists: although we are looking at the barmaid head-on we do not see the male client except way off to the right side in the mirror reflection at an impossible angle if we try to grasp the picture as a univocal, unitary statement. Given this "juggling of fact and illusion," as Robert Rosenblum has described its visual complexities, it is altogether unsurprising that the work's contradictions sparked stormy debate in its own time and continues to do so in the present.[3]

47

It is especially the mirror motif that has given rise to so much confusion and discussion; Manet has allowed his accessory to do most of the work of suggesting the spacious horseshoe-shaped theater with its balconies and loges and shimmering lights that gave the Folies— at once a theater, a café, and a garden promenade—its unique "cachet boulevardier."[4] Mirrors, always popular in the decor of Parisian theaters and Parisian public life in general,[5] lined the perimeter walls including the balcony level, where Manet has depicted his refreshment alcove. (The balcony level is identifiable by the proximity of the reflected chandeliers and by the thick pilasters to which the electric globes are attached.[6]) The mirrors of the Folies were an integral feature of its ambience, mentioned often in contemporary texts. Maupassant observed in his novel *Bel-Ami* that the "tall mirrors" behind the women working the refreshment counters "reflected their backs and the faces of the passers-by."[7] Huysmans, in his famous "Les Folies-Bergère en 1879," wrote that the "aroma of cigar and of woman becomes thicker; the gas-lights burn more heavily, reflected in the mirrors that reverberate them from one end of the theater to the other."[8]

The new public space is viewed as a magic-lantern show of dazzling optical illusions that deceive the crowd by blurring the boundaries between consumption and production. The crowd sees itself in reflection as fortunate consumers of urban brilliance and luxury, while its class-bound participation in the productive process is obscured. Everything the crowd desires is displayed as commodities that mesmerize even if unattainable, offering pleasure in the spectacle alone. Even social relations basked in the aura of commodification captured by the surrounding mirrors: in the restaurant it was possible to be next to a stranger and at the same time consume that person in fantasy at a distance through the mirrored reflection on the opposite side of the space.

Manet seems to have shared the fascination of contemporary writers for the fantasy stimulated by the mirror effect, reflecting the larger space in which the viewer is stationed and setting up a multi-layered representation of reality that actually questions the very nature of the "real." By aligning the counter and the mirror with the picture plane, the canvas almost pretends to be a reflection of our world with the barmaid negotiating the interval between the fictional and actual realms. This exchange in the mirror that blurs the boundaries between a fictional and an actual beholder and encour-

ages a "Through the Looking-Glass," anti-matter experience occurs also in Emile Zola's novel set against the backdrop of a colossal department store, *Au bonheur des dames,* written in 1882 and published early the next year. Zola's research notes on department stores indicate that he was deeply impressed with their seductive decor of mirrored walls, repeating such phrases as "Glaces partout" and "Le jeu des glaces."[9]

A curious parallel exists between the speculative ventures of department store and music hall, both designed to attract and to cater to a cosmopolitan throng through the mesmerizing glitter of spectacle. They were public arenas pretending to be intimate spaces, the one miming an upper-class private interior and the other constituting a kind of salon for strollers.[10] Both the Bon Marché—the first full-fledged *grand magasin* on which *Au bonheur des dames* was modeled—and the Folies-Bergère were founded in 1869, growing from small scale enterprises into mass consumption empires through deployment of the latest marketing and advertising strategies. Ironically, the space of the Folies-Bergère made its first appearance in 1860 as a large furniture shop specializing in bedding, adding a "salle des spectacles" in the back of the store three years later to catch the busy street traffic. This proved to be so successful that in 1869 the business shifted entirely to variety shows. It was taken over in 1871 by Léon Sari, a shrewd entrepreneur who enlarged and remodeled it into a synthesis of fashionable promenade, café-concert, and theater. He booked internationally popular circus and vaudeville entertainers and transformed the Folies into an attraction for chic Parisians and wide-eyed tourists alike.[11] Similarly, Aristide Boucicaut, the founder-impresario of Bon Marché, perceived selling consumption as dazzling showmanship, turning his marketplace into a fantasy world so compelling "that going to the store became an event and an adventure."[12] The impression on entering his edifice was that of entering a theater and the vast open displays within immense galleries surrounded by balconies and festive decorations invited rapt spectatorship. As at the Folies, a refreshment bar (*un buffet de rafraîchissements*) was tucked inside a squarish alcove on the *premier étage*.[13] Grand staircases conveyed the shoppers to the various tiers as if they were climbing to the boxes at the Opera (fig. 6). Indeed, Boucicaut organized a series of in-house musical concerts at first performed by the employees themselves but later including well-known opera stars. On concert evenings merchandise counters gave way to a stage, replete with exotic flowers and silk hang-

ings. The realms of mass entertainment and consumption were now organized as inseparable categories.

Zola's ambitious department store magnate, Mouret, modeled loosely on Boucicaut, also strives to create a kind of "colossal entertainment" to seduce his predominantly female clientele by organizing an architectural space so richly festooned and illuminated that it strikes one customer as an enchanted "fairyland."[14] He opened a refreshment alcove arranged as at a theater to serve customers free light refreshments; it displayed a large marble counter with rows of bottles on the shelves behind. Central to Mouret's overall effect are the glittering mirrors on all sides of the main galleries that

> carried the departments back into infinite space, reflecting the displays with portions of the public, faces reversed, and halves of shoulders and arms; whilst to the right and to the left the lateral galleries opened up other vistas, the snowy background of the linen department, the speckled depth of the hosiery one, distant views illuminated by the rays of light from some glazed bay, and in which the crowd appeared nothing but a mass of human dust.[15]

Later, Mouret's mistress, Henriette Desforges, engages as a customer with her rival Denise Baudu, a saleswoman in the ready-to-wear department, where again mirrors dramatize the frenetic space. As Henriette surveys the scene she glances into the mirror, contemplating and comparing herself with Denise who is unknowingly captured in the mirror while the glass "reflected the entire department with its commotion [*turbulence*]"[16] Here the reader is drawn into the extended play of reflections akin to Manet's painting, as the scene pivots on the double movement of an encounter between a desiring customer and magnetic salesperson with her displays and a boundless space containing a crowd that inevitably embraces the reader-beholder.

Manet's contemporary, Jules Comte, writing for the center-right newspaper *L'Illustration*, struggled with the mirror motif in the painting whose incorrectness he associated with typical Impressionist negligence:

> But what strikes us first of all is that this famous mirror, indispensable to an understanding of all these reflections and perspectives, does not exist: did Monsieur Manet not know how to do it, or was he satisfied with just an *impression* of it? We shall refrain from answer-

50

ing this question; but let us simply note this fact, that all of the picture takes place in a mirror, and there is no mirror. As to the incorrectness of the drawing, as to the absolute inadequacy of the form of the woman, who is, after all, the only person shown, as to the lack of correspondence between the reflected objects and their images, we shall not insist on these things: they are lacunae which are common to these Impressionist gentlemen, who have excellent reasons for treating drawing, modelling, and perspective with lofty disregard.[17]

I intend to argue in this paper for a different reading of Manet's activity in seeing it as an attempt to embrace the scenic totality of the Folies as a construction of multiple views and states of mind. By so doing, I hope to resolve the most puzzling of its ambiguities and restore to it a narrative structure which has been elided in all of its previous discussions.

In 1951 Hans Jantzen, concluding his analysis of *Un bar,* contrasted the oil sketch with the definitive version and recorded the following observations:

Im vollendeten Werk erscheint das Mädchen plötzlich "monumentalisiert", sie ist als reine Frontalfigur in die Bildachse gerückt, und das Spiegelbild löst sich merkwürdig traumhaft von ihr los und wiederum so, dass der Mann, mit dem sie spricht—er trägt jetzt einen Zylinder—, nur wie in Gedanken von ihr erschaut wird. Der Ausdruck ihres etwas verträumten Blickens lässt auch gar nicht auf ein dialogisches Motiv schliessen, und ihr Gespräch mit einem Herrn wäre als Realität nicht so im Spiegel zu gewahren. Vielleicht ist es nur des schattenhafte "Nachbild" einer bereits vorübergegangenen Unterredung?[18]

(In the finished work the girl suddenly appears "monumentalized"; she has shifted into the picture axis as a strict frontal figure, and the mirror reflection peculiarly detaches from her as in a dream, and again so that the man with whom she converses—he now wears a top hat—is being imagined by her only in her thoughts. The expression of her somewhat dreamy glance does not allow us to suppose a dialogic exchange has taken place, and her conversation with a gentleman as disclosed in the mirror cannot be taken as the reality. Perhaps it is only a shadowy "after-image" of a discussion already passed?)

Jantzen did not develop his tantalizing insights, given almost as an afterthought, and left the field to others to explore. It is no coinci-

51

dence, however, that this highly original interpretation—the only one that I am aware of that dared to speculate beyond the tortured confines of the empirical data—has been consistently overlooked in the literature. Only Robert Herbert seems to have considered its implications when he writes that the customer's "disembodied image seems to stand for a male client's hidden thoughts when facing such an attractive woman."[19] But unlike Jantzen, Herbert puts all the emphasis on the male's "powers of wish-fulfillment" and passes by the mutuality of the encounter. It is here that I believe that Jantzen's few lines hold out the possibility of helping us to rethink this modernist icon from a fresh perspective.

The painting was one of two pictures that Manet sent to the Salon of 1882—the other being *Jeanne: Springtime*—his last submissions to the official exhibition before his death the following year. He was then quite ill from the effects of syphilis, and later that year he drew up his last will and testament. His close friends implicated the work for the Salon of 1882 in his creeping paralysis that began around the autumn of 1878. Walking became increasingly difficult and from 1882 he was "presque cloué sur sa chaise."[20] Suffering intensely from what medical specialists of the era diagnosed as locomotor ataxia—a neurosyphilitic disease of the central nervous system which attacked his left leg—he had to paint *A Bar at the Folies-Bergère* from a seated position.[21]

Perhaps the most dramatic testimony to Manet's condition comes from the painter Georges Jeanniot, who visited Manet's studio in January 1882 when he was still working on *A Bar at the Folies-Bergère*. Manet reached out to shake hands from a seated position and apologized for not getting up to greet him: "It's a nuisance, excuse me, I am obliged to remain seated, I have a bad foot. Sit down over there." Jeanniot watched him at work for a while, then more people came in, and Manet stopped painting and sat himself down on the couch against the wall at the right. Jeanniot recalled, "Then I saw how much he was suffering from his illness; he walked, supported by his cane and he seemed to tremble; despite this he stayed cheerful and spoke of his early recovery."[22]

Manet's friend Proust observed that in the course of that year their exchanges grew more frequent, and he seized every opportunity to visit the painter in his studio at 77, rue d'Amsterdam. Proust also noted that the conversations of that period tended towards nostalgic reminiscences of the past as Manet preferred to recall his travels than

speak about more recent events.[23] Under these circumstances, it is understandable that his thoughts, as Jacques-Emile Blanche—who also frequented Manet's studio at the time—suggested, would have naturally turned to recollections of the period of his greatest mobility:

> Memories of that part of the boulevard between the Chausée d'Antin and the rue de Richelieu, then the fashionable strolling grounds for *flâneurs* . . . and the intoxicating air (or so we have been told) once inhaled by the likes of Musset, Rossini, and Théophile Gautier must have made Manet nostalgic, especially when he was no longer able to descend from the Butte, and make the rounds of Tortoni's, just before returning to his sober home life.[24]

The Folies would have been inevitably associated with these and other memories of his previous active social and political life: during the siege of Paris, for example, when Manet served in an artillery unit of the National Guard, the Folies was converted into a public hall, and Manet attended meetings there with Degas and his brother Eugène.[25] Tabarant reported that Manet, despite his failing health, tried to keep up the pretense of the *flâneur* by visiting the Folies in the latter part of 1881 and sketching the decor while moving agonizingly around the promenades of this "vast establishment of pleasure, at once theater, circus, and café-concert."[26] I believe that the progress of the degenerative disease in 1881–1882 and his response to it expressed in the form of nostalgia is a key to the narrative structure of *A Bar at the Folies-Bergère*.[27]

I do not believe it to be a coincidence that the original model for the male client was the artist Louis-Henry Dupray,[28] a military painter who was described by one contemporary reviewer as "a tall handsome fellow, with an aristocratic profile, whose mustaches and sideburns recall one of those young and magnificent officers that Géricault bequeathed to the Louvre." A riding accident, however, had left Dupray permanently lame and dashed his dreams for a gallant military career.[29] Dupray's collection of martial hardware and dedication to military life constituted part of an elaborate structure of illusions that served him as a vicarious alternative to the lived thing. His idealizing self-portrait of 1883 shows himself fastidiously and elegantly attired, his cane held jauntily under one arm, looking to all the world as the epitome of the Parisian *flâneur* (fig. 7). It is thus surpris-

ing to suddenly shift to Manet's study which considerably reduces the stature and suavity of his model (fig. 1).[30] In the case of both artists, the elegant cane accessory that signified the dandy-*flâneur* simultaneously functioned as a sign of their infirmity.

Manet's work gains in pathos when we recall that he must have closely identified with Dupray at the time he executed the first sketch.[31] Manet painted the definitive work in his studio when he was barely able to walk. Once upon a time, the active *flâneur* gleaned a novel aesthetic and sinister beauty from the welter of shoddy and steamy urban public spaces through which he jauntily strolled. The fact that Manet rendered this scene of one of his favorite haunts amid a tremulous spectacle and bustling crowd perhaps testifies to an expression of resistance against his current affliction. His violations of traditional pictorial protocol and abrupt dislocations further attest to his need to flaunt himself as author in this work. For what it shows us is a *flâneur* in the twilight of his career reflecting kaleidoscopically on a past charged with extravagant impressions and haunting phantoms.

The mirror distorts to maximize the field of conceptual as well as perceptual vision, with Manet manipulating it to reveal a sort of double exposure: a simultaneous view of a customer strolling past the bar and momentarily catching the barmaid's eye and an imagined glimpse of the same customer or another chatting with the barmaid at the counter.[32] It is optically possible to see people in a mirror that are not in the direct field of vision, but in this case we are looking dead on at the barmaid, meaning that the reflection of the male should be behind her and the silhouette of the client in the direct line of vision, as one cartoonist of the period projected (fig. 8). Yet we are seeing her and the client from a different angle at the same time, a direct image from one angle and a reflected image from another. This conflation of multiple views in a single compound image could be explained by assuming two separate states of reality depicted simultaneously: one in real-time space in which the *flâneur* moves across the spectator's field of vision from right to left, pausing momentarily in front of the barmaid, and the other in which that moment is perceptually held in place like a split-second afterimage (Jantzen's "Nachbild") or out-of-body experience. Thus the saunterer, who concocts fanciful narratives from his chance encounters while theoretically in continual motion, can witness himself or an alterego spectator-like in the mirror for an instant as a protagonist of a projected fantasy. To put this scenario another way: the *flâneur*-spectator (im-

plying our space) has crossed our field of vision from right to left, momentarily catching the eye of the woman at the counter, then advancing still further and imagining himself glancing sidewise over his shoulder to see both the woman and himself in reflection as he leaves the field of direct vision. (Beholding the mirror from this angle adjusts more accurately the reflection in Manet's painting, except that the barmaid's back would appear to her right in the mirror.) What is true for the male passerby is also true for the barmaid, who weaves her own fantasy about their imagined encounter. The suppressed or hidden impulse to look back to confirm the communication (as in Baudelaire's poem "A une passante") is here visualized as an allegory of equal partnership in which the male and female act out their desires for contact in fantasy. Thus two moments in time are being recorded simultaneously in the picture: one occurring in actuality and the other in the shadowy dream world of the mirror.

That the mirror world could function this way in naturalist creative strategies is seen again in the work of Manet's literary counterpart, Emile Zola. Near the conclusion of *La Curée*, when Renée's incestuous relationship with Maxime is discovered by Saccard, Renée is abruptly left alone in her room where she contemplates herself in the glass of the wardrobe. Her life unfolds before her, including nostalgic flashes of her childhood and adolescence. Suddenly, in the vaporous blue reflections of the mirror she imagined she saw the figures of Saccard and Maxime rise up, one behind the other, as "two apparitions" mocking her illusions and physical being now in the throes of its final agonies.

Although at this moment Renée sees herself as the exploited victim of male conniving, in her sexual relations with Maxime she took the active role and relished her "domination." Similarly, Manet's austere figure of the barmaid or *serveuse* (server of drinks) dominates the composition and controls the narrative interaction. Discussions surrounding her often focus on her ambiguous social status and the expression on her face. The barmaid (actually posed for by a *serveuse* at the Folies-Bergère named Suzon[33]) wears a deadpan expression which has been variously interpreted in the modern era as a sign of loneliness, impassivity, boredom, aloofness, fatigue, and even as "no expression."[34] Although one critic in 1882 noted her "air embêté" (bored look), others that year perceived her in a more positive light such as Paul Alexis, who described her as "bien vivante," truly alive, and Le Senne, who observed "le miroitement du regard," the radi-

ance of her gaze. Clark, writing a hundred years later, sees her above all as *detached*, looking out "steadily at something or somebody." This strikes me as right, giving her the pivotal position within the composition.

Her attitude is in a sense determined by the environment: as many scholars of the work have noted, her gaze is alienated from the whirl of pleasure and vivid color surrounding her. But if we cover up that environment and isolate her head, the expression seems perfectly appropriate with the lips on the verge of a smile. Bracing herself against the counter, her reveries have been momentarily interrupted by the *flâneur* who enters her field of vision. Her somewhat out-of-focus expression is therefore transitional, held in suspension while she sizes him up. Her detachment has proven troubling in another way, since she clearly does not wholly coincide with the role she is supposed to play. The gravity and dignity of her posture and even the severity of her coiffure puts her at odds with the flirtatious barmaid of contemporary novels and popular imagery. She is not easily pigeonholed as the typical barmaid of low morals, though many contemporaries, knowing the reputation of the Folies-Bergère, had this knee-jerk reaction. Instead, Manet has invested her with a solidity and poise out of proportion to her quotidian role in the class relations of production, freeing her momentarily from her public performance and allowing for her subjectivity—and therefore that of his own as well.

Standing motionless behind the bar for the sole purpose of providing service, she resembles Manet at the moment of demanded performance, immobile and confined. Despite her elegant costume and proximity to the entertainment, she is unable to participate as a spectator in the communal pleasure. Her immediate surroundings are alien to her in a way that the surroundings say of Manet's *Olympia* and his *Portrait of Zola* are not. Akin to the shopgirls at the Bon Marché (and in Zola's *Au Bonheur des Dames*), she occupies an ambiguous social space somewhere between petit bourgeois and working class. What is a site for spectacle and exotic encounters between fashionable Paris and the demi-monde is to her only a job. She revives only when the client approaches—for both male and female, politeness in a service job such as the friendly greeting signifies subservience to the customer and exploitation by the employer. In this case, the customer is an autonomous male and the *serveuse* is a vulnerable female, thus leading to numerous speculations about the

possible sexual exchange transpiring. Perhaps the male customer breaks the monotony of the moment and offers her a foretaste of a different life, something beyond the tedium of her routine. She meditates the transaction that positions her as one more item on the counter for sale.

Hippolyte Taine, in his satirical reflections on Parisian society in the person of an imaginary American oil magnate of French origins, M. Frédéric Thomas Graindorge, believed that

> the triumph of a French woman, is to be the lady of a café, a handsome café be it understood; a pretty woman, well dressed, spending her time smiling, and selling, in state at her post, half-decent and half-enticing, agreeable for five minutes, and to everybody, in a hall which is at once a boutique and a salon; she is there like a kid [chèvre] in its meadow.[35]

Although the bar at the Folies-Bergère is not a *café*, it is possible that the barmaid (akin to so many of Zola's heroines[36]) dreams of owning her own establishment instead of working for someone else. Her fantasies would include relationships that might bring her into sudden wealth to finance her scheme.

Yet the absence of the male in the line of direct vision gives the barmaid some of the power of the *Olympia* and the central woman of *Luncheon on the Grass*. It is her gaze that we encounter, and although somewhat tentative it is neither seductive nor flirtatious. It functions as a protective mask, shielding her from potential humiliation and disillusionment as she hears the client out. The client, posed by Gaston Latouche in the definitive tableau, wears a mask of such seriousness that it cannot be mistaken as the kind of flirtatious tryst that comes to us from popular contemporary posters or illustrations and texts by contemporary writers such as Maupassant, Huysmans, and Zola (figs. 9, 10). The client is in deadly earnest, indeed, almost seems to be imploring the barmaid, who continues to maintain her detached expression. In this sense, this mask is part of the job, part of the professionalism of her workplace.

Some critics considered her expression "sphinx-like." Taine's Graindorge perceived social-climbing women in a similar way, underscoring their self-control and poise that puts off the male viewer:

> Cleopatras; the rottenness and culture of Egypt forced into life, eighteen centuries ago, flowers as intoxicating and splendid, as sickly

and dangerous, as those of the Parisian compost heap, from which we draw our vigor and our ills. At first sight they are sphinxes. Look at them directly in the face; at two steps' distance they do not change countenance, not a muscle quivers. With three opera-glasses turned straight upon her, the youngest is motionless. She will not notice your presence; not a blush comes to her forehead, not a quiver to her lips; she goes on talking, looking about through her glass. She treats you as though you were only a wooden peg on which three pieces of black cloth are hanging. She is like a soldier in uniform, under fire; the nerves are braced, but the front serene and head erect. But the hairdo, the robe, a bit of ribbon, a twisted curl, the lightest and most careless of the movements of her fan, each one has its voice, and each one cries out: "I desire; I shall have more; I desire, and I shall have, without limit and for always."[37]

Thus the double image in the direct and reflected fields correspond to two states of mind. As Clark and others have observed, in the reflection the woman seems to be leaning towards the client suggesting a more compliant and sympathetic state of response. In a sense, her thoughts register in this form in the mirror—thus attesting again to two states of mind. The passerby, or stroller, catches a glimpse of her as he strides by reminiscent of the chance encounter of the poet and an imposing woman in Baudelaire's poem "A une passante": "A lightning flash . . . then night! Fleeting beauty / By whose glance I was suddenly reborn, / Will I see you no more before eternity?" As their eyes meet for a moment and she returns the gaze with shared insight, he intones: "Oh you whom I might have loved, Oh you who knew this might be!"

Female roles and presence predominate in the painting: the pyramid of brightly attired ladies in the gallery who observe the entertainment, the trapeze artist who provides it, and the monumental barmaid on the central axis who waits on the spectators. The trapeze artists of the Folies-Bergère occupied a special niche in Parisian leisure pursuits, and the mastery of the female performer was profoundly respected. Just prior to the period that Manet conceived his picture, a female trapeze artist from Louisiana, Leona Dare, "this new queen of the trapeze," electrified audiences at the Folies-Bergère with her audacious stunts.[38] Manet's friend and defender Mallarmé wrote in 1877 that Dare was an object of public adulation.[39] The director of the Folies, Léon Sari, established his reputation for capital-

izing on the vogue for exotic theatrical attractions such as the coura-geous Creole from the U. S. A. Her portrait, surrounded by vignettes of her performing stupendous feats while wearing the laced, high-topped shoes glimpsed in Manet's picture, displays a face of self-confidence and determination that contrasts with the tentative ex-pression of the barmaid (fig. 11). At the same time, however, the posi-tion of the *serveuse*'s bared arms pushing against the refreshment counter echo the fleshy legs of the acrobat perched on the trapeze and reinforces her own visual primacy. There is a subtle, almost grid-like, connection on the left-hand side of the picture between the fe-male members of the crowd (one of whom actively peers through binoculars), the trapeze artist, and the woman at the counter who together form a dominant female presence. In addition, an imaginary line traced through the horizontal bar of the trapeze across the pic-ture intercepts the brim of the man's tall silk hat and operates as its counterweight. This assumes symbolic signification when we realize that the healthy gymnast's feet poised on the trapeze in the reflection are poignant reminders of Manet's predicament at the time he painted the picture.

Sari publicized the entertainment of the Folies for the entire fam-ily, and his numerous circus acts were meant to appeal to children as well as adults. But the acrobats and trapeze acts were the specta-cles that attracted the crowds, especially the American female per-formers. Maupassant's novel *Bel-Ami* opens with a key scene at the Folies-Bergère, touted by the journalist Forestier as a *flâneur*'s para-dise, and the entertainment consists of three men on the trapeze.[40] Huysmans also waxes ecstatically about the robust acrobats on the trapeze.[41] Manet himself paid homage to the Hanlon Lees, Ameri-can trapeze artists who were also performing at the Folies in the late 1870s, by including a poster advertising their act in the window of his painting, *At the Café* of 1878 (fig. 12). This preoccupation with daring trapeze artists and powerful gymnasts, even as relegated to the peripheries of his painting, must have assumed a special impor-tance for him in 1882. It makes one think as well of Edmund de Goncourt's novel, *Les frères Zemganno* (1879), admittedly inspired by Léon Sari and the Hanlon Lees, that tells the story of a famous pair of trapeze artists whose act is destroyed when the younger brother breaks both legs doing a stunt. The novel ends with the two brothers weeping in each other's arms, and the elder, renouncing future performances, states that now they are only "two screeching

violinists . . . who now perform . . . with their rear ends glued to their chairs."

Analogous to Manet, the *serveuse* is stuck behind the counter and unable to join in the crowd. She must keep alert to approaching customers and therefore cannot concentrate on the spectacle as do the members of the audience. She is held in suspension.[42] Her inactivity echoes that of the artist who interposes between him and her his alterego in the conflated form of the painters Dupray and Latouche. There is a disjunction, however, between her job and her public persona. She has allowed her private world to obtrude on her public persona, disrupting the function of merely serving refreshments to the customers.[43] There is a residue of subjectivity that does not permit her to coincide with her public performance. This residue of subjectivity separates her momentarily from the scene, allowing her to examine and evaluate it. In this sense, she may be considered a *flâneuse* or female equivalent to the *flâneur* who gives as good as she gets. Even under the most constraining circumstances, there is a hint of freedom. Hence Manet is both barmaid and customer, and gives the barmaid the final say. Thus he resists in his painting the role that nature had assigned his body by transferring his daydreams to the woman tending the bar.

Proust tells us that during the period under discussion Manet paid a visit to the busy salon of Mme Virot, a celebrated milliner, who upon noticing him leaning on his cane, offered him a chair. Manet responded brusquely with evident irritation: "I have no need of a chair, I am not impotent." After returning to his studio later in the day, he mused to his friend: "Imagine wanting to pass me off as a legless cripple (*un cul-de-jatte*) in front of all those women there! Ah, women! Yesterday, I met one on the Pont de l'Europe. She walked as only Parisian women know how to walk, but with an extra special snap in her step (*quelque chose de plus enlevé*). I intend to make a keepsake of her, because there are things that stay engraved in my memory."[44] The incident is revealing both of Manet's denial of his suffering in the presence of women (the machismo of *flânerie*) and of his simultaneous projection of wish-fulfillment on to robust female surrogates.

I have already pointed out that Hippolyte Taine, Manet's contemporary and a powerful influence on Zola, could compare the ambitious woman of the Second Empire with a soldier under fire, an

analogy he repeats on more than one occasion. Taine's persona, Graindorge, observing the ambiguity of sex in France, recalled a print by Raffet of a *vivandière* whose son was killed by a ball, and instead of crying takes up a musket and enters the fray against the enemy. Here he compares a French woman with woman of other nations, and declares that the French female behaves more like a man. And he continued:

> In fact woman in France is a man, but a man passed through the crucible, refined and concentrated. They have our initiative, our military vivacity, our taste for society, our need of display, our passion for amusement, but with more nerve and stronger enthusiasm. Hence they require the same employments that we do, only of a finer order, those where the passions are controlled, where characters are observed, where there is combat and victory, not brutally and by force, but by address and skill:—the ambassadress, the shopkeeper, and the courtesan. Tell me if there is a spot in the world where the salons, shops and alcoves are more fashionable resorts than in Paris?[45]

Although Taine means to be satirical, he clearly is able to make this gender leap in his imagination; in fact, he later compares the habits, tastes, and ideas of his dandified nephew with those of a "pretty bourgeoise."

Baudelaire and other writers of the time likened poets and journalists to prostitutes. Since their craft consisted in marketing their mental and physical energies, in selling them they were essentially prostituting themselves. Just as prostitutes were streetwalkers, so the writer—and by extension the visual artist—in their guise as saunterers were people of the streets. This identity of male and female as both prostitute and *flâneur* is operative in the *Bar* but less in terms of professional designations than in the sense of a shared understanding and heightened awareness "of the dark recesses of urban life."[46]

The picture is ultimately about the subjectivity of the barmaid as imagined by a male trying to suppress difference. Manet merges his subjectivity with that of the *serveuse*.[47] The engagement takes place in the imagination, in the form of nostalgia for the erotic fantasies of the carefree rambler who once could see potential lovers in the crowded street. In this way, Manet creates the female equivalent of himself—the *flâneuse*. Although the notion of the *flâneur* has

61

emerged in postmodern feminist discourse as the quintessential bearer of the "male gaze"—the capacity to dominate women visually and voyeuristically—its heretofore gendered definition depends on the myths of capitalist culture and the patriarchal tradition.[48] As Janet Wolff has written, "The literature of modernity describes the experience of men."[49] For her, moreover, the category of the *flâneur* excludes the female, except under exceptional circumstances such as the case of George Sand who maneuvered in the public sphere behind a male disguise. There could be no such creature as a *flâneuse* due to the sexual divisions of public and private arenas: the literature of modernity is bound up with the male-dominated public sphere and ignores the private or women's primary field of action. Wolff argues that women can only appear in the male zone by way of "their illegitimate or eccentric routes"—that is, "in the role of whore, widow or murder victim."[50] Although she agrees that the rise of the department store and mass consumerism "provided an important new arena for the legitimate public appearance of middle-class women," she denies its affiliation with her interpretation of "the modern" which embraces the fleeting, the anonymous encounter, and purposeless strolling.[51]

I would argue with Wolff's position and other writers who take the conventional explication of the male stroller too literally or define it too narrowly.[52] This figure and the dandy were likewise consumers of food and drink and the latest fashions, and the fantasies they spun were not all confined to, or dependent upon, the public sphere.[53] Gazing from the window in the privacy of one's apartment at the teeming street traffic and the parade of pedestrians, or from a bench or a cabriolet in the park, or from a merchandising counter in a shop,[54] or from a quiet alcove in a public place could also constitute a meaningful brush with the transitory and ephemeral experience of chance encounters.[55] The male saunterer could function in his role in a stationary position and still weave his narratives about anonymous contacts. This means that shopgirls, barmaids, female cashiers, and women at home could legitimately claim status as a *flâneuse* and nurture their own fantasy life, possibilities inherent even in the male-dominated literature on modernity. While denied "equal" access to social spaces where men roamed easily, lower middle-class and working-class women, deprived of a "respectable" private sphere, thronged the streets and public places. Like their male counterparts, they could gaze at the dream aspects conjured up by the glittering

surfaces of the urban spectacle, the simulacrum generated by capitalism. As Wilson put it, they "may look but not touch," all the while imagining compensatory satisfactions and ultimately aestheticizing the misery of their daily lives.

The fact that no historical category for the female rambler ever emerged could be laid at the doorstep of a patriarchal-driven culture. That the *flâneuse* was theoretically possible for Zola is seen in his novel set against the abundant foodstuffs of Les Halles, *Le Ventre de Paris,* where the women vendors occupy key roles in the surveillance of the district. Mademoiselle Saget, for example, the local gossip, "was complete mistress of the whole neighborhood of the markets. . . . She could have narrated the secret history of every street, shop by shop." What missing bits of information and gaps in her narrative she could not learn from her vile espionage and sinister strolling, she put together in her imagination as much as any *flâneur.* The proud wife of the delicatessen owner, Lisa Quenu, occupies another key point in the narrative as surveyor of the neighborhood markets from her lookout post. In one dramatic scene, the watching *flâneuse* is in turn watched by the awestruck *flâneur* in a dazzling play of mirror reflections. Standing behind her marble counter and facing in the direction of the markets, Lisa is an imposing and monumental figure who intimidates the novel's hero, Florent. Unable to gaze at her directly, Florent inspects her secretly by beholding her reflection in the mirrors that line the walls of the stop.

> in which her back and face and profile were reflected. The mirror on the ceiling, too, reflected her head, with its tightly rolled coil of hair behind, and the little bands over her temples. Florent seemed to be gazing at a perfect crowd of Lisas, some of whom displayed the breadth of their shoulders, some their powerful-looking arms, and others their round, full breasts, so peaceful and reposeful as to be incapable of arousing a single carnal thought. . . . Pieces of pork and of bacon fat were hanging from hooks along the whole line of mirrors and marbles, and Lisa's profile, with her strong neck, curvy lines and swelling bosom suggested an effigy of a queen hung up among the lard and raw meat.[56]

Trapped behind the marble counter, the barmaid in Manet's painting also commands her post and deploys it for her moments of introspective freedom. The spectacle lies spread out before her like the crowd confronting the stroller, and not able to participate as paid

spectator she uses her free moments to identify the faceless and nameless members of the throng. She is as much an occupant and observer—albeit marginalized—of this public sphere as the male rambler. Like him, she creates her own spectacle, a form of self-entertainment that momentarily emancipates her from the job and perhaps gives her a sense of superiority to the crowd through her imaginative control.[57]

The visually absent male *passant* catches her eye—remaining non-committal—and both engage in an exchange in their fantasy outside the range of direct vision. Manet can identify with her subjectivity because of his physical condition that has essentially terminated his career as a stroller. As a passer-by he does not exist except in the imagination of the barmaid; he lives only in the world of reflections, that is, the dream world generated by capitalist spectacle. Indeed, he writes himself out of the script, so to speak, by effacing himself from the main event. By so doing, he leaves a gaping absence or empty space in which the spectator must inscribe her or himself. Manet is essentially the "invisible flâneur," just as he was at the moment of producing the painting. Instead of standing in the dominant position at the easel as he typically did, he had to sit while portraying the barmaid at the Folies-Bergère. This meant that he would have assumed a point of view below conventional eye-level, which may explain why the *flâneur*-spectator is not visible in the space before the barmaid. It is significant, I believe, that in the painted sketch the barmaid towers over the counter to look down at the diminutive Dupray beyond the limits of the pictorial space, although seen in reflection (Fig. 1).[58] As previously seen, Manet's subjugation of Dupray was in striking contrast with Dupray's own idealized self-projection as if to deliberately diminish his stature in the world.

I believe that another visual clue to Manet's mental state at the time is his *Portrait of M. Pertuiset, the Lion Hunter,* painted in the period 1880–1881. Although Pertuiset loved to cast himself as a heroic adventurer in the bigger-than-life mold of the African game hunter, he also appeared in everyday life as a dandy and witty raconteur who specialized in tall tales, and was himself the subject of several comic anecdotes. Manet chose to present him from a low angle kneeling down next to a stuffed lion skin, rather than standing triumphantly over a giant beast as in the standard depictions of wild animal hunters. Pertuiset seems barely able to support the heavy, double-barreled carbine, a feature the cartoonist Stop delighted in exaggerating along with the stuffed lion skin.[59] The satirical features

of the work were thus evident to Manet's contemporaries, and it would appear that, as in the case of Dupray, Manet wanted to bring down Pertuiset a notch or two. The outsized phallic gun, like Dupray's cane, takes on elements of irony in this context.

It is the powerful columnar tree bisecting the composition that carries Manet's signature and helps convey the sense of physical strength in the picture. Similarly, the axiality and physical dominance of the modish barmaid lends backbone to the composition of *A Bar at the Folies-Bergère*, what Herbert has described as her "immense dignity and self-containment."[60] Thus she is not wholly a "victim" of the new commercialized leisure, as Herbert has also written. Here I would like to return to Zola's *Au bonheur des dames* for an analogous heroine, previously mentioned in connection with the mirror motif. Both the *Bar at the Folies-Bergère* and *Au bonheur des dames* are allegories of Parisian commercial spectacle. In Zola's story, a powerful *flâneur* with almost unlimited capacity in the world to rule over the realm of the female is overcome by the shopgirl Denise Baudu, a working-class woman whose steadfast virtue, intelligence, and "immense dignity" not only force him to submit to her position but win her a dominant role in the running of the firm. Throughout the work Denise herself usurps the role of the *flâneur*, studying the passers-by as she moves on the street, looking out through a window at the traffic or physical changes below, or piecing together in her imagination the structure and psychology of the modern department store and its impact on the small-scale entrepreneurs in the neighborhood. Although Mouret symbolically and typically positioned himself at the top of the central staircase to survey "his nation of women," he became obsessed with "the proud and avenging image of Denise, whose victorious grip he could feel at this throat." By the novel's end, her's is the controlling gaze that eventually displaces Mouret's and shifts her to the pivotal role in the organization, "toute-puissante."

Analogously, the barmaid in the Manet refuses to yield to the gaze of the spectator, presumably male, and maintains her own steady presence. She has set out her delectable treats on the counter to be looked at but not touched. She aestheticizes and dominates her universe of action like the designer of a window display. The male glimpsed in the mirror does not consume the food and drink, and potential distinctions in wealth and power are abolished at the counter. Here it is a case of the *flâneuse* mastering the *flâneur*, not the other way around. This is not a demonstration of the *flâneur* in a moment of masculine power, but in the moment of the attenuation

of that power as he yields up his subjectivity to the female. The male is seen only in fragmented and displaced reflection and even there seems to display a supplicatory gesture akin to a humbled and tearful Mouret reduced to begging Denise to marry him.

Typically, the mirror world, like the shop window, could sustain the phantasmagoric image only as long as one's money and one's ability to sustain the illusion lasted. In the case of Manet, however, the collapse of the dream existence stemmed less from flow of income than from the disintegration of his health and sense of self, the point at which deception was bound to break down and reality assert itself. The unstable character of the composition is owing in large part to the uneasy conjunction of the *flâneur*'s world of artifice with an expression of its dissolution. Thus The Man in the Mirror represents a floating fragment of angst rather than a tangible manifestation of male prerogative.

NOTES

I want to express my gratitude to Pam Davis and Steve Kivelson, Department of Physics, UCLA, for their help in disentangling the science of reflections. Ron Cobb and Mitch Suskin also helped clarify the ambiguities in Manet's picture. I enjoyed a mutual scholarly exchange with Ruth Iskin, who broadened my feminist perspective while I directed her to Zola's work. Richard Shiff and Alex Waintrub helped by locating crucial bibliographical materials. Thanks are due also to Wayne Andersen, Georg Kauffmann, and Eunice Lipton for pushing me to think through the issues. Since my original article appeared in *Zeitschrift für Kunstgeschichte* 56, no. 2 (1993), 234–48, two insightful essays have appeared whose themes overlap somewhat with mine, but differ sharply in their emphases and interpretive strategies. See M. M. Gedo, "Final Reflections: *A Bar at the Folies-Bergère* as Manet's Adieu to Art and Life," in *Looking at Art from the Inside Out* (New York, 1994), 1–55, 228–46; R. E. Iskin, "Selling, Seduction, and Soliciting the Eye: Manet's *Bar at the Folies-Bergère*," *The Art Bulletin* 77 (March 1995), 25–44.

1. T. J. Clark, *The Painting of Modern Life* (New York, 1984), 239–58; G. Pollock, *Vision and Difference* (London and New York, 1988), 52–54, 85–86; J. Gilbert-Rolfe, "Edouard Manet and the Pleasure Problematic," *Arts Magazine* 62 (February 1988), 40–43; R. L. Herbert, *Impressionism: Art, Leisure, & Parisian Society* (New Haven and London, 1991), 79–81.

2. For a general study of this problem, see R. Thorne, "Places of Refreshment in the Nineteenth-Century City," *Buildings and Society*, ed. A. D. King (London, 1980), 228–53.

3. R. Rosenblum and H. W. Janson, *19th-Century Art* (New York, 1984), 371.

4. J.-K. Huysmans, "Les Folies-Bergère en 1879," *Croquis parisiens* (Paris, 1855), 38.

5. For the metonymic implications of mirrors in Parisian public life, see W. Benjamin, *Gesammelte Schriften*, 7 vols., ed. R. Tiedemann and H. Schweppenhäuser, with the collaboration of T. W. Adorno and G. Scholem (Frankfurt am Main, 1972 *et passim*), V (*Das Passagen-Werk*), 666–73, 1049. See also S. Buck-Morss, *The Dialectics of Seeing: Walter Benjamin and the Arcades Project* (Cambridge, MA, 1989), 80–82.

6. This may be seen in an illustrated program reproduced in the separately paginated insert, "The Hidden Face of Manet. An Investigation of the Artist's Working Processes," *Burlington Magazine* 128 (April 1986).

7. G. de Maupassant, *Bel-Ami*, ed. D. Leuwers (Paris, 1988), 15.

8. Huysmans (as in n. 4), 12.

9. E. Zola, *Carnets d'enquêtes*, ed. H. Mitterand (Paris, 1986), 186, 188–89, 191, 193. He reminds himself at one point: "Ne pas oublier que les glaces des coins, des côtés, reflètent l'étalage, font tourner les motifs en les répétant. Une science approfondie du jeu des glaces."

10. E. Wilson, *The Sphinx in the City: Urban Life, the control of Disorder, and Women* (London, 1991), 58.

11. P. Derval, *The Folies Bergère*, trans. L. Hill (London, 1955), 5–6; Herbert (as in n. 1), 79–80.

12. M. B. Miller, *The Bon Marché: Bourgeois Culture and the Department Store, 1869–1920* (Princeton, 1981), 167.

13. "Grands établissements de Paris: Les nouveaux magasins du 'Bon-Marché'," *L'Illustration* 59 (30 March 1872), 206. See also R. H. Williams, *Dream Worlds: Mass Consumption in Late Nineteenth-Century France* (Berkeley and Los Angeles, 1982), 66–72, 101.

14. For an excellent analysis of the novel and the commodification of the gaze, see R. Bowlby, *Just Looking* (New York and London, 1985), 66–82.

15. E. Zola, *Au Bonheur des dames* (Paris, 1883), 301. Zola's fascination for this effect, already anticipated in his research notes, appears again in his *Le Ventre de Paris*, where he describes the lavish new delicatessen (*charcuterie*) launched by Lisa and Quenu: "From an immense square mirror on the ceiling, surrounded by an elaborately gilded and ornamented cornice, hung a crystal chandelier with four branches. Over the whole of the wall panel behind the counter, and at the left side, and also at the end of the shop, were other mirrors, pools of light let into marble frameworks, which had the effect of doors opening into other halls to infinity, all filled with an endless display of meats." Later, at Monsieur Lebigre's café, Zola's creates an effect startlingly reminiscent of Manet's painting. After describing the colorful arrangement of the fruits and bottles, he writes: "Standing on the glass shelf in the bright glow of the mirror, these flasks appeared as though they were suspended in the air." E. Zola, *Le Ventre de Paris*, ed. M. Baroli (Paris, 1969), 108, 220, 222.

16. Zola, *Au Bonheur des dames*, 309.

17. J. Comte, "Les Salons de 1882," *L'Illustration* 79 (20 May 1882), 335. Except for minor changes, I have relied here on Clark's excellent translation: see Clark (as in n. 1), 240.

18. H. Jantzen, "Edouard Manets 'Bar aux Folies-Bergère'," *Essays in Honor of Georg Swarzenski* (Berlin, 1951), 232.

19. Herbert (as in n. 1), 81.

20. T. Duret, *Histoire de Edouard Manet et de son oeuvre* (Paris, 1906), 242–45.

21. For a thorough clinical analysis of Manet's illness, see now M. M. Gedo, "Final Reflections: *A Bar at the Folies-Bergère* as Manet's Adieu to Art and Life," in *Looking at Art from the Inside Out* (New York, 1994), 6–9. Gedo's essay takes his disability as central to her psychoanalytic understanding of his late work. Gedo suggests that the scanty data available and rudimentary state of neurological knowledge in Manet's era do not permit us to make a conclusive diagnosis of Manet's illness. She speculates that he may have suffered from syphilis, multiple sclerosis, or some other form of ataxic disease.

22. G. Jeanniot, "En souvenir de Manet," *La grande revue* 46 (10 August 1907), 853–54.

23. A. Proust, *Edouard Manet. Souvenirs* (Paris, 1913), 117–18.

24. J.-E. Blanche, *Manet* (Paris, 1924), 49.

25. Proust (as in n. 23), 59. See also Derval (as in n. 11), 6. The Folies became a hall for political meetings in which an outraged electorate railed against the conservative deputies in exile at Bordeaux, deciding the fate of the war with Prussia.

26. A. Tabarant, *Manet et ses oeuvres* (Paris, 1947), 423, stated: "Il aimait à flâner, le soir, dans les promenoirs de ce vaste établissement de plaisir."

27. Jeremy Gilbert-Rolfe, reversing Freud's notion of the pursuit of pleasure as the deferral of reality, sees in Manet's painting the giving of pleasure as "reality deferred," and also studies the picture for three related concepts: "desiring to desire, the power (erotics) of unresponsiveness, and the presence of death in the erotic." This is a provocative theoretical reading germane to my own investigation. See Gilbert-Rolfe (as in n. 1), 40.

28. Gaston Latouche claimed that he posed for the mustachioed man with cane in the definitive picture. G. Latouche, "Edouard Manet souvenirs intimes," *Le journal des arts* (15 January 1884). According to Jacques-Emile Blanche, Dupray was a neighbor of Manet and on close terms with their mutual friend Méry Laurent. J.-E. Blanche, "Quelques notes sur Manet," *Propos de peintre. De David à Degas* (Paris, 1927), 142, 145.

29. A. M. de Bellina, *Nos peintres dessinés par eux-mêmes* (Paris, 1883), 318–21.

30. The handwritten annotation (probably by Léon Leenhoff) on the back of a photograph of the work taken in 1883 states: "painted from sketches made at the Folies-Bergère. Henry Dupray (the military painter) chats with the girl at the counter. Painted in the studio on the rue d'Amsterdam."

F. Cachin and C. S. Moffett, *Manet 1832–1883,* The Metropolitan Museum of Art (New York, 1983), 483 no. 212.

31. Gedo (as in n. 21), 49, although not aware of Dupray's disability, emphatically states that Dupray functioned as Manet's "surrogate" and "alter ego of choice."

32. For the spatial effect of the mirror, see Jantzen (as in n. 18), 230–31.

33. A. Tabarant, *Manet: Histoire catalographique* (Paris, 1931), 412; idem, *Manet et ses oeuvres,* 424–25.

34. N. Ross, *Manet's Bar at the Folies-Bergère and the Myths of Popular Illustration* (Ann Arbor, 1982), 2. Ross otherwise supplies an excellent description and analysis of the painting.

35. H. Taine, *Notes sur Paris. Vie et Opinions de M. Frédéric-Thomas Graindorge* (Paris, 1880), 61.

36. Taine's influence on Zola may be seen in the number of Zola female characters who aspire to become "une dame de comptoir": one thinks of Gervaise in *L'Assommoir,* Lisa in *Le Ventre de Paris,* and Zoé in *Nana.* See also Ross (as in n. 34), 84–85.

37. Taine (as in n. 35), 141–42.

38. "Le théâtre des Folies-Bergère: Miss Leona Dare," *L'Illustration* 68 (16 December 1876), 390. It is possible that the trapeze artist in the reflection is Dare's successor, Katarina Johns, who was performing at the Folies in 1881. Johns was compared to Dare: see Ross (as in n. 34), 76–77, 100 n. 8.

39. S. Mallarmé, *Correspondance, 1862–1885,* ed. H. Mondor, 2 vols. (Paris, 1959), II: 159. For Manet and Mallarmé, see Proust (as in n. 23), 73–77.

40. Maupassant (as in n. 7), 15.

41. Huysmans (as in n. 4), 21–22, 25–26, 35–36.

42. One critic described her as being "paralyzed on the spot": see C. de Beaulieu, *Salon de 1882: Publié dans La Mode Actuelle* (Versailles, 1882), 1–2. For a full discussion of contemporary critical responses to the work see Clark (as in n. 1), 239–48.

43. She refutes the popular ads and texts of the time that depict the barmaids as "charming girls whose playful glances and delightful smiles attract a swarm of customers." See J. W. Bareau, "The Hidden Face of Manet. An Investigation of the Artist's Working Processes." Separately paginated edition of the catalogue of the Courtauld Institute Galleries in *Burlington Magazine* 128 (April 1986), 77.

44. Proust (as in n. 23), 113. Gedo (as in n. 21), 12, 20, points to Manet's lifelong body narcissism that would have made the public display of his progressive disability all the more difficult to accept, as well as to his intense self-denial.

45. Taine (as in n. 35), 64–65.

46. Wilson (as in n. 10), 55.

47. Gedo (as in n. 21), 50, 52, agrees that Manet chose Suzon as his "alter ego" and "final symbolic representative," but sees her in part as a complex

symbol of Manet's vanished youth as well as a site of displaced desire for dignity rather than as an image of empowerment in the present; finally, Gedo makes her bear the additional weight of a "covert Christ image" that signifies at once "the Savior in the tomb" and the resurrection.

48. Wilson (as in n. 10), 56; E. Wilson, "The Invisible Flâneur," *The New Left Review* 191 (January–February 1992), 90–110; E. Ann Kaplan, "Is the Gaze Male?," *Powers of Desire: The Politics of Sexuality*, ed. A. Snitow, C. Stansell, with S. Thompson (New York, 1983), 309–27.

49. J. Wolff, "The Invisible *Flâneuse:* Women and the Literature of Modernity," *Feminine Sentences: Essays on Women & Culture* (Berkeley, 1990), 34.

50. Ibid., 44–45.

51. Ibid., 46.

52. Here I am following the lead of Wilson (as in n. 10), 98–101. But I disagree with Wilson's claim that there could never be a *flâneuse* for the reason "that the *flâneur* himself never really existed." Ibid., 109. Such a conclusion opens the way to dispensing with all "role models," fictional or otherwise. There is plenty of material waiting to be mined in support of the *flâneuse*. The pioneer French critic of advertising claimed that the poster was the ideal form to attract the *flâneur*—intriguing when we recall that so much of early advertising was aimed at women; an American female critic, thoroughly imbued with Manet's aesthetic, wrote that no individual "who walks about in New York in that receptive condition of mind characteristic of the artistic *flâneur*, can have failed to note the increasing love of color everywhere manifested." See E. Mermet, *Guide Mermet; la publicité en France* (Paris, 1878–1880), pp. 64, 73, 79; C. Adams, "Color in New York Streets," *Art Review 1* (September 1886), pp. 17–19.

53. See Williams (as in n. 13), 111–53.

54. E. Wilson, *Adorned in Dreams: Fashion and Modernity* (Berkeley, 1987), 149–50.

55. Taking off from Walter Benjamin's *Passagen-Werk*, Susan Buck-Morss elaborates on the social meanings of the *flâneur* and delivers it from its conventional interpretation. See S. Buck-Morss, "The Flaneur, the Sandwichman and the Whore: The Politics of Loitering," *New German Critique* 39 (Fall 1986), 99–139.

56. Zola, *Le Ventre de Paris*, 138.

57. W. Benjamin, *Charles Baudelaire: A Lyric Poet in the Era of High Capitalism* (London, 1985), 35–66.

58. Gedo (as in n. 21), 30, describes the visual relationship quite eloquently: "Clasping his round-headed cane to his chin, the bowler-hatted Dupray regards the barmaid with the somewhat nonplused [sic] air of a Lilliputian who unexpectedly finds himself in the country of the Amazons."

59. Cachin and Moffett (as in n. 30), 473.

60. Herbert (as in n. 1), 80.

Art History in the Mirror Stage: Interpreting
A Bar at the Folies-Bergère

DAVID CARRIER

"Der liebe Gott steckt im Detail."
Ernst Gombrich, quoting Aby Warburg[1]

Much traditional art history treated paintings in formalist ways, isolating them from the context in which they were produced, purchased, and displayed. T. J. Clark's highly controversial work has recently been one important model for post-formalist art historians. An older Marxist tradition urged that analysis of the class structure of the society in which paintings were produced could help explain the content and composition of artworks. Clark's different approach involves placing the artwork in the context of critical commentary by contemporaries of the artist. Such commentary displays the values of a culture; reading it to learn what critics see, and fail to see, in a painting is immensely instructive. "Clark's various statements on modernism have probably received more comment than any other recent body of art-historical writing."[2] This is not surprising. Often identified, somewhat misleadingly, as a Marxist, he has written about Impressionism, a much loved art that he does not altogether admire, employing a methodology most art historians will feel to be alien from a political position conservatives, liberals, and some leftists find repugnant.[3] But the resulting discussion of his work, focused mainly on partisan criticism (or praise), has failed to do justice to the complex methodological issues. It is by focusing on those issues, and not upon the narrow political debate, that discussion can best be advanced.

The issues Clark raises are important for historiography. What is at stake, ultimately, are several questions of broad concern for art history, and for interpretation in general: how are we to evaluate radically

71

original interpretations of familiar artworks?; how may such new accounts get us to see artworks differently?; and, how may we compare and contrast conflicting interpretations? Whatever the ultimate judgment of art historians about the value of Clark's particular approach, these are questions that any radically original interpretation raises. For the most part, Clark presents his interpretations without devoting much explicit attention to these methodological problems. And so, a reader who seeks answers to these questions must go beyond Clark's own texts.

I do that by arguing that the key to understanding Clark's approach in all of his work is provided by one book mentioned in the bibliographies, but not in the texts, of his two books published in 1973, *Image of the People. Gustave Courbet and the 1848 Revolution* and *The Absolute Bourgeois Artists and Politics in France*. Since my present essay focuses on another later text by Clark, I sketch this claim only briefly, without offering a reading of these complex books. When in 1973 Clark's two books were published, Jacques Lacan's *Ecrits* (1966) had become enormously influential in France. (A book length selection from that book was not published in English until 1977, although some essays appeared earlier.) Since most of the items in Clark's bibliography deal with either art history or French social history, the inclusion of Lacan's book, not discussed in the body of the text, ought to have been something of a mystery. *Ecrits* has nothing to say about visual art. Lacan does say a great deal about language and its interpretation and it is here, I believe, that his account exercised an important influence on Clark. This claim can be supported by a close analysis of his interpretation of Manet's *A Bar at the Folies-Bergère*.

In these two earlier books, as in this more recent accounts of Manet, Clark repeatedly adopts the same strategy. What we find in the confused contemporary commentaries on Courbet by both leftists and conservatives, those in the arts and those outside, is "an unsureness which the language of aesthetics can hardly articulate, a kind of critical vertigo."[4] Clark claims that these confusions inadvertently reveal the shared ideology of these commentators. In his analysis of the contemporary criticism of Manet's *Olympia*, he treats such texts "as evidence in which *the real appearance* of *Olympia* can be made out, in however distorted a form."[5]

I take this phrase "the real appearance" to be of great importance. Like the neurotics to whom Lacan listened, these critics are incapa-

ble of saying what they really mean because doing that would require them to articulate what in their culture almost inevitably remained repressed. What is repressed by these critics reveals their ideology. These commentaries thus might be called neurotic texts.[6] The analogy between neurotics and these critics must be used with care. To say that a text is neurotic is not to imply that its author is neurotic. The speech of neurotics reveals their unconscious neurotic ideas; the texts of these art critics, as read by Clark, reveal shared worries about class conflict and sexuality. Freud's analysis of his patients uncovers what they are unable to say, and reveals why they repressed these beliefs. Analogously, Clark's interpretation of the critics' neurotically confused writings recovers what they cannot say, that ideology that explains why their texts are confused. An ideology might be described as a shared neurosis. Insofar as Clark's goal is to see through that ideology, what he claims to provide is both a clearer view of the paintings and the ideology of such critics. In analyzing the ideology, we learn not only about the artworks, but also about the society in which they were created. This parallel between neurotic speech and such neurotic texts is, if correct, a fecund analogy.

In his account of *A Bar at the Folies-Bergère* frontispiece Clark applies this procedure to the comments by contemporary critics on this work, shown in the Salon of 1882 (PML 239–45). Manet depicts the barmaid facing us and shows her at an angle facing a man in the mirror. The picture cannot be consistent, not if we suppose that it is the same barmaid who appears in both places. (The space is not big enough to contain two barmaids, and so this must be the same woman.) And so if we do not believe that Manet was just inept, it is natural to ask the meaning of this obvious inconsistency in his image. That mirror "on its own did not seem to provoke any great uncertainty in Manet's first public: it was either straightforwardly a failure or sketched in boldly enough for the job it had to do" (PML 241). The older accounts suggest that Manet was not very good at composing pictures. If the perspective in many of his pictures is defective, that was, they said, simply because he was inept. But now commentators find a method in these seeming errors, which are seen rather as intentional.[7] Or, if he was inept at composition, he intentionally used this weakness to good effect.

When thought about that way, what now seems fascinating about *A Bar at the Folies-Bergère* is the questions it raises about the identity of the spectator who, standing before that painting, sees the barmaid

shown twice, once facing him or her and once at an angle. As Clark writes:

> in order to confront 'the beholder' with the unity of the picture *as painted surface* all the other kinds of unity which are built into our normal appropriation of the work of art—including the unity of ourselves, the 'beholder'—have to be deconstituted.[8]

Even some commentators who do not agree with his account agree that there is some problem here.[9]

Manet painted two versions of this picture. All the commentators I have read, Clark included, treat the preliminary study (fig. 1) as an unsatisfactory version of the final picture. It is natural that they do this. Describing the first version as "a preliminary study" already assumes as much. If a painter does the same scene twice, the first time as a study, then it is natural to suppose that he resolved the second time the difficulties of the first version. Very often painters (and writers) believe that the later picture (or text) they produce is better. We all like to believe that we are progressing in our work, though of course this is not always true. Sometimes penultimate drafts are better than final versions of texts; occasionally artists spoil paintings by reworking them. This assumption that Manet was progressing plays an important role in the way the later version of the picture is understood.

Just as Manet painted two versions of that painting, so Clark has published two accounts of it. The first was an essay published in 1977; the second, his 1985 book, *The Painting of Modern Life*. Often of course an author will incorporate into a later book essays published earlier. But since Clark says that his second account "largely disagrees with" (PML 303, n. 2) the early version, clearly he thinks these two accounts different. Since he doesn't himself spell out how they disagree, identifying them is a task left to the reader. And doing that is not easy, for in some important and obvious ways the two texts adopt the same approach. Both offer a great deal of sociological evidence to show why such an image of a cafe was hard for contemporary writers to interpret. Classes mingle in the cafes "but it was not clear whose class *was* secure" (PML, 238). Hence "the critics' unconscious way of thinking" is to assume that "an image which seems in many ways to us so plain and straightforward . . . must also provide an equally uncomplicated set of expressions and exchanges" (PML, 243).

Both accounts ask the same two questions: Where are the depicted figures?; where are we in relation to the man in the mirror?

> Where does he stand in relation to her, in relation to us? . . . 'We' are at the centre, he is squeezed out. . . . His transaction with the girl who leans towards him taking his order cannot be the same as our transaction with the girl who gazes back at us (BFP, 236–37).

His transaction with the barmaid cannot, surely, set the tone for ours. (PML 250).

In his earlier version of the picture Manet gives "a readable, eye-catching relation between the barmaid and man in the mirror" (PML 252). In the later one we find that the mirror reflects "Manet's attitude toward . . . modern life in Paris," a conflict between that orderly solid world and the play of appearances of the society of the spectacle.[10] Clark's absolutely crucial assumption in both accounts is that the figures depicted in this picture stand as if in a determinant relation to the spectator. The picture revealingly mirrors bourgeois society because "what begins as a series of limited questions about relationships in space is likely to end as scepticism about relationship in general" (PML 251).

How exactly, then, do Clark's texts differ? I identify this as a problem now because when I read and reread them I had difficulty both asking this simple question and answering it. Looking back, it was clear why I had this problem. Both accounts argue that we cannot find a place for ourselves before the mirror. Both mention the role of class in the dance hall, citing T. S. Eliot's account (BFP 245; PML 216–7) of Mary Lloyd. When in the earlier account Clark describes the painting as a mirror image of alienation (BFP 252), he states in a simpler way what he later says in the more elaborate account. But his basic claim does not seem different.

The one obvious difference between Clark's two narratives is the position in which the painting is placed within his texts.[11] Although both versions of the text include a good deal of the same material, the order of the presentations differs. Clark's earlier analysis begins directly with the account of the painting, and only then gives a social history. The second version has a thirty-page discussion of classes in the cafes, lighting, songs and their censors, and the commercialization of leisure before it gets to the painting. In the article we first read Clark's view of the painting, and then his account of the social his-

tory; in his book the analysis of the painting is a surrounded by an account of the social history. A formalist art historian will be puzzled at that surrounding material. Why discuss cafe songs when no one is singing in this picture? But for Clark the content of the picture can only properly be understood when it is placed in this cultural context. Perhaps the felt limitation of his earlier account was that by placing this social history after the account of the picture proper, his analysis of the painting seems unmotivated.

There is a second, less obvious difference between the two texts which also is worth noting. In Clark's book Manet's earlier painting is contrasted to the later, better known work to show

> how easily things might have been sorted out . . . if that had been what Manet had wanted. . . . He might have put the barmaid and her reflection together, back to back, with the mirror established between them. He could have pushed the counter back in space. . . . But of course he did not: he seems to have worked instead to discover and exacerbate inconsistencies in his subject (PML 252).

The preliminary version seems less skilled according to Clark, but since, as he admits, in both versions the barmaid faces us *and* the man reflected in the mirror, why does he describe the second version thus?

What is important for Clark is one further point: the exact place and role of the mirror. It "must . . . be frontal and plain, and the things that appear in it . . . laid out in a measured rhythm" (PML 252). Many of the contemporary commentators, almost like Clark in his earlier account, found no puzzle here. Either the picture was a failure or the mirror image a muddle, which in their cartoons (fig. 8) was straightened out in "corrected" versions of the image (PML 241). And yet the second picture *is* different. It both "delights in flatness" and "offers . . . a form of explanation . . . a form built into the picture's visual structure" (PML 253), which explains this flatness.

Just as the mirror image both duplicates and does not match the scene before its surface, the picture as a whole both shows in a literal way the Folies-Bergère and, because it does not accurately depict that scene, marks the difficulty (for Frenchmen of the time) of bringing such a scene into focus. "It is plain as well as paradoxical, fixed as well as shifting" (PML 253). This is a complex statement, for it brings together opposites in a way that is hard to sort out. The seeming untruthfulness of the picture, Clark is saying, is a way of marking its

essential truthfulness. How can one picture be both truthful and untruthful at the same time?[12] Perhaps we can think of it that way only by comparing it with the earlier version, and setting it in the social history that Clark provides. In that account, Manet's literally untruthful perspective provides a way his picture can reflect the problems of bourgeois ideology. That way of describing the picture is itself complex. Since the picture actually depicts a mirror, here the word "reflects" is used in both its literal and metaphorical senses. Clark flirts with paradox when he says that the picture "lacks an order" (PML 253), since of course he thinks that this apparent lack of order is, when properly understood, but a revelation of the deeper order which *is* truthfully displayed in his text. Earlier Clark focused on the uncertainty in the image, upon "that uncertainty of surface (which) infects our whole relation to the girl, to the exterior that stands there at the centre, offered to us" (BFP 250). Now he finds the image more ambiguous. "It is plain as well as paradoxical, fixed as well as shifting" (PML 254).

I return to my earlier questions: why does Clark describe the picture twice?; why does he get it right only the second time? The second time the social history comes before the account of the picture; and the first unsatisfactory version of the picture is contrasted with the second successful version. These changes in Clark's rhetorical strategies explain why he now interprets the picture differently. This is why my parallel between the two versions of Manet's picture and Clark's two texts is very suggestive. Just as Manet can only get the picture right—that is, can only express all the ambiguities of Manet's Paris which Clark's social history aims to reveal—the second time, so Clark's text only interprets the picture right the second time. Clark both rearranges the order of his commentary, so that the social history comes first, and brings into the interpretation the first and second versions of Manet's picture. Taken in isolation, the picture seems ambiguous; framed by the social history, its ambiguities fall into place. Placed in relation to the early version, whose indefiniteness makes it a less adequate mirror of the ambiguities of this social world, the second version resolves Manet's gropings by creating these unresolvable ambiguities. Again, it is hard for me to state this claim without flirting with paradoxes like those Clark finds in the picture. The picture seems ambiguous, but really is unambiguous only when placed in the right context. The unit of art historical discourse is not just the painting in isolation, but that painting as it may be placed in

an account such as Clark's. Manet's painting can be called both ambiguous and unambiguous only when it is set in such a narrative which spells out its meanings.

I am only applying to Clark's account the approach he himself adopts in analyzing the earlier commentaries. Just as he thinks that "the real appearance of *Olympia* can be made out, in however distorted a form" (PML 98) in the critics' early commentaries, so I think that the real appearance of *A Bar at the Folies-Bergère* can be seen in distorted form in his texts. Unlike him, I deny that there is any neutral narrative describing the picture as it actually is, apart from how it is contextualized. I think it is mistaken to speak of "the real appearance" of such an artwork apart from how it is presented in an art historian's commentary. Of course the picture has a real appearance. But any interesting interpretation of that artifact must make controversial claims about how to describe its appearance.

Here I come to the much discussed problems of relativism. Some writers think that an objective viewpoint on texts, pictures, and social institutions is possible. Others believe that every individual perspective carries with it assumptions which from another viewpoint may be questioned. A version of this debate has developed within art history. Conceptual conservatives ask that we not go outside the pictures themselves, but let them "speak for themselves." Pictures, this metaphor implies, have a self-evident meaning when looked at properly. Such conservatives think that Clark goes outside Manet's picture when he places it in his social history. The critics of these conservatives deny that it is possible for a picture to speak for itself. What, they ask, is the real distinction between what is within a picture and what is outside of it?

These spatial metaphors are not easy to interpret. Since pictures are placed by every commentator in some context, the real question is in what context paintings should be placed? Sometimes conceptual conservatives appeal to connoisseurship. Art history, they say, should talk about only pictures, not about the social history that lies beyond the frame. Connoisseurs are interested in Manet's body of work; they study his changing styles of picture-making. But when we go beyond that practice, understanding the principle upholding their criticism of social historians is not easy. The difference between a connoisseur who urges that we focus on the picture itself, relating it only to other pictures by Manet, and the social historian like Clark is that they have different ideas about how to place paintings in con-

text. For that connoisseur to compare *A Bar at the Folies-Bergère* to other works by Manet requires going outside that one picture, relating it to the body of his art. For Clark, we understand that picture by learning about the place it depicts. In either case, the commentary goes beyond the bounds of that individual picture.

Elsewhere I have discussed the implications of such claims about the role of rhetoric in art history.[13] Now I extend that discussion by dealing with two points raised by this commentary on Clark. First, how in light of this discussion of his rhetoric should we understand Clark's appeal to Lacan? Second, if all artwriting must deal with the rhetorical problems I have raised by appealing to such notions as "narrative" and "metaphor," then how could a methodologically self-conscious art historian build upon Clark's text to interpret *A Bar at the Folies-Bergère* in new ways?

What is striking to a reader who notes the apparent importance of Lacan's work in Clark's earlier account is the combination of a Lacanian reading of the contemporary texts describing *A Bar at the Folies-Bergère* with a resolutely unLacanian analysis of the image itself. Lacan's essays on painting collected in *The Four Fundamental concepts of Psycho-Analysis* under the title "of the gaze as *Objet Petit a*" offer a sustained attack on that model of the relation between picture and viewer that Clark adopts.[14] ("Object Petit a" here may initially be understood as a codeword referring to that anonymous "Other" described in Sartre's philosophy.) Of course, there is no reason that Clark need be consistent in this way, especially in dealing with so highly elusive a writer. Lacan's view of texts may be separable from his analysis of pictures. For Clark's purposes, what Lacan's *Ecrits* provides, I have suggested, is a way to read texts.

But when Lacan writes, "In any picture, it is precisely in seeking the gaze . . . that you will see it disappear" (FFC 89) what he says is relevant to *A Bar at the Folies-Bergère.*[15] According to Lacan, the child first forms an idea of its own identity by perceiving its mirror image, which thus "symbolizes the mental permanence of the I at the same time as it prefigures its alienating destination." The infant discovers its body in that imaginary space behind the mirror which is both visible and inaccessible; the self, paradoxically is located "out there" in this imaginary space. Though presented in a psychoanalytic context, this account develops out of a Hegelian tradition which laid great emphasis on the link between alienation and self-discovery.[16]

This seems a developmental account, a story about how the child becomes an adult. At a certain stage in its life, the child comes into the mirror stage: "A description of the Imaginary will . . . require us to come to terms with a . . . space . . . *not yet* (my italics) organized around the individuation of my own personal body, or differentiated hierarchically according to the perspectives of my own central point of view."[17] But as commentators have emphasized, the notion of discovering the self during the mirror stage is highly paradoxical. "The mirror stage is a turning point. After it the subject's relation to himself is always mediated through a totalizing image which has come from the outside."[18] How can this mirror stage be a turning point if it is also the origin of the awareness of self, "the moment of the constitution of that self. What proceeds it?" Before that moment there was no subject, and so we cannot contrast the self as it was before the mirror stage and that self as it becomes after that moment. Since Lacan aims to tell the story of how persons discover themselves, he needs to explain how they think of themselves prior to the stage when they look into the mirror. Before the mirror stage the child had a body, but no conception of self.

The self, it thus seems, is created in the mirror stage. But how then can we speak of what happened to that person *before* that moment?[19] Perhaps thinking of the mirror stage as a developmental stage is mistaken. What Lacan is really describing is the nature of perception, not a moment in real time. And the concept central to his account of perception is the split between the eye and what he calls "the gaze": "I see only from one point, but . . . I am looked at from all sides. . . . consciousness, in its illusion of seeing itself seeing itself, finds its basis in the inside-out structure of the gaze" (FFC 72, 82). When I see the external world I am aware that it contains other persons like myself, other perceivers.[20] That much is obvious. What Lacan adds is the more complex idea that I always think of myself as seen by these other perceivers. He is not just making the trivial point that sometimes I am seen by others. His more interesting (and obscure) claim is that I always think of myself as potentially exposed to the gaze of these others. This claim provides the connection between his approach to psychoanalysis and visual art. When I perceive, "I turn myself into a picture under the gaze . . . I am looked at, that is to say, I am a picture" (FFC 106).

The mirror stage reveals that I the perceiver who view an image am at a position I can locate only in the imaginary space of the mirror, a

place—like that marked by pigment in an illusionistic picture—which I can see but not physically reach. (I can of course touch my image in the mirror. But that no more counts as reaching *into* that imaginary space than touching the pigment on a painting counts as reaching into the illusionistic picture space.) Common sense tells that I am located where my eyes are. But Lacan's account of the mirror stage requires that we give up this common sense view. This split between the eye and the gaze has further consequences. By itself, the embodied self is in one sense incomplete. Whenever I see the world, I also see myself being seen by others. My awareness that I exist in an intersubjective world in which others perceive me is built into the very structure of perception. I cannot think of myself apart from knowing that these others see me.

Lacan presents his theory of the self using an image of two intersecting triangles, the gaze placed in the base of that triangle at whose apex the subject is positioned. The line formed by joining the points where these triangles intersect, a plane perpendicular to a line joining that gaze to the subject, forms what he calls the screen. Perception involves three elements: between the *gaze* and the *subject* stands that *screen* on which the image is cast. Although Lacan never mentions Manet in this text, his diagram of perception looks very much like a model of *A Bar at the Folies-Bergère*. This is unsurprising, for both Lacan and Manet are interested in the relation of the self to a mirror image. Lacan does note that his image is very much like the image of a painter making a painting. "If I am anywhere in the picture, it is always in the form of the screen" (FFC 107). But this picture is not the traditional Albertian painting, the perspectival construction containing viewer, image, and represented scene. Rather, Lacan's diagram looks like two such paintings superimposed, one marking the position of the viewer who looks at the world, the other defining the place of that gaze out in the world looking back at that viewer.

One reason Lacan's analysis is hard to understand is that it is difficult to visualize. Common sense tells us that we are where our eyes are, and that others—who reason similarly—are also where their eyes are. And so when Lacan seeks to undermine this intuition, it is hard to imagine how he would have us think of perception. Common sense takes a Cartesian view: the world is centered on the perceiver. In a literal way, common sense is egocentric. What common sense neglects, for Lacan, is the essentially social dimension of perception. The world I look at from my viewpoint is a world in which other

viewers perceive me. Perception, Lacan is saying, is not a dualistic relation between perceiver and perceived, but a triangular structure in which the three positions are occupied by the subject, the gaze looking at that subject, and the screen, or image, which comes from superimposing the two dualistic relationships: subject looking at gaze; gaze looking at subject. When I look at another person, I see them seeing me. Only such a triangular structure, Lacan is claiming, does justice to the mutuality of seeing, the social dimension present in that act of perceiving. For Lacan, unlike Descartes, the social dimension of perception is built in from the very start.[21]

Lacan's account of perception suggests a view of Manet's painting that is very different from Clark's. If a triangular arrangement is central to perception, then in *A Bar at the Folies-Bergère* we find stand-ins for his three picture elements: the barmaid at the center facing us; the couple at the right; the mirror between them. What on Clark's reading of the picture space is an apparent contradiction, the man standing in our place before the picture, is on this Lacanian interpretation a juxtaposition of the gaze before the subject, the barmaid who is engaged with the man at the right, projected onto the screen, here shown as a mirror. It is hard to compare this Lacanian interpretation to Clark's account. As given, it offers no immediate way of linking the interpretation of Manet's picture to a social history of Paris. This abstract appeal to "the other" does not tell us how to link this painting to the social history of Manet's Paris. For my present purposes, we need not pursue this interpretation which deserves development in more detail. What interests me here is what this account teaches us about Clark's well-worked-out analysis.

I would apply to Clark's own texts on *A Bar at the Folies-Bergère* those strategies of critical interpretation that he uses in reading the texts of other commentators, Manet's contemporaries. When Clark reads those neurotic texts, he assumes that his methodology permits him to identify their confusions. He is able to use interpretations of paintings to read the ideology of the commentators who write them. I agree that all art criticism reveals ideology, but unlike him I doubt that his text, or mine, can escape from these problems which he finds in the accounts of others. What is neurotic about Clark's texts commenting on *A Bar at the Folies-Bergère* is his need to begin the analysis twice. In the commentary of a bourgeois art critics, such a repetition would provide the natural point for a Clarkean critical analysis. Such repetition often manifests genuine uncertainty. In one

of *his* neurotic texts Freud writes: "A man who doubts his own love may, or rather *must,* doubt every lesser thing."[22] Ironically, doubt enters into Freud's text, and causes him to repeat himself, precisely at the point where we would expect him to be decisive. Freud, it is natural to believe, has some doubts about this assertion. A suspicious reader will wonder what Freud is inadvertently saying about his own love.

A Bar at the Folies-Bergère thus is, or has become, a highly ambiguous image.[23] In pointing to problems with Clark's account my aim is not to show that his claims are false. It is, I believe, possible to find such problems with any account. That is why the interpretation of pictures is an open-ended process. With luck and skill, it is possible both to offer objections to every older interpretation and to present ingenious new interpretations. Clark's work has generated so much interest because he offers this highly complex reading, which makes the older accounts seem too simple. Once such an analysis has been produced, unless dramatic new archival evidence is published, it probably is hard to return to the older approaches. Indeed, the assumption that such evidence could be produced is itself perhaps problematic. One reason Manet's art lends itself to multiple interpretations is that he was not a very verbal person. Suppose, however, that somewhere he described his inability to correctly do the perspective in this picture. This would not constitute knock down evidence that all the recent interpretations were wrong. Maybe here, as in some other texts, Manet was being ironical. Perhaps that letter does not mean what it seems to say.

Despite some real problems with Clark's interpretation, now it would be anticlimactic to simply revive those older views. This is not to argue that Clark's account is correct, or even plausible. On the contrary, I have noted the difficulties in his account. But this does emphasize how, as debate about such interpretations proceeds, it becomes difficult to simply reject such novel interpretations. Conservative critics of Clark are inevitably forced into the position of arguing that the meaning of the picture is really straightforward. My belief that such a rhetorical strategy is rarely convincing is one reason I turn to a Lacanian interpretation which treats the picture as a highly complex image.

The debate about the value of Clark's account of Manet has been embroiled in a controversy about his political claims. But similar debates occur frequently in many other cases where no immediate

political concerns are so obviously at stake.[24] Then there is a dispute between art historians who admire and imitate such accounts and others who argue that they are over-interpretations. Such argumentation is, in part at least, unavoidably circular.[25] Critics who reject Clark's methodology are unlikely to be won over by his analysis. A conservative or a methodological conservative is sure to reject that account. Certainly such writers may change their mind. But if a conservative accepts Clark's account or a Clarkian becomes a conservative, then that change is so radical as to be akin to religious conversion. Like a believer who becomes an atheist, such an art historian will have to change many beliefs. Abandoning a style of interpretation is a dramatic change. This is not to imply that there can be no argumentation among art historians who offer competing interpretations. On the contrary, what is suggestive about Clark's interpretation of Manet's painting is how much dispute it has inspired. It is difficult in such a situation to speak of a definitive interpretation, or even to offer an neutral way of comparing interpretations.

We may like to believe that definitive interpretations are possible and that we can compare interpretations. But in truth are either of these situations really desirable, or even possible? Were a definitive interpretation offered, then in the future no one would be able to offer an interestingly original account of the picture. Of course, sometimes one interpretation may become definitive, at least for a time. Now that this one Manet has been so much discussed, perhaps nobody would find any interesting new way of discussing it. But we need but consider what would happen were this situation to occur throughout a discipline like art history in order to appreciate the practical problems posed by a definitive interpretation. If everyone agreed that the existing interpretations were essentially adequate in this fashion, then it is hard to imagine how such a field could remain intellectually challenging. All that would remain for younger scholars to do is fill in the gaps, describing artworks that were too minor to be discussed by their senior colleagues.

Once Clark had drawn the attention of art historians to the importance of Lacan's way of thinking about neurotic texts, then it was natural for me to look at another portion of that psychoanalyst's writings, his account of pictures. Since Clark's commentary on *The Bar at the Folies-Bergère* has attracted so much attention, it seems worthwhile to develop such an account which extends his approach. Because Lacan's work is fashionable, it was almost inevitable that

someone would apply his account of the mirror stage to this image containing a mirror. The institutional framework of our intellectual life provides a place for commentary such as mine, and tends to reward those who develop it. Just as painting depends upon the art-market, which provides a support system for original artists, so the modern university provides the material basis for extended critical discussion such as mine. Just as Manet's painting could only have been made in a society with a sophisticated tradition of artmaking, so my commentary would only have been offered after that painting has been so much discussed by my precursors. Nineteenth-century commentators did not write commentaries on Manet like Clark's or mine.

Once so many accounts have been given, there is a certain pressure, I am suggesting, to develop an original approach. How can we evaluate these different accounts? To compare and contrast such different interpretations of the same painting may seem a modest goal. Unless we can compare interpretations of *A Bar at the Folies-Bergère*, how can intercourse among art historians be a rational enterprise? And if we cannot do that, how can we understand the process in which styles of interpretation change? Putting the questions this way implies that there is some straightforward way of answering them. On reflection, however, it is easy to question that claim.

It would be nice to find some neutral, mutually agreed upon way of comparing these very different accounts. But that is very hard to do, for the disagreements among these art historians about this particular painting are bound up in many larger disputes. Insofar as Clark and his critics disagree about how to proceed, it is unlikely that we will find such a neutral standpoint. Focusing on those disagreements may make art history seem a contentious enterprise. Just as Christians, Muslims, and atheists have difficulty finding some common ground, in a more parochial way, the same is true of art historians. But in art history, these disagreements are not the whole story. Another way to look at this debate is to observe how much implicit agreement there is. Today most art historians agree that the seeming inconsistency in the mirror image is intended to be meaningful. (The older claim that Manet was just inept will, I predict, be revived by an art historian who argues that all of these writers overinterpret the picture.) The disagreements come when they provide different explanations of Manet's intentions.

Could we find some neutral standpoint from which to judge these seemingly opposed accounts, then debate would come to an end and

so the argumentation of art historians would no longer seem interesting. It is precisely because there is that genuine disagreement which I have described that such argumentation is exciting. Once we recognize that the unit of discourse is Manet's painting embedded in the various art historian's texts, then we can see why any attempt to achieve unanimity is unlikely to succeed. Were we comparing different accounts of the selfsame entity, then it would seem surprising that there could be so much disagreement. How can Clark and his critics describe the same artifact so differently? Once we recognize that what they are dealing with is that artifact in context, then their differences are less surprising.

Manet's painting is an object on the wall of a London museum. But once that object is interpreted, it is placed within the context of an art historian's text. And once we allow that there are these many different ways of placing it in context, then the claim that there is *one single best way* of interpreting that picture is highly problematic. The picture is an object before which Clark and his critics have stood. But insofar as they say something about the picture, they must place it within texts, finding a way of enplotting the narrative of the scene Manet presents. And since there are many different ways of presenting that story about the picture, the painting itself now must seem highly complex. Is that to say that there is only one best way to tell that story? If so, how can we determine which is the best way of telling it? In real space, persons and things must have a definite position. But the space in *A Bar at the Folies-Bergère* is an illusionistic pictorial space, and so how we conceive of the place of the barmaid in relation to the viewer depends upon how we contextualize this picture in an interpretation, in a text that may identify this visually ambiguous space as reflecting ideologies found in Manet's society.[26]

NOTES

1. E. H. Gombrich, *Aby Warburg. An Intellectual Biography* (Chicago and Oxford, 1986), 1986), 13–14, n. 1. As he explains, there has been dispute about the source of this phrase.

2. Richard Shiff, "Art History and the Nineteenth Century: Realism and Resistance," *Art Bulletin* LXX (1988), 45, n. 84.

3. Judging by the references in his *The Painting of Modern Life, Paris in the Art of Manet and His Followers* (New York, 1985), 271, n. 3 his most important

political influence was the writings of the Situationalist International, a group in opposition to the European communist parties. See Guy Debord, *Society of the Spectacle*, trans. anonymous (Detroit, 1977); *Situationist International. Anthology*, ed. and trans. K. Knabb (Berkeley, 1981); Guy Debord, *Commentaires sur la societe du spectacle* (Paris, 1988); Sadie Plant, *The Most Radical Gesture. The Situationist International in a Postmodern Age* (London, 1992); and the articles in the issue of *Arts Magazine*, January 1989, focused on the Situationist International. See also T. J. Clark, "Preliminary Arguments: Work of Art and Ideology," *Caucus for Marxism and Art* (Los Angeles, 1977), 3–6.

4. T. J. Clark, *Image of the People. Gustave Courbet and the 1848 Revolution* (London, 1973), 138.

5. Clark, *The Painting of Modern Life:* 98, my italics. Hereafter referred to in the text as PML.

6. Freud's account of The Rat Man is neurotic in its obsessive concern with establishing the objective reality of that patient's primal scene, particularly when after much discussion Freud suggests that for his purposes it may not mater whether the scene was real or fantasy. And these muddles may be explained when Freud himself says both that the scene is banal and that it is disagreeable "for many of us" to imagine "that the parents copulated in the presence of their child." (*The Standard Edition of the Complete Psychological Words of Sigmund Freud*, trans. J. Strachey [London, 1955], XVII, 58.) To speak of a neurotic text is not to identify Freud's neuroses, but to point to ways in which his narrative itself is needlessly obscure, in ways which no doubt reflect both his personal concerns *and* those of his culture.

7. See my "Manet and his Interpreters," *Art History* 8 (1985), 320–55.

8. T. J. Clark, "The Bar at the Folies-Bergère," *Popular Culture in France from the Old Regime to the Twentieth Century*, ed. J. Beauroy, M. Bertrand, E. Gargan (Saratoga, California, 1977), 237 n. 9. Hereafter referred to in the text as BFB.

9. "The reflections of the two figures in the study (i.e., the earlier version) become implausible in the painting, where they propound a more complex poetic truth" (Francoise Cachin, catalogue entry in *Manet 1832–1883* [New York, 1983], 484). "Poetic truth" means literal falsity. The obvious limitation of this account is that it provides no explanation of why such error creates poetic truth.

10. Here I borrow from Shiff (as in n. 2): "ideological mirrors still reflect when cracked, although they can do so only imperfectly. . . . Whenever . . . 'literal' reading of an image proves unrewarding . . . the image can still be read metaphorically."

11. What is needed in the exegesis of this work, I believe, is an "engagement with the whole." As with a painting, any account in which "a disproportionate acreage of the canvas remains unaccounted for is unsatisfactory."

Here I apply to texts an observation made about images in Leo Steinberg, "Velazquez' *Las Meninas*," *October* 19 (1981), 46.

12. Truth in pictures is discussed in Mark Roskill and David Carrier, *Truth and Falsehood in Visual Images* (Amherst, 1983).

13. See my *Principles of Art History Writing* (University Park, 1991).

14. Jacques Lacan, *The Four Fundamental Concepts of Psycho-Analysis*, trans. A. Sheridan (New York, 1978), Ch. 6–9. Hereafter referred to in the text as FFC. This book was published in French in 1973 as Jacques Lacan, *Le Seminaire*, ed. J.-A. Miller (Paris, 1973), XI.

15. Jacques Lacan, *Ecrits*, trans. A. Sheridan (New York, 1977), 1–7. The difficulty with Lacan's suggestive account, as the many expositions of it reveal, is that it is not easy to explain his analysis in so many words. See Catherine Clement, *The Lives and Legends of Jacques Lacan*, trans. A. Goldhammer (New York, 1983), 84–96, and Jane Gallop, "Lacan's 'Mirror Stage': Where to Begin," *SubStance* 37/38 (1983), 118–28. J. Laplanche and J.-B. Pontalis, *The Language of Psycho-Analysis*, trans. D. Nicholson-Smith (New York, 1973), definition, "mirror stage," 251; and Anne Norton, *Reflections on Political Identity* (Baltimore and London, 1988), 16–19. For a skeptical view see Noël Carroll, *Mystifying Movies. Fads & Fallacies in Contemporary Film Theory* (New York, 1988), 63–66.

16. It is at this point that Lacan's views diverge radically from those of the Situationalist International. A study of the history of his account could usefully begin with "La personalite selon l'experience commune" in his doctoral thesis, reprinted as Jacques Lacan, *De la psychose paranoiaque dans ses rapports avec la personnalite* (Paris, 1980), 32–36.

17. Fredric Jameson, "Imaginary and Symbolic in Lacan," reprinted in his *The Ideologies of Theory. Essays 1971–1986* (Minneapolis, 1988), 85.

18. Jane Gallop, *Reading Lacan* (Ithaca and London, 1985), 79.

19. Some origins are a matter of degree. Lacan's mirror stage seems rather to mark a difference in kind between an inability to know a unified self and an identification of that self with the mirror image of the body. But when the subject achieves that self-awareness, it cannot think of itself as continuous with that being who existed before the mirror stage. Its body, it is true, did exist continuously; but this subject, who only discovers its existence in the mirror stage, cannot be identical with its body. How then can that self conceive of itself as coming to self awareness in the mirror stage? Some art historians find the analogy between the discovery of the self in the mirror stage and the development of perspective through the use of mirrors suggestive. That parallel suggests one way of interpreting *A Bar at the Folies-Bergère*. Perhaps Manet's inability to create a consistent perspectival image shows that with the birth of modernism we reach the end of that tradition that began when Brunelleschi used a mirror to create the first perspectival image. See my "Painting and Its Spectators," *The J. of Aesthetics and Art Criticism*

XLV, 1 (1986), 5–17, and Hubert Damisch, *L'origine de la perspective* (Paris, 1988).

20. A Cartesian philosophy of mind beings with self-consciousness and only then deduces the existence of those other embodied consciousnesses, those others who can perceive my body. For Lacan, my relationship to the gaze of those others must be brought into the analysis of perception right at the start.

21. Descartes' dualistic model of perception immediately involves him in the problem of other minds. Everyone is in the same position, aware of only the contents of their own mind. Hence I must reason by analogy. If I am aware of others who appear intelligent beings, then they also must have minds like mine and so, similarly, be aware of me. It is here that Descartes got into problems which the history of post-Cartesian philosophy of mind shows are not easy to solve.

22. *The Standard Edition of the Complete Psychological Works of Sigmund Freud*, trans. J. Strachey (London, 1955), X, 241, italics in original.

23. My neurotic hesitation in this sentence reveals an important conceptual problem, taken up in my articles on art history to which I referred earlier. Should I say that Manet's picture always was ambiguous, though only recently has its ambiguity been perceived? Or, rather, do I mean that it has become ambiguous after being interpreted by these commentators. My claim is that this is a distinction without a difference. Linda Nochlin describes the picture very differently, focusing on the "detached legs . . . dangling from a trapeze" links the presence of the mirror to narcissism, cropping, and Roman Jakonson's "assertion that the rhetorical device of *synedoche* . . . is fundamental to Realist imagery." (Linda Nochlin, *Realism* (Harmondsworth, 1971), 164–65.) She does not develop these ideas, which suggest a feminist interpretation at odds with Clark's. A feminist would not describe this woman as a "girl," as does Clark (BFP 250). In his more recent account Clark calls her "the woman" and "the girl" in successive sentences, a kind of neurotic writing to whose ambiguities feminism has made us sensitive (PML 250). (In correspondance, responding to the original published version of this article, Clark said that he was describing her as people would have in Manet's society.)

24. This is one central claim of my *Principles of Art History Writing*.

25. Compare the account of this Manet by George Mauner, *Manet, Peintre-Philosophe. A Study of the Painter's Themes* (University Park and London, 1975), 161–62. Mauner, a student of Schapiro, uses Baudelaire's religious ideas to conclude that the mirror shows "another dimension . . . the duality of human nature." This claim that Manet systematically presented Baudelaire's religious ideas is not, in principle, any shakier than the view that his is a political art. Both theories can appeal to some indirect evidence. But this argument was, I believe, less likely to be successful than Clark's political

interpretation. Perhaps Mauner's timing was unlucky. When in the 1980s art critics and historians, inspired in part by Craig Owens' Benjaminian interpretation of postmodernism (1980) and by Jameson's *The Political Unconscious* (1981) wrote much about allegory, this style of reasoning seemed less exotic.

26. I thank Richard Shiff who helped me to see one important error, and a number of problems of detail, in the earlier published version of this essay, *History and Theory* XXIX, 3 (1990), 297–320, which appears with substantial revisions as chapter 7 of my *The Aesthete in the City* (University Park and London, 1994); and Albert Elsen, who asked the question that in part inspired this essay. He asked, how could an art historian legitimately discuss what is *not* in the picture?

Le Chef d'Oeuvre (bien connu)

KERMIT S. CHAMPA

Just like the charming barmaid who must be bright, alert,
and well disposed for fourteen hours a day, if she wishes to
keep her place! How much better than being on the streets![1]
Bernard Shaw, 1889

A more informal kind of artistic entertainment and
something sought by a mixed public are the Café-Chantants
and the Spectacles-concerts, which since the "Freedom
of the Theater-Law" also occasionally perform
vaudeville, operetta, farce, etc.
The most visited and best example of such local vernacular
entertainment, half theater, half Café-chantant is the *Folies-
Bergères*, Rue Richer 32, near the Boulevard Montmartre
(entrance charge two francs). Whoever does not want to sit
in the main audience area can wander in the spaces
adjacent to the latter, while on the stage jugglers, singers of
couplets, etc., follow each other with their performances.
The crowd, by the way, is very diverse.[2]
Baedeker's Paris und seine Umgebungen, *1878*

Who could have painted what looked like an idol belonging
to some unknown religion? Who could have made her of
marble and gold and precious stones and shown the mystic
rose of her sex blooming between the precious columns
that were her thighs, beneath the sacred canopy that was
her belly? He had plunged into something beyond reality.
His face was turned towards the picture and quite close to
the Woman whose sex blossomed as a mystic rose, as if his
soul had passed into her with his last dying breath, and he
was still gazing on her with his fixed and lifeless eyes.[3]
Emile Zola, L'Oeuvre, 1886

A Bar at the Folies-Bergère is certainly the most
phantasmagorical work ever painted by Manet. Out of his

91

mastery of the play of light he devised an unreal setting
for the barmaid who is his central figure. She is shown
standing, directly facing the spectator, but there is nothing
static about her. The ornaments, the bottles, the flowers in
the vase suffice to give her a phantomlike appearance. And
this effect is infinitely increased by the mirror behind her, in
which we see that she is talking to a customer and see also
the crowd sitting at tables in the bar—all of this scarcely
hinted at, as in a daydream. No painter before or since
Manet has transposed reality into such a phantasmagoria
of lights. This girl's image is magical precisely because
she is a phantom among phantoms, with a grace
that is extremely attractive.[4]
Lionello Venturi, Impressionists and Symbolists, *1950*

QUICKSAND is the only word to describe what one feels under-
neath oneself in attempting to move from the experience of visual
"speechlessness" before Manet's great image (frontispiece) to the
exercise of verbal interpretation. The move should not be made too
rapidly since the image is immensely rich in the sensations—both
nameable and unnameable—that it provides. Like any true enigma
the painting stubbornly remains most coherent on its own terms. It
becomes increasingly impenetrable and incoherent in direct propor-
tion to the a-perceptual distance (or interpolated context) which is
brought forward to account for the inherent density of the picture's
own visual proclamations. As Manet's last "masterpiece" (and proba-
bly known in process as likely to be so) the *Bar* manages to en-
courage and then seemingly to frustrate every attempt to decode sys-
tematically its only half articulate sensory signage. But how many
attempts there have been at decoding—some comparatively straight-
forward and many more ideologically convoluted—each assuming to
posit something like an ultimate solution. But of what?[5]

What are the barriers to definitive interpretation posed by the *Bar*
and how are they posed? And are they really any different from those
posed by Courbet's *Atelier,* earlier Manets, or any number of Ver-
meers, Watteaus, or Corots? Subject paintings—particularly figural
ones—have from a comparatively early date flaunted (or at least

toyed with) textual ambiguity by the very act of withholding resolved narration. Without closure (or even clear opening) the non-narrative figure painting *as text* contributes, whenever it is presented, a double option to would-be critics—take it or leave it *or* assume unities of narratively devious sorts. Art historians, like historians, are never very comfortable with the first option because it leaves them (God-forbid!) potentially inarticulate. Thus the second option invariably prevails to encourage critical excursions of at times almost inconceivable complexity, when judged against the object (the painting) that presumably initiates them. The weaponry of those attached to the second option are the more or less generically unspecified "written" texts usually referred to as *documents* and deployable as *evidence*. Ideally the discourse in the second option involves several historians or critics agreeing on the rules of the game for the meaning (hence the use) of certain species of documents. This agreement makes discussion (agreement and contradiction) possible within the game, whether or not the game is an interesting or even a useful one. Obviously, without agreement no game and no critical discourse, but the simple existence of discourse in no sense guarantees relevance to the object/subject (or painting, in the present instance) from which agreed-term (and document) discourse presumably derives. At a certain point in any critical discourse ostensible subject and ostensible interpretative strategy seem almost naturally to reverse roles, with the latter finally displacing the former almost completely as the locus of inquiry. To say this in 1991 is perhaps simply to utter a truism, but sometimes truisms need repeated.

The entire process of second option interpretation seems inevitable simply because of the way any historically based inquiry develops. Whether admitting it or not, practitioners of historical interpretation (and I include myself among them) identify documents (or evidence) and deploy them in such a way as to have them—the documents—say what it is wanted for them to say and in the way that it is wanted to be said. But we must accept that interpretative solutions, which presumably are what are proposed, are only comprehensible (acceptable or not) in the discursive ambience of consensus document fact-types. As David Carrier has pointed out in so many different ways, the incompatibility of different discursive ambiences—the lack of unanimity on what to call facts/documents and the ideological underpinnings of the "callings"—virtually eliminates the possibility of productively

comparable routings of interpretations and the cross-referencing of interpretations, once interpretations of whatever sort become truly self-referential.[6]

All of this makes the task of entering a "new" interpretation of a painting as ideologically mauled as Manet's *Bar* something less than a grateful one. If one chooses a modified option one position—an essentially primitive formalist position—who that has thought or written from a more or less Marxist, more or less semiotically and psychoanalytically sophisticated social history perspective, whether Herbert's, Reff's, or Clark's type, has any vested interest (or even curiosity) in reading what is offered?[7] To assume that the painting itself ought to be re-consulted "straight," so to speak, runs against the entire grain of what is currently seen as academically mandatory (and politically correct) contextualization. "Pre-iconographical inspection" wasn't given much in the way of intellectual time-credit by the institutionally dominant iconologists of the 1950s and 1960s. It is given even less by politically accented (in various ways) social historians writing after the mid-1970s.

The problem with proceeding from option one is that it appears to be *prima facie* unintelligent, or to be more precise, illiterate. But is it? Klaus Herding, who is himself no stranger to contextual analysis, had some hesitations regarding Clark's *The Painting of Modern Life* (1985), a book in which several major Manet paintings, including the *Bar,* are discussed at great length.[8] Writing in a not unfavorable review published in 1987, Herding nonetheless proposed a few bothersome warnings regarding the direction of Manet studies—a direction which after 1977 was in essence first dictated, then driven, by Clark. "It would seem more reasonable to postpone the inquiry into historical links until the actual visual facts of a painting prove impervious to direct analysis or pose a dilemma that only background information can solve." Later in his review, Herding goes even farther by suggesting that, "the attempt to read deep significance into the most miniscule of visual signs, that is, to imply a conscious intention on the artist's part, may well strike some as a relic of the rationalist thinking that was so widespread during the late 1960s."[9] Without rejecting the intellectual attractions of Clark-type second option social history interpretation (or for that matter pre-Clarkian iconology as practiced on Manet) Herding is simply pointing to something like the discourse as subject problem posited above. Largely because of Herding one is encouraged to re-enter into Manet studies gener-

ally, and discussions of the *Bar* in particular, with art prominently in view.

This being the situation, there are in fact a fair number of immediately pre-Clark interpretive perspectives to be reconsidered—perspectives proceeding from rather than aiming at painting. That the most important of these were simply left out of Clark's book (even left out of its seemingly exhaustive bibliography) is reason in itself to recognize them here, if only in brief. Working with what Clark "leaves out" provides both a useful and fascinating exercise, particularly because the *textes refusés* (or *textes maudits*) tend to be (as Herding has noted) written in German by Germans or to have been produced chronologically between 1968 and 1972, in English, presumably the gestative years of Clark's intellectual/ideological virgin birth (or rebirth?).[10] Niess, Fried, Roskill and the present author all advanced one or another form of Manet interpretation in this period. Not all focused on Manet alone, but each in one way or another presented either a scheme or priorities or a model of looking/reading that assumed the primacy of Manet's objects (paintings) as subjects. Fried's study, of course, is absolutely exemplary in this regard.

What Fried offered in his *Manet's Sources* of 1969 was a closely argued view that what resided in the artist's constant employment of quotations (from past art) in the first half of the 1860s had an inner consistency that tracked, consciously or not, the mid-nineteenth-century art historical debates regarding national artistic character. In Manet's instance, as Fried saw it, the issue of Frenchness was the primary locus for pictorial borrowings (or quotations) followed rapidly by the addressing of issues of artistic internationalism. Fried foregrounded what were, in Manet, operations of intense artistic self-consciousness. The combinations of quotations Fried identified often became in his analysis highly speculative and at times so seemingly farfetched as to open his entire discussion to the suspicion of massive over-interpretation in detail. Yet detail aside, Fried's study (which is long overdue for re-publication) ought to have been taken more seriously than it was, if for no other reason than the fact of its intelligence. But, following Reff's irritated review, only Hanson and Cachin continued to make routine gestures towards recognizing the existence of Freid's work.[11] In the writings of the former, Fried's positions were unfortunately often misrepresented (at least in part) and in the work of the latter the above-mentioned "suspicion" has seemed to remain in force underneath a veneer of respect.

Lamentably, Fried did not undertake to discuss the later work of Manet. His interest was in the artist's primary aesthetic strategy. By implication Fried's interpretation of this strategy cast certain forward shadows, but these have not been pursued, largely, one suspects, because of the ascendence of the neo-academic social history model of interpretative correctness in the decade after Fried's study appeared. Had Fried laid some clearer claim to all of Manet, his work would have been harder to marginalize, but he did not.

Unlike Fried, Roskill and Hofmann were primarily concerned with the artistic situation of the 1870s and early 1880s when they undertook in the 1970s to interpret the aesthetic and theoretical components of that situation. Needless to say, Manet's work figured more or less strongly in their quite different interpretive perspectives. Roskill offered the notion of a sort of calculated style-merger to account for the seemingly hybrid character of Manet's behavior in his last masterpiece, the *Bar*. The painting is seen by Roskill as a sort of *summa* combining (even superimposing) aspects of quintessential 1860s Manet with equally quintessential 1870s alternatives of both a technical and imagistic sort.[12] Hofmann was more interested in the development, elaboration and metamorphosis of Manet's "mythic" females—the last of whom is of course the Folies barmaid.[13]

While it would be difficult to argue the proposition in much depth, there are enough elements in common within the Fried-Roskill-Hofmann discourse to make that discourse appear, if not actually (overtly) conversive, at least potentially so. To begin with, all three writers seem to want in some way or other to keep paintings *in full view* as they discuss them. They need the paintings in order that what is said about them finds a home that can be re-visited by the reader/spectator. Collectively their interpretations undertake to amplify a visually perceived stimulus or series of stimuli. That this amplification proceeds art historically in Fried, in terms of style dialectics in Roskill, and in a sort of image association fashion in Hofmann is beside the point. In each instance image or images initiate and to a degree control interpretation even while that interpretation branches outward into various forms of personalized contexting.

Fried, Roskill, and Hofmann are hardly left in a wordless void of discourse as they pursue what I would term extended first option forms of interpretation. In fact they seem to have found nearly as much to discuss, standing (figuratively speaking) in front of their pictures as have their social history colleagues working with their backs

96

turned and in rapt contemplation of their socio/political notes. Herding seems to have been right in suggesting that the reach beyond the picture for interpretation before the picture exhausts itself as a visually declarative structure risks being located beside the point, so to speak, rather than being on the nose.

Axiomatically expressed, but hardly uncontroversially so, it would appear that for the benefit of the production of genuinely conversant discourse—in the absence of absolutely fixed common terms, definitions and perspectives—interpretations (of whatever sorts) ought ideally to require the primary existence *and* the continuous referenceability of the object interpreted in order even to be termed interpretations. When this is not the case the "discourse as subject" phenomenon is imminent. Perhaps what has been differentiated in the above, as first or second option interpretation, ought to be abandoned in favor of more relative distinctions that insist of the second option only that accountability to the ostensible subject/object be strenuously maintained. No particular form of contexting ought to be privileged in principle so long as the elaboration of context (however that is conceived) is irrevocably linked to the precise object under scrutiny—an object whose particularity precludes being replaced by any other one more or less "like" it. Some (but certainly not all) social history written over the last two decades is in fact responsible to the standard of referenceability in much the same way one expects of contextual study that is not overtly socio/political in prospect. In some rare instances (usually in Herbert's work) it has been at times even more responsible.

So much for what has been a preliminary exercise in positioning the interpretation of the *Bar* that eventually follows in this study. Let us begin approaching the painting (without ever forgetting it) by introducing the interpreter clearly in order to give the *Bar* in advance the necessary means for its own defense. Some manner of authorial autobiography is probably appropriate at this point, even though as all such presentments, it is likely laden with much bad memory and a considerable amount of more or less clever and convenient retrospective invention.

I (the present author) have spent extended periods of time looking at the *Bar* in various geographical locations—first in London in 1963 and in 1968, then in New York in 1983 (where it was hung much too high), and in Chicago in 1987. My Chicago viewing, besides being the

most recent, was also the most extended, lasting on and off over two days. I have been fairly diligent over the years keeping up with the ongoing bibliography of the painting, but never until the last six months working to review that bibliography with the intention of producing a study of my own. Obviously I had much of Venturi, Rewald, and Novotny in my head in 1963.[14] By 1968 when my attention was primarily focused on Impressionist landscape painting of the 1860s, I was probably more primed with Zola (L'Oeuvre) and Laforgue; and yes, my then senior colleague Robert Herbert had caused me (thereby engaging my perennial resentment) to read some Walter Benjamin.[15] By 1983 I had developed with my graduate students an ambitious exhibition and catalogue, *Edouard Manet and the Execution of Maximilian* (1981) and probably had the primary and secondary bibliography on Manet more at my mental fingertips than at any previous or subsequent point.[16] In 1987 I was just beginning my more or less total immersion in visual and written materials which I believed argued for the notion of a master model, resident in the French reception of German symphonic music, for a good deal of what transpired in post-1830 French landscape (and to a lesser degree) figure painting. This notion formed the critical substance of my *Rise of Landscape Painting in France: Corot to Monet* (1991).[17] In retrospect, I realize (or perhaps just imagine) that my study of the *Bar* in Chicago in 1987 focused to a large degree my treatment at least of Manet in the *Rise*. Whatever the case, I grant the painting in recent years a sort of personal "muse" status.

Like other moderately-privileged academic sub-superstars I've done a lot of undergraduate and graduate teaching of late nineteenth-century material over twenty-five years, but in all honesty I can't remember what profundities or foolishness I uttered in the classroom regarding the *Bar* until fairly recently. After 1988, though, I'm aware of spending more lecture time on the picture for different reasons in different contexts and, perhaps more to the point, joining the extra time to the required reading of Zola's *L'Oeuvre*. Why I began to couple an emphasis on the *Bar* and *L'Oeuvre* so persistently after 1987 I can't recall, and I'm not sure which—the painting or the book—led when it did to the partnering of the other. Again, prodding my unreliable memory, I think I read *L'Oeuvre* first in 1962, then not again until 1980. I know I read it first (along with three other Zola novels) to prepare for my Ph.D. exams. I don't know why I re-read it in 1980, but I'm glad I did, because I remembered the broad outlines of

the book well enough in 1987 to want to look at it again to follow Zola's complex handling of the activities of painting, music and writing. Four months ago, in preparation for the present essay, I read *L'Oeuvre* a fourth time and re-read as well Robert J. Niess' compendious study of the novel, published in 1968 under the title *Zola, Cézanne, and Manet*.[18]

None of the foregoing "autobiography" would be especially germane to the present study were it not for the fact that in the fall of 1987 something about the *Bar* began to obsess me while I was in London (and where the painting temporarily wasn't). I had been invited to lecture on the Courtauld Collection travelling exhibition during its stop-over in Chicago. I prepared my lecture in the Courtauld Institute Library and then flew off for my two days in Chicago. As already suggested, I was in 1987 interested intellectually in essentially one thing, my evolving musical master model. That interest and the fact that the *Bar* was to a greater or lesser extent the prime object in the Courtauld Collection combined to foreground certain "facts" about the painting (or surrounding the painting) which while not exactly new to me began to take on an accelerated life. Cooper's *The Courtauld Collection* and Cachin's Manet Retrospective catalogue entry of 1983 on the *Bar* reminded me that the first truly substantive act of critical appreciation (excluding relatively predictable reviews, post-mortems, etc.) was Emmanuel Chabrier's purchase of the painting from the estate auction of 1884 at a *very* considerable price.[19]

The painting's first owner, Manet's long-time friend who was alone in attendance when the artist died, was a *composer* of music—and not only a generic practitioner, but one of the leading lights among the younger *French* Wagnerists, as opposed to the Franck-inspired Wagnerists who happened to be French (like Vincent d'Indy). Why, I wondered (and still do), did Chabrier want the *Bar* in order to hang it over his piano in his studio? As a collector of Impressionist pictures Chabrier might have bought any number of works at the estate auction for better prices, but he clearly had his mind set on the *Bar*. Looking through the Cooper catalogue and the rather hastily assembled travelling catalogue of 1987 by John House, I discovered that the *Bar* was in one very important respect not unique in Samuel Courtauld's collection.[20] Another masterpiece, Gauguin's *Nevermore*, was also from a composer's collection, this time Frederick Delius'. As with Chabrier and Manet there seems to have been at least a brief period of personal contact between Delius and Gauguin in the mid-1890s.

Courtauld, then, chose to own two composers' choice pictures by two of his favorite nineteenth-century master painters. Was this sheer coincidence, or were the *Bar* and *Nevermore* privileged by association as pre-eminently "musical" paintings by Courtauld (or perhaps by his eminent friend, the critic Roger Fry)?[21] The question is intriguing, but it is not answerable in any definitive way. What can be said is that "pre-eminently musical" would have been uniquely high praise for any painting cited in critical discourse in England from Pater through Fry. Additionally, the Courtauld family was investing culturally in more than just painting in the 1920s. Mrs. Courtauld personally covered financial deficits for the Covent Garden Opera during several of its most fragile years and founded (and endowed) the Courtauld-Sargent "popular" symphonic concerts in 1929.[22]

What I have so far deployed as autobiography is a rough record of my visitations to the *Bar,* coupled with suggestions of what likely controlled or inflected my seeing at one or another time. To this day, I've never approached the painting disinterestedly—not that I haven't tried, I just haven't succeeded. I had always been reading before I looked, and that reading to a considerable degree conditioned (if not absolutely, at least partly) what I saw and the order I saw it. The most persistent *leitmotif* in my reading-conditioned looking has certainly been Zola's *L'Oeuvre.* It was in my head before I ever saw the picture (as opposed to reproductions of the picture) and it remains there after I last saw the picture. All of this suggests that for some reason, or combination of reasons, possibly related exclusively to the way my particular critical thinking happens, looking at the *Bar* has always involved mentally referencing *L'Oeuvre* consciously or subconsciously. It is an uninterceptable part of my experience of the painting, and strangely it doesn't seem to be so for any other scholar, at least to the same degree.

It is not unusual in any sense to see in the bibliography on Manet one or another scholar "leaning" on Zola. In fact one can anticipate, at least schematically, the direction of many interpretations by many authors simply by noting which Zola novels (along with Zola's criticism) a given scholar references. Looking at random, one notices Herbert using *Thérèse Raquin, L'Assomoir, Nana,* and *La Curée.* Clark uses *L'Assomoir* and *Nana;* Hanson uses *Nana.* Cachin in her discussion of the *Bar* uses *La Ventre de Paris* very extensively. But anything—even a glance in the direction of *L'Oeuvre*—is hard to find. Moving away from strictly Manet interpretation the situation changes considerably, as

Rewald and Loevgren (among others) base a good deal of their account of the art-political situation of the early 1880s on both the fact and reception of this novel.[23]

I'm not particularly interested (in the present study) in following out the Rewald/Loevgren reading of *L'Oeuvre*. What I am interested in doing is sorting as best I can my fixation—my arguably neurotic fixation—on the mirroring that I feel between the painting and the book. I know that I thought I was seeing "the Masterpiece"—that unnamed allegory of the city of Paris and its life focused in the figure of a beautiful woman—the first time I walked into the old Courtauld galleries and saw the *Bar*. To what degree I expected or prepared myself for this experience I can't possibly judge, but there were enough things materially "wrong" about the feeling that I have to believe the painting filled in a lot of gaps by itself, and that I just witnessed the filling instead of noting the gaps. Once I saw that the painting could be, as an image presence, what it clearly wasn't as a literal subject (as Zola had described it in the frustrated workings of his chief painter-character Claude Lantier), I could never put the experience away. From 1963 on the painting was, for me at least, most about what it wasn't about. Zola's novel foregrounded what it wasn't about, but it left just enough fictional space for "what it was about" to blossom in its own real space outside the novel.

Zola, I suspect, was able to envision the details of failure surrounding Claude Lantier's picture *because* he had confronted its opposite in the *Bar*. That is why so much of his fictional history oscillates between his authorial imaginings about the *Bar* and about its failed opposite. The timing of the completion of the picture and the novel is important to note in this regard. As in the case of Manet's *Nana* and Zola's book with the same title, the painting came first but after the plan for the novel. The rather different situation that obtains around the *Bar* and *L'Oeuvre* is that Manet died in the middle of the sequence. The effect of Manet's death on Zola, coupled with that of Wagner in the same year (1883), is difficult to measure, but whatever that effect, Zola did not begin *L'Oeuvre* until 1885, well after his elusive written "appreciation" of Manet in the catalogue for the latter's commemorative exhibition at the Ecole des Beaux Arts in 1884. While there is some uncertainty regarding the precise degree of personal closeness between Manet and Zola in the decade before Manet's death, there seems little doubt of Zola's emotional re-involvement in the years right after—the years that culminated in the publication of *L'Oeuvre*.

101

One of the dominant thematic currents in Zola's novel is a kind of wish/fascination with the problem of artistic impotence. Claude Lantier is only one of a whole host of impotent artists in Zola's text, where both the sexual and aesthetic connotations of the term "impotence" are perpetually toyed with. The most frontal form of impotence is the inability to create (to finish) anything important at all. The qualified form is described in terms of artists who can't regenerate the power of their celebrated early work. Much has been written regarding Zola's displacement into various characters of *L'Oeuvre* his own free-floating self-doubt regarding the question of potency and "living up to early promise." Most critics seem to feel that Zola (as an artist) works himself into several artists practicing different media in *L'Oeuvre*, while at the same time posing fictively as the "novelist" Sandoz and of course standing as the inventor of the actual novel's text as well.

The novel purports to take place (in a realist fashion) in the years between c. 1862 and the early 1880s, with the plot built around advanced painting, as it first appeared at the Salon des Refusés of 1863, as it lost its way and then collapsed completely. Advanced fiction, Zola's realism, tracked advanced painting without seeming so overtly to lose its way, yet at the end of the novel, realist fiction too is suspected of never having overthrown the burden of Romanticism— in other words to have failed even while persisting. What has thrived in Zola's fictional account? Seemingly only music (Schumann and Wagner), but Zola's one artist-character, Gagnière, who becomes absorbed with music, loses his grip on his own medium, namely, painting. Women (of various sorts) float through the novel, being both necessary to the practice of art, yet like music operating as a powerful and dangerous distraction or intoxicant. To the bitter end of the novel, real woman as model and painted woman as art (more real than real), contest one another for "control" of artists (always male in Zola's text). *Liebestod* between the real woman, the painted woman and the artist replaces a conventional Pygmalion and Galatea terminus to the novel.

What has all this to do with the *Bar*? Arguably a great deal. With the *Bar* complete (as with Wagner and *Parsifal*) Manet died potent, with his aesthetic boots on and still shining. Throughout *L'Oeuvre* Zola rhapsodizes in a variety of ways over the bliss of an artist's death at full power—before full or partial impotence, as fact or just fear, are experienced. The alternative is positively purgatorial. It is in the exis-

tence, endured as half reality, half mortal dread by Sandoz and Bongard (the older generation modern painter-character) in *L'Oeuvre's* final lines.

Zola had tracked Manet and Wagner throughout his mature life. In Aix along with Cézanne he had been a member of a local Wagner society. In Paris, he rapidly bonded artistically with Manet, and in spite of "social" differences (perhaps even jealousies on Zola's part) he kept a close, self-calibrating watch on the painter until the latter's death. In the early 1880s Zola certainly knew, as everybody who was anybody did, that the twin pillars of modern art (conceived in broadest Baudelairian terms) were physically infirm, although neither was truly "old." Miraculously, though, both mustered the strength and the will to produce a masterpiece that rounded out an old series of masterpieces—a final masterpiece as fresh if not fresher than the first. This is exactly what Zola's Claude Lantier *could not do!* Why? Because he had a sort of unspecified genetic (?) weakness that drove him in directions opposed to those which he might successfully manage artistically. In their late years Manet and Wagner, too, had their share of potentially self-frustrating impulses. With the music-drama finished, Wagner fancied himself doing symphonies (presumably nine) while Manet had begun as early as 1879 to propose (for the Paris Hôtel de Ville interior) vast allegorical "decorations."[24] He seems even to have envisioned going back to religious subjects and doing a *Crucifixion.* Fortunately, Death intervened in both instances to prevent either artist from acting on what were very likely aesthetically unsound notions.

But Zola remained alive for a considerable time and in being alive certainly knew that he might not be so lucky, so he seems to have undertaken in *L'Oeuvre* to displace his fear through the invention of a complex fictional situation in which the threatening accomplishment of the *Bar* was prevented from taking place. He contexted failure, using much in terms of the details of a plausible historical context (probably more of them than in any "straight" historical text) that had in fact produced a masterpiece in the *Bar*. Working, one suspects, at least in part to preserve his own sanity Zola fictionally destroyed Manet's masterpiece accomplishment. Significantly he called his own novel *L'Oeuvre* and not *Le Chef-d'Oeuvre* (even though English translations thoughtlessly translate the latter). He risked in his title (and in the novel itself) simply producing "work." *L'Oeuvre* was not Zola's literary masterpiece—even though it begins as though

it were going to be. More important than literary quality was the elaborated activity of denial—denial of the fact that the great pictorial realist, Manet, had managed the gloriously elusive, and perhaps for Zola, ultimately the impossible—the late, perhaps even the definitive masterpiece.

While it would no doubt be a wild exaggeration to suggest that Manet's accomplishment in the *Bar* literally and totally programmed *L'Oeuvre,* the sheer aesthetic willfulness and power of the painting was certainly not lost on Zola, and the author's reaction in his novel remains a very personal, if potentially very informative one. But of what is it informative? Clearly Zola was in some way reactive to the "conjuring" as opposed to "recording" activity of ambitious modern painting *and* modern realist writing. In the context of *L'Oeuvre,* however, he seems systematically intent on portraying painting's conjuring as being more dangerously uncontrollable than writing's. He faults Claude Lantier's work for its lack of discipline, direction, and consistency of method. For Zola, the lack of all this virtually guarantees the impossibility of producing work of genius. With much system of work in his own writing Zola had become increasingly discontent with (or perhaps threatened by) the continuing tendency he noted in the painting of Manet and his Impressionist friends to work in a sort of one picture at a time fashion, rather than proceeding toward the consolidation of a "great" modern style.[25]

Re-reading any of Zola's criticism after the mid-1870s, one wonders, though, what Zola would have recognized as pictorial "great" style if he had seen it. Manet's production of the singular, late masterpiece of the *Bar* might have been read by Zola in either of two ways, and he seems in *L'Oeuvre* to have conflated them. Either he was unable to accept the achievement of modern style that Manet's work posited so powerfully, or he simply didn't understand it (or want to). As perturbing as the accomplished last masterpiece must have been—and as enviable—there remained for Zola always a sense of uncertain premises and a sort of randomness that gave to all Manet's masterpiece achievements the appearance of "luck." Lucky conjuring could not produce great modern style in Zola's terms or, if it could, his own work, which proceeded very much as style in the everyday sense of the term, might not be what he thought it was—namely, modern.

Zola's problems with Manet have, in many respects, a lot in com-

mon with those of a considerable number of late twentieth-century Manet scholars. A fundamental unwillingness to accept the lack of any non-aesthetic program or social "higher" functioning of critical intelligence (which in many respects defines Manet's practice quite well) initiates the discomforts of interested witnesses experiencing Manet nearly a century apart. Like Zola, contemporary scholars of the socially sensitive sort force themselves to interpret Manet in ways that make of what he doesn't do the implied true meaning of what he does. This line of critical reasoning easily posits system in non-system, a consciousness of social tensions in the refusal to picture them, and a range of populist sensitivities encoded in the "conscious exclusion" of clear signs of such.

What one encounters is an absolute refusal to permit idiosyncratically original modern painting to be what it seems, pre-eminently in Manet's instance, to be, namely, original in ways stamped with unmistakable signs of individuality. The performance of originality, even in Shiff's terms, the calculated fashioning of the pictorial terms of originality, are not left to be self-indexing.[26] The terms must (in order to be worthy of the powerful effects achieved) encode more than self, and obviously the more politically radical, the better. Aesthetic and social radicalism must go hand in hand, musn't they? If they don't, what excuse could possibly be managed to justify the interest in (the liking and respect for) radical painting by politically radical spectators. Human nature, being what it is, hates the prospect of friction between the forms of loved experience and loved "values." The embrace of some species of anarchism or mysticism seems the only manner of psychological ventilation available if and when this ur-friction becomes unbearable and undeniable. Significantly, the decade that contained the appearance first of the *Bar* and then of *L'Oeuvre* (rather like the decade of the 1980s) was marked by a persistently increasing number of intellectual defections in the direction of one or another species of anarchism and mysticism. The privileging of the irrational and unnameable and the psychologically troubled leads, almost inevitably (or so it seems in retrospect) to Freud's psychoanalysis of human behavior and the theosophist's complex models of the great order of being.

Such facile intellectual pronouncements aside and returning to the *Bar,* one is ultimately confronted by the fact that what one stares at is and remains pre-eminently a painting by Manet—one which only he could or would have devised, and which could or would never have

been devised as it is without twenty years of the artist's own painting standing in the background and cheering it on. To experience the painting is to experience Manet's private art history—to watch what has been done first to muster, and then dispense, something thoroughly unique. Fried's argument that Manet's art simultaneously discovered and identified itself through complex processes of quotation is at once re-affirmed in the *Bar* and at the same time inevitably mutated. The aesthetic momentum that Manet had to develop through borrowing from past art in the early 1860s now resides in the richness of his own twenty-year achievement as a painter, and in his experience of the work of his contemporaries. Replacing the spectator-provoking operations of his painting of the early 1860s, and his broadened pictorial treatment of the 1870s, there is in the *Bar* something totally unique—not classifiable simply as a style merger, but rather more of what Venturi was reacting to when he called the painting "phantasmagorical."[27] This is not a term Venturi or anyone else would be likely to apply to any other of Manet's works. Yes, there are plenty of puzzling ghost/shadow parts of certain paintings beginning with the *Absinthe Drinker* and continuing through the Poe illustrations and the *Portrait of Faure as Hamlet,* but none of these truly anticipates the comprehensive "phantasmagoria" that Venturi found the *Bar* to be.

Probably the closest Manet ever came to a "phantasmagoria" (as defined in realist terms) was in his 1864 *Dead Christ with Angels* (New York, Metropolitan Museum of Art) where he painted a quasi-conventional *Dead Christ* in an indistinct sepulchral setting with attendant angels. Although obviously posed by models, and clearly demonstrated as having been so in the literal and publicly (contemporary) offensive "bodiness" of the main figure, Manet's painting nonetheless proceeded as a pictorialized enactment of a religious fiction. The pictorially demonstrative fictionality of Manet's imaging in this picture (including angels) is far stranger than such would appear in the following year's *Jesus Mocked by the Soldiers* (Chicago, Art Institute) where *tableau-vivant* elements are more consistently in place. Mysteriousness would continue on and off in Manet's post-1860 work—narrative ambiguities, spatial oddities, etc.—but mystery as "Phantasmagoria" vanishes only to re-appear in the *Bar.*

What else of "Manet" re-appears in the *Bar?* Principally there is the recurrence of his tendency to build an ambitious painting around a female figure. Clothed, unclothed, or costumed female figures in

more or less consistently legible ambiences are a constant in Manet's early imaging practice (not that there are no males) and they continue to be so right into the early 1880s. Sometimes the women are portraits, but more often they are something like characters, ranging from the overt prostitute in the *Olympia* (Paris, Musée d'Orsay) or the *Nana* (Hamburg, Kunstmuseum) to the independent (and more or less self-explanatory) woman of the *Déjeuner sur l'herbe* (Paris, Musée d'Orsay), the *Woman with a Parrot* (New York, Metropolitan Museum of Art), *The Balcony* (Paris, Musée d'Orsay), *Le Repos* (Providence, Museum of Art, Rhode Island School of Design), the *Gare St.-Lazare* (Washington, National Gallery of Art), and *The Plum* (same location), to mention only a few. While it is possible to problematize these images at will and more or less indefinitely through various strategies of interpretative enterprise, none seems really to demand much complicated "reading."

Appearances, while often somewhat surprising in various ways, are (at least after the *Déjeuner*), never effortfully confusing. Instead the various female figures seem to serve as familiar and interesting imaging pegs for Manet to hang his paintings on, and pretty much the same could be said for his male figures. Whatever their gender, Manet's figures tend to be motific and readable as such. Their development is, however, always stunningly original in pictorial terms. At base, figures are Manet's way of seizing his viewer's attention rapidly, at times frontally using spectator-contacting gaze, at other times both frontally and laterally to introduce a kind of perpendicular pictorial counterpoint, but one which always refuses either to narrate, or to indent the picture surface spatially in any abrupt or complicated fashion. A fictive pictorial immediacy is what Manet seems to want, and what he usually gets. In addition, the narratively thin character of that immediacy serves rapidly and very consistently to foreground Manet's images as "paintings"—as original Manets.

Figures (whether male or female) specifically guide the virtuoso paint construction that is a Manet. Different figures call up different forms of construction. Repetition (or any particularity of continuous or developing style) is avoided by the quirky painting to painting differences of figural presentation and avoidance of anything truly typical. The technical components of Manet's craft are reasonably continuous after 1866, but the order and proportion of the deployment of expressive effort (whether in color, paint structure or drawing) is highly unpredictable. Zola was right in observing the absence of clear

and conclusive system (or style) in Manet, but he was wrong to see it as an aesthetic limitation. It is, in fact, Manet's refusal of style that makes him always so open to the moment of particular pictures, and so able to act on his intuitions of the moment. This is where the "modern" in Manet resided, and it made him routinely able to make expressive content of his technique rather than to be imprisoned by it.

Until very late in his life Zola was willingly imprisoned in his technique, feeling all the while quite virtuous (at least on the surface) about having devised it.[28] How, one wonders in retrospect, could he have been able to grant Manet the respect his achievement in "unstyled" modernity obviously merited. Obviously he couldn't, any more than many Manet scholars writing today. The intellectual self-annihilation stakes are just too high! How much safer it is to persist in thinking of everything as a contextually spewed text (filling in missing words as necessary) than to grant Manet his sublimely inconsistent and changeable intuitions and his genius in converting them into masterpieces.

It would be absurd to say that the *Bar* is as a motif anything but Parisian and in some manner an image of modern life. But this argument ought to follow rather than lead an engagement with what is first and foremost a major, major Manet painting. To use a well-worn, but still marginally fashionable term, it is the undeniable "present-ness" of the *Bar* that marks it off, like so many of Manet's works, as thoroughly distinctive things in themselves, as objects more free than not, willed into being by a very particular individual in ways very particular to that individual and no other. Manet, the individual in this instance, was a person of immense artistic culture. He was this before, during, and after being a charming *flâneur* of indeterminate political leanings. His culture causes Paris to vibrate in the *Bar,* and as noted above it is a culture first inherited and then powerfully inflected with a succession of aesthetic masterworks.

Wiping aside thoughts of Zola's *L'Oeuvre* (an admittedly impossible task for the present writer) it is amazing how fresh, immediate, and even natural the *Bar* is at first sight. That all of this derives from Manet's imaging and technical fictions is beside the point. Equally beside the point are all of the "gaps" that appear when the painting is materially dissected as painted illusion. Like all of Manet's best works the *Bar* looks right before it looks wrong, and the latter sensation never completely subverts the former.

Part of the painting's seeming naturalness (as opposed to its real-ism) comes from the "knowing" viewer's sense of its breeding. The scene is familiar as a monumental variant of a considerable group of Manet's paintings of bar, restaurant, and *café-chantant* images begin-ning with the lithograph *At the Café* (1869) and continuing through the *ébauche* for the *Bar* (fig. 1). The inclusion of mirrors (or other reflective surfaces) and the image-dominating female figure are familiar features of paintings both within this group from the 1870s and outside it (*Le Repos* and the *Gare St.-Lazare*, for example). The unfolding of this group of works has been discussed many times, most recently by Herbert, so there is no need to review the situation here, except to remark that the "serving" woman becomes increas-ingly prominent in the *café-chantant* images after 1875.[29] A major exception is the weirdly conceived *Le Bouchon* (Leningrad, Her-mitage) of c. 1878 where two figures are superimposed in an exercise of radical foreshortening in the center of the image, so that at first glance they seem one.

What else is familiar in the *Bar's* barmaid is the all-dominating presence of the centrally positioned figure. She is the *modern* art his-torical motif within the picture, recalling, besides several of Manet's 1860s women, one by his partner in scandal at the Salon des Refusés, Whistler's *White Girl* (Washington, National Gallery). And Whistler hangs in the background in other ways as well. Mirrors and reflec-tions figure more routinely in his work of the late 1850s and early 1860s than in that of any other advanced realist. The most significant instances occur in *At the Piano* (Cincinnati, Taft Museum), c. 1859, *The Music Room* (Washington, Freer Gallery), 1860, and *Little White Girl* (London, Tate Gallery), 1864. In the last of these Ingres' use of a mirror in his well-known *Comtesse d'Haussonville* (New York, Frick Collection), is quoted overtly, but made to function in reverse.

Mirrors and image-dominating women were obviously a substan-tial element in whatever Manet remembered of the early 1860s, but the former were positioned just outside his work. They were Whist-ler's. In the 1870s mirrors increasingly became Manet's (and to a lesser degree Degas'). What was precisely Manet's in the 1860s, besides the simply frequency of image-dominating women, that is brought forward (and reinforced by her incontestably hieratic posi-tion) in the *Bar* exists in the barmaid's pose, which unmistakably repeats that of the head and torso of the *Dead Christ*.

In spite of the art historical "breeding" of the barmaid figure, it

doesn't look like a quotation; it looks like a nicely dressed, red-headed barmaid, set semi-plausibly at her working station—a station whose magnificence is magnified by the apparent vastness and opulence of the space over which she presides—the space in *front* of her, known to the spectator *via* the mirror. There are, of course, lots of problems with the reflected space if one questions it visually, as many have in various ways. Suffice it to say here that proportions, positions, and distances (perspectives) are sheer chaos to describe, if one assumes that such description is necessary or even desirable.

The most fascinating elements of the chaos occur up close, in the mirror's most forward reflection. Here one sees a) the absence of the reflection of the artist-spectator b) the repetition without scale reduction of the still-life elements on the bar and c) the appearance on the right of the barmaid, reflected from the rear and addressing an otherwise unaccounted for, therefore doubly troubling, "client." There is a fictive/fictive spectator implied, but no fictive/real one. Finally, there is another problem generated by the mirror—this one having to do with the fictive function of the bar itself.

How does the barmaid-customer transaction work, and what is it about? It has often been remarked that the ale, cognac, champagne and liquor bottles are unopened.[30] Less attention has been paid to the absence of glasses to serve anything in. There are none on the bar or, judging from the unreliable mirror, underneath or behind it. What is there for anyone, barmaid or customer, to do, besides gaze? Manet gives no answer, and in refusing to do so literally snares his spectator into a condition of something like inarticulate visual babbling.

If the painting weren't so sensuously beautiful continuously from edge to edge, the spectator would, one suspects, cry rather loudly for help disentangling him/herself from a nightmare—Venturi's "phantasmagoria." What I am obviously suggesting (or at least it is obvious to me) is that Manet reduces the spectator of the *Bar* to the condition of a supplicant before his great canvas! When mirrors lie and bars can't serve, what kind of spectacle is being offered? The answer is ultimately a simple one, the spectacle of painting as painting—an answer implied if not developed most recently by Cachin.[31] She, virtually alone among contemporary commentators, seems to find the painting quite soothing overall.

By setting his whole image against a continuous mirror (of a seemingly conventional rather than Lacanian sort) Manet employs the oldest paradigm for representation, only to have it self-deconstruct

before the spectator's eyes. He adds to this the newest technology of "illumination"—namely, bright, unfiltered electric light (or at least the newly familiar appearance engendered by such). Electric light passes into Manet's representation *via* emphatic white-brightness, the emphasis on high values of hues and the lightening of greys. His medium is drier than ever (approaching pastel) and it accepts a great deal of last minute grey / white overpainting and accenting. Pictorially the effect of all the lightness and comprehensive dryness of surface is to make the painting more fresco-like than any other painting Manet ever produced. Perhaps he was thinking in advance about Hôtel de Ville decorative possibilities, perhaps not. In any event the *Bar* holds and amplifies the wall like no imagistically concentrated painting produced after Velásquez's *Surrender at Breda* (Madrid, Prado).

From a strictly pictorial point of view, the Bar, having gloriously problematized legibility, proceeds to become the penultimate ellision between representation, "painting" sensation and finally decoration. Its unity, which is needless to say of a very particular and precarious sort, results from Manet's intuitive sure-footedness in what is a magnificently complex tour-de-force of technique. He painted many pictures more materially sensuous, but never one so complexly delectable, while at the same time so troubling.

The iconographic and psychological teasings, the discontinuous positionings of legibility, are as exciting and as precarious as the pictorial ones. Abandoning my earlier contention that, for me at least, the *Bar* had for many years solved itself imagistically by being the reverse of Zola's fictional (and failed) *Allegory of the City of Paris,* and now entering, with some dread, a second "fin-de-siecle," I'm feeling more or less conventional religious vibrations as well. Or, to put it more accurately, I'm feeling Manet's feeling of them.

What are we to make of Manet's picturing of a young, sexually attractive, fashionably dressed redhead, positioned in priestly manner tending a bar, that is obviously not a bar in the normal sense? In fact, as Manet arranges it, it's *much* more like an altar. Arguably symbolic flowers emerge from the vase on the bar and from the barmaid's bodice. Her potions (ointments?) are more or less symmetrically positioned to her left and right. As *we* see her, she is not what she is seen in the mirror as being (we see only her back, figuratively, her past). Perhaps she is repentent—a Magdalen rather than the prostitute most scholars would have her be. Perhaps she is there to heal us, the socially and spiritually disoriented urban bourgeois specta-

tors and Manet, the physically failing artist. Perhaps, too, *he has passed into her* (which is why we don't see him in the mirror), so that he and she are both healers possessed of different potions or lotions but with equivalent powers and promises (or at least comparable degrees of compassion).

With all these "perhapses" in place, what might we have in the *Bar?* Paris (Modern Life), Manet, and La Madeleine as a complex socio-psychological and aesthetic unity—a unity that first irritates and then soothes. I think Matisse would have understood what I'm suggesting.

(fin)

NOTES

1. Bernard Shaw, "The Dead Season," *Shaw's Music: The Complete Musical Criticism in Three Volumes*, 2nd rev. ed., edited by Dan H. Laurence, vol. 1 (London, 1981), 745–751; esp. 749.

2. K. Baedeker, *Paris und seine Umgebungen* (Leipzig, 1878), 58–59.

3. Emile Zola, *The Masterpiece*, trans. Thomas Walton (Ann Arbor, MI, 1968), 351 and 356.

4. Lionello Venturi, *Impressionists and Symbolists*, trans. Francis Steegmuller (New York and London, 1950), 24 and 25.

5. For the most recent review of the literature, see David Carrier, "Art History in the Mirror Stage: Interpreting *Un Bar Aux Folies Bergères*," *History and Theory: Studies in the Philosophy of History* 29/3 (Middletown, CT, 1990), 297–319.

6. Ibid., and David Carrier, *Principles of Art History Writing* (University Park, PA, 1991). The present essay is deeply influenced by Carrier's brilliantly irritating interpretations of art historical interpretation.

7. Robert L. Herbert, *Impressionism: Art, Leisure, and Parisian Society* (New Haven and London, 1988); Theodore Reff, *Manet and Modern Paris*, exh. cat. (Washington, D.C., 1982); T. J. Clark, *The Painting of Modern Life: Paris in The Art of Manet and His Followers* (New York, 1985).

8. Klaus Herding, review of T. J. Clark, *The Painting of Modern Life*, October 37 (summer 1986), 113–25.

9. Ibid., 122 and 123.

10. Robert J. Niess, *Zola, Cézanne and Manet* (Ann Arbor, MI, 1968); Michael Fried, "Manet's Sources," *Artforum* 7/7 (March 1969), 28ff.; Mark Roskill, *Van Gogh, Gauguin and the Impressionist Circle* (Greenwich, CT,

1970); Kermit S. Champa, *Studies in Early Impressionism* (New Haven and London, 1973).

11. Theodore Reff, "On Manet's Sources," *Artforum* 8/1 (September 1969), 40–48; Anne Coffin Hanson, *Manet and The Modern Tradition* (New Haven and London, 1977); Françoise Cachin, Charles S. Moffett, and Michel Merlot, *Manet 1832–1883* (New York, 1983).

12. Roskill (as in n. 10), 230.

13. Werner Hofmann *Nana: Mythos und Wirklichkeit* (Cologne, 1973).

14. Venturi (as in n. 4); Fritz Novotny, *Painting and Sculpture in Europe, 1780–1880*, Pelican History of Art Series (Baltimore, MD, 1960); John Rewald, *The History of Impressionism,* rev. ed. (New York, 1961).

15. Jules Laforgue, *Selected Writings of Jules Laforgue,* ed. and trans. William Jay Smith (New York, 1956); Walter Benjamin, *Illuminations,* ed. Hannah Arendt, trans., Harry Zohn (New York, 1968).

16. Kermit S. Champa, ed., *Edouard Manet and the Execution of Maximilian,* exh. cat. (Providence, 1981).

17. Kermit S. Champa, *The Rise of Landscape Painting in France: Corot to Monet,* exh. cat. (Manchester, NH, 1991).

18. Niess (as in n. 10).

19. Cachin (as in n. 11), 482; Douglas Cooper, *The Courtauld Collection* (London, 1954).

20. John House, Dennis Farr, Robert Bruce-Gardner, Gerry Hedley, and Caroline Villers, *Impressionist and Post-Impressionist Masterpieces: The Courtauld Collection* (New Haven and London, 1987).

21. Roger Fry, *Vision and Design,* rep. (New York and Scarborough, Ont., 1956), esp. "Essay in Aesthetics," 16–38; Champa (as in n. 17), 58–59.

22. Cooper (as in n. 19), 24.

23. Rewald (as in n. 14), 534 and 543; Sven Loevgren, *The Genesis of Modernism: Seurat, Gauguin, Van Gogh, and French Symbolism in the 1880's,* rev. ed. (Bloomington and London, 1971), 40–50. I will be presenting very shortly an essay on Zola's *L'Oeuvre* and its status as an art historical text.

24. Hanson (as in n. 11), 129. For Wagner, see Cosima Wagner, *Cosima Wagner's Diaries,* 2 vols., ed. Martin Gregor-Dellin and Dietrich Mack trans., Geoffrey Skelton (New York and London, 1977). Odd but persistent mentions in vol. 2 after 1879.

25. Hanson (as in n. 11), 26–27.

26. Richard Shiff, *Cézanne and the End of Impressionism: A Study of the Theory, Technique, and Critical Evaluation of Modern Art* (Chicago and London, 1984), esp. "Part Two. The Technique of Originality," 55–154.

27. Venturi (as in n. 4).

28. Grange Wooley, *Richard Wagner et le Symbolisme français: Les rapports principaux entre le wagnerisme et l'évolution de l'idée symboliste* (Paris, 1931).

See pp. 154–156 for a discussion of Zola's late "conversion" to Wagner-ist/symbolist practices.

29. Herbert (as in n. 7), 59–92.
30. Cachin (as in n. 11), 482.
31. Ibid.

The Dialectics of Desire, the Narcissism of Authorship: A Male Interpretation of the Psychological Origins of Manet's *Bar*

> It is a fruitful illusion in which the artist lulls himself when
> he claims to be solitary . . . the reality of the matter
> is that he is answering other creators.[1]
> —*Guy Davenport*

> Man draws out of himself and puts *before himself* what he
> is . . . in order . . . to enjoy in the shape of things
> . . . an external realization of himself.[2]
> —*G. W. F. Hegel*

THIS ESSAY depends on two convictions. The first is that while all human expressions are a response to some stimulis, those we would call substantive are replies to a particular aspect or aspects of an individual's discursive field.[3] Manet's *A Bar at the Folies-Bergère* (frontispiece), I will argue, articulates his dialogic response to a current and long-standing tradition of images of women wherein an illusion of psychological and therefore physical intimacy is afforded the male spectator.

In arguing this thesis I will be answering, sometimes explicitly, assertions made in my discursive field, not only about Manet's *Bar* but about art history itself, its methods and objectives. Art history is going through an exciting if turbulent period. The standard practices and assumptions that had evolved from those employed by late nineteenth- and early twentieth-century German pioneers have lately been challenged and rejected by a generation inspired by develop-

ments in other fields, notably literature and philosophy.[4] Except for the psychoanalytic, the various approaches conveniently (if in many ways inaccurately) referred to as "New Art History" all reject an earlier preoccupation with an artwork's authorial meaning in favor of a concern with its implications for some spectator or spectators, historical or contemporary. Although this shift may be rationalized by compelling post-structuralist arguments against the myth of the author as a centered "origin" of clear intentions[5] and by the astute Peircian observation that meaning resides not *in* art works but in the minds of those who perceive them,[6] the shift of emphasis ultimately rests on the conviction that investigations of historical origins are less relevant to our current collective crises than those that emphasize art's social dimensions.[7]

Although I have no theoretical quarrel with the various attempts to investigate the way art is or has been consumed, I consider it hasty to abandon the old quest for origins simply because we can never be certain of our findings. All art history, including the semiotic, is conjectural and therefore tentative. For those cases, like Manet's, where sufficient evidence exists to form possible hypotheses (interpretations) about the conditions and meanings of an artwork's origins, there is no reason for us not to pursue the matter. Nor should we give up such investigations because post-structuralists have claimed the death of the author. To acknowledge that the self is both multiple and to a large extent socially constructed does not obliterate the concept of identity. The self is neither inchoate nor a mere product of social forces but a discrete entity capable of mustering meaningful responses (either of agreement or dissent) to the forces that would shape it. To say that the old Cartesian author/creator is dead is not to say that some identity (however mobile and constructed), with personal views and aims (however contradictory or uncertain), does not stand in some meaningful relation to his or her work.

Moreover, unlike some, I think there is good reason for us to inquire into that relationship. The investigation of origins, as I understand it, deals with the ways humans have responded to and coped with the individual and social circumstances of their lives. Such investigations, while always tentative and subjective (in the best sense), nonetheless allow us to stretch our understanding of our species, of what it means to be human.

The second conviction on which this investigation rests, hinted at above, is that all human actions are strategic, that is, aimed at satisfy-

ing some need. For the art of any age, the questions we need always to ask, I would insist, are: What ends did a given work possibly serve its maker(s) or patron(s)? What pleasures or satisfactions did it afford the person(s) responsible for it? What problems did it solve or allay? What needs did it relieve?[8] In the case of *A Bar at the Folies-Bergère* I will argue a humanist conclusion: The painting, like this essay, served to satisfy certain transhistorical psychological needs—the author's Hegelian desire for "recognition" as well as his (Manet's and mine) Lacanian need for a narcissistic mirroring of the "imaginary" self.

Manet painted the *Bar* in the winter of 1881–82 with the intention, later fulfilled, of exhibiting it at the Salon of 1882.[9] After his return from Versailles around the first of October—where he had spent the summer convalescing from the circulatory problem that would soon kill him[10]—Manet revisited many of his favorite Parisian haunts, including the Folies-Bergère,[11] in search of a suitable theme. Apparently on the basis of sketches made on the spot in a pocket note-book,[12] Manet painted a small watercolor of one of the bars in the balcony of the main hall (fig. 13).[13] The watercolor shows a barmaid, wearing a sleeveless, low-cut dress, casually and somewhat provocatively leaning on her bar and gazing in our direction. Her pose exposes to the spectator much of her breasts and cleavage. In the mirror behind her, sharply silhouetted against the dark ground of top-hatted patrons, is another, slightly fuller view of her scantily and tightly clad curvaceous figure.

The sketch stands in a long line of nineteenth-century French paintings that utilize a mirror in order to provide the male spectator a more complete inventory of a female subject's physical charms. Works by Ingres, such as *The Comtesse d'Haussonville* (1845), are perhaps the best-known examples of the type. Two of Manet's closest artist friends, Alfred Stevens and James Tissot, both specialists in paintings of beautiful women, often used the device. In the work of these and others, the mirror reflection is usually a peripheral element, one that merely adds information. In Manet's work, however, the reflected back receives slightly more space, and thus attention, than the woman herself. Manet's emphasis suggests that the barmaid exists less as a tangible person than as a spectacle for our masculine gaze.

Sometime after this little watercolor Manet made a more ambitious painted sketch of the subject (fig. 1). A photograph of the small

oil taken in 1883 bears the handwritten annotation of his son: "Painted from sketches made at the Folies-Bergère. Henry Dupray [a military painter who had a studio nearby] chats with the girl at the counter. Painted in the studio on the rue d'Amsterdam."[14] A comparison of the work with the earlier watercolor demonstrates that Manet's approach to the subject had by this point changed radically. Its fundamental terms have, in fact, been reversed. The woman, still curvaceous, is more modestly dressed and posed. And rather than looking towards us in an engaging fashion, she is now inaccessible as a result of the self-absorbed turning of her head and gaze away from us and the crossing of her arms in front of her body. Rather than open to us, she is now effectively closed. The male spectator, who was only implied in the watercolor sketch, is now seen in the mirror to the right of the barmaid's reflection looking up at her—not chatting with her as Manet's son had claimed. The mirror, which had been used to reveal her more fully, is now a device for revealing the spectator.[15] And whereas we had formerly been looking slightly down at her—implying our dominance in the situation—she now towers over the somewhat dwarfish figure of our counterpart, whom she appears to ignore. What had been a fairly conventional rendition of the male fantasy of erotic mastery has been transformed into a very unusual statement of male inferiority and female inaccessibility.

Tabarant claims that the woman in the painted sketch was a barmaid at the Folies-Bergère, whom Manet had brought to the studio to pose. As a result of her decision or Manet's, she did not return for further work and Manet hired another of the establishment's *verseuses*, a woman by the name of Suzon, to pose for the final stages of the painting.[16] Suzon appears in the third and last of the extant sketches for the painting, a small watercolor (fig. 14) that Manet gave his longtime friend and early chronicler, Antonin Proust.[17] Suzon, dressed like her predecessor in the Folies-Bergère's regulation uniform,[18] also ignores us as she looks placidly and indifferently past us. Her open, emphatically frontal posture just to the left of center now gives this lack of connection a new force and urgency, for it is clear from the mirror reflection of our confrontation with her that her failure to acknowledge us cannot be easily or circumstantially explained. These changes, in conjunction with the limited attention given the ambient details, suggest that by this point Manet had decided to make the discrepancy between our physical closeness with the hand-

some barmaid and our unexpected psychological distance from her the thematic focus of his painting.

Manet seems to have made the Proust sketch while at work on the final painting. The recent radiograph of the *Bar* (fig. 15) reveals that he began by transferring the figures from the painted sketch (fig. 1) to the larger canvas and then proceeded to make the changes that resulted in the final image.[19] The Proust sketch was probably instrumental in those changes, that is, made to test and develop his changing thoughts on the subject.

The final painting is essentially a refined, sharpened treatment of the theme as conceived in the Proust watercolor. Some of the elaboration is minor. In the back, the legs and feet of the trapeze artist, hastily indicated in the watercolor, have been reduced to an even smaller element at the very margin of the canvas. More significantly, the balcony seen behind the barmaid is now filled with a host of elegantly dressed men and women, many of whom are actually identifiable as the artist's friends and associates.[20] Manet's inclusion of friends and colleagues makes clear his feelings of identification with the establishment, and with his painting of it.

In the sketches Manet had placed several bottles of uncertain contents on the bar. In the final painting he added more bottles and carefully distinguished their varied contents, which include champagne, liqueur, beer, and whiskey. These beverages not only identify the woman's profession but also characterize the place. The champagne, especially, suggests an atmosphere of happy, uninhibited conviviality. Manet's willful use of this wine may be judged from the fact that it would not have been served warming to room temperature, as shown.[21]

Manet also added a bowl of oranges and a glass with two roses. Although fruits have traditionally been used in images of women as a symbol of fertility, feminist art historians have recently pointed out that fruits and flowers have also frequently been used to suggest an equally essential male conception of the female purpose: to provide sensual pleasure for men. The sybaritic beverages on the bar must also be identified with the barmaid, then. These bar items seem to have been carefully, if intuitively, chosen to establish certain expectations not only about the Folies-Bergère but about the woman who serves us. As his eyes move up from these promising edibles to the woman who offers them, the male viewer is pleased to find numer-

ous correspondences in her figure, coiffure, and attire. We quickly, if subliminally, note, for example, that her swelling hips, strong neck, and closely combed crown of golden hair have formal echoes in the bottles that surround her, especially the champagne. Psychologically, however, she denies all that such correspondences pledge, for her facial expression suggests that she is neither happy nor accessible.

The barmaid's face has been the subject of considerable debate. Two observers, Ross and Herbert, claim that she betrays no discernible emotion.[22] Another describes her as "daydreaming" and "coldly detached."[23] Although I find these descriptions perfectly accurate for the barmaid in the watercolor, I do not think they apply as well to the woman in the painting, whose gaze is literally, and thus figuratively, somewhat downcast. I agree with Mortimer, who sees her as "tired and glum," and with Cachin, who finds her "absent, weary, dispirited."[24] Clark offers a third reading: "The look . . . is a special one: public, outward, 'blasé' . . . impassive, not bored, not tired, not disdainful, not quite focused on anything."[25] Our inability to agree on the barmaid's psychological state might ironically be a key to understanding it. By creating an elusive, indefinite psychological state for the barmaid, Manet may have meant to widen the psychological gap between us, making it, in fact, unbridgeable. Not only does she refuse to relate to the male spectator, but he cannot fully relate to her. Even the kind and degree of intimacy provided by empathy is denied him.

The barmaid's inaccessibility is reinforced through two formal features. For the final painting Manet slightly toned down the warm browns and creams of the painted sketch for a more emotionally equivocal balance of warmer and cooler tones.[26] More importantly, the viewer's sense of her inaccessibility is buttressed by the hard textures that dominate the work. As one perceptive writer recently observed, the yielding softness of flowers, fruit, and flesh are minor elements in a painting that emphasizes—through its mirror, marble countertop, and glass containers—impenetrability.[27] Our masculine gaze, which at first seems to penetrate the depths of the establishment's interior space (the sexual connotation is real, I think), is actually rebuffed by the mirror and thrown back on itself.[28] And in a most revealing detail, the provocative cut of the bottom of the barmaid's velvet redingote opens not to something resembling the soft, aromatic flowers suggestively placed against it but to a shield-like area of paint whose color and striations echo the cold, hard countertop that

120

separates us from her. The peculiar drama of invitation and denial played out here seems a microcosm of the painting as a whole.

The disappointing contrast between the response we want—and are lead to expect—and the one we get is most clearly expressed in the difference between our depicted encounter and its reflection. In the watercolor sketch Manet had brought the two heads close together in the mirror to accentuate the disparity between physical closeness and psychological distance, but in the final painting he improved the device considerably, I think, by having the mirrored pair bend forward towards one another.[29] The two are shown, in fact, apparently eye-to-eye. In short, the barmaid's apparent receptivity to the intent, desirous male customer—with his phallic walking stick— stands in sharp contrast to the physical and psychological facts as indicated at the center of the work.

The puzzling divergence between what seems to transpire in the mirror and what transpires across the bar is underscored by the naturalistic impossibility of the reflection. In the three preparatory sketches Manet had generally respected the laws of optics. Even the situation described in the Proust watercolor (fig. 14) is still naturalistically acceptable because the barmaid is placed to the left of center. By shifting her and the reflected encounter to the right, however, Manet created a situation impossible to reconcile. Indeed, it is a disturbing effect, one that all students of the work have noted. That Manet intended this effect, which he could easily have avoided, is obvious. Manet seems to have sensed that the work's fundamental optical incongruities effectively reinforce the work's more important psychological one.

An analysis of both the finished painting and its generative process suggest that the precise theme of Manet's work is an unexplained disappointment of carefully cultivated male expectations. Why Manet should have chosen to treat the recreational theme of the work in this deflationary manner is the question that we must answer. An analysis of the contextual evidence and the kinds of conclusions that have been drawn from it only clarifies the question.

By 1880 the Folies-Bergère was recognized as the very epitome of the Parisian ideal of pleasure. An 1878 article in *La Vie Parisienne* said of the establishment: "It is a kind of Mohammedan paradise seasoned to the Parisian taste. . . . Everyone understands the universal language that is spoken at the Folies-Bergère, because it is the universal language of pleasure." The article added that the owner, "M. Sari,

has sown in his magical garden every kind of seductive temptation," including women employees: "Everywhere are counters tended by charming waitresses, whose mischievous eyes and gracious smiles attract a crowd of clients."[30]

The Folies opened in 1860 as a department store near the rue Bergère. A "sale de spectacles" was added in the rear three years later. In 1871 Léon Sari bought and remodeled the building, creating two large spaces for entertainment, a covered garden, and a horse-shoe shaped theater with fixed seats and balcony.[31] His music hall thus combined the cafe-concert's freedom of movement with certain features of the theater. A client could come for the lavish entertainments —circuses, acrobats, operettas, ballets, and comedians—or to socialize.[32] In the foreground of Chéret's 1875 poster for the Folies-Bergère (fig. 10) we see elegantly dressed men and women, amicably chatting and drinking, oblivious to the acrobats above.

Importantly enough, in the right foreground of Chéret's advertisement is a bar at which two gentlemen stand, one of whom has the full attention of the pretty barmaids. With eyes firmly focused on his handsome face, the barmaids lean sharply forward toward him, as if drawn magnetically by his looks and charm. The prominent detail, in conjunction with the written accounts reported above, indicates that contemporary male expectations generated by the painting would have been shared and well understood by the men who frequented the Folies around 1880. Entrepreneurs such as Sari had learned that attractive and responsive waitresses and female bartenders greatly increased drink sales.[33] Women employees were expected to smile at the male customers and appear receptive. Sari may well have stipulated the prominent inclusion of the bar scene in Chéret's poster.

As Herbert, Ross, and others have also discovered, many of the female employees were selling more than liquid refreshment. By the mid-1870s the bar had a reputation as a "permanent fair for prostitutes."[34] The barmaid's formal resemblance to the liquid wares displayed on the bar, noted above, might suggest that she, too, is for sale. At least one recent historian, Hollis Clayson, apparently comes to this conclusion.[35] If Manet's barmaid is a clandestine prostitute, her uncongenial response to us, while still surprising, might, at least, have an explanation. Rather than unwilling to smile, she might simply be unable. If we see her as a victim of a complex patriarchal system of economic and sexual exploitation, as Clayson does,[36] it also becomes easier to read her mood as tired, dispirited, glum. Our male

disappointment and feelings of inadequacy might suddenly be transformed to pity and moral outrage at the sad, debilitating plight of this lovely young woman—who will no doubt soon resemble the wilting, tired-eyed "merchant of consolation" pictured in Stop's caricature of the painting (fig. 8).

The problem with this line of reasoning is that we cannot be sure the barmaid is a prostitute. That many were is no guarantee that this one is.[37] Even Clark, who was the first to raise the possibility, eventually came to this conclusion.[38] In the absence of the clear evidence Manet provided to identify the occupation of *Olympia* (1863) and *Nana* (1877),[39] the question of what the barmaid is selling, like the question of her mood, must remain indeterminate, another of the work's puzzling uncertainties.

In pursuing the question of whether her body is for sale or not, we lose sight of the fact that she is a kind of prostitute; she is selling something of herself, if only her smile. This barmaid, like all those who sell commodities to the public, is expected to prostitute herself to some degree. To sell drinks and maximize her tips she must appear to be what she probably is not: genuinely responsive to her customers. Clayson's observations on the barmaid's profession are apt: "the brassserie waitress's job must have been the most psychologically demanding because so much acting was required."[40] Like the acrobat behind her, the barmaid, too, is a performer. The difference between them is ethical. As in Manet's painting—where the one is all legs and the other lacks them—the two are opposed sides of the same broad profession. Whereas the successful trapeze artist depends on honest craft, the successful barmaid relies on a kind of craftiness. Whereas the former openly acknowledges her performance, the latter must not.

Is this, then, the key to understanding the discrepancy of Manet's *Bar*? Have we simply caught the barmaid in a moment when her mask is off, a moment when the weight and effort of maintaining the charade referred to in the mirror, having become unbearable, slips to reveal the sad hollowness beneath? Something of the sort is argued by both Herbert and Clark, who see the barmaid as a victim of a dehumanizing capitalist system.[41] Despite their disagreements on its causes, both suggest that Manet's painting is ultimately a kind of sociological mirror.[42] The problem with this line of interpretation is that it virtually omits the artist, leaving him or her little more than a temperamental role in the choice of subject. Modern psychology

123

would no doubt consider this essentially unselfish, unmotivated view of the artist as inadequate. If, as Freud and his followers have demonstrated, the human psyche is a complicated network of drives and needs in search of satisfaction, then we must consider Manet's *Bar* a *mediated* view of the kinds of social conditions Herbert and Clark describe, one produced not to record those conditions—which it does imperfectly and as an ancillary function—but to achieve some personal satisfaction, address some need or needs.

The one art historical approach that has emphasized the strategic role of personal interest in art production is the feminist. A number of female art historians, including Clayson, have together demonstrated that much of the art featuring women was produced to satisfy selfish male needs and interests.[43] While I would not quarrel with either this general thesis or with most of its specifics, I am nevertheless troubled by the frequently voiced view that male interest in depictions of attractive females is essentially sexual. To claim that sex plays little role in such art would be foolish, but I think feminists and their supporters have missed the fundamental psychological dimension of the male fantasy figured therein. Clayson's view of Manet's *Bar* is a case in point. The gentleman's fascination with the barmaid goes well beyond the vulgar question imagined by Clayson: "will she or won't she?"[44]

In order to establish the way in which Manet's *Bar* throws new light on the question of erotic male fantasies, we need to know more not only about Manet's life and work but about the artistic context in which he worked.

Manet was born into a conservative haute-bourgeois family. His father, chief of staff at the Ministry of Justice and later a magistrate, wanted him to be a lawyer, but the young man decided on a less conventional career as an artist. His father, who died in 1862, may well have been further disappointed with his son's anti-conventional views on art and early forays in naturalism—one of which was a portrait of his anxious parents (fig. 34).[45] Edouard's temperate mother and father were also distressed by the young man's hedonistic lifestyle around 1860,[46] which is documented in *Music in the Tuileries* (1862). The painting is a social portrait of the thirty-year-old artist and his sophisticated male friends, men devoted not simply to creativity but to elegant dress, intelligent conversation, light entertainment, and the company of beautiful women.

Throughout his maturity Manet remained committed to these

values, especially the latter. By all accounts he was the very epitome of the *boulevardier* or *homme du monde*. In the company of other impeccably dressed "mondains, artistes, et gens de lettres" he frequented the most fashionable cafes and music halls where he and they flirted with the attractive women whom they brought or met there.[47] Manet, like many of his closest friends, loved beautiful, elegantly dressed women, loved looking at them, being with them, and talking to them. He even loved their clothing and accessories. In the last years of his life he often accompanied his close friend, Méry Laurent (shown in the rear of the *Bar* wearing white), on shopping trips to her couturiers, furriers, and milliners because, as he admitted, feminine finery intrigued him.[48]

Manet's passion for *la parisienne* is well documented in the reminiscences of his friends. The painter Joseph de Nittis, for example, recounts an amusing incident that tells us much about Manet's proclivity, as well as his wife's good-natured tolerance of it:

Faithful, he certainly was, in spite of appearances. One day when he was following a pretty young girl, slim and coquettish, he was unexpectedly accosted by his wife who said with a laugh, "I've caught you this time!"

"Well, well, that's funny," he replied, "I thought it was you!" although Madame Manet was in fact a placid Dutchwoman and, if anything, on the heavy side and had nothing in common with the delicate little Parisienne. She used to tell this story herself with a good-natured smile.[49]

Another telling anecdote comes from Antonin Proust, who remembers Manet telling him in the early 1880s of a brief encounter:

Ah! Women! Yesterday I met one on the Pont de l'Europe. She was walking as only Parisiennes know how, but with something a little extra. I will do her from memory. There are some things which remain engraved in my mind.[50]

The story is significant, I think, because it demonstrates in microcosm the fundamental generative force behind much of Manet's art. Although Manet treated a complex variety of themes, he was particularly drawn to and enthralled by those involving beautiful women. The tendency, clearly evident in his work from the 1860s, intensified during the last decade of his life. Nearly two thirds of the paintings done between 1876 and the onset of his final illness in 1882 fea-

ture attractive women; over twenty of these are portraits of *demi-mondaines*.[51]

Early paintings such as *The Surprised Nymph* (1859–1861), *Gypsy with Cigarette* (1862?) and *Mlle V. . . in the Costume of an Espada* (1862) present young women in various foreign and historic guises. In works done after 1862 he treated them exclusively in modern terms. Manet's decision to follow this course seems to have been prompted by his close friend Charles Baudelaire's 1863 essay, "The Painter of Modern Life." Manet's *Music in the Tuileries* was the first indication of its maker's commitment to a Baudelairean conception of naturalism.[52] An essential part of that conception, and one that has apparently gone unnoticed, was a male fascination with woman in her modern dress. Manet seems to have been impressed not only with Baudelaire's conception of the artist *flâneur*—the apparently indifferent but deeply concerned spectator[53]—but with his stress on "the immortal thirst for beauty" whose object is "Woman":

> The being who, for the majority of men, is the source of the liveliest and even—be it said to the shame of philosophic pleasures—of the most lasting delights; the being towards whom, or on behalf of whom, all their efforts are directed; that being as terrible and *incommunicable* [my italics] as the Deity (with this difference, that the Infinite does not communicate because it would thereby blind and overwhelm the finite, whereas the creature of whom we are speaking is perhaps only incomprehensible because it has nothing to communicate); that being . . . for whom, but above all *through whom,* artists and poets create their most exquisite jewels. . . . She is a kind of idol, stupid [stupide] perhaps, but dazzling and bewitching, who holds wills and destinies suspended on her glance.

Baudelaire is careful to explain that the ideal female of classical painting and sculpture is less interesting than her contemporary, costumed counterpart:

> Everything that adorns woman, everything that serves to show off her beauty, is part of herself; and those artists who have made a particular study of this enigmatic being dote no less on all the details of the *mundis muliebris* than on Woman herself. . . . What poet, in sitting down to paint the pleasure caused by the sight of a beautiful woman, would venture to separate her from her costume?[54]

These remarks seem to have struck a deeply responsive chord in the young painter. From *Olympia* (1863)—inspired by a particular passage in "The Painter of Modern Life"[55]—to *The Bar at the Folies Bergère,* one of Manet's conscious goals as a naturalist was to capture the bearing and style of *la Parisienne.*

Manet had another, deeper aim in such works as *Olympia* and the *Bar,* one probably also triggered by Baudelaire's remarks on women: to record the basic problematic of male-female relations. Although the majority of Manet's paintings of women are straight-forward tributes to individual grace and beauty, the more interesting are the many that subtly document the failure of men and women to communicate. If woman was Manet's particular subject, the psychological gap between the sexes was his particular theme. In answer to Baudelaire, who blames that failure on a fundamental deficiency in women (their stupidity), Manet offers a different, more penetrating view of the matter: their Otherness.

Manet announced what would become the leitmotif of his oeuvre in the two great paintings from 1863, *Olympia* and *Déjeuner sur l'herbe.* Each features an attractive female nude who looks directly at the spectator. Although neither face is hostile, each is psychologically impenetrable, self-contained in a special, absolute sense. The absence of psychological intimacy between us is particularly disturbing because it seems more than anecdotal; it seems, instead, somehow permanent, ontological even. The spectator's sense of disjunction is reinforced within each work in a number of ways. In the *Déjeuner,* for example, the pyramidal grouping, a standard integrating device, is contradicted by the unexplained actions of the distant figure at the top and by the independent psychological activities of the main trio. In a similar vein, *Olympia* is divided down the middle by a line that separates the thin, naked white woman from her ample, fully dressed black servant. The cautious hesitancy with which that servant proffers the flowers further underscores this internal disunity.

The male spectator's sense of exclusion from these fragmented realms is puzzling and disappointing because it is so unexpected. The women's glances, almost as effectively as the black cat's arched back in *Olympia,* prevent entry into just those pictured places—idyllic parks and boudoirs—that the entire Western tradition of the nude since the Renaissance had encouraged males to believe were both whole and particularly welcoming. That Manet meant not simply to engage what we might call the Venetian tradition but to contra-

dict it is made clear from the well-known fact that each of Manet's paintings is a conscious revision of a prominent exemplar of that tradition. *Olympia* is based on Titian's *Venus of Urbino* (1538), a work he had copied on a visit to Italy in 1856; and the *Déjeuner* depends on Titian's *Concert Champêtre* (c. 1508; formerly attributed to Giorgione). More than modernize these two Renaissance paintings, as is sometimes claimed, Manet completely changed their terms. Their warmth, intimacy, and invitation to erotic fantasy are programmatically denied in Manet's versions. In effect, Manet's willful repudiation of the two Titians remind us not only that such works are male fantasies but of the usual relations between the sexes that make those fantasies so appealing.

During the 1860s Manet frequently contested the idealizing terms of Renaissance and Romantic painting through his mundane revisions of famous works.[56] After about 1870 Manet seemed to discontinue his dialogue with past art, apparently preferring instead to record his solipsistic sense of male-female relations more directly. Works such as *The Railroad* (1872–73), *The Cafe Concert* (1878; The Walters Art Gallery, Baltimore), *In the Conservatory* (1979), and the *Bar,* each of which reiterates the psychological fragmentation of *Olympia* and *Déjeuner,* have no direct sources in older art.[57] Such works do have numerous approximate counterparts in the painting of the 1870s and 1880s, however; depiction of beautiful women in modern circumstances was a leading tendency in the period. Impressionists (Renoir, Degas, Cassatt, and Morisot), conservatives (Tissot, Stevens, and Charles Chaplin among others) and caricaturists (Alfred Grévin and J. L. Forain most notably) together constituted a veritable cult of the Parisienne *in situ.* The idealizing works of Renoir and the immensely successful conservatives represented the latest phases in the long modern tradition inaugurated by Giorgione and Titian. Whether naturalistic or anecdotal, their work continued to picture women and events conducive to male tastes and fantasies.

Although Manet sometimes participated directly in this tradition with representations of single women little different from those of his close friends Tissot and Stevens,[58] his paintings of male-female relations invariably deny the observant spectator the easy psychological satisfactions provided in works such as Renior's *Swing* (1876) or Tissot's *Holyday* (c. 1876).[59] The sharp difference between the gratifying psychological circumstances of their works and the problematic ones of his own suggest that Manet's critical dialogue with the Venetian

tradition did not end in the 1870s but was merely updated and less directly phrased.

The possibility or likelihood that Manet's pessimistic convictions on relations between the sexes were sharpened and given shape by his reaction to the optimistic terms of a pervasive and long-standing artistic tradition suggests that we might profitably examine the *Bar* as another antithetical statement, another dialectical or dialogic refusal to validate the legitimacy of those terms. Such a perspective is most revealing because the key problematic of Manet's painting, the barmaid's unexplained refusal or inability to respond positively to the male spectator's intense gaze, upends one of the crucial features of the Venetian tradition: the returned gaze.

The essence of what I call the Venetian tradition—in all its historical incarnations from its origins in the late Classical period to its complete vulgarization in late twentieth century girlie magazines—is the acquiescence of an attractive female subject, shown nude or potentially so, to the erotic desires of the male spectator. Many of the women in such art—those pictured in Titian's *Venus of Urbino*, Goya's *The Nude Maja*, or Tissot's *Quiet* (c. 1881; fig. 16), for example—meet the male spectator's gaze with an expression that combines quiet warmth, directness, and sincerity. The look might best be described as one of love. Although one could argue that this returned gaze is simply a device to signal the female's ready inclination to participate in the male spectator's sexual fantasies, one could also reverse the terms and argue that their overt sexual availability is itself a signal of a deeper, more satisfying psychological intimacy between the depicted female and her implied male spectator. This, of course, is not always the case in works of this general type. In many examples—here a number of nineteenth-century academic nudes by the likes of Bouguereau and Cabanal come immediately to mind—the slightly lascivious cast of the female's gaze suggests that the issue is fundamentally if not entirely sexual. But the best examples of the Venetian tradition—and this is perhaps why they appear better to us—address more than a purely sexual desire; they address, as well, an arguably more fundamental desire for the wholeness and fullness of existence that Plato called "Being" and Jacques Lacan called desire itself.

The concept of desire is central to Lacan's attempt to rescue the pessimistic thrust of Freudian theory from the psychoanalytic profession's emphasis on its therapeutic potential. In a seminar Lacan gave in 1954–55 he noted:

129

> The Freudian experience starts . . . by postulating a world of desire. It postulates it prior to any kind of experience, prior to any considerations concerning the world of appearances and the world of essences. Desire is instituted within the Freudian world in which our experience unfolds, it constitutes it, and at no point in time, not even in the most insignificant or our manoeuvres in this experience of ours, can it be erased. The Freudian world isn't a world of things, it isn't a world of being, it is a world of desire as such.

Although Freud said that this desire was sexual, he should not, according to Lacan, be taken literally: "Freud tells them [analysts] that desire is sexual desire, and they believe it. That is precisely where they err—for they don't understand what that means." The deficiency that stands behind all desires "is the lack of being ("manque-à-être") properly speaking. It isn't the lack of this or that, but lack of being whereby the being exists."[60]

For Lacan this "lack of being"—usually translated as "a want-to-be"[61] but more accurately a "deficiency-of-Being"—not only drives all human actions but is responsible for the very origin of self-consciousness. Lacan considerably revised Freud's notions on the formation and nature of the ego. According to Freud, the ego—presumably formed during the infant's narcissistic stage—is responsible for reconciling the id's instinctual appetites with the requirements of the external world. Lacan, on the other hand, argued that the ego is simply the dissatisfied, alienated self-awareness formed in what he calls the "mirror stage" of development. Somewhere between six and eighteen months the infant becomes aware—either through seeing his image reflected in a real mirror or, presumably, the figurative mirror of the mother's gaze—of his own body as a totality, a gestalt. The unity of this reflection and his mastery of it fills the infant with triumph and joy. The child thus anticipates both the mastery of his body that she has not yet objectively achieved and a feeling of wholeness that she can never realize. Before any auto-erotic physical relationship with her fragmented body, the child loves her imaged self. In Lacan's view, any future relation with reality will be marked by this "*imaginary*" expectation of perfect autonomy. What the ego will henceforth seek through its relationships with the environment is the illusory mastery and wholeness it glimpsed at its inception: "The mirror stage is a drama whose internal thrust is pre-

cipitated from sufficiency to anticipation."[62] The ego's function is not mediation but a fundamental misconception ("méconnaissance") of reality, of what is possible for the subject.[63]

The mirror image not only establishes an impossible but compelling ideal; it also inaugurates the alienation that language will complete— not only because it presupposes a distinct speaker and listener but because a signifier is the absence of the signified.[64] The ideal is not simply imaginary, then, but external. The subject sees her ideal integration but only in relation to the surrounding space and objects, the fundamental "otherness" of the world. The subject is not only split from the world but from herself. Seeing her own body as "other," she knows herself as a thing apart, a divided, fragmented self.[65]

Lacan uses the term "objet petit a" as a kind of algebraic sign to stand for the world outside the self. The small "a," which stands for "autre," is meant to distinguish it from the capitalized "Autre" or "grand Autre" of his lexicon. The "Other" is apparently the *significant* other, the other to whom both our speech demands and our desires are directed in the hope that the intimate connection established with that other might fill the promise first seen in the mirror, might satisfy our fundamental lack of Being. The Other is, in short, a kind of mirror in which we need to see reflected that first and formative image of self: "The Other . . . is the field of that living being in which the subject has to appear."[66] According to Lacan, what we desire of the Other is that He, She, or It desire us, or that we desire the same thing: "man's desire is the desire of the Other."[67]

Lacan's ideas on the subject of desire are based on those of Hegel as taught to a generation of French intellectuals prior to W.W. II by the noted scholar and teacher, Alexandre Kojève.[68] Kojève began his course of lectures on Hegel with a discussion on the origins of self-consciousness in desire, a discussion that clarifies much of what is unclear in Lacan's elliptical writing on the subject. In distinguishing animal from human desire, Kojève observes:

> Thus, in the relationship between man and woman, for example, Desire is human only if the one desires, not the body, but the Desire of the other; if he wants "to possess" or "to assimilate" the Desire taken as Desire—that is to say, if he wants to be "desired" or "loved," or, rather, "recognized" in his human value.

Later in the lecture Kojève adds:

131

There, to desire the Desire of another is in the final analysis to desire that the value that I am or that I "represent" be the value desired by the other: I want him to "recognize" me as an autonomous value. In other words, all human, anthropogenetic Desire—the Desire that generates Self-Consciousness, the human reality—is, finally, a function of the desire for "recognition." . . . Therefore, to speak of the "origin" of Self-Consciousness is necessarily to speak of a fight . . . for "recognition."[69]

The observations of Hegel and Lacan on desire provide us, I think, with a crucial insight into the motives that generated and sustain the tradition of which Manet's *Bar* is a part. The women in works such as *The Venus of Urbino* and *Quiet* (fig. 16) are not, in fact, "sex objects" or mere "objects of desire," as is frequently claimed.[70] They are, instead, the Lacanian Other, the mirror in whom we males wish to see reflected our "imaginary" self: whole, healed, complete, perfect— in a word, desired.[71]

Only by understanding this psychological aspect of the male fantasy figured in the Venetian tradition can we fully understand the *Bar at the Folies-Bergère*, a painting that refuses its terms. In failing to smile at us, to respond to our presence, the barmaid refuses to "recognize" us, to value us, to desire us, to be the mirror in which we may see reflected the sensation of autonomy and wholeness we desire. Her disregard leaves us feeling alienated and insufficient. The painting forces us acutely to experience what Hegel and Lacan, at least, consider the fundamental human experience: our pathetic human deficiency, our essential "lack-of-Being."

What remains to be explained, of course, is why Manet should have chosen, almost programmatically, to counter the attractive lie of the Venetian tradition, to make us face the sad (masculine?) truth that generates and sustains it. The obvious answer, I think, is that he— like Antoine Watteau, Edward Hopper, and so many others—knew that truth too well to ignore it. Such an explanation is only partially satisfactory, however, for it avoids the positive facet of such a course. We must address, as well, the fact that Manet often *preferred* to paint the problematic human truth and found, we must assume, positive satisfaction in doing so.

Psychology and philosophy offer us guidance on this matter, as well. Although Lacan would certainly reject the idea, a Freudian therapist might argue that Manet's refusal to participate in the *mécon-*

naissance perpetuated by the Venetian tradition was healthy; the *Bar* and works like it would have strengthened his ego (as conceptualized by Freud) to bear the burden of its solitude and insufficiency.[72] A Nietzschean philosopher, on the other hand, might counter that the painting provided Manet with both an actual and a metaphorical compensation for the sense of inadequacy the picture creates. Both the artist's handling of paint and his ability to control the barmaid's representation would have provided him with a positive sense of mastery, a sense that may well have exceeded and thus all but eliminated any feelings of insufficiency generated by or referred to via that representation. In short, the feelings figured in the picture would have been overcome in the picturing.

Finally, we might consider the Lacanian perspective. His ideas on the mirror stage of human development would seem pertinent to a painting that not only prominently features a mirror but treats the subject of desire. It is perhaps safe to say that all art historians, regardless of their other disagreements, assume that a modern art work, at least, embodies the consciousness of its maker. Might we not say, in fact, that it mirrors, or aims to mirror, that consciousness? In arguing against the view that the *Bar* mirrored the social conditions of the era, I have attempted to demonstrate that the work mirrors, instead, Manet's deepest and long-standing convictions about the male condition. If, as I claim, the painting successfully *reflects* some fundamental aspect of Manet's consciousness, it would have provided him with a means to overcome the alienation pictured therein. That is, in looking at the work Manet would have seen, in addition to the alienating or alienated barmaid, an object and its image with which he profoundly identified. In fact, he may well have seen the barmaid's somewhat downcast emptiness as the very mirror of his own. The split between the self and the world produced in the mirror stage and figured in the painting would have been overcome, however partially and temporarily, by the artistic mirror.

Lacan contends that the ego is fundamentally a narcissistic agency, one of whose basic functions it is to bolster a fictive sense of unitary selfhood by finding objects and individuals in the world with which we can identify, or love.[73] The making of art might be considered the ultimate expression of this egotistic search, in the domain of things, at least. The self, in seeing one of its fundamental facets thus externalized, would experience an even stronger narcissistic delight than is ordinarily achieved through the appropriation of an object made

by nature or another. As Hegel acutely observed in his *Aesthetics* (1835): "man draws out of himself and puts *before himself* what he is . . . in order . . . to strip the external world of its inflexible foreignness and to enjoy in the shape of things . . . an external realization of himself."[74]

The foregoing interpretations of the gratification Manet may have derived from an essentially pessimistic work should not be considered mutually exclusive. My conviction that the painting would have provided Manet with a range of quite different psychological satisfactions is grounded in my own experience as a scholar and writer. Art history provides its practitioner a diverse range of pleasures, including a double sense of Nietzschean mastery. In the first place one achieves a sense of mastery over the material. According to the German philosopher, "Our so-called will to truth is the will to power because the so-called drive for knowledge can be traced back to a drive to appropriate and conquer."[75] Jane Gallop, in a provocative analysis of art criticism, argues this case: "The critic [or art historian] experiences the work of art as 'overwhelming,' it moves [her] him, has a tremendous power over [her] him, and [she] he rebels against the power." By interpreting the work the critic/historian "would counter the object's power with her understanding." The critic/historian thereby "presumes a position of superiority."[76]

If the act of interpretation provides the historian with a sense of mastery over the object, the act of arguing it may provide a sense of ascendancy over the reader. The scholar obviously hopes that many readers will be convinced, i.e., overpowered, by the *force* of his or her argument. One understands quite well, however, that the best minds, stronger and better informed, will not be completely convinced, will find, in fact, much with which to quarrel. From such readers—most importantly—one wants respect. In short, from one's peers one wants what the male viewer of Manet's *Bar* wants: "recognition" in the Hegelian sense.

That any writer, even the historian, hopes to gain from his or her work professional "recognition" suggests the ultimately personal nature of that writing. An essay such as this is not simply my work but, in a very real sense, my self. When it is praised, I am confirmed; when it is damned, I am damned. Even before it is read and judged, however, it may provide a crucial psychological function. At the point when I am satisfied with it, satisfied that it says what I mean to say as

clearly and effectively as it might, I will look at it and, hopefully, admire my "imaginary" self *reflected* in it, masterful and momentarily whole. I will know what Manet surely felt when he finished his *Bar at the Folies-Bergère:* the narcissism of authorship.

NOTES

1. Guy Davenport, "The Artist as Critic," *Every Force Evolves a Form* (San Francisco, 1987), 69.

2. G. W. F. Hegel, *Aesthetics: Lectures on Fine Art,* trans. T. M. Knox (Oxford, 1975), 31.

3. The literary theorist responsible for the concept of the "ideological environment" (what we now call discourse), Mikhail Bakhtin, argued that language utterances exist within a particular intellectual context or "linguistic community" and that these are not heterogeneous and stable but contested and in flux. See, for example, M. Bakhtin and P. N. Medvedev, *The Formal Method in Literary Scholarship* (Baltimore, 1978), esp. 13–15.

4. For a brief, largely anecdotal overview of the recent controversies in the field, see Sara Day, "Art History: Crisis or New Horizons? Art History's New Warrior Breed," *Art International* 6 (Spring 1989), 78–89. For a more detailed and sophisticated introduction to both the new methodologies and to the conservative resistance to them, see *The Art Bulletin*'s recent series on "The State of Research" in the sub-disciplines. In particular, see Egbert Haverkamp-Begemann, "The State of Research in Northern Baroque Art," 69 (December 1987), 510–19; and Richard Shiff, "Art History and the Nineteenth Century: Realism and Resistance" 70 (March 1988), 25–48. See also, A. L. Rees and Frances Bordello, eds., *The New Art History* (London 1986).

5. The attack on the old Cartesian idea of the author as one who knows what he or she means to say appears at various points in the writings of Jacques Derrida and Roland Barthes. See, for example, R. Barthes, "The Author is Dead," *Image—Music—Text,* ed. and trans. S. Heath (New York, 1977), esp. 145–46, and J. Derrida, "Signature, Event, Context," *Glyph* 1 (1977), 180–183.

6. Charles S. Peirce, anticipating the poststructuralists' connotive (as opposed to denotive) notion of the sign, observed c. 1910 that a "sign, or *representamen,* is something which stands to somebody for something in some respect or capacity. It addresses somebody, that is, creates in the mind of that person an equivalent sign, or perhaps a more developed sign." C. S. Peirce, "Logic as Semiotic: The Theory of Signs," *The Philosophy of Peirce: Selected Writings,* ed. Justus Bushler (New York, 1950), 99.

7. As two leading spokespersons for the semiotic approach recently stated:

"We are less sure than many of our [conservative] colleagues about the possibility of reconstructing those origins and the relevance of the attempt to do so." Mieke Bal and Norman Bryson, "Semiotics and Art History," *The Art Bulletin* 73 (June 1991), 206. Bal and Bryson use both Peirce's notion of the sign and the poststructuralist argument for the death of the author to support their own claims. Ibid., 182–83 and 188–89.

8. For a more developed parallel view, see David Summers, "Real Metaphor: Towards a Redefinition of the 'Conceptual' Image," *Visual Theory: Painting and Interpretation* ed. Norman Bryson, Michael Ann Holly and Keith Moxey (New York 1991), 231–59.

9. For the only time in his life Manet was exempt from the necessity of submitting his work to the jury as a result of having been awarded a second-class medal at the Salon of 1881. He knew, therefore, that he need make no concessions to the jury—not that he seems to have made many previously. George Heard Hamilton, *Manet and His Critics* (New York, 1969), 241 and 249.

10. The circulation problem in his legs that had developed in the winter of 1879–80 as a result of syphilis required him to spend his remaining summers away from Paris resting. Manet died in April of 1883 shortly after the amputation of his left leg. Ibid., 248 and 258–59.

11. Adolph Tabarant, in his generally reliable account of the facts of Manet's life, *Manet et ses oeuvres* (Paris, 1947), 423, claims that "the artist loved to stroll (flâner) in the evening along the promenades of this vast establishment of pleasure."

12. For an account of these notebook sketches, as far as I know still unlocated after their sale in 1954, see Novelene Ross, *Manet's Bar at the Folies-Bergère and the Myths of Popular Illustration* (Ann Arbor, 1982), 143 n. 7.

13. J. Mathey, in his catalogue of Manet drawings, *Graphisme de Manet* (Paris, 1961), 33 no. 134, calls the work "une premiere idée pour *Le bar aux Folies-Bergère* de 1881." For a discussion of the possible illegitimacy of both this and the watercolor given Antonin Proust, which I will discuss shortly, see Nils Walter Ramstedt, Jr., "Edouard Manet's *Bar aux Folies-Bergère*" (Master's thesis, University of California, Santa Barbara, 1971), 30 and 37 n. 5. Although not all Manet scholars accept his authorship of this little watercolor/drawing, its examination is warranted, I think, because it may well be by his hand and because its relationship with the final painting is consistent with Manet's working methods. In the process of working out an idea, he often moved—as he did in the case of *Olympia* (1863), for example—from a more intimate initial idea to a more impersonal final solution.

14. The annotation was apparently written by Leon Leenhof (probably Manet's illegitimate son), as a part of the inventory of Manet's studio after his death. Francoise Cachin and Charles S. Moffett, *Manet: 1832–1883*, exh. cat. (New York, 1983), 483.

15. Ross (as in n. 12), 6–7, perceptively notes that Manet's use of the mirror here to establish the milieu is quite similar to Mary Cassatt's use of the device in *Lydia in a Loge, Wearing a Pearl Necklace* (1879), which was shown in the fourth Impressionist exhibition of 1879. Ross rather wisely concludes: "It may be that Manet's. . . . mirror reflection was directly inspired by the example of Cassatt's work, or, simply, that these two painters of like concern working on a similar topic arrived simultaneously at a similar invention."

16. Tabarant (as in n. 11), 423–424.

17. Ibid., 423. Tabarant claims that the watercolor preceded the oil sketch, but this seems highly unlikely. It is possible, instead, that it followed the final painting, but given the many important differences between the two versions, this seems unlikely as well.

18. Ibid., 424.

19. See Juliet Wilson Bareau, "The Hidden Face of Manet: An Investigation of the Artist's Working Processes," *The Burlington Magazine* 128 (April 1986), 79 and 86.

20. See Ross (as in n. 12), 8, and Cachin (as in n. 14), 479.

21. I am indebted to Cachin (as in n. 14), 482, for the observation.

22. Ross (as in n. 12), 2, claims that she "betrays no expression." Robert L. Herbert, *Impressionism: Art, Leisure, and Parisian Society* (New Haven, 1988), 80, describes "her impassive gaze."

23. Anne Coffin Hanson, *Manet and the Modern Tradition* (New Haven, 1977), 205.

24. Raymond Mortimer, *Edouard Manet: Un Bar Aux Folies-Bergère* (London, n.d.), 7. Cachin (as in n. 14), 479.

25. T. J. Clark, *The Painting of Modern Life* (Princeton, 1986), 253.

26. Reproductions of the work often suggest an overall bluish tonality to the work when, in fact, the painting is firmly structured around an equilibrium between the pinks, mauves and browns, on the one hand, and the greens and blacks, on the other.

27. Jeremy Gilbert-Rolfe, "Edouard Manet and the Pleasure Problematic," *Arts Magazine* 62 (Feb. 1988), 40–41.

28. The entry of the masculine gaze into the female's pictured space in works such as Titian's *Venus of Urbino* (1538), for example, has I think, a sexual implication. Picasso seems to have well understood it when he flattened the space in his *Desmoiselles d'Avignon* (1907), thus preventing the male spectator both literal and metaphorical entry. Picasso may well have been inspired by Manet's example in the *Bar.*

29. I am indebted to Herbert (as in n. 22), 80–81, for the observation.

30. Cited in Ross (as in n. 12), 75–76.

31. The covered garden is shown in Ross (as in n. 22), fig. 7. For a view of the auditorium see Bareau (as in n. 19), 79.

32. Herbert (as in n. 22), 79.

33. Ibid.

34. Alain Corbin, *Les Filles de noce: Misere sexuelle et prostitution aux 19e et 20e siecles* (Paris, 1978), 209. Cited in Clark (as in n. 25), 245. See also Herbert (as in n. 22), 79–80; Ross (as in n. 12), 78–81; and Cachin (as in n. 14), 478.

35. See Hollis Clayson, *Painted Love: Prostitution in French Art of the Impressionist Era* (New Haven, 1991), 151.

36. Ibid., xviii.

37. Herbert (as in n. 22), 80, offers the case of one of Sari's employees, Blanche Rose, who was not. He adds: "We can be quite sure that Blanche Rose and Suzon lived less conventional lives than a proper bourgeoisie, and that they might well have had lovers, or occasionally slept with a theater manager. But between this and prostitution there is an enormous gap."

38. In 1977 he calls her a "whore." T. J. Clark, "The Bar at the Folies-Bergère," *The Wolf and the Lamb: Popular Culture in France* ed. J. Beauroy, M. Bertrand and E. Gargan (Saratoga, CA, 1977), 251. In 1984 he more cautiously concludes that she is "probably for sale herself—or believed to be so by some of her customers." Clark (as in n. 25), 253.

39. For a discussion of *Olympia*, see Theodore Reff, *Manet: Olympia* (London, 1976). For *Nana*, see Clayson (as in n. 35), 67–73.

40. Ibid., 150.

41. Both historians rely heavily on the insights of Georg Simmel, an early twentieth-century sociologist, who perceptively analyzed the adverse effects of the new money economy on human behavior and relations. Herbert actually calls the barmaid both "a participant and a victim of commercialized leisure." See Herbert (as in n. 22), 50–57 and 80, and Clark (as in n. 25), 238–39 and 252–55.

42. Clark seems to accept Marx's view that the economic *base* determines the cultural *superstructure:* like everything from politics to manners, art is a secondary manifestation or epiphenomena of base action, regardless of what the artist thinks s/he is doing. Herbert sees the art produced in the circle of the Impressionists as a sociological record because of the artists' conscious decision to pursue a naturalist goal. See Herbert (as in n. 22), ch. 2: "Impressionism and Naturalism."

43. See, for example, Linda Nochlin's collection of her pioneering work in this area, *Women, Art, and Power: And Other Essays* (New York, 1988).

44. Clayson (as in n. 35), 152.

45. See Hamilton (as in n. 9), 20–24.

46. Mme. Manet was particularly distressed by her son's lavish spending in the early 1860s. She kept careful track of the monies he received from her and his father, and noted in 1866 that "It seems to me high time to call a halt to this ruinous downhill path." Juliet Wilson Bareau, ed., *Manet by Himself: Correspondence & Conversation* (Boston, 1991), 12.

47. For this portrait of Manet I am chiefly indebted to Ross (as in n. 12), ch. 4: "L'Homme du monde."

48. Cachin (as in n. 14), 485.

49. Cited in Pierre Courthion and Pierre Cailler, eds., *Portrait of Manet by Himself and His Contemporaries* (New York, 1960), 86.

50. Ibid., 98.

51. Ross (as in n. 12), 71.

52. The major essay on the subject remains the first: Nils Gosta Sandblad, *Manet: Three Studies in Artistic Conception* (Lund, 1954), 17–68. See also Bradford R. Collins, "Manet's *Luncheon in the Studio:* An Homage to Baudelaire," *Art Journal* 38 (Winter 1978–79), 107–13. Baudelaire's essay was written in the winter of 1959–60 and eventually published by *Figaro* in three installments late in 1863. Manet and Baudelaire were particularly close during the period when Baudelaire was seeking a publisher for his essay.

53. See Bradford R. Collins, "Manet's *Rue Mosnier Decked with Flags* and the Flâneur Concept," *The Burlington Magazine* 117 (Nov. 1975), 709–14.

54. Jonathan Mayne, trans. and ed., *The Painter of Modern Life and Other Essays* (New York, 1965), 3 and 29–31.

55. "If a painstaking, scrupulous, but feebly imaginative artist has to paint a courtesan of today and takes his 'inspiration' . . . from a courtesan by Titian or Raphael, it is only too likely that he will produce a work which is false, ambiguous and obscure. From the study of a masterpiece of that time and type he will learn nothing of the bearing, the glance, the smile of the living 'style' of one of those creatures whom the dictionary of fashion has successively classified under the coarse or playful titles of 'doxies,' 'kept women,' *lorettes,* or *biches.*" Ibid., 14.

56. See, for example, Cachin and Moffett (as in n. 14), nos. 74, 87, 91, 104, and 115. Considerably more needs to be done on the subject.

57. For an excellent analysis of *At the Cafe* (1878), which features an inattentive spouse, see Herbert (as in n. 22), 71. Unlike Herbert, who sees Manet's work as a "commentary on [modern] marriage and the bourgeois family," I am suggesting that Manet, like myself, may have seen the problem as more than social.

58. Compare, for example, Manet's *Spring* (1881) with Stevens' 1874 version of the theme. The two are illustrated in ibid., 184 and 185. Both paintings allow the male spectator visually to ravish a passive, curvaceous beauty presented not as another human but objectified as nature.

59. For a reproduction of *Holyday* (c. 1876), see Christopher Wood, *Tissot* (Boston, 1986), fig. 98.

60. J.-A. Miller, ed., and S. Tomaselli, trans., *The Seminar of Jacques Lacan,* Book II (New York, 1988), 222–223.

61. Jacques Lacan, *The Four Fundamental Concepts of Psycho-Analysis,* ed. J.-A. Miller, and trans. A. Sheridan (New York, 1978), 29.

62. Jacques Lacan, "The mirror stage as formative of the function of the I," *Ecrits: A Selection,* trans. Alan Sheridan (New York, 1977), 4. See also, 1–7 and 137–39.

63. In 1949 Lacan argued against seeing the "ego as centered on the *perception-consciousness* system, or as organized by the 'reality principle.' . . . Our experience shows that we should start instead from the *function of méconnaissance* that characterizes the ego in all its structures, so markedly articulated by Miss Anna Freud." *Ecrits* (as in n. 62), 6.

64. For a good introduction to this aspect of Lacan's thought, see Terry Eagleton, *Literary Theory: An Introduction* (Minneapolis, 1983), 166–168.

65. For a good introduction to Lacan's theory of the mirror stage, see Bice Benvenuto and Roger Kennedy, *The Works of Jacques Lacan: An Introduction* (New York, 1986), 47–62.

66. Lacan (as in n. 61), 203.

67. Ibid., 38.

68. Lacan, Sartre, and a number of other important French thinkers were strongly influenced by the course of lectures on Hegel given by Kojève at the Ecole des Hautes Etudes between 1933 and 1939 wherein he "humanized" many of Hegel's metaphysical notions. Madan Sarup, *An Introductory Guide to Post-structuralism and Postmodernism* (Athens, Georgia, 1989), 20.

69. Alexandre Kojève, *Introduction to the Reading of Hegel* (New York, 1969), 6–7 and 19.

70. See, for example, Patricia Matthews, "Returning the Gaze: Diverse Representations of the Nude in the Art of Suzanne Valadon," *The Art Bulletin* 73 (Sept. 1991), 417. Matthews further claims that: "Rather than being inhabited by a consciousness, these bodies become vessels to be inhabited by male desire. . . . There is no subject behind the image, but only an 'other.'" Ibid.

71. The complex of issues involved in male representations of beautiful women involves more than a simple desire for "recognition," however, although I have insufficient space here to do more than sketch in some of the possible complications. Hegel claims that the struggle for recognition usually results in a Master/Slave relationship. Paradoxically, this situation is generally more satisfying for the Slave than for the Master, because the recognition given by an inferior is essentially worthless. (See Kojève [as in n. 69], 6–7 and 19.) According to this view, via representations of beautiful women the male artist and spectator would reduce the female to the role of Slave—yet the value accorded her "recognition" suggests that she is not, in fact, considered so. The more conventional feminist perspective on the male desire to gain control of the female through such representations is provided by Jane Gallop, who notes: "For Freud, sexual arousal is a state of tension, a disequilibrium in the psyche which generates a drive to reduce that tension. The subject is moved, overwhelmed, experiences something very powerful. He is not in control of the situation. . . . His gesture is to possess the disturbing

140

object so as to reassert command of the situation. . . . The solution to the experience of [sexual] desire in which the subject feels he is out of control is to possess the object . . . and reduce it to dependency through a view of its inadequacy." Jane Gallop, "Psychoanalytic Criticism: Some Intimate Questions," *Re-Visions: New Perspectives of Art Criticism,* ed. Howard Smagula (Englewood Cliffs, 1991), 80.

72. This is the conception of the role of the psychoanalyst that Lacan rejects. See Juliet Flower MacCannell, *Figuring Lacan: Criticism and the Cultural Unconscious* (Lincoln, Nebraska, 1986), 62.

73. Lacan would never say it this clearly, of course. See, for example, *Ecrits* (as in n. 62), 240–45. As Lacan acknowledged (ibid., 267), his ideas on "narcissistic identification" depend on those expressed in Freud's *Group Psychology and the Analysis of the Ego* (1921), trans. and ed. James Strachey (New York, 1975), 37–48.

74. Hegel (as in n. 2).

75. Cited in Sarup (as in n. 68), 51.

76. Gallop (as in n. 71), 79–80.

On Manet's Binarism: Virgin and/or Whore at the Folies-Bergère

MICHAEL PAUL DRISKEL

A CENTRAL THESIS of George Mauner's fascinating *Manet, Peintre-Philosophe* is that dualism was deeply inscribed in both Manet's art and worldview. According to Mauner, *A Bar at the Folies-Bergère* (frontispiece), with its use of a mirror image to create a symbolic doubling, best illustrates the "problem of the *homo duplex*" which preoccupied the artist throughout his career.[1] In a classic example of Panofskian iconographical analysis, he carefully adduces textual equivalents for the many borrowings and quotations from earlier art found in Manet's oeuvre and attempts to reconstruct the thought processes of the artist. His study is at once an exploration of the artist's mind and the revelation of complex literary texts encoded in his works.

Despite the elegance of Mauner's interpretations, it is difficult to accept the validity of his approach. The avant-garde intellectual milieu Manet occupied was vastly different from that of the humanist circles of Renaissance Florence or Baroque Rome, where the iconographical method is often appropriate, and there are few examples of other artists in Manet's circle adopting complex iconographic strategies to give unseen philosophical or literary content to their paintings. But more important, it was a cardinal rule after 1850—one promoted by the avant-garde and even endorsed by many in the rear-guard—that significant art should avoid the conflation of the visual and the literary. Possibly the most trenchant statement of this doctrine is an unfinished essay begun by Charles Baudelaire in 1858, concerning something vaguely entitled "L'Art philosophique," which consists of an attack on German art and a type of art emanating from the city of Lyon. According to Baudelaire, what both had in common was the tendency to use the visual arts as a rival for the book; both were guilty of misusing the medium of painting to do what the print-

ing press could do better. Thus, these endeavors represented a rever-
sion to the artistic practice characteristic of the "infancy of peoples."
In this genre of art everything depended on "allegory, allusion, hiero-
glyphs, and rebuses."[2]

Underlying Baudelaire's comments is the distinction between the
intrinsic natures of literature and painting that was a primary con-
cern of Lessing's famous *Laokoon* (1766). However, while Lessing dif-
ferentiated literature and painting on the basis of their respective
concerns with space and time, Baudelaire perceived the difference to
be one between nonverbal expression and linguistic exposition of
ideas. This shift in emphasis from the space / time dichotomy to one
of plastic expression / discursive presentation is among the most sig-
nificant in nineteenth-century art theory and, under different guises,
this expression / discourse opposition recurs repeatedly in French
criticism after the mid-century. Thus, if Manet consciously con-
structed a complex and coherent philosophical discourse for his
paintings, accompanied by symbolic clues for the beholder, it goes
against the very grain of the concept of modern art with which we
assume he identified. But having said this, let me state that I agree
with Mauner's claim that dualistic organization pervades Manet's art
and is strikingly exemplified in *A Bar at the Folies-Bergère.*

Rather than adopting the hermeneutical strategies of the iconogra-
pher to unlock the meanings of Manet's picture, one might consider
the manner in which Jacques Derrida deals with the problem of dual-
ism in his anti-book *Glas* (1974). Besides being a founding figure of
deconstruction, Derrida is a leading theorist of intertextuality, or the
method of interpretation that shifts the locus of meaning of works of
art from the authorial mind to the universes of discourse within
which they were generated, and considers meaning a product of the
interplay of different texts. *Glas* represents his attempt to provide a
concrete example of the mutual interaction of ostensibly disparate
texts within a literary work created by himself.

The format of his book consists of two columns on each page
within which he conducts separate analyses of two far different texts.
In the left-hand column he ruminates on the idea of the family in
the philosophy of Hegel and his *Philosophy of Right.* Opposing this
discourse is a discussion in the right column of *Our Lady of the
Flowers,* a celebrated novel by a marginal member of French society,
the petty thief, pederast, and male prostitute Jean Genet. As one pro-
ceeds through Derrida's work a series of radical oppositions are set

up between central binary ideas of western culture, such as spirit and body, patriarchal and maternal authority, property and theft, law and disorder, and virtue and depravity. In reading either column, one is constantly aware of the presence of the discourse of the other and their implied interrelation. One theme that appears numerous times in both columns, and forms a link between them, is the doctrine of the Immaculate Conception (often abbreviated "I.C." in his text). There is no didactic argument in the book linking the content of the two columns. Instead, by its anti-programmatic format readers are issued an invitation to make their own connections and conflations between the texts, in keeping with his concept of "undecidability."

To underscore the radical differences between the discourses of Hegel and Genet, Derrida employed the visual and stylistic means of typesetting. Whereas the left-hand column of the book is extremely regular in its methodical left indents, typography, and text blocks, the other column is set in a different type font and size, is full of gaps, incomplete sentences, and argot of the street, seeming to sprawl casually down the page. The visual contrast is that between the highly formal and the extremely informal, or between what one might call "hieratic" and "natural" visual modalities, one which corresponds to the nature of the texts discussed in the opposed columns. In what follows I will maintain that there is an extraordinary similarity between the structures and functions of Derrida's duplex text(s) and *A Bar at the Folies-Bergère*. This is to say that the virtual and reflected images of the barmaid in Manet's painting will be likened to the two opposed textual columns in Derrida's book, each representative of pervasive, interpenetrating, and multidimensional cultural discourses.

In his *Of Grammotology* (1967) Derrida conducted his most complex assault on ideas of origin, unique meanings, and authorial intentions that have pervaded the humanities in the west for centuries. However, despite his continued attack on traditional notions of authorial intent as the source of meaning of texts, Derrida certainly could not deny that he had a "purpose" or "purposes" in mind when constructing *Glas*. Indeed his text might be termed an instance of "purposive undecidability." In a like manner Manet's creation of a binary structure for his painting was a purposive act committed in the thoughtful silence of the atelier by a single author, but the painter left the task of interpreting the relationship between the two halves of this structure to the beholder. Thus, I will accept Manet's invitation to make the appropriate connections between the parts of his picture

and to place it in the field of social, cultural, and linguistic relationships that co-existed with its production.

Before exploring the dyadic nature of Manet's work, however, the existence of binary social structures themselves might briefly be put in a larger theoretical perspective. Dualism, the organization of thought and institutions in patterns of binary opposites as a means of imposing order on the unruly complexity of human social life, is a phenomenon that structural anthropologists claim to have found in societies all over the globe. The sheer number of examples of dyadic organization described by working anthropologists and ethnologists in the most diverse regions has suggested that it may be a primordial structure of consciousness.[3] However, since the late 1960s, binary analysis of cultures as practiced by structuralists has been challenged by post-structuralist theoreticians, the principal of whom is Jacques Derrida. Their principal objection is that the structuralist project pretends to an impossible ideal of scientific objectivity and that binary classification contains an implicit hierarchy privileging one half of a dyadic structure over the other. But, as much as Derrida disputes the metaphysical claims or truth-value of binary analysis, he does not question the *historical* fact that dualistic schemas have pervaded western thought for centuries. In accord with Derrida's arguments I make no claim that structuralism reveals any deeper metaphysical truths or universal structures of consciousness, and I agree with his assertion that binary organization pervaded the *historical* epoch in which Manet lived. It is the historical forms taken by this dyadic mode of categorization that I am trying to recapture.

Let me begin my interpretation of the dualistic structure of *A Bar at the Folies-Bergère* by presenting a table of categories arranged as ordered lists of oppositive pairs that are either inscribed in or dialectically engaged by the painting:

Surface	Depth
Frontality	Obliqueness
Symmetry	Asymmetry
Timelessness	Time
Being	Becoming
Symbol	Narrative
Authority	Individualism
Sacred	Profane
Purity	Concupiscene
Virgin	Whore

I should stress that this table does not pretend to completeness and that the space constraints of this essay do not permit me to treat these interrelated categories in the depth they require. My primary focus will be the last dyad in the series, and this emphasis will result in a reading far removed from previous interpretations of the painting and the ostensible subject matter suggested by its title.

One major component of pictorial representation Manet's painting calls into question is the relationship between the implied viewer and the personages depicted on the canvas, or the underlying implications of the different modes of pictorial looking. It represents and juxtaposes two opposed, primordial viewing relationships. The barmaid in a strict frontal pose addresses me, the viewer, in direct relationship of "I" to "You," or the visual equivalent to the grammatical distinction between the first and second person singular. On the other hand, when I-the-viewer shift my focus to the reflected images of the barmaid and top-hatted gentlemen in the mirror, the location of the first person singular likewise shifts. "I" the beholder witness a close encounter between "Them," or two individuals who occupy a third person plural position in respect to the viewer.[4]

This distinction is important because it is related to a primal difference in pictorial representations that has a long history in western art. The difference was first clearly articulated by Pope Gregory the Great in a letter defining two different classes of images: *imagines* and *historia*, which had fundamentally different functions.[5] The first type demands a nondiscursive, devotional attitude from the worshiper before a sacred image, and the second entails a discursive stance, as the beholder reads the depicted action in the image and places it in a sequence of events constituting religious history. In short, one represents the thing to be worshipped and the other explains why. To use more familiar terminology, the difference is one between iconic and narrative images. Therefore, employing the categories of Gregory the Great to Manet's outwardly secular subject, one might say that it juxtaposes in one rectangular frame the formal elements of both the *imagine* and *historia*.

These different representational modalities are strikingly exemplified in Manet's two major religious paintings, his *Dead Christ with Angels* (1864) and *Christ Mocked by the Soldiers* (1865). Beneath the similarities of paint handling, refusal to idealize the Christ figure, and the ambiguity of setting for each work there is a fundamental categorical difference: the first is a traditional symbolic image of the *imago pietatis* type, while the latter is a narrative or illustrative pic-

ture depicting a specific biblical event.[6] One might note that the symbolic composition of Christ's arms and hands in the first picture are repeated in the image of the solemn barmaid.

The symbolic position of figures within the frame of an iconic image is directly related to the composition of the entire work. A symmetrical composition is most appropriate to symbolic themes, while asymmetry, which suggests the disorder of everyday life, is consonant with depictions of action or narrations of a text. One type of composition implies stasis, resistance to temporal change, and timelessness, or the mythic "eternal present," which is a reason for its prevalence in iconic or devotional images, while the other demands active reading by the viewer and serves to stress the temporal order.[7] Again in Manet's painting these two basic compositional formats are combined. The barmaid stands in a position of the strictest symmetry, her hands placed in identical positions beside her body, in the dead center of the picture frame. On either side of the bar objects are placed in positions of symmetrical balance. Breaking this rigid symmetry are the identical globular forms in the mirror that establish a counterpoint to the centrality of the barmaid, but more importantly, the impossible reflection of the woman and her customer in the mirror, who are engaged in a temporal act.

To find the deeper meanings in this juxtaposition of the atemporal and the temporal, we might translate the opposition into the concepts "permanence" and "change" and reinsert them into the social rhetoric of Manet's era. A primary theme in the cultural rhetoric of the time was the idea of "progress," a new religion for many in the nineteenth century, which was equated with dynamic change and set in opposition to the stultifying permanence of tradition.[8] If forced to reduce this vast discourse to one example, I would cite a book bearing the formidable title *Du Progrès intellectuel dans l'humanité; supériorité des arts modernes sur les arts anciens* (1862). In the tome Eugène Véron, argued that movement and change were defining characteristics of both modern art and of progressive society, and further established a binary opposition between modernity and religion, which he equated with tradition: "Every conception that pretends to be immutable will one day be outmoded by the progress of humanity. When man values himself more than his god, he will pass it by. Every official belief, immobilized as a consequence will be passed by."[9] Among the many hundreds of examples of such rhetoric one that is most relevant to Manet's painting was published the following year by Charles Baudelaire, a friend and frequent dinner companion of Manet. In his

147

famous essay on the art of Constantin Guys, Baudelaire, rather than proposing a novel idea, gave lapidary form to a cliché of his time: "Modernity is the transitory, the fugitive, the contingent, one half of art of which the other is the eternal and the immutable."[10] Therefore, the formal oppositions in Manet's picture, when situated in the inescapable discourses concerned with the ideas of modernity and social progress, do have philosophical content.

One well-known painting by a contemporary of Manet might illustrate the immutable "other half" of Baudelaire's dyad: Ingres' celebrated *Virgin with the Host,* which was completed in 1854 (fig. 17). This picture, the best known of his six versions of the theme, was shown at the Universal Expositions of 1855 and 1867. In 1868 Ingres' series of images was enthusiastically praised in one of the most important books on modern religious art written during the century: "The different Virgins of the Host are the true religious creation of the master. The type is the same . . . but there is in these Virgins, who contemplate and adore, . . . a sentiment of ardent faith and maternal charity that transfigures them."[11] These words issued from the pen of Augustin-Jean Hurel, a priest and author who was a close friend of Manet from around 1860 until the artist's death and who administered last rites to the artist.[12]

The first of these works was exhibited in Ingres' studio in Paris in 1841, where it elicited a great deal of curiosity and criticism. Raphael's images of the Virgin are clearly the works against which Ingres' paintings established their difference. In contrast to Raphael's graceful, curvilinear vision of the Madonna, Ingres rendered his *imagine* with an austerely rectilinear compositional structure, careful symmetry, and absolute frontality. The motif of the Adoration of the Host, however, does not appear in the art of Raphael or any of his contemporaries. This unprecedented theme obliged Ingres to introduce a structure not found in Ralphael's oeuvre: the altar table in the immediate foreground of the composition that separates the Virgin, behind the altar, from the viewer-worshipper, who is the implied presence on the other side.

Critics of the first and subsequent versions of the theme struggled to articulate a fundamental dichotomy resident in them: one between the hieratic form of the image and the sensuality of the figure of the Virgin with her full lips, pliable flesh, and rounded forms. Visiting Ingres' studio in 1841, the social philosopher Proudhon was struck by this contrast, declaring that no devotional image had ever before produced such an effect and that the artist had painted the

Virgin as one of his odalisques.[13] Théophile Thoré, writing in 1841 about the first work in the series, pointed up the same contrast between the format of the image and the visage of the central figure, commenting that it belonged "more to a courtesan than a Virgin."[14] Although no commentators stated it precisely, most realized in some way that Ingres' work combined two different aspects of their concept of "woman."

Therefore, it may not be inappropriate to compare Ingres' dualistic image to *A Bar at the Folies-Bergère*. The most obvious similarity lies in the frontal poses of the hieratic female figures and the placement of barriers, in the forms of an altar table and a countertop, on which objects are positioned more or less symmetrically, between the female figures and the implied viewer-worshipper or viewer-buyer. But Manet's figure, standing with arms at her side resting on the bar with the buttons of her dress arranged in a vertical line bisecting her visage, is even more symmetrically disposed than Ingres's Madonna. Whereas the chalice occupies a position in the center of Ingres' symmetrical composition, Manet's equivalent, placed slightly off center, is a wine glass containing a rose.

The position of the arm and shoulders of Manet's barmaid also resonate with another art historical reference. Among Marcantonio Raimondi's famous engravings after the works of Ralphael is one representing the Virgin in such a pose lamenting the death of Christ. These engravings were the visual primer studied by every art student who passed through the academic system in nineteenth-century France and it is not surprising that many painters incorporated this symbolic pose in their own works. As is well known, Manet appropriated another image from the series of engravings for his notorious *Luncheon on the Grass* (1863). Among the paintings explicitly quoting Raimondi is a *Mother of Sorrow* that Hippolyte Flandrin, generally considered to be the best religious painter in France at mid-century, sent to the Salon of 1845 (fig. 18).[15] Here the Virgin stands frontally in the center of the composition and extends her symmetrically arranged hands outward in order to display the instruments of the Passion. Raimondi's engraving naturally interested those committed to the *Ingresque* tradition, but Delacroix, painting his renowned *Greece on the Ruins of Missolonghi* seventeen years earlier, likewise both appropriated and transformed this same source.[16]

While I am arguing that Manet chose a format associated with devotional imagery for the central figure in his secular image of Paris

nightlife or adopted an iconographic convention associated with the Virgin Mary, it should be noted that this borrowing from Marian imagery may not be the first in his oeuvre. Harry Rand has claimed that in Manet's *The Gare Saint-Lazare* (1873, National Gallery, Washington, D.C.), the figure of Victorine Meurent, who is interrupted while reading a book and glances at the implied beholder, is based on the iconographic tradition of the Madonna of Humility. In support of his theory, he cites a painting by Rogier Van Der Weyden (a panel from the "Granada Altarpiece," c. 1444, The Metropolitan Museum of Art), one of many using the same iconography, in which Christ appears to his mother, who puts down her book and looks up in surprise.[17] If this is the case, there is dark irony in the work in that Meurent, a woman who supplemented her wages as a model by casual prostitution and posed for Manet's *Olympia*, a notorious representation of a Parisian prostitute, is recast as the Virgin, or re-presented as the opposite of the role in which she had attained notoriety.

Although the visual resemblance between Manet's figure of the young Parisian and images of the Madonna of Humility is not strong, Rand might have strengthened his case by exploring the social history of the the Virgin at the time or the specifically *historical* factors that may have placed her image in the foreground of Manet's consciousness. This would be a relatively easy task because the person of the Virgin Mary assumed a greater place in Catholic piety during the period than ever before in the history of France. So great was the resurgence of the cult of the Virgin between 1840 and 1900 that certain Church historians have labeled the period the Marian Age. Mariolatry received one of its most significant official encouragements in 1839 with the canonization of the eighteenth-century Italian theologian Alphonsus Liguori, who had placed unprecedented emphasis on the role of the Virgin in Catholic worship.[18] In France the strongest advocate of the moral theology of Liguorism was Thomas Gousset, a Jesuit theologian who wrote several major works on the thought of the Italian saint which were quickly distributed in seminaries throughout France. Within the institutional structure of the Church the Jesuit order assumed the vanguard in the promotion of Liguorism, the cult of the Virgin, and increased papal authority, the three of which were interconnected. The increased devotion to the Virgin is witnessed even more dramatically by the growth of the Archiconfrérie du Saint et Immaculé Coeur de Marie, founded in 1838, with its center at the Parisian church of Notre-Dame-des-Victoires. One

sociological study has shown that the organization spread through-out France like wildfire, incredibly enrolling six to ten percent of the French population in its ranks by 1843.[19] Accompanying this greatly increased position of the Virgin Mary in Catholic thought were her various appearances in France, the most celebrated and controver-sial of which were the apparitions at La Salette in 1846, at Lourdes in 1858, and at Pontmain in 1871. One of the most conspicuous signs of the new status of the Virgin was the mass pilgrimages to the shrines at La Salette and Lourdes organized by the Assumptionist order, beginning in 1872. The masses of pilgrims who descended on the railroad stations of Paris each August for transportation to the shrines became a popular topic of conversation and an inescapable feature of urban life in the city. Accompanying these mass spectacles were the ubiquitous tales of miraculous cures at Lourdes, which in turn provided fuel for the scorn of anticlericals.[20] Typical of the anticleri-cal response to this display of piety were the articles that Emile Zola, Manet's staunch defender and steadfast (mis)interpreter, published in the republican journal *La Cloche* in 1872 in which he denounced stories of these miracles as inventions of the unscrupulous to dupe the credulous and bring profits to the thaumaturgical industry that had grown up at Lourdes.[21]

In keeping with his special devotion to the Virgin, Thomas Gousset published a book in 1855 on the newly proclaimed doctrine of the Immaculate Conception.[22] It appeared less than a year after a papal Bull of 8 December 1854 officially decreed that the Virgin was con-ceived without the taint of original sin and was completely free from concupiscence. This was the first of a series of controversial decrees during the pontificate of Pius IX that included the notorious Syllabus of Errors and the Decree of Papal Infallibility, which were political acts designed to reassert papal authority. The decree sparked a heated debate in the following decades. Since the issue of the Immaculate Conception had been discussed for centuries by the doctors of the Church and no consensus had been arrived at con-cerning its validity, this decree was taken as an arbitrary exercise in power by its critics, while supporters of absolute papal authority greeted it with enthusiasm. The relation of this doctrine to the growth of devotion to the Virgin on a mass level might be summa-rized in the account of Bernadette Soubirous, the humble peasant girl to whom the Virgin appeared in a series of visions in the Grotto at Lourdes. Pressed by the local clergy, Bernadette asked the Virgin her

151

name during one of her visions, and reported that in response the Lady replied "I am the Immaculate Conception."

This papal decree also promoted an animated debate over the proper way to represent the Virgin under the sign of the Immaculate Conception.[23] A prototype for the symbolism for the Immaculate Conception had already been provided in 1830, when the Virgin Mary appeared a number of times to Sister Catherine Labouré in a convent of the Sisters of Charity on the rue du Bac in Paris. In her graphic accounts of the visitations, the Virgin was surrounded by an oval and stood on a globe, crushing underfoot a serpent. She wore a white robe with a blue mantle, symbolizing purity and innocence, and held her arms by her side extended downward and out. Rays of light radiated from her open hands. At the top of the oval were the words of an invocation that began "Mary, conceived without sin, pray for us." During the visions the Lady asked that a medal be struck with this image on it. Shortly thereafter the archbishop of Paris authorized the production of these medals and within a decade millions of copies of the Miraculous Medal had been distributed throughout the world and the iconography adopted in all manner of mass-produced holy cards and other printed images of piety (fig. 19).[24] This is to say that almost twenty years before the papal Bull the iconography of the Immaculate Conception was indelibly imprinted in the minds of the masses of the faithful. It is not surprising that both Bernadette of Lourdes and the visionaries of Pontmain described one of the poses of the Virgin during her appearances as like that of the Miraculous Medal, but without the rays of light. Thus, the pose of Manet's barmaid had precedents both in the high art of Raphael, known only to a relatively small number of art lovers, and in the commercial religious imagery, or religious kitsch, sold in many shops in the area around the church of Saint-Sulpice in Paris.

The controversy over the appropriate representation for the doctrine was also the subject of a chapter in an important book on religious art published in 1857 by a prominent Protestant. Athananse-Josué Coquerel, son of a famed Protestant clergyman, denounced all the proposed schemas on the grounds that they were just one more example of the attempt of the authoritarian members of the Catholic Church to "absorb the thought of the individual in the dogmatic decree of the clergy, collective unity of the Church, sovereign and infallible authority of the pope."[25] By this remark we can see how the posture of the outstretched arms entered the larger cultural discourse of the nineteenth century that

152

opposed the concepts of authority and individual liberty and acquired a political dimension.

As might be expected, the doctrine of the Immaculate Conception and the discourse over the proper way to represent it became the object of humorous derision among anticlericals. An instance is a caricature that Jean-Paul Laurens, a distinguished academic history painter, fierce anticlerical and acquaintance of Manet, published in the satirical journal *Le Philosophe* in 1867.[26] The image depicts a corpulent priest paying a visit to a painter's studio to commission a painting of the Immaculate Conception and assuming the pose of the Miraculous Medal, with arms extended symmetrically from his side, as a model for the work (fig. 20). On a much more crass level the sign system of traditional religious imagery was turned against itself in anticlerical publications such as Léo Taxil's *Vie de Veuillot immaculé* of 1884. On the title page the combative ultramontane journalist, editor of the Catholic daily *l'Univers*, and champion of the dogma of Papal Infallibility and the Syllabus of Errors was depicted in one of the poses of the Virgin of the Immaculate Conception, extended arms dripping blood, instead of radiating light (fig. 21). In *Calotte et Calotins*, an earlier work by Taxil, who founded a publishing house dedicated to promoting the most virulent anticlericalism, an illustration adapted traditional iconography and put it to a new end (fig. 22).[27] Marianne, the secular Virgin of republican devotion, wearing Phyrgian cap and a halo in the form of an egalitarian level, crushes underfoot a serpent-Jesuit, while holding her arms in the position some recommended for the Immaculate Conception. The position of the arms repeats the form of the isosceles triangle above, thereby turning the pose into a sign for "equality" and other republican values.

From this brief discussion of the Marian revival and the iconography of the Immaculate Conception, it should be apparent that an image of a single female standing in a pose of direct address to the viewer, with arms outstretched and hands facing outward, was one of the most emotionally, politically, and socially charged visual signs in nineteenth-century France. Its symbolic charge was as great, if not greater, than that of any other in the popular repertory of pose and gesture, and was a sign whose implications any figure painter interested in the language of the body would almost of necessity have been aware.

Having interpreted one half of Manet's duplex figure, I should turn to her other. The exact nature of the exchange between the barmaid and the top-hatted customer have been the subject of considerable

speculation. From what we know of the social ambience of the café concert, it is indisputable that many of the poorly paid women who worked as barmaids or *serveuses* in these establishments supplemented their meagre incomes with casual prostitution. T. J. Clark, in an essay published previous to the more nuanced reading in his book on Manet's work, has argued that the young woman confronting the viewer in Manet's picture is in the actual act of offering herself for sale.[28] In response Françoise Cachin has commented that "it would be easy to slip from one metier to the other . . . but that the model at the moment of the painting at least is very firmly on the other side of the bar, an indifferent observer."[29] Seeming to acknowledge the dualistic aspects of this picture, Cachin then drew a contrast between the immobile and impassive frontal figure and her reflection, the latter seeming to "be at your service" or engaged in an encounter of a dubious nature. From her remarks one might conclude that the woman in her dual aspects is and is not engaged in sexual barter at one and the same time. My own interpretation of the meaning of the frontal barmaid would support the reading of the reflected image as a sexual transaction if the principle of alterity, which I have argued pervades the picture, applies to her persona and if the concept "Virgin" is placed in its historical context in western culture. That is if the concept "Virgin" is defined by its position within the larger social construction "female sexuality," the differential concept "whore" would occupy the other pole within this domain.

Speaking of the social definition of an unmarried woman in the Christian tradition, Marina Warner has succinctly described the nature of this conceptual structure: "Together, the Virgin and the Magdalene form a diptych of Christian patriarchy's idea of woman. There is no place in the conceptual architecture of Christian society for a single woman who is neither a virgin nor a whore."[30] This opposition, of course, was not restricted to those calling themselves Christians. One famous pagan recitation of the social and ontological status of women is found in Jean Jacques Rousseau's *Emile* (1762). Rousseau certainly did not originate his view of women; he only gave a pervasive cultural stereotype memorable literary form. As Susan Okin and historians of sexuality have convincingly demonstrated, Rousseau's conception of women contained at once a profound dichotomy and a conflation of categories. On one hand, he demanded that women be chaste and asexual beings, as a check on unlimited male desire; on the other, to satisfy male desire, he believed women should be seductive beings accomplished at stimu-

lating the desire for pleasure.[31] A consequence of his binary categorization of women was the development of the so-called "double standard" regarding the behavior permitted to bourgeois men and women. Whereas women of the middle class were generally expected to retain their sexual impulses, if one assumed that they had any, in their relations with their husbands for the sake of propriety, it was tacitly accepted that men would find satisfaction for their less respectable desires in the company of servants and prostitutes, or members of the lower class. Griselda Pollock has pinpointed the class dimension in this construct: "The bourgeois 'lady's' (a)sexuality was defined against not only the prostitute but also a sexuality imputed to working-class women in general."[32]

One interesting literary example of a writer recognizing the nature of this duality and the class values entailed in it is found in a book published in 1842 by the utopian socialist Alphonse Esquiros. Entitled *Les Vierges sages,* this book was part of a trilogy of books (the other two are entitled *Les Vierges folles* and *Les Vierges martyrs*) inspired by his conversations with a feminist school teacher on the condition of women and the problem of prostitution. Esquiros put forth the idea that society had constructed a concept of femininity that placed the Virgin Mary and the prostitute at its two defining poles.[33] In the future classless society, according to the author, the characteristics of these two types would be fused into a radiant whole.

Another social construction enriching the semantic field in which Manet's image was inscribed is a fallen woman very prominent on the Parisian social scene: the "Lorette." This term was commonly employed to designate a group of women of indeterminate social class who were partly respectable, frequented stylish places of bourgeois leisure, yet having no financial resources, supported themselves through casual prostitution. Fashionably dressed and conspicuously part of the Parisian bohemia, these women were a recurrent element in the social discourse of the time and are frequently depicted in both literature and caricature. Gavarni's series of satirical prints devoted to them is probably their best known visual representation. Their lives were discussed in detail in Emile de Labédollière's *physiologie* of Paris published in 1860 and illustrated by Gustave Doré.[34] The sobriquet designating these women of easy virtue derives from the quarter in Paris where they were most in evidence: the environs of the new church of Notre-Dame-de-Lorette. This richly decorated church, which was inaugurated in 1836, is dedicated to the Virgin of Loreto, the center of whose cult is the House of the

Virgin in Loreto, Italy. Thus, there was an intentional irony in the popular designation for this type of individual, one that summoned up in one figure two antithetical conceptions of women. While both *lorettes* of the rue de Breda and *serveuses* of café concert engaged in prostitution of sorts, there was a significant difference between them. According to de Labédollière the former were notoriously indolent and refused to work at any occupation. Therefore, my claim is not that Manet's fatigued barmaid is a *lorette,* but that she *functions* like the popular rhetorical figure of the *lorette,* conjoining opposites, or combining Virgin and whore, the sacred and the profane. Placed under the trope of irony, Manet's barmaid is a visual equivalent, if not a literal representation, of a *lorette.*

Baudelaire, in his previously cited essay on Guys, makes a categorical distinction between women and prostitutes or fallen women, representations of the latter group being a speciality of the artist. In the section where he discusses the polarity of the fugitive and the immutable, he equates the latter with Eve before the fall, or her state of virginity before eating the forbidden fruit: "This transitory, fugitive element, whose metamorphoses are so rapid, must on no account be despised or dispensed with. By neglecting it you cannot fail to tumble into the abyss of an abstract and indeterminate beauty, like that of the first woman before the fall of man."[35] In his typological pairing Baudelaire may have had in mind the Christian tradition in which Mary the sinless Virgin is prefigured by Eve before the fall or is considered the second Eve, whose virtues effaced the original sin of her predecessor.[36] At issue in the juxtaposition of Eve and the Virgin in Christian thought is the problem of lust. According to Christian belief, sexual desire and knowledge arose when Adam and Eve partook of the forbidden fruit. Before that event they did not engage in sexual intercourse, but after it they initiated the sin of concupiscence. The antitype of concupiscence is sexual purity, a holy state of physical intactness that is symbolized by the Virgin. Thus, when Baudelaire talks about prostitutes it is clear that they exemplify at one and the same time both concupiscence and the fugitive aspects of reality, which in his belief system were also primary signs for "modernity." This is to say that his categories of woman before and after the fall or the perennial categories of Virgin and prostitute have cognates in the elemental philosophical categories of "being" and "becoming," in two fundamental modes of pictorial representation and most importantly in the concepts of "modernity" and "tradition," which were of paramount importance in his mental universe.

While T. J. Clark does not cite this passage in Baudelaire's work in his discussion of Manet's *Olympia*, he does adduce examples from a wide variety of sources demonstrating convincingly that Baudelaire was far from being eccentric in his view of prostitutes as either symptoms of or metaphors for "modernity." He summarizes his reading of this discourse concisely: "She seemed the necessary and concentrated form of Woman, of Desire, of Modernity (the capital letters came thick and fast)."[37] More recently Hollis Clayson in her study of the image of prostitution during the period has concluded similarly that for avant-garde artists of the period prostitution was "an emblem of modernity."[38] Therefore, it seems reasonably certain that in the discursive field inhabited by Manet's picture there was a close relationship between the female antitype of the Virgin and the emerging concept of "modernity."

To give visual clarity to the universe of discourse circumscribing *A Bar at the Folies-Bergère*, one might construct a map of a system of fundamental oppositions and interrelationships. This map would include both categories of social discourse and of pictorial language and assign a privileged place to the dichotomy Tradition/Modernity.

TRADITION

Virgin	Purity
Symbol	Being
Symmetry	Sacred
Frontality	Timelessness
Surface	Authority

Concupiscence	Whore
Becoming	Narrative
Profane	Asymmetry
Time	Obliqueness
Individualism	Depth

MODERNITY

157

One diagonal line, running from upper left to lower right (and visa versa), represents formal, pictorial qualities, or the line of opposition between opposed visual signifiers. The other diagonal links and sets in opposition the axiological implications inherent in these visual properties. Bisecting this map, the broken horizontal line demarcates the boundary between the concepts "tradition" and "modernity." The vertical lines that connect and set in opposition qualities on either side of the horizontal division are meant to emphasize that "modernity" is a relative concept, which only gains meaning from alterity, or through its differential relation with "tradition." It should be noted that this privileging of "Modernity" and "Tradition" as terms subsuming the others on either side of the horizontal axis is somewhat arbitrary in that terms, such as "Virgin" or "Whore" or "Authority" and "Individualism" might exchange places with them. The important thing is that regardless of which term is assigned the status as the privileged heading, the system of fundamental oppositions would remain.

Having mapped the field of meaning in which Manet's painting was situated, I should insist that it would be remarkably farfetched to believe that Manet himself ever consciously drew up or imagined such a schema as a "program" for his painting, or that there could be an isomorphism between my tightly controlled, linear exegesis of his work and the actual creative process as it unfolded during its execution. My strongest claims regarding Manet's share in the production of meaning for his work are that he willfully appropriated the iconograpy of the Immaculate Conception and placed it in an ambience where he knew prostitution of one type or another was commonplace, and thereby inscribed in his picture a *lorette* or the trope of irony consisting of two opposed, yet interrelated conceptions of women which had broad cultural resonance and rich associations. By the act of exhibiting his painting, he inserted this dualistic image and the trope it embodies into a structured discursive field. Whether or not the extent and complexity of this field was ever present in his mind in more than a fragmentary and disjointed way at any point in the creative process is both unknowable and irrelevant to the interpretation of his picture. After it entered the cultural arena, this discursive field gave it meaning.

Finally, since I have placed the picture within a clearly structured field of oppositions, I should stress that this does not preclude the possibility that there were unstructured ways of interpreting the

terms in these polarities or that the beholder was restricted from engaging them in a free-form play of signifiers in a Derridean fashion. This is to say that the historical existence of this structure did not preclude the individual viewer from acting in accord with Derrida's idea of undecidability and refusing to play according to the rules. I should also acknowledge the possibility that Manet himself may not have considered his two figures as being apposite and that his own understanding of his image may have conflated the logic of oppositions. To make this clearer, I should cite another work by Derrida that may be relevant to the painting. This is his *Dissemination* (1972), a book in which he treats for many pages a central metaphor in the poetry of Stéphane Mallarmé, the closest friend of Manet at the time of *Bar at the Folies-Bergère* and a champion of his painting. This leitmotif in both the writing of Mallarmé and Derrida is "hymen," a term of special interest because it signifies in French and English both material evidence of virginity and sexual union. In Mallarmé's essay on Richard Wagner, published in *Revue wagnérienne* in 1885, the figures of the virgin, the hymen, penetration, fusion, and the "song spurting out of the rift" provide an erotic subtext for the discussion of music.[39] However, rather than this essay, Derrida dwells at great length on Mallarmé's short prose poem "Mimique," first published in 1886, and in particular on a passage describing the way a mime operates: " The scene illustrates but the idea, not any actual action, in a hymen (out of which flows Dream), tainted with vice yet sacred, between desire and fulfillment, perpetration and remembrance: here anticipating, there recalling, in the future, in the past, under the false appearance of a present."[40] In Derrida's reading of this passage "hymen" represents an impossible state confounding reason; at one and the same time the membrane is placed under the sign of both the sacred and the profane, establishing (con)fusion between a set of oppositions, yet remains a barrier separating the terms.

Could it be then that Manet shared the irrational desire of Mallarmé simultaneously to place his work within a matrix of oppositions and to conflate them; that he considered his canvas a hymen, at once opaque and transparent, upon which tradition and modernity are delineated and confounded? Did he wish to undermine the A/not-A or "either/or" logic of noncontradiction and unravel structural boundaries and categories? Was/were his barmaid/barmaids both a Harlot of the Immaculate Conception and/or a Virgin of the Concupiscent Confection? Fortunately, we shall never know.

NOTES

1. George Mauner, *Manet Peintre-Philosophe; A Study of the Painter's Themes* (University Park, PA, 1975), 161–62.

2. Charles Baudelaire, "l'Art philosophique" in *Curiosités esthétiques, l'Art romantique et autres oeuvres critiques,* ed. J. Crépet (Paris, 1962), 508, 511. Baudelaire's ideas regarding the relation of the textual and visual are astutely discussed by Elizabeth Abel, "Redefining the Sister Arts: Baudelaire's Response to the Art of Delacroix," in *The Language of Images,* ed. W. J. T. Mitchell (Chicago, 1989), 37–58. For a similar opinion on the confusion words and images by a conservative member of the French Academy see Charles Beulé, "Peinture Décorative," *Revue des Beaux-Arts* (1860), 134.

3. On the different approaches to binary analysis and discussion of methodological difficulties see *The Attraction of Opposites; Thought and Society in the Dualistic Mode,* ed. D. Maybury-Lewis and U. Almagor (Ann Abor, 1989), and *Right and Left; Essays on Dual Symbolic Classification,* ed. R. Needham (Chicago, 1973), xxiii–xxviii. While these books concern primarily non-western and tribal cultures, Edmond Leach in England and Mary Douglas in America are renowned for their imaginative applications of the binary method to contemporary western culture.

4. For a more detailed discussion of the different grammatical relationships entailed by different kinds of images see Meyer Schapiro, *Words and Pictures; On the Literal and the Symbolic in the Illustration of a Text* (The Hague and Paris, 1973), 38–39. One should note the similarity between Schapiro's analysis of the function of the personal and impersonal pronoun forms in visual imagery and the discussion of the same grammatical forms in speech by Emile Benveniste, "Structure des relations de personne dans le verbe," in his *Problèmes de linguistic générale,* vol. 1 (Paris, 1966), 229–250. This essay was originally published in the *Bulletin de la Société de Linguistique* in 1946.

5. See Sixten Ringbom, "Icon and Narrative: The Rise of the Dramatic Close-up in Fifteenth Century Devotional Painting," in *Acta Academiae Aboensis* 31, no. 2 (1965), 11–12.

6. Manet's two religious paintings and their relationship to the modalities "hieraticism" and "naturalism" are discussed at much greater length in my book, *Representing Belief; Religion, Art, and Society in Nineteenth-Century France* (University Park, PA, 1991), passim.

7. The relation between pictorial composition and differing concepts of time is adroitly analyzed by Yves Bonnefoy, "Time and the Timeless in Quattrocento Painting," in *Calligram; Essays in New Art History from France,* ed. N. Bryson (Cambridge, 1988), 8–26.

8. On the discourse of progress in France at this period as it relates to pictorial naturalism see Driskel (as in n. 6), 165–75.

9. Eugène Véron, *Du Progrès intellectuel dans l'humanité; supériorité des arts modernes sur les arts anciens* (Paris, 1862), 484.

10. "Le peintre de la vie moderne," in H. Lemaitre, *Curiositiés esthétiques et autres oeuvres critiques de Baudelaire* (Paris, 1962), 467.

11. Abbé Augustin-Jean Hurel, *L'art religieux contemporain* (Paris, 1868), 353.

12. On the relationship between the two men see Adolphe Tabarant, "Manet, peintre religieux," *Bulletin de la vie artistique* (15 June 1923), 247–50.

13. Pierre-Jean Prudhon, *Du principe de l'art et de sa destination sociale*, in P. J. Prudhon, *Oeuvres complètes*, vol. 15 (Paris, 1939), 127.

14. Théophile Thoré, "La Vierge à l'eucharistie," *Revue indépendante* 3 (1842), 798.

15. On the painting see Jean-Pierre Cuzin, *Raphael et l'art français*, exh. cat. (Paris, 1984), 112, no. 91.

16. Sara Lichtenstein, *Delacroix and Raphael* (New York, 1979), 97–99.

17. Harry Rand, *Manet's Contemplation at the Gare Saint-Lazare* (Berkeley, 1987), 41–45. The discussion of the theme is muddled because the figures and the captions are incorrectly labeled.

18. On the theology of Liguori and the place of the Virgin in it see C. Dillenschneider, *La mariologie de S. Alphonse de Liguori, son influence sur le renouveau des doctrines mariales et de la piété catholique après la tourmente du protestantime et du jansénisme* (Freiberg, 1931).

19. See Claude Savart, "Pour une sociologie de la ferveur religieuse: L'Archiconfrérie de Notre-Dame-des-Victoires," *Revue d'histoire ecclésiastique* 59, nos. 3–4 (1964), 837.

20. The mass displays of religious fervor in the Third Republic and their political implications are discussed at length by Thomas Kselman, *Miracles and Prophecies in Nineteenth-Century France* (New Brunswick, N.J., 1983).

21. These articles on religious chicanery appeared in *La Cloche* on 6 June, 16 July, and 29 September 1872. They were thus written almost twenty years before he made his first investigatory excursion to Lourdes to gather material for his novel by that name published in 1894.

22. Thomas Gousset, *La croyance générale et constante touchant l'immaculé conception de la bienheureuse Vierge Marie* (Paris, 1855). The introduction contains a passionate argument for the idea of papal infallibility. The Immaculate Conception and its social implications are discussed by Marina Warner, *Alone of All her Sex; The Myth and the Cult of the Virgin Mary* (New York, 1976), 236–254, and Barbara Corrado Pope, "Immaculate and Powerful: The Marian Revival in the Nineteenth Century," in *Immaculate and Powerful; The Female in Sacred Image and Social Reality*, ed. C. Atkinson, C. Buchanan, and M. Miles (Boston, 1985), 173–96.

23. In response to this representational issue, the Archbishop of Mechelen in Belgium published a treatise on the question in 1855 and commissioned an enormous window for the cathedral of the town with his notion of the proper iconography. See Cardinal T. Sterckx, *Courte dissertation sur la manière de représenter par la peinture le mystère de l'Immaculé Conception de la très-sainte Vierge Marie* (Mechelen, 1855). In response the Archbishop of Bruges wrote a long treatise in 1856 concerning the iconography of the Immaculate Conception that disagreed completely with the other cleric's ideas. And in turn Charles Cahier, a member of the Jesuit order and the leading Catholic archaeologist in France, published his own ideas on the matter the same year that disagreed with the prescriptions of both. For summaries of their different views see two articles by the painter Claudius Lavergne in *L'Univers,* 6 September and 7 November 1856.

24. See Père Aladel, *The Miraculous Medal,* trans. "P. S." (Baltimore, 1880) for detailed discussion of the events surrounding this miracle.

25. Athanase Coquerel fils, *Des Beaux-arts en Italie au point de vue religieux* (Paris, 1857), 277.

26. On Laurens' anticlericalism and combat with the Church see my "To Be of One's Own Time: Modernization, Secularism and the Art of Two Embattled Academicians," *Arts Magazine* 61, no. 4 (1986), 80–89.

27. Léo Taxil (alias for Jogand-Pagès), *Calotte et Calotins,* vol. 2 (Paris, 1879), 141. This and the other illustrations in the work were by Frid'rick, the prolific anticlerical caricaturist, who illustrated many of Taxil's scurrilous works. That this image is intended as a parody of iconography of the Immaculate Conception is clear when one views the caricature of the statue of the Virgin in the Grotto at Lourdes on p. 125 of the book.

28. T. J. Clark, "The Bar at the Folies Bergère" in *Popular Culture in France* (Sarasota, CA., 1977), 233–252. On the forms of prostitution associated with these places of popular entertainment see Theresa Ann Gronberg, "Femmes de Brasserie," *Art History* 7, no. 3 (1984), 329–44.

29. Françoise Cachin, *Manet, 1832–1883,* exh. cat. (Paris, 1983), 478–79.

30. Warner (as in note 22), 235.

31. Susan Moller Okin, *Women in Western Political Thought* (Princeton, 1979), 99–102.

32. Griselda Pollock, *Vision and Difference* (London, 1988), 113. The essay was originally published by Pollock and D. Cherry, "Woman as Sign in Pre-Raphaelite Literature; A Study of the Representation of Elisabeth Siddall," *Art History* (June 1984).

33. See Jacques Van der Linden, *Alphonse Esquiros; De la bohème romantique à la république sociale* (Paris, 1948), 183.

34. Emile de Labédollière, *Le Nouveau Paris: Histoire de ses vingt arrondissements en 1860* (Paris, 1860), 140–41.

35. Baudelaire (as in note 10), 467.

36. The obscure textual origins of this topology are discussed by Geoffrey Ashe, *The Virgin* (London, 1976), 124–27.

37. T. J. Clark, *The Painting of Modern Life: Paris in the Art of Manet and His Followers* (New York, 1985), 110.

38. Hollis Clayson, *Painted Love: Prostitution in French Art of the Impressionist Era* (New Haven, 1991), 152.

39. Stéphane Mallarmé, "Richard Wagner, réverie d'un Poête français," *Revue wagnérienne* 1 (1885), 195–200.

40. Jacques Derrida, *Dissemination*, trans. and ed. B. Johnson (Chicago, 1981), 175.

Looking into the Abyss: The Poetics of Manet's
A Bar at the Folies-Bergère

JACK FLAM

Mᴀɴᴇᴛ's *A Bar at the Folies-Bergère* is so finely nuanced and fraught with ambiguity that it virtually demands a diversity of interpretations. In fact, the very notion of finding the "right" interpretation of the painting—or even of there being a single right interpretation— verges on the absurd. But while we cannot solve all the mysteries evoked by such a work, or even resolve its most apparent contradictions, we can illuminate them by probing those aspects of the picture that we feel to be most important. That is, we can distinguish between what we might call stronger and weaker readings of it. And taken together, various strong readings can give us a fuller picture of what we are looking at.[1]

In this essay I will focus on certain aspects of what might be called the poetics of the *Bar at the Folies-Bergère:* its suggestive ambiguities, its strikingly original use of traditional iconographical elements, and the provocative way in which this picture redefines certain aspects of realist painting.

Wʜᴀᴛ Wᴇ Sᴇᴇ

A Bar at the Folies-Bergère is, among other things, an extended meditation on a number of dualities. One of the most striking aspects of the picture is the centrality of the barmaid and the way that she seems to define or mediate everything else depicted. She stands exactly in the center of the painting in a nearly symmetrical pose. Her gaze is distant, melancholy, absent; although she is firmly rooted in her surroundings she also seems detached from them, as if she is focused on something in her mind rather than in the world before her eyes.

164

The marble-topped bar that she leans on supports a provocative array of objects. The champagne and the beer seem to make a wry reference to the broad spectrum of social classes, tastes, and even nationalities of the Folies' clientele. But the combination of objects is also puzzling. Why are so *many* champagne bottles set out like this where they will lose their chill? And why the bowl of mandarin oranges—so unexpected in such a place?[2] Don't the two roses in the stemmed glass call a bit too much attention to themselves as a warm "personal touch" on this public bar? And why is the glass with the roses seen from a different angle than the other objects on the bar—in profile and more flattened out?

What we see on the bar, however, represented as "real," is only the beginning of what eventually becomes a dizzying array of disparities between what is seen inside and outside the mirror, and these are emblematically reinforced by the way the insistent perspective of the left edge of the bar thrusts our eye into the mirror, while outside the mirror the bar suggests an indefinite lateral extension. The mirror does not reflect exactly *any* of the real things we see before it and sometimes reverses our expectations. The reflections of *all* the bottles on the left side of the bar, for example, are depicted on its wrong edge. (On the bar, the bottles are at the edge closest to the barmaid, while in the mirror they are near the edge farthest away from her.)

The whole world in the mirror seems to exist in another kind of space. At the lower left, for example, we see reflected the ground floor of the Folies, complete with columns, walls, and people. But amazingly, there is nothing between the edge of the bar and the precipitous drop down to the ground floor below—no balcony rail (such as we see across the way), no space to stand or walk. While in the actual Folies-Bergère, there would have been a good deal of space in front of such a bar—enough room for a promenade and a row or two of tables—in the painting it seems as if the marble bar top is suspended at the edge of an abyss. And if this is so, then where are *we* supposed to be standing?

Our own supposed distance from the bar is relatively easy to determine. Judging by the 45 degree angle at which its left edge is reflected, and from the curves of the bottoms of the bottles, we would estimate our position to be directly in front of the woman and about two meters away from her. This is borne out by our view of the woman herself; we appear to see her full front and from a slight distance. But since there appears to be virtually no floor space in front

of the bar, in order to see the woman and bar as we do we would have to be hovering in thin air.[3]

Once we have adjusted to these flagrantly incongruous elements, the fact that the reflection of the balcony across the way appears to be too close—as if we were looking into a magnifying mirror—has its own peculiar logic. For once we enter the world of this magic mirror, its lower limits indicated by a gilt frame and its surface insisted upon by irregular scumbles of blue-grey paint, we are obviously required to suspend our disbelief.

The far balcony is a curious mixture of precise details and general impressions. It, too, is full of mirrors, which seem to evoke an infinity of reflections, as suggested by the flickering images of globed lanterns and crystal chandeliers. Two of the women on the far balcony seem to be watching the stage show—which includes a trapeze artist whose calves and green slippers hover incongruously at the upper left. This, we now realize, may be an indirect reference to the incongruousness of our own position, for we too are hovering in mid-air. But even more important, the trapeze seems to be in motion, thus introducing a striking image of instantaneity that contrasts sharply with the stillness of the barmaid (and with the rigid frontality of the trapeze artist's legs). Another woman across the way seems to be fanning herself, while still another looks out across the chasm that separates that balcony from our own. But the most unsettling person across the way is the mustachioed man in the top hat, seated in the front row of the balcony at the picture's far left. He and the top-hatted man standing next to the barmaid look remarkably alike. And he seems to be looking directly at us; or, more to the point, directly at the barmaid.

His gaze brings us back to our own contemplation of the barmaid. We notice that her hair falls over her forehead in low bangs and we have the impression that at the back of her head it is pulled back and up, perhaps in a compact bun or small ponytail. Around her neck she wears what appears to be a cameo suspended from a black ribbon. We can almost make out what is represented on the cameo, a miniature picture within the picture, but it remains indecipherable. In a curious way, it becomes a kind of sign for the questionable legibility of other things in the painting.

Her bodice is cut low, bordered with lace and decorated with flowers which are rendered so impressionistically that it is difficult to say what they are: perhaps peonies or small roses. Just below this

corsage a row of buttons leads our eye down the center of her close-fitting jacket, which is parted at the bottom to reveal a gray triangle bisected by the broken line of what appears to be a seam. And here a most unsettling thing happens. We realize that this triangular area very much resembles a pudendum—a reading that is reinforced by the insistent vertical of the seam. A kind of pudency almost blocks out this perception, but it is so obviously suggested, underlined as it were by a bold horizontal brushstroke, that it is difficult to ignore.[4] This triangular shape is given emphasis by the way it rhymes with a number of others, including the large triangular shape of the woman herself.

The woman's body is a crucial transitional point in the rightward warp of the image in the mirror, and by extension of the whole picture space. For on the right side of the painting the willful distortions of the mirror become even more pronounced. As our gaze moves toward her from the left, we are aware of a gradually increasing reflective distortion toward the right. At her body, this warping effect becomes intensified, and in the right side of the picture the intensity of the distortions increases radically. The spatial incongruity of the glass of roses gives emphasis to this transitional passage; its flatness modulates the tangibility of the woman and prepares us for the spatial shift that occurs just to the right of her.

It is here, of course, that we find the most striking incongruity in the picture: the contrast between the image of the woman standing behind the bar and her reflection in the mirror, in which she is seen addressing a man. If the woman we face is erect, austere, and remote—an elaborately decorated object of desire, at once very much present but also disengaged—the woman whose back we see in the mirror seems to lean forward and she appears warmer, gentler, eager to please. She not only behaves differently, she actually *looks* different. She is plumper, her hair falls in unexpectedly casual wisps, she wears no earring, and her jacket appears undecorated and severe. And of course, even more obviously than with the bottles, her reflection is in the wrong place. It is at this point that we become aware of just how much the mirror reflection has been warping to the right, how intense the pressure of separation between the worlds outside and inside the mirror has been. Throughout the mirror image, the brushstrokes are choppier and things are more impressionistically rendered and more evanescent; but here this becomes especially exaggerated. The scumbling becomes most highly inflec-

ted here, and the smudges of gray seem to act as a painterly commentary on the human encounter and to emphasize that the mirror image is indeed part of another world. Thus when we confront the man who stands before the woman in the mirror, his presence is jarring but not entirely unexpected. We only wonder, where on earth is he standing after all? Our first impulse is to seek some simple physical explanation for this weird disparity. Surely, the mirror must be curved, or set at an angle to the picture plane. But it is at precisely this point that the picture becomes even more insistent on the impossibility of our denying the impossible.

For it is at this point that the picture insists most strongly on the position of the mirror being parallel to its own surface plane, by the assertive presence of the mirror's gilt frame just below the reflected confrontation. Although the frame here is slightly lower than it is on the left side of the painting, it is still clearly parallel to the edge of the bar and to the picture plane. Try as we may, there is no way for us to deny what is clearly meant to be undeniable.

STRUCTURE AND ICONOGRAPHY

In Stop's cartoon satirizing *A Bar at the Folies-Bergère* (fig. 8), the cartoonist has automatically, and without mentioning it in the caption, repaired the fracturing of continuous space in the picture by placing a group of bottles on the bar to cover the mirror's frame. If Manet had also done this, he would have encouraged (or at least permitted) the argument that perhaps the right side of the mirror is not parallel to the picture plane, and it would be much less clear that the image in the mirror represents a physical impossibility.[5] Instead, Manet went out of his way to insist upon an ambiguous and contradictory reading of the image in the mirror.

The *Bar* offers the most striking instance in Manet's art of the primacy of mental vision over actual sight. The spatial ambiguity in the construction of the painting is more extreme than anything in Manet's earlier painting; more extreme, for example, than that in the *Execution of Maximilian,* or in *The Railroad,* both marked by a severe compression and contraction of space. Although the spatial ambiguities in those paintings enhance the "modernity" of their realism, the spatial contradiction in the *Bar* calls into question the very notion of realism.

In fact, one of the most striking aspects of the *Bar* is the way in which it embodies the transformation of Manet's attitude toward realism, which began to change drastically after around 1870. In most of his major paintings of the 1860s, Manet had found a way to go beyond representing merely the surface of everyday life by filling his pictures with allusions to earlier art, as in the *Dejeuner sur l'herbe* and *Olympia*. After around 1870, these obvious allusions virtually disappear from Manet's art. This shift in his ongoing dialogue with the history of painting coincided with his growing friendship with Monet, and is usually called Manet's "Impressionist" phase. But something else may actually be involved here. Granted, especially after his experiences at Argenteuil with Monet and Renoir during the summer of 1874, Manet's work underwent a marked stylistic change. To attribute these changes merely to "Impressionism" as an abstract force, however, is to assume something like a disavowal of his earlier work and to underestimate the degree to which so much of Manet's enterprise had been involved with reconciling the realism associated with everyday life—*il faut être de son temps*—with a desire to create imaginative pictures that had a deeper significance.

On the evidence of his paintings, Manet's attitude toward realism seems to have been quite similar to Baudelaire's. In his "Salon of 1859," Baudelaire had discussed imagination as the primary faculty of the artist, which combined "both analysis and synthesis" and allowed him to rise above the mere imitation of nature. Moreover, as Margaret Gilmore has noted, Baudelaire conceived of imagination as the spiritual faculty that supplied the artist with the means for perceiving correspondences, the "power of crossing the bridge from the visible world to the invisible," and of "not only seeing, but of seeing meanings."[6] The imaginative use of the mirror is one of several aspects of *A Bar at the Folies-Bergère* in which a bridge is created between imagination and reality—in which the visible world is explored in a realistic way, but without being limited merely to surface realism.

As we have seen, the essence of the *Bar* develops around a series of related polarities. One of the most crucial is that between the center and the margins, which is echoed in the polarity between foreground and background, real and reflected. Whereas in most of Manet's paintings of cabaret scenes and public life during the 1870s the compositions tend to be asymmetrical and frequently employ open centers, in the *Bar* the woman occupies the exact center of the painting and is conceived as a nearly symmetrical, triangular form. It is hard

to imagine a compositional motif that is more hieratic or that could supply a greater sense of stability. Around her, however, everything is in flux. She is surrounded by glitter and reflections and she herself is the only undeniably real person in the picture. Everyone else is seen only through the untrustworthy mirror.

The woman is at once separated from and intricately related to her immediate environment, with which her body is engaged in an elaborate network of visual rhymes and echoes. Principal among these is the audacious way that her torso in its tight-fitting jacket rhymes with the champagne bottles on the counter next to her, and the way the flowers on her bosom echo those on the bar. She is, among other things, an object of desire among other objects of desire, a commodity among other commodities. But it seems to me that to deduce from this that she is merely, or even clearly, a prostitute—as has been insisted upon in recent writings about the painting—is to ignore the extraordinary, and systematic, complexity of the painting as a whole.[7] The world of the picture is full of disjunctions. And among them is this one: that if the woman is a sign of desire, desire itself is fractured and ambiguous.

This sort of ambiguity toward women, and toward desire itself, runs throughout Manet's paintings and is present also in the writings of Baudelaire. In "The Painter of Modern Life," Baudelaire speaks of Woman in terms remarkably appropriate to the image of the woman represented in the *Bar:*

> Rather she is a divinity, a star, which presides at all the conceptions of the brain of man; a glittering conglomeration of all the graces of Nature, condensed into a single being; the object of the keenest admiration and curiosity that the picture of life can offer its contemplator. She is a kind of idol, stupid perhaps, but dazzling and bewitching, who holds wills and destinies suspended on her glance. . . . Everything that adorns woman, everything that serves to show off her beauty, is part of herself; and those artists who have made a particular study of this enigmatic being dote no less on all the details of the *mundus muliebris* than on Woman herself.[8]

The bridge between the visible and the invisible is one that the art of painting cannot easily cross, and it is one that Manet seems to have contemplated a good deal during the final years of his life, along with the contradictory nature of human behavior. Antonin Proust tells us how one day during those last years, when he and Manet were

170

walking in Meudon, they met a young girl who was selling flowers. Manet asked her about her parents and she told them that her family was very poor but that on some days she was able to add two francs to the family income. The two men gave her six francs and she went away happy. Manet was moved by the girl, and as he and Proust walked along he said that if his health were better he would have gone home to get his paint box. What most struck him about her was what he called "this contrast between the gaucheness of a child and the aplomb of a young woman."[9] The contradictory and mysterious reflection of the woman in the mirror, which allows us to see reality in more than one way at the same time, presents the same kind of contradiction that Manet had noted in the young flower girl.

Although this kind of multiple point of view has been described as anticipating the supposed multiple viewpoints of Cubism,[10] it seems that something very different is involved here. What we seem to be offered instead is the sort of psychological view of a person that is commonly given in literature but generally almost impossible to give in painting: that is, we are shown two different realities at the same time. The mirror quite literally forms a bridge between the visible and the imaginary, inscribing on its surface both an image of the real world and a representation of reverie. This discrepancy makes us sharply aware of a difference between inner and outer perceptions of things—a task nearly impossible in traditional painting. A kind of interior monologue develops as we become intensely aware of the interaction between these two different psychological realities. It has been suggested that at least some of what we see in the mirror can be taken to be a visualization of what the woman is actually thinking. Although this may be too literal a statement when baldly stated this way, it should not be dismissed out of hand, since the image in the mirror is surely to be taken as a mental construction as well as the depiction of a physical reality.[11]

In fact, the use of multiple viewpoint in the *Bar* is strikingly similar to Edouard Dujardin's development of what he called *monologue intérieur,* in his novel *Les lauriers sont coupés,* published in 1887, just a few years after the *Bar* was painted. In the same way that Dujardin's interior monologue (which directly inspired Joyce's "stream of consciousness") made it possible for the reader to perceive experience both from the inside and the outside of his characters, so Manet in the *Bar* allows us a similar double vision through the medium of the magical mirror. Leon Edel has remarked that in "the novel of subjec-

tivity," which was pioneered by Dujardin, "we become observer and actor at the same time."[12] In the same way that Dujardin stresses the "unheard and unspoken speech by which a character expresses his inmost thoughts," and the way those "inmost thoughts" are recorded "without regard to logical organization,"[13] so Manet probes the interiority of the woman through a multiplication of narrative surfaces. Valerie Larbaud's description of the motivation for Dujardin's innovation could also describe what Manet was doing in the *Bar*—and what, in very different ways, he had done in so many of his other paintings: "He wanted to express something that had not been expressed before him; and it is this that led him to the discovery, to the creation of this form."[14]

As Stephen Kern has pointed out, Dujardin's development of *monologue intérieur* was indicative of radically changing ideas about time and happening during the 1880s, and symptomatic of abrupt shifts in chronological sequence and narrative viewpoint in writing of the period.[15] In many ways Manet's painting, like Dujardin's book, expresses "the inner workings of the mind with its brief span of attention, its mixture of thought and perception, and its unpredictable jumps in space and time."[16] If part of the modernity of Manet's earlier paintings was expressed in their discordant spatial shifts, sense of alienation, and paralyzed narratives, in the *Bar* he explores the possibilities of multiple narratives and multiple levels of consciousness, and connects the manipulation of space to that of time.

Our sense of actual space and time are particularly called into question by the presence of the man in the top hat. For while the other illogical parts of the painting might be characterized as compositional distortions, his very presence is an overt and blatant physical impossibility and fairly begs us to interpret him symbolically.

One aspect of the *Bar* that seems to have been given surprisingly little serious attention is the way that it draws upon a number of fairly traditional iconographical points of reference. The combination of the mirror reflection, the young woman, the flowers, and the worldliness of the place and of the objects within it are standard features of the iconography of *vanitas* paintings, or remembrances of mortality. Even the kind of flowers represented is significant: roses were considered "a symbol of love and beauty, an image of the transience of beauty, and an emblem of Venus."[17]

Within this context, it is interesting to see the man in the top hat as

playing some of the same eerie role that figures of Death do in *danse macabre* imagery and in representations of the theme of Death and the Maiden, further reinforcing the *vanitas* symbolism.[18] This is a theme that was dealt with in poetry and music by a number of Manet's contemporaries. Saint-Saëns' *Danse Macabre* was published in 1874, and Moussorgsky's *Songs and Dances of Death* dates to 1875–1877. The theme had also been treated by Baudelaire, by Sully-Prudhomme, and by Théophile Gautier. And Manet, moreover, presumably would have been familiar with numerous Renaissance depictions of the theme. The mysterious, eerie quality of the figure of the man, whose features have been described as "almost waxen in their rigidity,"[19] is emphasized by the fact that he quite literally appears to be a kind of phantasm without a clear corporeal reality. My point here is not that this man must unequivocally be read as a literal personification of Death, but rather that Manet strongly suggests the possibility of such a reading, thus adding an allegorical overtone to what at first appears to be a scene from everyday life. And within the generally naturalistic framework of the painting, he pushes this suggestion as far as he can without crossing the line into overt fantasy.

The *Bar* not only contains certain traditional aspects of *vanitas* imagery, such as the mirror, the young woman, the flowers, and the fruit, but the very nature of the place that is represented—the music hall with its atmosphere of manufactured gaiety—reinforces the subject of the vanity of worldliness, of material possessions, and of sensuality. Moreover, the picture is painted with a tremulous, suggestive brushstroke that emphasizes the fleeting nature of the worldliness that we see reflected in the mirror.

If in this painting Manet pushes the art of painting to a limit, he also pushes the capacities of the viewer to a limit, perhaps beyond the limits that we ordinarily are willing to tolerate in a naturalistic painting. In giving us more than one view of that which is present, the artist evokes other, absent meanings. *A Bar at the Folies-Bergère* gives to everyday life a resonance that transcends the quotidian. In this way, Manet was able to remain within the general framework of realist painting without having to accept its more mundane limitations. In the *Bar at the Folies-Bergère,* he transcends the limits of naturalism by deconstructing naturalistic space from within its own conventions and in a sense deconstructing realism itself.

JACK FLAM

ART AND ARTIFACT

In recent years *A Bar at the Folies-Bergère* has been written about in a mode of social art history that is especially favored by American and British art historians. To a much greater degree than is generally acknowledged, they have imposed their own specific local circumstances upon the interpretation of this and other paintings of the period, especially with regard to concerns about class and in their somewhat puritanical attitude toward relations between the sexes in late nineteenth-century Paris.

In particular, the study of prostitution in nineteenth-century French art has been extended to representations of working women who are suspected (by the writers) of having been engaged in a possible "dual role" of working woman and amateur prostitute.[20] Particular attention has been given to the possible dual role played by the barmaid in *A Bar at the Folies-Bergère,* and in some quarters it is accepted as a matter of fact that she was understood to be a clandestine prostitute in 1882 and must still remain one. This case was most notably made by T. J. Clark, who showed how certain discussions of the painting when it was shown at the Salon of 1882 seemed to refer to her sexual availability. Although Clark was surely correct in his assumption that this was *one* of the ways in which the woman in the painting was seen in 1882, he tended to overemphasize this aspect. His citation of Ernest Chesneau's remark in 1882 that "it is not possible to be more of a *fille* than this creature the artist has installed . . . behind the marble,"[21] for example, highlights what we might call the "illustrational content" of the picture. But this was virtually the only sentence in Chesnau's review that discussed the subject matter per se; most of Chesnau's text was about the painterly values that he considered to be the most important aspect of the painting. A similar caution might be advised when reading Paul Eudel's 1884 description of the picture. Eudel described the woman as follows: "A bar maid, with a hairstyle à la chienne, surrounded by flagons of champagne, with a mirror behind her, in which is reflected a gentleman at whom she is making eyes. Is it a success? Is it a setback?"[22] Aside from the fact that it is difficult to construe the woman as "making eyes," the question of success and setback can surely be set within contexts of flirtation other than prostitution.

So far as I know, the first unequivocal statement that the woman is

174

actually engaged in prostitution appears in a 1944 text by an English writer, Raymond Mortimer. He describes the woman as a "sulky, life-size creature in her vulgar bodice" and asks "what motive could there be for such a wallowing in ugliness? And then the libertine in the tall hat—prostitution was a social necessity."[23] Mortimer goes on to describe the barmaid as "tired and glum, while the man might be buying only a drink, were it not that a certain fixity of gaze suggests the *blasé* rake upon his habitual hunting ground."[24] (Interestingly, Mortimer considers the man to be initiating the encounter, while in 1884 Paul Eudel thought it was the woman who was "making eyes." Sexual forwardness, like beauty, seems to be in the eye of the beholder.)

More recently, Hollis Clayson has taken this discussion of the barmaid as a prostitute a step further, by asserting that the "ambiguity used to represent women working in the 'suspicious professions' perpetually calls into question the morality of the women's sexuality. A deadpan treatment of such a subject will always raise the question 'is she or isn't she?'"[25] Clayson goes on to say (inaccurately) that early critics assumed "that Manet's painting posed *explicit questions about the server's morality* [emphasis mine]" and discusses the commercial transaction at the bar as "being provided with two possible outcomes. In one, 'she does'; in the other, 'she doesn't.'"[26] Clayson concludes her treatment of the picture by saying that "the answer to the quintessentially modern question—will she or won't she?—is only of interest to a libidinous, heterosexual male interlocutor."[27] Leaving aside Clayson's spurious claims about what she calls the "normative protocols of gendered spectatorship," it seems to me that to assert that the painting's central question is "will she or won't she?" is more appropriate to the "does she or doesn't she?" milieu of an American high school than to Manet's Paris. In relation to this particular painting, Clayson's question seems trivial and reductive.[28]

Clearly one of the main subjects of the *Bar* is desire. I do not think that one can say, however, that this projection of desire necessarily privileges only one of its forms. While the possible sexual availability of the woman can be seen in relation to clandestine prostitution, this is only one of the forms that desire takes in this picture, and I believe that to insist on its primacy limits our view of the painting. The woman is presented as an object of desire, whether or not she is actually available. And in a sense she is emblematic of the world that is mirrored behind her, which is full of pleasures that are in them-

selves desirable—as are the bottles, the flowers, and the sunny mandarin oranges in the bowl before her. Aside from the fact that Manet painted the picture when he knew he was dying, I think that one has to see this painting in large measure as a projection of desire in the abstract, as a kind of longing to grasp that which is fragile and fleeting, very much present yet constantly elusive.

A painting like *A Bar at the Folies-Bergère* can, of course, be used as a form of social documentation, as an image of an actual place and ambiance, as a kind of illustration of manners and mores. At the same time, it is difficult to say what this sort of information tells us about the *Bar* as a work of art, or just how reliable the deductions drawn from an unmediated consideration of such information may be. For *A Bar at the Folies-Bergère* is primarily a fictional construction, painted in Manet's studio, the artist working from memory and from sketches made at the Folies-Bergère, as well as from the live model posed behind a marble-topped table in his studio. According to the painter Georges Jeanniot's eyewitness account, "the model, a pretty girl, was posing behind a table laden with bottles and comestibles. . . . Manet, though painting from life, was in no way copying nature; I noticed his masterly simplifications; the woman's head was being formed, but the image was not produced by the means that nature showed him. All was condensed; the tones were lighter, the colors brighter, the values closer, the shades more diverse."[29]

In fact, the degree to which Manet meant the *Bar* to be a poetic rather than a literal interpretation of its subject can be seen by comparing the painting to the small oil sketch he did during the summer of 1881 (fig. 1), before he started the final painting, which shows a rather different scene.[30] Léon Leenhoff described this picture as follows: "Sketch for the Bar at the Folies-Bergère. First idea for the picture. It is the bar on the first floor, to the right of the stage and the proscenium. Portrait of Dupray. Was painted in the summer of 1881."[31] The information on the Lochard photograph card is more specific: "Painted from sketches made at the Folies-Bergère. Henri Dupray is talking to the barmaid in the studio on the rue d'Amsterdam."[32]

The oil sketch provided the basis for the Courtauld painting in a very direct way. As is apparent from x-rays, Manet originally had transferred the basic elements of the oil sketch to the larger Courtauld canvas and used that composition as a point of departure, which he gradually modified and developed into the image that we

now see. The painstaking process of revision was made even more difficult by Manet's illness. According to a letter from Eugène Manet to Berthe Morisot, Manet reworked the canvas extensively: "He is still reworking the same picture: a woman in a café."[33]

In the oil sketch the barmaid and the man beside her are seen at a greater physical distance than in the final painting. The objects on the bar are more realistic, as is the woman's reflection in the mirror. (It ought to be noted, however, that the position of the man in relation to the woman is already somewhat problematical; his reflected image is so close to hers that he ought to be present within the real space of the painting, but he is not.) The divergences from a credibly realistic scene, however, are not nearly as exaggerated here as they are in the final painting; and because of the sketchy paint application, and because the frame of the mirror is not shown, the spatial discrepancies are not nearly as troubling.

The psychological relationship between the man and the woman is also much less equivocal in the sketch. The man regards her with an openly hungry look. The discrepancy between their heights, and between the impassivity of the woman and the man's apparent lust are quite striking. Here one could clearly make a case for the image overtly representing a potential sexual encounter. Because the large, rather blowsy woman seems so hardbitten and so indifferent to the nasty-looking little man's advances, we are intensely aware that his only possibility of possessing her would be by purchasing her favors. And because of the way Manet has represented them, it is also evident that this possibility is very much on the man's mind. But one of the main themes of the painting is that his open (and rather repellent) lasciviousness seems to be thwarted by her aloofness.

Compared to the final painting, the oil sketch seems more like a slice of life, with a more nearly narrative subject. It is much closer to the modalities of popular illustration than is the final painting. One might even say that the oil sketch shows us to a large degree the kind of everyday subject that Manet eventually *distanced* himself from in the course of reworking and revision. It is anecdotal and contains a fair measure of what might be called social realism—elements that were utterly transformed in the final painting. In a sense, it tells us a lot about what the final painting is *not*.

My emphasis on the fictive, poetical qualities of the final painting is not meant to imply that we can simply disregard either the social context in which the painting appeared or those aspects of its setting

that are relevant to our interpretation of the image *as a painting*. The question remains as to how we can judge the degree of mediation involved. What are some of the things that it might be useful for us to know in order to reintegrate the painting into its social context?

There has been a good deal of discussion, for example, about just where within the actual Folies-Bergère this painting is supposed to be set. It now seems fairly certain that the setting evokes a bar on the first floor balcony of the Folies, although Manet largely reinvented the place in his picture.[34] As will be seen below, knowing where in the Folies-Bergère the *Bar* was set does help enhance our sense of the picture (although I am not sure that, conversely, the image of the Folies presented in the painting much enhances what we know about the Folies-Bergère).

A good deal of attention has also been given to the people who posed for the characters in the painting. The model for the barmaid has been identified as a woman named "Suzon" who actually worked in such a job at the Folies.[35] Other than her given name, though, virtually nothing is known about her—apparently not even her family name. Moreover, as she is represented in this painting, she has quite clearly been transformed into a kind of fictional character. This is especially evident when one compares the way she is depicted in a pastel portrait that Manet did of her around the same time that he painted the *Bar* (fig. 23), in which she bears strikingly little resemblance to the woman represented in the *Bar*.

Despite the fact that in the *Bar* the model has been transformed into a personage who is more like an invented character in a novel than a particular real person, most of the recent American literature on the painting refers to her as "Suzon," as if the model and the character within the painting are one and the same. (One is tempted to speculate that the familiarity implied in calling the woman by her first name is also quite typical of late twentieth-century America, where sales clerks, bank tellers, and waiters feel quite comfortable about calling perfect strangers by their first names.)

In fact, I think that referring to the woman in the painting as Suzon, which seems at first to be a scholarly use of historical information, falsifies the nature of the painting by trivializing the image of the woman depicted and by confusing the personage in the painting with the woman who modeled for her. As Joel Isaacson has pointed out, there is an enormous difference between the ways popular images illustrate life and the sort of mediation offered in pictures by

artists such as Degas and Manet, in which "seriousness of purpose takes the form of a content respectful of human dignity within the compromising and precarious urban world they chose to depict."[36]

A fair amount of attention has also been given to the models for the other characters in the *Bar*.[37] We are informed that some of the characters on the distant balcony are based on real portraits—such as that of Méry Laurent at the left, wearing yellow gloves and a round black hat, and Jeanne Demarsy, to her right, dressed in beige. The man with the moustache seen reflected in the mirror addressing the barmaid is known to have been posed for by the painter Gaston Latouche, and Latouche also appears to have posed for the man on the far left side of the balcony. This information seems potentially more interesting since, as we have seen, the resemblance between these two men is quite apparent in the painting—a matter I shall return to shortly. In any case, the assertion that "the importance of these portrait figures in the *Bar* speaks significantly to the content of this painting and to that of Manet's oeuvre in general" needs further consideration.[38] For it seems that this is not necessarily equally true of *all* the "portrait figures" in the painting. In any case, the choice of a model for a character in a painting is frequently a simple matter of convenience for an artist, and one cannot always assume that it has symbolic significance. It is not known, for example, why Manet changed models between the oil sketch for the *Bar* and the final painting.[39]

The indeterminate nature of Manet's use of particular models seems to hold true for a number of Manet's paintings of this period, in which he used friends and relatives as points of departure for painted characters that he created largely through a subtle mixture of observation and invention—somewhat like a novelist. In paintings like *Boating* or *Beside the Sea*, where we know the names of (some of) the models, it is nonetheless not easy to relate those real-life people to the specific roles of the fictional characters portrayed in the pictures. It seems to me to be as misleading to refer to Suzon by name as it would be to refer to the reflection of the man in the top hat as "Gaston"—or to refer to the woman at the bar in *At the Café* (fig. 12) as "Ellen" because she was posed for by the actress Ellen Andrée. In fact, if one were to take to its limit the practice of identifying the characters in paintings with the models who posed for them, one would have to refer to the figures in Degas' *Absinthe* as "Ellen and Marcel," since Ellen Andrée posed for that painting too, along with Marcel Desboutin.

The exact mechanisms by which an artist feels a particular person would be an especially appropriate model for a character in a painting are often difficult, if not impossible, to discern. Sometime between 1880 and 1882, around the same time that Manet painted the *Bar*, for example, he told Antonin Proust that he would like to have him pose for Christ on the cross: "It is something that I've always had an ambition to do. I would like to paint a Christ on the cross. Only you would be able to pose for it for me in the way that I understand it. While I was doing your portrait, this idea haunted me. It was an obsession. I made you into a Christ wearing a hat, with a frock-coat and a rose on your lapel. That's Christ going to the Magdalen's house. But Christ on the cross. What a symbol! One could dig around until the end of time, one wouldn't find anything like it. Minerva is fine, Venus is fine. But the heroic image, the image of love will never be worth as much as the image of suffering. It is the core of humanity. It is its poem."[40]

If Manet had gone ahead and done this painting, would we then be obliged to call his Jesus, "Antonin"?

My main point here is that in much of the literature about the *Bar*, there seems to be a certain amount of confusion between what might be called seeing the work of art as an historical artifact, and seeing it as a work of art, or poetic image. Although Manet's *Bar* draws upon the ambience of the Folies-Bergère as it actually existed in the 1880s, it is not so much a painting about Paris per se, as it is a painting about Manet's relationship to his Parisian milieu—and, by extension, about the uncertainty of human relationships and of life itself.

And this of course raises the question of what is actually happening in the painting, and the related question of whose story the painting tells.

Further Reflections

The relationships between the various elements of the painting suggest several different scenarios, all of which have a certain internal consistency, and none of which, I believe, can be privileged exclusively over the others. Like the pictorial structure of the painting, its narratives are complex, fractured, disjunctive, and self-reflexive.

The mirror in the *Bar* both reveals and distorts much of what we see. On a simple physical level, it shows us what the woman is seeing,

for the mirror that is behind her and in front of us allows us to see what else (besides ourselves) is in front of her. The mirror reflection also allows us to see what is behind us as we contemplate the painting, and locates us within a spatial continuum that makes us to some degree participants in the painted event. This is something that Manet had done in a number of his earlier works, such as *Olympia* and the *Dejeuner sur l'herbe,* in which the viewer's presence is made explicit by the outward stare of someone inside the painting. But in the *Bar,* the relationship between the woman and the spectator is much more ambiguous. She looks out toward us, but does not really engage us, nor even seem to see us. She seems in fact to look past us, or even to look *through* us, as if we were not even there. And it is this combination of our own simultaneous presence and transparency that is one of the most unsettling aspects of the whole picture.

The painting also seems to verge on telling a story, though we are not quite sure precisely what that story is. One obvious possibility is that the image in the mirror brings together what the barmaid sees and what she thinks. In this reading, the presence of the man is like the visualization of a thought in her mind, something contemplated, perhaps even desired, but not actually present.

Another reading is that it is the observer who reflects upon the duality of the woman, seeing her on the one hand as cool, aloof, and detached, and on the other as responsive, warm, and caring. This reading allows for two definitions of "the observer": either as ourselves as we stand before the painting, or as ourselves as embodied by the man in the top hat. Although these are radically different constructions of the observer, the openness and equivocal nature of the painting support and seem to invite them both. And of course, within the fictive world of the picture, it is possible to conceive of ourselves as both, just as we psychologically position ourselves differently to a written text that changes from the first to the third person in the course of its narrative.

As we have seen, the mirror reflection allows neither room for us nor for the man in the top hat, so that in a sense we are equally disembodied viewers, though in different ways: we are able to exist only outside the mirror, while he is able to exist only within it. In a sense, we are his double, placed in the position of Baudelaire's "*Hypocrite lecteur.*"

Another, rather more literal narrative reading emerges. We have noted that only a single figure on the far balcony seems to look

directly at the woman—the mustachioed man with the top hat who bears a striking resemblance to the man who addresses the barmaid. This suggests another persuasive reading: that what we see is this man's view of the woman. It is he who stares at her from the distant balcony, unseen by her, imagining himself as the object of her attention. He not only resembles the man addressing the girl, but formally rhymes with him and is in a sense his double. The compression of the picture space, what we have referred to as the magnifying effect of the mirror, lends an added force to the energy of his gaze.

Once we realize this, we must also acknowledge that someone seen in a mirror can usually be seen by the person he sees. This phenomenon underlies what I take to be one of the strongest narrative readings of the picture, and one that is borne out by the three-part organization of the composition, as read from left to right: namely, that what the mirror shows us is a kind of imaginary encounter between the man and the woman, a kind of shared reverie, based on their mutual awareness of each other, and their differing reactions to that awareness.[41]

It would be tempting, given the physical resemblance between the man in the mirror and Manet himself—and given the fact that the man who posed for it was himself a painter—to privilege this reading above the others. But it is not possible to do so, any more than it would be possible to know what exactly is on her mind, or exactly how available she might be for a flirtation, or for a price. One is, nonetheless, tempted to say that in a sense the barmaid is a kind of surrogate for the artist—observer and observed—the person who unifies and mediates everything that we see before us.

The paradox of the simultaneous intensification and undermining of our sense of our own reality through the use of the mirror, and the crossing of different narrative lines to multiply the picture's narrative possibilities, is a powerful example of the expressive and symbolical potentials of *mise en abyme*.[42] This untranslatable term has been described by Lucien Dällenbach as a kind of *reflexion*, "a means by which the work turns back on itself," and he lists among its principal devices mirrors and pictures within pictures. Dällenbach defines *mise en abyme* broadly as "any aspect enclosed within a work that shows a similarity with the work that contains it," and he gives three paradigms that describe the nature of *mise en abyme:* what he calls "'simple' reflexion," "infinite reflexion," and "paradoxical reflec-

tion."[43] (In English literature, the most famous instance of *mise en abyme* is the play within the play in *Hamlet*, which is an example of what Dällenbach calls "'simple' reflexion.")

Manet appears to use, in varying degrees, all three kinds of *mise en abyme* in *A Bar at the Folies-Bergère*. Within the mirror image are inscribed divergent doubles of things depicted in the "real" space, and the undecipherable image contained within the barmaid's locket acts as an impenetrable form of a representation contained within the overall representation, another kind of picture within the picture. Equally provocative and nearly as ambiguous are the suggestions of the infinite reflections of the mirrors on the opposing balconies of the Folies-Bergère, which Manet was able to evoke with fragmentary indications of the repeated lantern globes precisely because he assumed his viewers' familiarity with such arrangements.[44]

But of course the most striking sort of *mise en abyme* in the *Bar* is the "paradoxical reflexion" between the mirror images of the woman and the top-hatted man and the way they relate to the "real" spaces around them. As Jorge Luis Borges has suggested, what disturbs us most about such paradoxical instances of *mise en abyme*, such as Don Quixote being a reader of the *Quixote* and Hamlet a spectator of *Hamlet*, is that "these inversions suggest that if the characters of a fictional work can be readers or spectators, we, its readers or spectators, can be fictitious."[45]

This annihilation, as it were, of the spectator's physical reality is a crucial aspect of *A Bar at the Folies-Bergère*. And it is part of Manet's more general strategy, through the use of *mise en abyme*, to transform what at first appears to be straightforward physical description into a kind of elliptical, metaphysical narrative. The contradictory reflections create the visual equivalent of what C. E. Magny has referred to in a literary context as "the sense of metaphysical vertigo we feel as we peer into this world of reflexions which suddenly opens up beneath our feet; in short, the illusion of mystery and depth inevitably produced by these stories whose structure is thus 'en abyme.'"[46]

As is well known, Manet painted *A Bar at the Folies-Bergère* when he was terminally ill and aware that he would soon die. Although the readings that we have just discussed, including the interpretation of the painting as a *vanitas* picture, exist independently of the artist's biography—in what could be called the "universal" as well as the "local" sense—one cannot help feeling that this picture is, among

other things, a kind of farewell painting. In this context, the fact that his dear friend Méry Laurent is the most clearly identifiable person among the portrait representations on the far balcony seems significant. In a sense, the world reflected in the mirror represents much of what Manet was most fond of—and what through memory he was able to summon up and give form to as he worked in his studio from the sparsest props: "A pretty girl . . . posing behind a table laden with bottles and comestibles."

It is a world of frivolity, gaiety, high spirits, and erotic encounters, a world dedicated to surfaces and to the stirring of appetites and desires. When Manet painted this picture it was also a world that he could no longer move in, and that he quite literally had to summon by an act of imagination aided by memory. *A Bar at the Folies-Bergère* not only seems to sum up a number of Manet's artistic concerns, but also appears to embody a contemplation of his own past. One can't help remarking, for example, that the black ribbon and the gold bracelet remind us of two memorable props from *Olympia;* and that this bracelet had belonged to Manet's mother, and that she had kept in it a lock of her son's baby hair.[47]

Perhaps in this valedictory painting, Manet both personified and personalized desire in this woman, by decorating her with this bracelet. Perhaps within this context of reflection answering reflection with reflection, she is also a surrogate for the artist, both detached and engaged, absent but always present. Like the artist, she stands at the edge of an abyss, contemplating the transience of all pleasures and all things.

NOTES

My thanks go to Miriam Deutch for helping with the research for this essay, and to Derin Tanyol for her thoughtful feedback while I was writing it.

1. The response to the first public showing of the picture at the Salon of 1882 was quite varied. Even the notorious mirror was conceived of differently by various writers. Jules Comte, for example, was critical of both the perspective and the rendering of light, remarking that "all of the picture takes place in a mirror, and there is no mirror" (as cited in T. J. Clark, *The Painting of Modern Life: Paris in the Art of Manet and his Followers* [New York, 1984], 240). While Comte remarked on "the absolute inadequacy of the form of the woman," Paul Alexis found her to be "a beautiful girl, truly alive, truly modern," and described the scene in the mirror as if it were reflected literally

(ibid., 239). The criticism and interpretation of the painting have been fraught with similar contradictions up to the present day.

2. The incongruity of the mandarin oranges on the table was alluded to in 1884 by Paul Mantz in *Le Temps* (16 Jan. 1884): "Why . . . is the doll sitting at the counter selling oranges. Merely because she is wearing a blue dress and because M. Manet knows the color of the paper on which stall holders display their 'fine oranges' in the streets." As cited in Pierre Courthion, *Edouard Manet* (New York, 1961), 175–76.

3. This irrational hovering effect is set in direct contrast to the rather tangible spatial relationship that exists between ourselves and the woman. For example, the actual size of her image on the canvas is slightly smaller than life-sized. Hence, she is represented so that we understand life-sized to be exactly at the picture plane. (The heights of the bottles corroborate this.) It is here, at the picture plane, that the absolute scales of her world and ours intersect. (Velázquez creates a similar effect in *Las Meninas*.) This heightens the flow between the painting's space and our own, and intensifies the illusion that our space and its space are coterminous, despite the obvious spatial contradictions.

4. In all the vast literature on the painting, this fairly obvious trope has apparently been remarked only once before. After I had written this, I came across an erratic but perceptive article by the painter Jeremy Gilbert-Rolfe, who writes: "Manet has emphasized the barmaid's vagina through the arrow-like cut of her vest, and through the echoing outlines of the compote on the right and through the other objects lined up on the bar." Jeremy Gilbert-Rolfe, "Edouard Manet and the Pleasure Problematic," *Arts Magazine* 62 (February 1988), 43.

5. The desire to "correct" the reflection and repair the rupture is strong. For example Tabarant, in direct contradiction of the visual evidence, explains that the mirror is placed at an angle rather than parallel to the picture plane. See Adolph Tabarant, *Manet: Histoire catalographique* (Paris, 1931), 410. Tabarant repeats this assertion ("*placée de biais*") in *Manet et ses oeuvres* (Paris, 1947), 423.

6. Margaret Gilmore, *Baudelaire the Critic* (New York, 1971), 127–28. See especially sections III and IV of "The Salon of 1859," in *Art in Paris, 1845–1862*, translated and edited by Jonathan Mayne (London, 1964), 155–63.

7. These are discussed below. Such a simple reading also ignores the complex understanding Manet must have had of sexual relationships, in light of his own rather labyrinthine experiences with Suzanne Manet and other women.

8. Charles Baudelaire, *The Painter of Modern Life and Other Essays*, translated and edited by Jonathan Mayne (London, 1964), 30.

9. Antonin Proust, *Edouard Manet souvenirs* (Caen, 1988), 71. This edition reprints Proust's 1897 text, which is somewhat different from that published in the 1913 edition, where the same story is recounted in a slightly different way on pp. 131–32.

10. See Sharon Ruswinkle Kokot, "Behind the *Bar at the Folies-Bergère*" (M.A. thesis, Ohio State University, 1989), 46. Whether multiple viewpoints per se actually exist in Cubist painting is another matter.

11. Hans Jantzen ("Edouard Manet's 'Bar aux Folies-Bergère,'" in *Essays in Honor of Georg Swarzenski* [Chicago, 1951], 231) discusses the mirror reflection as a kind of dream or memory image related to the barmaid. Nils Walter Ramstedt, Jr. (*Manet's Bar aux Folies-Bergère* [M.A. thesis, University of California, Santa Barbara, 1971], 21–22) considers this reading but dismisses it, largely because he frames it as an absolute rather than as part of the network of multiple readings demanded by the picture.

12. Leon Edel, Introduction to Edouard Dujardin, *We'll to the Woods No More* (New York, 1957), xxv.

13. Edel (ibid., xiv), citing a later lecture by Dujardin on his method.

14. Valerie Larbaud, preface to the 1925 edition of *Les lauriers sont coupés* (rprt, Paris, 1981), v.

15. See Stephen Kern, *The Culture of Time and Space, 1880–1918* (Cambridge, Mass., 1983), 10–33.

16. Ibid., 28.

17. Pierre Zaccone, *Nouveau langage des fleurs* (Paris, 1858), 92. See also Theodore Reff, *Manet: Olympia* (New York, 1976), 106.

18. Indeed, one wonders whether the presence of the mandarins on the counter are not meant to be taken as reminders of the season in which the painting was painted. Mandarins are of course a winter fruit, and their sunny presence in this predominantly sober image underlines the allegorical overtones of the painting as being an image of Winter. See the discussion of the mandarins in Juliet Wilson Bareau, "The Hidden Face of Manet," *The Burlington Magazine* 128, 997 (April 1986), 82.

19. Novelene Ross, *Manet's Bar at the Folies-Bergère and the Myths of Popular Illustration* (Ann Arbor, 1982), 9.

20. For a recent overview, see Francine du Plessix Gray, "Splendor and Miseries," *The New York Review of Books,* 16 July 1992, 31–35. The French viewpoint on this subject is generally quite different from the English and American. See for example, Eric Darragon, *Manet* (Paris, 1989), 379–92.

21. Ernest Chesneau, *Annuaire Illustré des Beaux-Arts: 1882* (Paris, 1882), 223; as cited in Clark (as in n. 1), 243.

22. Paul Eudel, "La Vente Manet," *Le Figaro* (5 Feb. 1884); as cited in Courthion (as in n. 2), 181. As Joel Isaacson has pointed out, one of the main characteristics of modernist paintings was their seriousness of approach to what were subjects of satire to others. See Isaacson, "Impressionism and Journalistic Illustration," *Arts Magazine* 56 (June 1982), 110.

23. Raymond Mortimer, *Edouard Manet: Un Bar aux Folies-Bergères* (London, 1944), 4.

24. Ibid., 7.

25. Hollis Clayson, *Painted Love: Prostitution in French Art of the Impressionist Era* (New Haven and London, 1991), 151.

26. Ibid., 151. As noted above, such claims were not explicit, and in any case even the implicit claims were relatively rare. Compare the more balanced discussion in Darragon (as in n. 20), 386–87.

27. Clayson (as in n. 25), 151. Clayson seems unaware of the irony of her own statement, since on the evidence of her own writing, the answer to her question appears to be at least equally interesting to women. Clayson's diagrammatic reading has been espoused by Eunice Lipton in her review, "Feminism and Impressionism," *Art Journal* 51, 4 (Winter 1992), 99–103. A more balanced appraisal is given in Carol Armstrong's review of Clayson's book, "Images and Ideology," *Art in America* 80, 12 (December 1992), 29–33.

28. See Gray (as in n. 20), 35.

29. Georges Jeanniot, "En Souvenir de Manet," *La Grande Revue* XLVI (10 Aug. 1907), 853–54; as cited in New York, Metropolitan Museum of Art, *Manet,* exh. cat. (New York, 1983), 482.

30. See Wilson Bareau (as in n. 18), 76.

31. Ibid., 77.

32. Ibid., 77.

33. As cited in Clark (as in n. 1), 314 n. 92.

34. For many years the setting was assumed to be the ground-floor of the Folies. Ramstedt (as in n. 11), 43–44, documented in detail just how drastically Manet had altered the interior architecture of the actual Folies-Bergère in his painting, by combining different views, and described the setting of the *Bar* as an "impossible" architectural setting. Though Ross (as in n. 19), 76, also believed that the setting was a combination of different specific views that resulted in an impossible conflation of various viewpoints, she disagreed with Ramstedt about the bar's location and located the bar depicted by Manet in the garden of the Folies rather than on the first floor. But Robert Herbert (*Impressionism: Art, Leisure, and Parisian Society* [New Haven and London, 1988], 79), citing a contemporaneous poster by Chéret (fig. 10), made a convincing case for locating the bar depicted in the picture not on the ground floor promenade, but rather as one of the bars on the first floor balcony at the right side of the stage, thus providing clear evidence that Ross was mistaken. See also *Manet* (as in n. 29), 478, in which the Chéret poster is discussed; and Wilson Bareau (as in n. 18), 77–78. Interpreting Herbert's general location of the bar in an overly literal way, Kokot (as in n. 10), 61 n. 8, has recently asserted that Manet did not alter the setting as dramatically as Ramstedt supposed, and Kokot has gone so far as to claim that "in this case, Manet was simply representing what was there."

35. The identification is made by Tabarant 1931 (as in n. 5), 412; as cited in *Manet* (as in n. 29), 484. See also Paris, Musée de l'Orangerie, *Manet: 1832–1883*, exh. cat. (Paris, 1932), 65; Tabarant 1947 (as in n. 5), 424.

36. Isaacson (as in n. 22), 110.

37. See, for example, Ross (as in n. 19), 70; Kokot (as in n. 10), 17.

38. See Ross (as in n. 19), 8. A number of other details have been probed for specific information, but much of what has been discovered has remained difficult to use because it has remained fixed within the matrix of literalness that is so frequently applied to the painting. For example, a certain amount of attention has also been paid to the precise identification of the acrobat whose legs appear at the upper left. Both Ross and Kokot have proposed that the trapeze artist "may be a specific reference to an American performer named Leona Dare or to 'la délicieuse Katarina Johns.'" (Kokot [as in n. 10], 14.) In fact, as Kokot admits, secure identification cannot be made. And even if it could, we may wonder just what bearing the name of the trapeze artist might have on our reading of the painting—in which that person is presented to us as a pair of calves and two green slippers.

39. On the identifications, see *Manet* (as in n. 29), 478–83.

40. Proust (as in n. 9), 64.

41. It should also be pointed out that desire here can operate in both directions. For she can be as desirous of an encounter with him as he is with her, though perhaps for different reasons. If their impossible meeting in the impossible mirror is a kind of shared reverie, it is one not entirely devoid of irony.

42. This term was first used by André Gide in 1893, originally with reference to a heraldic device in which there was an image of a shield that contained in its center a miniature replica of itself. See Lucien Dällenbach, *The Mirror in the Text* (Chicago, 1989), 7–19.

43. Ibid., 8.

44. As noted above, there has been a good deal of discussion about exactly where in the Folies this painting is supposed to take place. Such discussions tend to be somewhat disappointing because writers often seem content merely to satisfy their curiosity about such details without discussing their possible significance within the fictive world of the painting. Understanding the suggestion of infinitely reflecting mirrors in the *Bar* thus provides a good instance of the potential usefulness of situating the locale of the bar that Manet depicts; for it reinforces our sense of the degree to which Manet would have taken for granted his "local" viewer's knowledge of the facing mirrors at the Folies, thus allowing him the freedom to create the desired effect through a shorthand suggestion of infinite reflection.

45. Jorge Luis Borges, "Partial Magic in the Quixote," *Labyrinths: Selected Stories and Other Writings* (New York, 1964), 196.

46. C. E. Magny, *Histoire du roman français depuis 1918* (Paris, 1950), 277; as cited in Dällenbach 1989, 22.

47. See Alain Clairet, "Le Bracelet de l'Olympia: Genèse et Destinée d'un Chef-d'oeuvre," *L'Oeil* 333 (April 1983), 37.

Dumbshows: A Carefully Staged Indifference

TAG GRONBERG

Silence is the element in which great things fashion
themselves together; that at length they may emerge,
full-formed and majestic, into the daylight of Life, which
they are henceforth to rule.
Thomas Carlyle, "Symbols," in Sartor Resartus[1]

The unperceived is *ipso facto* the vital.
Gerald Heard, "A Metaphysic of Mode" in Narcissus:
An Anatomy of Clothes[2]

METAPHORS OF SILENCE—of silence as the product of muting—
have played an important role in the interpretation of Manet's work.
Werner Hofmann, for example, compares Manet's *Nana* with the
"conversation pieces" between boulevardier and cocotte found in
French nineteenth-century popular illustration and concludes that
Manet's painting constitutes a "formal metaphor of speechlessness."[3]
Unlike the preparatory oil sketch (fig. 1) which shares many of the
conventions of contemporary illustration (the barmaid is clearly
characterized as a *fille,* and represented in conversation with a short
bowler-hatted man who excitedly sucks the handle of his cane), the
flattened, confrontational composition of *A Bar at the Folies-Bergère*
(frontispiece) eradicates (as Hofmann points out) the immediacy of
conversation and dispenses with the anecdotal narrative implied by
the depiction of boulevardier and barmaid in the mirror reflection.[4]
Following this interpretation, it can be argued that the figure of the
barmaid—represented as rigid and static, with a blank expression—
"silences" the implied sly repartee of the "conversation piece" as well
as the laughter invited by the double-entendres and sniggering asides
of what Novelene Ross has termed "the boulevardier journals."[5]
In Georges Bataille's monograph on Manet, on the other hand,

189

silence is interpreted as the significant characteristic of Manet's oeuvre as a whole: "What he insisted upon was painting that should rise in utter freedom, in natural silence."[6] According to Bataille, it is not the boulevardier imagery of contemporary illustration—the eroticism formulated as "conversation piece" between man and woman—that Manet's painting strikes dumb, but rather "a kind of time-honoured rhetoric, symbolized by the model in his heroic pose with his chest thrust out."[7] Bataille is concerned to represent Manet as "silencing" the narratives of academic painting, in particular those narratives on heroism produced through the depiction of a dramatically posed male body; he refers to an anecdote recounted by Antonin Proust concerning Manet when a student in the *atelier* of Thomas Couture:

> Finally [Manet] got hold of a model who, I believe, later became an actor in one of the boulevard theatres and, after that, a mesmerizer somewhere. Everything went fine to begin with. But it wasn't long before Donato was sticking out his chest with the best of them, bulging his muscles and taking heroic poses. Manet was heartbroken.[8]

Proust's *Souvenirs,* from which Bataille takes his extract, portray Manet in conflict with the studio models:

> Dubosc, Gilbert and Thomas Lours were the most illustrious professionals. Climbing on to the table, they traditionally struck up the most extravagant attitudes. . . . "Can't you be more natural?" Manet would exclaim. "Do you stand like that when you go to buy a bunch of radishes at the green grocer's?" . . . "M. Manet," uttered Dubosc in a voice strangled by emotion, "thanks to me, more than one painter has gone to Rome." "We are not in Rome and we have no desire to go there. We are in Paris; and that is where we should stay."[9]

Bataille's notion of Manet's work as "silencing" emphasizes the male body as point of confrontation between academic convention and Modernist invention. "Silence" replaces "eloquence" as inflections of the mundane are substituted for the declamatory postures of the heroic. In "silencing" the "rhetoric" of the strutting studio model Paris replaces Rome: the representation of the city as site of consumption displaces the representation of the posturing male body which signals the city as object of civic devotion and self-sacrifice.

A Bar at the Folies-Bergère is as effective a demonstration piece for Bataille's notion of silencing as for Hofmann's; indeed, Manet's last

major painting seems to constitute a paradigmatic work from the point of view of a Modernism construed in terms of "silence." Although not depicting a scene of buying "a bunch of radishes," *A Bar at the Folies-Bergère* represents a moment of exchange in the form of a composition whereby the male figure is emphatically side-staged. In depicting the Folies-Bergère, Paris has definitively replaced Rome; within the processes which Ross has characterised as the nineteenth-century "phenomenon of urban myth-making," the Folies-Bergère functions as a sign for Paris—of the city as spectacle.[10] The activities along the Folies' famous *promenoirs* were often represented as analogous to those of the crowded city streets, as Huysmans said of the Folies: "The hall-mark of the boulevards . . . is stamped upon it."[11] And like the Parisian boulevard, the Folies-Bergère implied a sexualized urban gaze, orchestrated around a male subject (the boulevardier) and female object. As mise-en-scène, the Folies-Bergère's *promenoirs* cast woman as object of this gaze by presenting her in the role of barmaid and prostitute.

The Folies-Bergère, however, comprised a complex double spectacle: that taking place on the *promenoirs,* as well as the performances on stage and in the auditorium.[12] The same might be said for a number of the larger Parisian cafés-concerts and café-spectacles, but the Folies-Bergère distinguished itself from these in the lavishness and scale of its stage entertainments; in particular, it was renowned for its acrobats and gymnasts, for its displays of pantomime.[13] The Folies-Bergère thus involved other circuits of looking than that enacted by boulevardier and barmaid; indeed, boulevard entertainments constituted a modern site for the display of the male body: "Donato" (the academic model mentioned in Proust's story about Couture's studio) apparently worked not only for painters but also as a performer in "the boulevard theatres." Something of this is suggested in Huysmans' musical analogy:

> For the *Folies* there are two kinds of waltz which are both necessary and delightful; one of them is joyful and pirouetting, expressing the swing and the trapezes . . . the rhythm of the body raising and lowering itself by the strength of its own arms . . . ; the other is unhealthily voluptuous, as it portrays the bloodshot eyes and trembling hands of interrupted acts of depravity.[14]

More-or-less the same figures featured in Huysmans' text appear on pages of illustrations devoted to the Folies-Bergère in 1877 and 1878 issues of the *Journal Amusant:* frock-coated boulevardiers flirting

with barmaids or surveying the passing parade of women on the *promenoirs* and a profusion of acrobats, clowns, and gymnasts (figs. 24 and 25). (Juxtaposed with—appearing immediately below—the scenarios of barmaid and boulevardier in the December 1878 issue, for example, is a large illustration of the Hanlon-Lees brothers in performance.) Both in Huysmans' essay and in the *Journal Amusant,* then, boulevardier, barmaid, and acrobat are represented as the main "performers" at the Folies-Bergère. To the extent that the Folies-Bergère connoted a microcosm of the modern city, it would seem that the male acrobat as much as the barmaid and boulevardier played a role in signifying modernity.

In the context of the *Journal Amusant,* all three of these characters are portrayed for the purposes of provoking laughter in the reader; with the clowns and acrobats, however, the humour might seem to be more innocent and straightforward, the consequence of the slapstick performances and contortions of the male performers rather than the smutty jokes produced through the depiction of the eroticized exchange between barmaid and boulevardier. Nevertheless, the laughter, as well as the snigger, invited by such "clowning about" seems to be "silenced" by Manet's *A Bar at the Folies-Bergère.* An echo of this laughter—some trace of the male comic performer—may be detected in Manet's earlier painting *Reichsoffen* (fig. 26; probably intended for the 1878 Salon). The setting for this large-scale picture is (according to contemporary sources) the Brasserie Reichsoffen.[15] Here we see the boulevardier (apparently posed by Manet's friend Henri Guérard), the barmaid (the brasserie waitress), and acrobats (in the form of a poster for the brothers Hanlon-Lees). The *Reichsoffen* project was abandoned, the canvas cut into two (surviving and repainted) fragments depicting scenes of Parisian café life: *At the Café* (fig. 12) and *Corner in a Café Concert* (London: National Gallery, 1877–79).[16] *A Bar at the Folies-Bergère* thus constitutes the retrieval of Manet's earlier failed attempt to produce a major Salon picture on the theme of modern urban life—to deploy the *café-spectacle* as figure of the city as spectacle. Significantly, in this work references to the male figures have undergone a shift of emphasis: the boulevardier, a prominent figure in *Au Café,* appears as an elusive and fragmented form in *A Bar at the Folies-Bergère.* And although both compositions eradicate the bodily presence of the male acrobat, *A Bar at the Folies-Bergère* substitutes the merest glimpse of a female trapezist's legs for the typographical allusion to the male acrobat—

the poster advertizing the Hanlon-Lees act depicted in the earlier picture.

The congruence of depicted mirror and canvas surface in *A Bar at the Folies-Bergère* suggests that this pictorial composition constitutes an all-inclusive view—a mirror-image—of that indoor spectacle that could so powerfully symbolise the modern city. But the illusion of a panoramic, free-ranging vision is belied not only by the work's determined focus on the figure of the barmaid but also by the rigorous marginalization of the male body. In fact, with the obliteration of the male acrobat Manet's painting constitutes an even more vigorous erasure of the spectacular male body than that suggested by the figure of the boulevardier. Pursuing Bataille's provocative association of "muting" with a rejection of the "heroic" male figure, my essay constitutes an attempt to focus on precisely those two male characters— the boulevardier and the acrobat—which *A Bar at the Folies-Bergère* makes so difficult to see. The painting has often been discussed in terms of spectacle, but what is the significance of this blinkering of vision—these tantalizing glimpses of the not-quite-seen? Ultimately, however, my concern with Bataille's interpretation will have less to do with proposing another "explanation" of Manet's picture than with considering the implications of using metaphors of silence in order to identify *A Bar at the Folies-Bergère* as a paradigmatic Modernist work.

BOULEVARDIERS: *HOMMES EN HABIT NOIR*

Nineteenth-century literary descriptions of the Folies-Bergère were mainly written from the point of view of the male visitor—the boulevardier. For example, in Guy de Maupassant's *Bel-Ami*, Duroy, the male protagonist, is introduced to the Folies-Bergère by the older Forestier amidst "a press of men in sober black":

> Who are the men? Study them. There's everything there, professional men of all kinds and every social class but mostly dissolute wasters. There are clerks, bank-clerks, shop-walkers, the lower ranks of the civil service, journalists, pimps, officers in mufti, men-about-town in evening dress, who have dined at a restaurant and are on their way from the Place de l'Opera to the Blvd. des Italiens and besides a crowd of shady individuals.[17]

This depiction of the Folies-Bergère as indoor boulevard echoes Baudelaire's image of the flâneur roaming the streets of Paris. The flâneur, Baudelaire's model for the "painter of modern life," constitutes one aspect of the boulevardier: the flâneur signifies "the joy of watching (as) triumphant." The "modern" is defined through this fantasy of masculinity as a mobile, free-ranging gaze. Crucial to the flâneurial persona is the ability to be invisible, to be able to lose oneself at will in the urban crowd: Duroy and Forestier are engulfed by a "forest of [top] hats." The desirable condition of remaining anonymous, "incognito," is both made possible and symbolized by a "uniform livery" ("une livrée uniforme")—by contemporary male dress.[19] Images of bourgeois male dress play a crucial role in Baudelaire's definition of modernity. On the one hand, the Baudelairean black frock-coat ("that outer skin of the modern hero") embodies a voyeuristic fantasy—the power to see without being seen.[20] But Baudelaire's conception of modernity is equally imbued with the fantasy of *being looked at,* and again, it is bourgeois urban dress—"our cravats and our patent leather boots"—that stand for the "great and poetic" aspects of modern life.[21] Formulating modernity in terms of "the heroism of modern life" legitimates this circuit of looking: at the level of representation, "heroism" demands the male body as spectacle. The flâneur's alter-ego is thus revealed as that of the dandy (another *homme en habit noir*). As Thomas Carlyle wrote in "The Dandiacal Body": "understand his mystic significance, or altogether misinterpret it; but do look at him, and he is contented."[22]

This narcissistic fantasy whereby the male body is construed as both subject and object of the gaze is narrativized in the form of an anecdote in "The Painter of Modern Life"; Baudelaire describes a scene from the childhood of a "famous painter":

> As a small boy, he used to be present when his father was dressing, and . . . he had always been filled with astonishment, mixed with delight, as he looked at the arm muscle, the colour tones of the skin tinged with rose and yellow, and the bluish network of the veins.[23]

The young boy gazes upon the partially clothed figure of his father, who is preoccupied with getting dressed, a sight that apparently produces pleasure in the viewer, a "delight" afforded by the spectacle of the lovingly delineated "arm muscle." This souvenir of the masculine toilette revealingly establishes an intimate connection between phallic male body and clothing. In defining the "heroism of modern life"

Baudelaire claims that the role of the *habit noir* is to mask the male body's blatant to-be-looked-at-ness:

> As for eccentrics, who used to be easily distinguishable by their violent contrast of colour, they content themselves nowadays with much more discreet differences of design and cut than of colour. Those grimacing folds, which play like serpents about mortified flesh, have they not got a mysterious grace?[24]

But a bit like the "mystic writing pad" described by Freud, the Baudelairean black frock-coat bears the imprint of a "previous" impression, the vestiges of an antique heroism.[25] In juxtaposing creases of cloth with "serpents around mortified flesh," the simile alludes to a pre-modern hero—the tragic figure of Laocoon strangled by snakes. "Those grimacing folds" signify the human form as well as snakes: in "grimacing" the creases suggest both the heroic straining of the body and Laocoon's agonized facial expression. This imagery of the *habit noir* thus reinscribes exactly that which Baudelaire claims the garment must obscure: the male body as spectacle.

Baudelaire's allusion is not only to the figure of Laocoon but also (at least implicitly) to an earlier text in which Laocoon is invoked in order to define a concept of the modern. In his essay "On the Imitation of the Painting and Sculpture of the Greeks" Winckelmann advocates the Vatican *Laocoon* as the "standard" for that imitation that will enable "the moderns to become great and perhaps unequalled."[26] Winckelmann also defined "the modern" by contrast with the past (the "ancients") but this difference is construed as modernity's loss. According to Winckelmann, it is Greek sculpture as epitomized by the Vatican *Laocoon* rather than the "vile (academic) model" which will provide the inspiration for artists to produce the modern in terms of the "heroic."[27] In his meditations on the *Laocoon* sculpture, Winckelmann imagines a piercing shriek muted to a muffled groan: "He pierces not heaven, like the Laocoon of Virgil."[28] It is Virgil's Laocoon, it seems, who must be silenced, the Laocoon whose "shrieks were horrible and filled the sky, like a bull's bellow when an axe has struck awry, and he flings it off his neck and gallops wounded from the altar."[29] In describing Laocoon's death by comparison to ritual slaughter—the decapitation of the sacrificial bull—Virgil's text elides the imagery of death with that of castration (according to Freud "to decapitate = to castrate").[30] In this sense, the figure of the "suffering" Laocoon—the "sacrificer" become sacrifice—suggests a

male horror of physical vulnerability and powerlessness, a terror of loss.

The Vatican *Laocoon* depicts the male body as brutally violated, and Winckelmann lays great stress on the sculpture's nudity—the absence of dress: "Had Laocoon been covered with a garb becoming an ancient sacrificer, his sufferings would have lost one half their expression."[31] Significantly, it is not the violence of Laocoon's death agony that Winckelmann proposes the modern artist should "imitate," but rather Laocoon's mastery of fear. For Winckelmann, it is important that "heroism" be defined not primarily in terms of the strength signified by the *Laocoon's* muscular and bulging physique but as the calming of the fear revealed by that body—as the "noble simplicity and calm grandeur" expressed by a muting of the voice. This "heroism" is crucially conceived through a conjunction of hearing and sight—an experience of looking construed in terms of male spectatorship. Just as the voice (Virgil's "shriek") is fantasized as being "silenced," so a metamorphosis of the body is imagined in terms of the hardness and rigidity of marble. Winckelmann recounts the interpretation of an earlier commentator: "Bernini pretended to perceive the first effects of the operating venom in the numbness of the thighs."[32] The reader is encouraged to discern a subtlety of surface execution in the Vatican sculpture, a depiction of Laocoon's body, poisoned by snake bite, beginning to go numb with impending death. This "rigor mortis," the desire to see a stiffening, can be read as symptomatic of a terror in the viewer. (Freud asserts that "becoming stiff means an erection"—that the transformation of the entire body into the symbolic equivalent of an erect penis functions as a "consolation," reassurance against castration anxiety.)[33]

Whereas Winckelmann's fantasy of the heroic—the counterpoint of the dying Laocoon's muffled cry and stiffening body—overtly positions a male nude as object of the gaze, Baudelairean physiognomies of the modern are more to do with dress as a means of playing down the overt theatricality of the male body. The dandy (Carlyle's "clothes-wearing man") figures as the nineteenth-century reformulation of the stoicism Winckelmann claimed for Laocoon, of the muted eloquence of the "heroic" male body: "a dandy may be blasé," asserts Baudelaire, "he may even suffer pain, but in the latter case, he will keep smiling, like the Spartan under the bite of the fox."[34] The dandy's indifference, "that calmness revealing strength in every circumstance" constitutes the updated version of Winckelmann's "noble simplicity and calm

grandeur."[35] As Barbey d'Aurevilly put it in his *Du Dandysme et de G. Brummell:* dandyism "introduces antique calm into modern agitations."[36] Dandyism articulates the "modern" through the discreet (almost surreptitious) display of the male body—through the displacement of phallic spectacle from posturing body to the nuance of dress, through a reassertion of the "heroic" in the guise of the blasé.

Later, in the twentieth century (with the writings of Adolf Loos and Le Corbusier for example), modernity continued to be theorized in terms of men's urban dress.[37] The "modern" is again defined through a validation of the unostentatious male body; in these more recent formulations, however, the "discreet" man's suit signifies not so much flâneurial anonymity or dandiacal reticence as that characteristic that is taken as emblematic of the "modern" world: standardization. Contemporaneously with this later nineteenth- and early twentieth-century literature on modernity, however, psychoanalytic theory set out to unveil the significance of the social fantasy—the masquerade—enacted by *l'homme en habit noir.* In his *Psychology of Clothes,* Flugel claims that the unconscious symbolization embodied in modern male dress allows a disguised public parade of the phallic in order to counter castration anxiety: "the stiff collar, for example, which is the sign of duty, is also the symbol of the erect phallus."[38] This psychoanalytic re-formulation of a "hats-and-spats" modernity makes a mockery of the dandy's urbanity; as Gerald Heard puts it in the revealingly titled *Narcissus: An Anatomy of Clothes:*

> All their carefully staged indifference, their convincing evidence that they are quite unconscious of their appearance, is nervous camouflage. Behind their mask and domino of standardised respectability . . . they peep out anxious lest any other should pierce their disguise.[39]

The *habit noir* is revealed as the attempt to "mask" man's constant need to reassure himself with the sight of the "heroic" male body.

THE ACROBAT

The figure of the acrobat could also signify modernity, but it involved a different conception of the "heroism of modern life" from that of Baudelaire. In nineteenth-century Paris the acrobat, like the dandy, was seen as a foreign import: both dandy and acrobat were repre-

sented as being of English derivation. Both dandyism and acrobatics put the male body on show; with the dandy this was a restrained performance: "dandyism is a whole state of being and exists only in a material and visible aspect. It is a state composed of fine shades."[40] In the case of the acrobat, however, it was more a matter of flagrant display. England was credited with having produced a "new" kind of acrobat, a hybrid of clown and acrobat. The Hanlon-Lees were the paradigmatic "modern" acrobatic troupe; they toured internationally, and their acts represented the most up-to-date techniques drawn from acrobatics, gymnastics, clowning, and pantomime (fig. 27).[41] Zola described the Hanlon-Lees as "revelling amid broken limbs and riddled trunks, triumphing in the apotheosis of vice and crime in the teeth of outraged morality."[42] According to Huysmans, this exaggerated emphasis on parts of the body in order to render it grotesque was analogous to caricature:

> The whole aesthetic of the English school of caricature is once more called into play by the performances of those side-splitting yet dismal acrobats, the Hanlon-Lees. Their pantomime, so true in its cold foolishness, so ferociously funny in its exaggeration, is none other than a new and charming incarnation of the lugubrious type of farce, the sinister kind of buffoonery so peculiar to the land of spleen, which has already been expressed and condensed by those magnificent, powerful artists Hogarth and Rowlandson, Gillray and Cruikshank.[43]

This performance presented a fragmented and disharmonious male body no longer in control of itself. But it was precisely the quality of being out-of-control that was interpreted as "modern"; the Hanlon-Lees act was described by one critic as "the embodiment of the age of mechanical invention. Next to the cruelty of their caricature, what was most remarked was the precision of their movements. They were human marionettes."[44]

The music-hall provided the stage for this pretended dismemberment and objectification of the male body. Horror was held at bay and distanced by emphasizing the acrobatic body as emphatically foreign, as inscribed with a characteristically English "*caractère de flegme et d'ennui noir,* . . . his knockabout business evoked *visions de Bedlam, d'amphithéâtre d'anatomie, de bagne, de morgue.*"[45] Acrobats performing in the "English" mode acted out modernity as boredom, madness, and death; as nihilism:

198

"What do you mean by your pantomimes?" a critic once asked . . . "Absolutely nothing," was the reply. "On the contrary, we try to destroy all connection between the scenes of our entertainment. We only wish to produce upon the audience the impression of violent terror and madness."[46]

This mute performance enacted the "modern" as the absence of harmony, self-control, and reason. What Lessing had particularly admired about the Vatican *Laocoon*, the way the sculpture represented the most dramatic moment of a narrative, an expressive and poignant *visual* immobility, becomes mere spoof in this acrobatic version: "They performed mute dramas, full of violent catastrophe, during which emotions of palpitating terror were frozen into savage caricature."[47] This parodic mimicking of a heroic "noble simplicity and calm grandeur" produces hysterical laughter: "Finishing on a note of extreme slapstick, of disorganized burlesque, this cruel study of the human machine at grips with fear has made the audience split their sides with guffaws."[48] Represented in this form, terror is rendered ridiculous; the acrobat's performance facilitates the attempt to deny anxiety—by laughing it off.

By contrast, Edmond de Goncourt's novel *The Zemganno Brothers* represents acrobatics as a revived antique heroism.[49] The Zemganno brothers, although apparently based on the Hanlon-Lees, are French; their performances are represented as the continuation of a Latin tradition (that of the commedia del arte). De Goncourt does not represent the brothers' act in terms of caricature; they go to England in order to train, but because they are French the Zemgannos are able to transform English acrobatic and pantomime techniques into mute "gymnastic poems of a new invention."[50] The Zemganno brothers do not invoke classical heroism as parody; rather they represent the embodiment of "antique" ideals. Nello, the younger brother, is endowed with a statuesque beauty and serenity:

> Then the child, with long hair and slender limbs, crossed his arms, and with one leg before the other, supported on his toe, placed himself naturally in the position of some antique statue, and might have been mistaken for a statuette of Repose in a gallery.[51]

The heroic is delineated through descriptions of the brothers' determined quest for self-control, a single-minded devotion to their art carried out as a form of sacred duty:

The brothers led a united, regular, sober, and chaste life. Their greatest dissipation was to take a walk on the Boulevard, during which they passed poster after poster upon which their name was printed. . . . they believed in the old Italian tradition . . . that men of their profession ought to keep themselves as strictly as if they were priests, and deprive themselves of the pleasures of Bacchus and Venus, a tradition handed down in a straight line from the wrestlers and muscular artistes of antiquity.[52]

The brothers are represented as totally self-sufficient, indifferent to desire.

Whereas (over time) the Hanlon-Lees troupe consisted of varying numbers of performers, in depicting the Zemganno brothers De Goncourt reduced the number to two thus producing a narcissistic scenario—the two brothers as complementary images of each other. The Zemgannos thus constitute a doubled protagonist: "they appeared to have but one mind governing two bodies."[53] These two bodies are distinguished by different gender characteristics. Gianni, the elder brother, represents the masculine in the form of the strong silent type: "in all these feats, performed by sheer strength of his arms, there was a measured harmony."[54] Towards Nello, Gianni takes on a protective, almost fatherly role: "Gianni's protecting hand was always around his little brother."[55] It is he who instructs the younger man in acrobatics, defines their ambitions and outlines the program for their joint career. Nello, on the other hand, "was the exact picture of his mother," endowed with a masculine delicacy.[56] So close is the fraternal relationship that it inspires fear: "women do not like to see such an intimacy between men . . . they justly fear such strong masculine friendship."[57] Here, all anxiety is displaced onto women. In order to sustain this fantasy of narcissistic plenitude, masculinity is represented as fused with femininity (the two brothers as constituting "one" being)—femininity as phallic (Nello's resemblance to his mother). Following an almost mythic scenario, the Zemganno's state of blissful togetherness is brutally ruptured. Gianni makes plans for the brothers to distinguish themselves in Paris by performing a super-human feat of strength: he choreographs an act involving an impossibly high vertical leap into the air. Nello, whose blind faith in his brother prevents him from protesting, whole-heartedly enters into the necessary practices and rehearsals. Partly due to the schemings of a woman who surreptitiously removes the safety net, the act is

a disaster and Nello is severely injured. Although the younger brother eventually recovers, it seems he will be crippled for life and unable to perform the astonishing feats for which the Zemgannos were internationally renowned. In the end, masculinity is revealed as disabled and incomplete.

As a figure through which to articulate the "modern," the acrobat had certain advantages: precisely because they were wordless, acrobatic performances—like the music-hall—could be represented as an index of the growing internationalism of the entertainment industry.[58] But judging by the narrative conclusion of *The Zemganno Brothers,* acrobatic "heroism" was more successful in its comic than in its tragic guise. Laughter is readily provoked by the acrobatic version of the "heroic" as for example in *Bel-Ami* with Maupassant's description of a young acrobat at the Folies-Bergère: "He thrust his chest out to conceal a prominent stomach. He looked like a barber's assistant with his hair carefully parted down the middle of his head."[59] This figure is not an idealized and timeless hero, but simply the man-next-door, the barber's assistant. Here, a thrust-out chest does not signify the male body ennobled through exertion or suffering; the bulging male body is merely ridiculous, puffed up in order to hide a less-than-perfect physique (fig. 28). Similarly, the acrobat's body-revealing silk suit—like the *habit noir*—could be construed as the "outer skin of the modern hero," but unlike the "mysterious grace" of the Baudelairean creased frock-coat, this suit rendered the "heroic" male body ludicrous:

> Thomas and Alfred [were] two splendidly built men. . . . The other brothers were—rather puny; they always wore double tights. Under the silk tights—worn outside—was another suit, called in the acrobatic vocabulary, a *thirty-two franc.* In the place of muscles this suit was arranged with fine woollen fringes, which were carefully combed upwards so as to obtain good curves; . . . false muscles.[60]

As a form of representation of the male body, the "thirty-two franc" involved a different strategy from the *habit noir;* the acrobatic suit— like the Hanlon-Lees' famous performances—blatantly displayed the possibility of an inadequate and anxious masculinity. Laughter was the required response.

In his 1955 monograph on Manet, Bataille marks the originating moment of Modernist painting with Manet's rejection of the academic male model:

His individual attitude was the first sign of a fundamental change
soon to come over all European painting . . . from the moment the
model's extravagant pose got on [Manet's] nerves, the issue was no
longer in doubt.[61]

He goes on to formulate his characterization of Manet's painting as a
form of "silencing" by comparing the painter's oeuvre to the history
of modern male dress:

One of the most surprising aspects of Manet's new painting was pre-
cisely its close connections with dress and costume. In fact, as I see
it, costume and painting have developed along parallel lines. At
least, this is true of masculine dress which, as it gradually lost the
majesty that had distinguished it in the seventeenth century, grew
more and more vulgar. It had once been eloquent, colorful, but fash-
ion relentlessly stilled its eloquence, dimmed its colors.[62]

According to Bataille, both Manet's painting and post-seventeenth-
century men's dress are "modern" in "silencing" the "eloquence"
embodied in the ostentatious display of the male body. This analogy
of Manet's "new painting" with modern male dress occurs in a chap-
ter entitled "Manet's Secret" ("*Le Secret*"); the idea of Modernism as a
form of secreting involves a preoccupation less with spectacle than
with concealment. This would seem particularly appropriate in the
case of a picture such as *A Bar at the Folies-Bergère* which, while in
many ways inviting interpretation in terms of spectacle, involves—as
I have already begun to argue—a series of (at least partial) erasures.
In the painting, the boulevardier appears as reflection, a figure shim-
mering at the edge of the canvas.[63] The boulevardier makes this
blurred appearance in order to act out the part of flâneur; chatting up
the barmaid, his presence signals (indeed emphasizes) woman as
spectacle—as object of the gaze. If the boulevardier has been par-
tially obliterated, however, that other modern "hero"—the male
acrobat—appears not at all. All that remains of this cancellation is
the often remarked upon tiny detail at the top left of the canvas, the
green-booted legs of the female trapezist. A female acrobat (indi-
cated only by a pair of legs) replaces the spectacle afforded by the
acrobatic male body. If the most effective "heroism of modern life"
enacted by the acrobat involved turning the male body into a joke, it
is perhaps not surprising that in the paintings which Manet intended
for the Salon (an arena of high culture) the visible presence of the

male acrobat should be reduced to a typographical trace (the poster in the window of *At the Cafe* [fig. 12], which we must read in reverse, as in a mirror) or transformed altogether into a pair of women's boots. (Indeed, we might interpret these boots as indicative of modern society's relegation of some of the male acrobat's best acts— notably hysterical contortions and objectification of the body—to woman).

A Bar at the Folies-Bergère thus constitutes a composition in which representations of the male body offer little distraction to the gaze directed at woman. Taking up Bataille's comparison of Manet's painting with the history of dress, we might read this picture as a particularly effective example of Flugel's theory of "great masculine renunciation" which identifies the displacement of vestimentary display from man to woman as a defining characteristic of modernity.[64] Flugel interprets the "great masculine renunciation" as a consequence of post-revolutionary society claiming that this vestimentary "renunciation" is the sign for both an acknowledged conflict over political authority (between aristocracy and bourgeoisie) and an unacknowledged conflict—that carried out at the level of the unconscious. According to Flugel, Man's narcissism and desire for self-display is projected onto woman, who is denigrated for the "vanity" signalled by her finery and adornment. Modern man shuns color and ornament (anything that would obscure the overall, clean-cut silhouette) in order that his clothing may produce the entire male body as "the little man," as reassuring phallic symbol. The spectacle constituted by the monumental figure of the barmaid, we might thus argue, functions as a kind of decoy, the stand-in for man's narcissism. The barmaid represents woman adorned, made-up (critics at the time commented on the apparently all-too-evident *maquillage*) and dressed-up in eye-catching clothing, jewellery, and flowers. At the same time, the figure is represented as expressionless, rigid, and stiff—the appropriate feminine accompaniment perhaps to the public parade of the phallic which Flugel claimed as the psychic function of the *habit noir.*

Bataille identifies *A Bar at the Folies-Bergère* as a "conversation piece" in order to argue that rather than in any way fulfilling the role of illustration, the painting enforces a "rule of silence."[65] Bataille is not, however, concerned with how the painting's composition—the depiction of barmaid and boulevardier—might be interpreted as "silencing"; for Bataille, the significance of Manet's last major work

lies less in its subject matter than in its physical presence as "an explosive festival of light, overrunning and absorbing the girl's motionless beauty."[66] This interpretation translates not only the painting's subject but also the very substance of paint into a vibration of light, into "a large composition in which no empty spaces were left . . . a bewitching interplay of lights gleaming in a vast mirror."[67] This language reveals a horror-vacuii; the painting is fantasized as plenitude ("large," "vast," and with "no empty spaces left"). Elsewhere in his book on Manet, Bataille deploys this imagery of light to signify a transcendence of the body, the overcoming of physical inadequacy and annihilation; for example, he quotes Malraux's description of Goya's *Milkmaid of Bordeaux* as "no more than a pure play of light, flickering beneath the old painter's hand."[68] The analogy with Manet becomes evident a few pages on where the dying Manet "for the last time . . . painted a large composition . . . *A Bar at the Folies-Bergère*."[69] *A Bar at the Folies-Bergère* is depicted as Manet's last gasp, the artist's memento-mori. Both in the case of Goya and Manet, it is the act of painting that Bataille represents as the mode of transcendence. Similarly, Bataille cites Manet's painting technique in *Suicide* (a modern male death scene, painted in the same year as *A Bar at the Folies-Bergère*) as evidence of a desire to sublimate the horror of death in an "unconcerned play of light."[70]

Bataille's interpretation of Manet's oeuvre is suggestive in its emphasis on the visual erasure of the spectacular male body as both means and evidence of the "silencing" of a rhetoric produced by "outdated" heroic posturings; this argument problematizes readings of Manet's work as "modern" in terms of its representations of woman or urban leisure. According to Bataille, however, it is not a different or more up-to-date subject matter but rather the quality of the picture surface—transformed by paint into a veil of shimmering light—that constitutes the ultimate muting of pictorial narrative. This substitution of the substance of painting for an apparently obsolescent "heroism" is revealing. Fifteen years before Bataille wrote his book on Manet, Clement Greenberg had proposed his "Newer Laocoon," formulated (to some extent) as a response to Lessing's *Laocoon* in which the "dumb language of the painter" is compared to "the signs which the mutes in the Turk's seraglio have invented for lack of utterance."[71] Greenberg's essay (like Bataille's on Manet) represents the attempt to positively re-validate the imagery of silencing in connection with visual representation—the high art of painting.

This involved disengaging metaphors of muting from their historical association with the physicality of the male body. At one level, heroism signifies male strength and control, but because that power is so often defined in terms of a response to some situation involving the male body at risk and endangered, heroism also raises the terrifying spector of masculine vulnerability. Even Baudelaire's ironic "heroism" gives away as much as it hides. The speechlessness and death symbolised by the *habit noir* in the poet's evocation of a "procession of undertakers' mutes, political mutes, mutes in love, bourgeois mutes" are intended as a sour comment on bourgeois society.[72] But this is an imagery reinforced by the implied equation of muting with powerlessness—and impotence. In the Modernist formulations where painting is construed as a matter of disembodied "voices of silence"—of "a song for the eyes of interwoven forms and colors," the quality of "silence" is displaced from "heroes" (whether antique or frock-coated) to painted canvas.[73] Characterized as silenced and mute, it is now the picture surface that acts as a means of fantasizing a purely pleasurable gaze, devoid of anxiety. Precisely because Manet's *A Bar at the Folies-Bergère* so effectively demonstrates such ideas of painting as desirably "silent," it becomes important to question not only what and how the picture represents, but also what interests might be at stake in the critical and art historical language that takes such pains to maintain the work's status as an exemplary Modernist masterpiece.

Notes

I would like to thank Kathleen Adler, Briony Fer, and Paul Overy for their comments on this essay. I am grateful to Neil MacGregor for inviting me to speak at the Warburg Institute symposium held in April 1986 to coincide with the Courtauld Institute Galleries exhibition *The Hidden Face of Manet* and to Juliet Wilson Bareau, whose research in connection with this exhibition first stimulated my interest in notions of "the hidden" in relation to Manet's work.

1. Thomas Carlyle, *Sartor Resartus: The Life and Opinions of Herr Teufelsdrockh in Three Books* (London, 1889), 204. (*Sartor Resartus* was first published in 1838.)

2. Gerald Heard, *Narcissus: An Anatomy of Clothes* (London and New York, 1924), 13.

3. "Manet lasst das Rankenwerk verbaler Empfindungsmasken beiseite und bringt die Partner zum Verstummen. . . . Das bedeutet den Bruch mit dem sittenbildlichen Konversationsstuck, das in zahllosen Abwandlungen . . . die Erotik der Mann-Frau-Beziehung auf die Ebene der tändelnden Plauderei fixiert." (Manet dispenses with the interlaced ornament of verbal encounters and mutes the partners. . . . This constitutes a break with the genre of the conversation-piece, which effects innumerable permutations on the theme of the erotic encounter of man with woman represented in terms of flirtatious chit-chat.) (my translation) Werner Hofmann, "Manet zwischen Salonkunst und Boulevard-Imagerie" in *Nana: Mythos und Wirklichkeit,* rev. ed. (Cologne, 1974), 76. Novelene Ross characterizes Hofmann's interpretation in terms of a "formal metaphor of speechlessness" in *Manet's* Bar at the Folies-Bergère *and the Myths of Popular Illustration* (Epping, Essex, England, 1982), 14.

4. Recent x-rays of the painting have revealed that Manet transferred the composition of the sketch (fig. 1) to the canvas of the larger work (frontispiece), and then reworked and changed it to its present form. See Juliet Wilson Bareau, "Cafés-Concerts and the Folies-Bergère" in "The Hidden Face of Manet," *The Burlington Magazine* CXXVIII, no. 997 (April 1986), 76–83 and 85–86.

5. Ross (as in n. 3).

6. "Ce dont il s'agissait, assez bizarre, était le silence de la peinture." Georges Bataille, *Manet* (Geneva, 1955 and London, 1983), 35. (Translations are taken from the English edition; page numbers in both editions correspond.)

7. "Quel était donc ce langage qu'avant Manet les peintres tenaient sur la toile? Evidemment, celui que tenait le modèle en poitrinant." Bataille (as in n. 6), 35.

8. "Il avait découvert un modèle appelé Donato, qui je crois a été depuis acteur dans un théâtre des boulevards et ultérieurement magnétiseur. Au début tout alla bien. Mais à la suite de la fréquentation des autres modèles, Donato poitrinait, faisait saillir ses muscles et prenait des poses héroiques. Manet était navré." Bataille (as in n. 6), 34.

9. "Dubosc, Gilbert, Thomas Lours étaient les professionels les plus illustres. En montant sur la table, ils prenaient par tradition des attitudes outrées. 'Vous ne pouvez donc pas être naturels, s'écriait Manet. Est-ce que vous vous tenez ainsi quand vous allez achete une botte de radis chez la fruitière?'

'Monsieur Manet, articula Dubosc d'une voix étranglée par l'émotion, grâce à moi, il y en a plus d'un qui est allée è Rome.

Nous ne sommes pas à Rome et nous ne voulons pas y aller. Nous sommes à Paris: restons-y.'" Antonin Proust, *Edouard Manet. Souvenirs.* (Paris, 1913), 21.

10. Ross (as in n. 3), 36.

11. J.-K. Huysmans, *Parisian Sketches,* trans. Richard Griffiths (London,

1962), 25. And according to another contemporary commentator: "The grand promenade circling the exterior of the loge, a boulevard in itself where one could socialise." Gaston Jollivet, *Souvenirs de la vie de plaisir sous le Second Empire* (1927), 254, quoted in Ross (as in n. 3), 64.

12. Georges Strehly categorizes the Folies-Bergère as a music hall, which have, according to him: "des ressources particulières fournies par les promenoirs dont le public se préoccupe de tout autre chose que du spectacle sur la scène." Georges Strehly, *L'Acrobatie et les Acrobats* (Paris, 1904), 54.

13. In his history of acrobatics and acrobats (see note 12 above), Strehly discusses how (during the nineteenth century) such acts moved from the circus to music-halls such as the Folies-Bergère. See also the entry for "Folies-Bergère" in the *Grand Encyclopédie* (Paris, 1887–1902), 17, 690–91 for a list of acrobatic performers.

14. "Il existe pour les Folies deux séries de valse nécessaires et charmantes: l'une pirouettante et joyeuse, rendant le balancé des trapèzes, . . . le rythme du corps que se hausse et se baisse à la force des bras, . . . l'autre maladivement voluptueuse, montrant l'oeil injecté et les mains tremblantes des polisonneries interrompues." J.-K. Huysmans, "Les Folies-Bergère en 1879" in "Croquis Parisiens," *En Rade/Un Dilemme/Croquis Parisiens* (Paris, 1976), 345–46. English translation taken from R. Griffiths (as in n. 11), 25. All future references are to these editions.

15. For a detailed account of the Reichsoffen project, see Wilson Bareau, "Reichsoffen—The Painting and the Place," in *The Burlington Magazine* (April 1986), 65–71.

16. See Michael Wilson, *Manet at Work* (London, 1983), 45–47.

17. Guy de Maupassant, *Bel-Ami* (Harmondsworth, Middlesex, England, 1975), 21, 22. "Quels sont ces hommes? Observe-les. Il y a de tout, de toutes les professions et de toutes les castes, mais la crapule domine. Voici des employés, employés de banque, de magasin, de ministère, des reporters, des souteneurs, des officiers en bourgeois, des gommeux en habit, qui viennent de dîner au cabaret et qui sortent de l'opéra avant d'entrer aux Italiens, et puis encore toute un mondes suspects qui défient l'analyse. Duroy dit:—Si nous faisons un tour dans la galerie?—Commue tu voudras. Ils sortirent, et furent aussitôt entraînés dans le courrant des promeneurs. Pressés, poussés, serrés, ballottés, ils allaient, ayant devant les yeux un peuple de chapeaux." Guy de Maupassant, *Bel-Ami* (Paris, 1895), 17–19. All future references are to these two editions.

18. Walter Benjamin, "Modernism," in "The Paris of the Second Empire in Baudelaire," *Charles Baudelaire: A Lyric Poet in the Era of High Capitalism* (London, 1973), 69. And: "at certain times Baudelaire thought his strolling was endowed with the same dignity as the exertion of his poetic power" (p. 96).

19. Charles Baudelaire, "The Painter of Modern Life," in *Baudelaire:*

Selected Writings on Art and Artists (Harmondsworth, Middlesex, England, 1972), 20, and "Of the Heroism of Modern Life," in "The Salon of 1846" (from the same edition), 105. Unless otherwise indicated, all English translations are taken from this edition.

20. Baudelaire, "Of the Heroism of Modern Life," 105. "L'habit, la pelure du héros moderne." Charles Baudelaire, "De l'héroisme de la vie moderne," in "Salon de 1846," *Baudelaire: Oeuvres Complètes* (Paris, 1968), 259. All subsequent quotations in French are taken from this edition.

21. Baudelaire, "The Salon of 1845," in *Art in Paris 1845–1862: Reviews of Salons & Other Exhibitions,* trans. and ed. Jonathan Mayne (London, 1965), 32. "Combien nous sommes grands et poétiques dans nos cravates et nos bottes vernies." Baudelaire (as in n. 20), 224.

22. "The Dandiacal Body," Carlyle (as in n. 1), 256.

23. "The Painter of Modern Life," Baudelaire (as in n. 19), 398. "Un de mes amis me disait un jour qu'étant fort petit, il assistait à la toilette de son père, et qu'alors il contemplait, avec une stupeur mêlée de délices, les muscles des bras, les dégradations de couleurs de la peau nuancée de rose et de jaune, et le réseau bleuâtre des veines." "Le peintre de la vie moderne," Baudelaire (as in n. 20), 552.

24. "The Heroism of Modern Life," Baudelaire (as in n. 19), 105–106. "quant aux excentriques que les couleurs tranchées et violentes dénonçaient facilement aux yeux, ils se contentent aujourd'hui des nuances dans le dessin, dans la coupe, plus encore que dans la couleur. Ces plis grimaçants, et jouant comme des serpents autour d'une chair mortifiée, n'ont-ils pas leur grâce mystérieuse?" "De l'héroisme de la vie moderne," Baudelaire (as in n. 20), 260.

25. "Now some time ago there came upon the market, under the name of the 'Mystic Writing-Pad,' a small contrivance that promises to perform more than a writing-tablet from which notes can be erased by an easy movement of the hand. . . . If we lift the entire covering-sheet—both the celluloid and the waxed paper—off the wax slab, the writing vanishes and, as I have already remarked, does not reappear again. The surface of the Mystic Pad is clear of writing and once more capable of receiving impressions. But it is easy to discover that the permanent trace of what was written is retained upon the wax slab itself and is legible in suitable lights. Thus the Pad provides not only a receptive surface that can be used over and over again, like a slate, but also permanent traces of what has been written." Sigmund Freud, "A Note upon the 'Mystic Writing-Pad'" (1925 [1924]), *The Standard Edition of the Complete Psychological Works of Sigmund Freud* (London, 1953–74), 19, 228–29.

26. J. J. Winckelmann, "On the Imitation of the Painting and Sculpture of the Greeks" (1755), in David Irwin, ed., *Winckelmann: Writings on Art* (London, 1972), 61.

27. Winckelmann (as in n. 26), 64–65.

28. "He pierces not heaven, like the Laocoon of Virgil; his mouth is rather opened to discharge an anxious overloaded groan." Winckelmann (as in n. 26), 72.

29. Virgil, "Aeneas' Narration—The Sack of Troy," in *The Aeneid* (Harmondsworth, Middlesex, England, 1982), 57–58.

30. "To decapitate = to castrate. The terror of Medusa is thus a terror of castration that is linked to the sight of something. Numerous analyses have made us familiar with the occasion for this: it occurs when a boy, who has hitherto been unwilling to believe the threat of castration, catches sight of the female genitals, probably those of an adult, surrounded by hair, and essentially those of his mother." Sigmund Freud, 'Medusa's Head' (as in n. 25; 1940 [1922]), 18, 273.

31. Winckelmann (as in n. 26), 72.

32. Winckelmann (as in n. 26), 72.

33. "The sight of Medusa's head makes the spectator stiff with terror, turns him to stone. Observe that we have here once again the same origin from the castration complex and the same transformation of affect! For becoming stiff means an erection. Thus in the original situation it offers consolation to the spectator: he is still in possession of a penis, and the stiffening reassures him of the fact." Freud (as in n. 30), 273.

34. "The Dandy," in "The Painter of Modern Life" (as in n. 19), 420. "Un dandy peut être un homme blasé, peut être un homme souffrant; mais, dans ce dernier cas, il sourira comme le Lacédemonien sous la morsure du renard." "Le Dandy," in "Le Peintre de la Vie Moderne" (as in n. 20), 560. For an account of the French literature on dandyism, see Rose Fortassier, "Deux dandys et leur *mundus muliebris*," in *Les Écrivains français et la mode de Balzac à nos Jours* (Paris, 1988), 77–96.

35. "Ces attitudes toujours calmes mais révélant la force, qui nous font penser, quand nôtre regard découvre un de ces êtres privilégiés en qui le joli et le redoutable se confondent si mystérieusement: 'Voilà peut-être un homme riche, mais plus certainement un Hercule sans emploi.'" Baudelaire (as in n. 20), 561. According to Benjamin, Baudelaire represents dandyism as "the last shimmer of the heroic." Benjamin (as in n. 18), 96.

36. Barbey d'Aurevilly, *The Anatomy of Dandyism, with some Observations on Beau Brummell,* trans. D. B. Wyndham Lewis (London, 1928), 17. "Le Dandysme introduit le calme antique au sein des agitations modernes. . . . Si un Dandy était éloquent, il serait à la façon de Périclès, les bras croisés sous son manteau." J. Barbey D'Aurevilly, *Du Dandysme et de Georges Brummel* (Paris, 1879), 28. See also Charles Bernheimer, "Barbey's Dandy Narratives," in *Figures of Ill Repute: Representing Prostitution in Nineteenth-Century France* (Cambridge MA. and London, 1989), 69–88. Barbey D'Aurevilly published a prose poem on Laocoon in 1857: "O Laocoon! Laocoon! nous te connais-

sons. . . . Nous avons assez fremi devant ton bronze muet crie. Nous te connaissons, Laocoon! N'es-tu pas encore plus terriblement sculpté dans nôtre-propre chair que dans l'airain des plus fort sculpteurs? Ne somme-nous pas tous des Laocoons dans la vie?" *Deux Rhythmes Oubliés: Laocoon/Yeux Caméléons* (Caen, 1857), 8.

37. See, for example, Adolf Loos, "Men's Fashion," in *Adolf Loos: Spoken into the Void—Collected Essays 1897–1900* (Cambridge, MA. and London, 1987), and Le Corbusier, *The Decorative Art of Today* (Cambridge, MA., 1987).

38. J. C. Flugel, *The Psychology of Clothes* (London, 1940), 76–77 (first published 1930).

39. Heard (as in n. 2), 10.

40. "Le Dandysme est toute une manière d'être, et l'on n'est pas que par le côté matériellement visible. C'est une manière d'être, entièrement composée de nuances." D'Aurevilly (as in n. 36), 12–14.

41. A number of sources claim 1872 as the year of the Hanlon-Lees' first appearance in Paris, for example David Leslie Murray, *Scenes and Silhouettes* (London, 1926), 128. According to Strehly, however, it was the brothers Hanlon, who had trained with the Hanlon-Lees, who appeared at the Folies-Bergère in 1872. Strehly (as in n. 12), 186. In Hugues Le Roux and Jules Garnier, *Acrobats and Mountebanks,* trans. A. P. Morton (London, 1890), 293, however, one finds the following account of the troupe: "The Hanlon-Lees! How many pleasant artistic feelings the name evokes in the memory of Parisians. The troupe is scattered now, throughout the world, there are the Hanlon-Lees on one side, the Hanlon-Volta on another, three of the brothers are dead, and their comrade Agoust has abandoned them to become manager of the Nouveau Cirque." Le Roux cites *Memoirs of the Brothers Hanlon-Lee* (preface by Théodore de Banville); I have been unable to consult this. Fig. 27 is taken from Strehly, p. 185. Strehly (p. 186) claims that the Hanlon brothers met the Volta twins (sometime after 1872) in the United States whereupon the two troupes joined to form the "Hanlon-Voltas."

42. As quoted in M. Willson Disher, *Clowns & Pantomimes* (London, 1925), 195, and Murray (as in n. 41), 129.

43. Huysmans (as in n. 11), 24. "Toute l'esthétique de l'école caricaturale anglaise est de nouveau mise en jeu par les scénarios de ces désopilants et funèbres acrobates, les Hanlon-Lees! Leur pantomime si vraie dans sa froide folie, si férocement comique dans son outrance, n'est qu'une incarnation nouvelle et charmante de la farce lugubre, de la bouffonerie sinistre, spéciales au pays du spleen et déjà exprimées et condensées par ces merveilleux et puissants artistes: Hogarth et Rowlandson, Gillray et Cruikshank." Huysmans (as in n. 14), 345.

44. Murray (as in n. 41), 129.

45. Murray (as in n. 41), 117. Quoted from Edmond De Goncourt, *Les frères Zemganno* (Paris, 1879), 169–71: "Sinistre est devenue la clownerie anglaise

de ces dernières années. . . . Et ce ne sont depuis quelque temps, dans l'arène des cirques et sur les théâtres des salles de concert de la Grande-Bretagne, que des intermèdes où les gambades et les sauts ne cherchent plus à amuser l'oeil, mais s'ingénient à faire naître, et des étonnements inquiets et des émotions de peur et des surprises presque douloureuses, de ce remuement étrange et maladif de corps et de muscles, où passent mêlés à des pugilats ricanants, à des scènes d'intérieur horripilantes, à des cocasseries lugubres, des visions de Bedlam, de Newcastle, d'amphithéâtre d'anatomie, de bagne, de morgue." For the relevant bibliographic reference, see note 49 below. The reference to "Newcastle" in the above quote should probably read "Newgate," the nineteenth-century English prison.

46. Murray (as in n. 41), 117.

47. Murray (as in n. 41), 117.

48. "Terminée en une pantalonnade excessive, en une charge désordonnée, cette cruelle étude de la machine humaine aux prises avec la peur a fait se tordre et pouffer la salle." Huysmans (as in n. 14), 345.

49. Edmond De Goncourt, *Les frères Zemganno* (Paris, 1879). De Goncourt, *The Zemganno Brothers* (London, 1886). All subsequent text and note references will be to this English translation and the French first edition. Disappointed with the apparently unenthusiastic reception of *Les frères Zemganno* (and specifically in response to the criticisms of the novel voiced by Barbey D'Aurevilly) De Goncourt wrote in his *Journal*: "cette original chose, essayée par moi dans ce roman, de cette tentative faite pour émouvoir avec autre chose que de l'amour, de la substitution d'un intérêt autre que celui employé depuis le commencement du monde." Edmond et Jules De Goncourt, *Journal: mémoires de la vie littéraire,* 18 May 1879 (Paris, 1956), 20.

50. De Goncourt (as in n. 49), 84. "Pourtant ils était les auteurs et les acteurs de petits poèmes gymnastiques d'une invention toute neuve." De Goncourt (as in n. 49), 194.

51. De Goncourt (as in n. 49), 45–46. "Puis l'enfant aux longs cheveux, aux membres grêles, naturellement et comme si les poses des statues antiques étaient nées de la gymnastique, croisait ses bras, et une jambe devant l'autre posée sur l'orteil, le talon relevé, semblait dans son immobilité une statuette du Repos dans un musée." De Goncourt (as in n. 49), 86.

52. De Goncourt (as in n. 49), 100. "Les deux frères menaient une existence tranquille, rangée, unie, sobre, presque chaste. Ils vivaient sans maîtresses, et ne buvaient guère que de l'eau rougie. Leur plus grande distraction: c'était, tous les soirs, une petite promenade sur le Boulevard, pendant laquelleils allaient auprès de toutes les colonnes, l'une après l'autre, lire sur chacune des affiches, leurs noms imprimés. . . . Puis en eux se conservait la pure tradition italienne, . . . que les hommes de leur état doivent s'astreindre à une *hygiène de prêtres,* et que la force ne se conserve dans toute sa plénitude et avec tous ses ressorts qu'au prix de la privation 'de Bacchus et de Vénus':

tradition venant en droit ligne des lutteurs et des artistes de muscle de l'antiquité." De Goncourt (as in n. 49), 253–54.

53. De Goncourt (as in n. 49), 65. "Cet accord semblait seul et unique pour les deux corps." De Goncourt (as in n. 49), 129.

54. De Goncourt (as in n. 49), 31. "Dans toutes ces choses exécutées par la force des bras, il y avait un rhythme cadencé du travail musculaire." De Goncourt (as in n. 49), 54.

55. De Goncourt (as in n. 49), 43. "Dans tous ces exercises, Nello avait toujours, autour de son essai, le rond de bras protecteur de son frère." De Goncourt (as in n. 49), 79.

56. De Goncourt (as in n. 49), 80. "Nello, sans rappeler sa mère par une ressemblance frappante au premier coup d'oeil, en était tout le portrait. Le dernier-né avait beaucoup de sa conformation physique, et un peu du féminin de la bohémienne était répandu sur la délicate masculinité du clown." De Goncourt (as in n. 49), 178.

57. De Goncourt (as in n. 49), 101. "Les femmes quelles qu'elles soient, n'aiment pas les intimités d'hommes . . . prend peur des grandes amitiés masculines." De Goncourt (as in n. 49), 257.

58. In speaking of Parisian music-halls, Strehly claimed: "comme leur spectacle ne parle qu'aux yeux, ils conviennent mieux au public international qui les fréquente." Strehly (as in n. 12), 54. Similarly, Murray described clowns as "international figures." Murray (as in n. 41), 128. Murray argues that mute play-acting derived from English pantomime was enthusiastically adopted in Paris in order to evade official surveillance: "dumb-show performances were not 'plays' within the meaning of the Acts protecting the great Paris theatres." Murray (as in n. 41), 126.

59. Maupassant (as in n. 17), 21. "Il gonflait sa poitrine pour dissimuler son estomac trop saillant; et sa figure semblait celle d'un garçon coiffeur, car une raie soignée ouvrait sa chevelure en deux parties égales, juste au milieu du crâne." Maupassant (as in n. 17), 16.

60. Hughes Le Roux and Jules Garnier (as in n. 41), 294.

61. Bataille (as in n. 6), 35. "Ce qui, dans ces anecdotes, est en cause est la transformation de la peinture. . . . Dès l'instant où les poses éloquentes de modèles l'ont enragé, l'exigence de Manet se révéla dans cette impatience."

62. Bataille (as in n. 6), 71. "Si l'on m'entend, le vêtement et la peinture ont suivi des voies parallèles. Du moins le vêtement masculin. Par degrés, le vêtement de l'homme s'embourgeoisa: il perdit de la majesté qu'il avait encore au XVIIe siècle. Il avait alors l'éloquence et la lumière. L'homme n'a plus aujourd'hui le lustre qu'il tenait de la dignité covenue, ni du vêtement qui répondait à cette dignité."

63. Linda Nochlin has studied the sequence of frock-coated male figures that appear in Manet's work; she investigates the ways in which these partial figures (fragmented by the picture frame) operate as "sexually suggestive" in

scenes of "erotic commerce." See "Manet's *Masked Ball at the Opera*," in *The Politics of Vision: Essays on Nineteenth-Century Art and Society* (London, 1991), 75–94.

64. Flugel (as in n. 38), 110–13.

65. Bataille (as in n. 6), 104. "[le] principe de silence."

66. Bataille (as in n. 6), 102. "*Un bar aux Folies-Bergère* est bien la fête illimitée de la lumière, absorbant la beauté inerte de la serveuse."

67. Bataille (as in n. 6), 88. "*Un bar aux Folies-Bergère* est un ensorcellement de la lumière que renvoie le jeu d'une glace de vaste dimensions."

68. Bataille (as in n. 6), 46. "N'est qu'un jeu de lumière traduit, saisi dans le tremblement de la vieille main."

69. Bataille (as in n. 6), 88. "Une dernière fois Manet donna l'absence du vide à l'une de ses compositions."

70. Bataille (as in n. 6), 50. "Mais c'est *Le Suicidé* de 1881, le pistolet pendant au bout du bras, qui manifeste le plus clairement un désir de nier—ou de surmonter—l'horreur et de la réduire à la naïveté de la lumière."

71. "Towards a Newer Laocoon" (1940) reprinted in John O'Brian, ed. *Clement Greenberg: The Collected Essays and Criticism*, vol. I (Chicago and London, 1986), 23–38. G. E. Lessing, "Laocoon or The Limits of Painting and Poetry" (1766) reprinted in William A. Steel, ed., *Laocoon/Nathan the Wise/Minna von Barnhelm* (London and New York, 1970), 42. See also, Irving Babbitt, *The New Laocoon: An Essay on Confusion in the Arts* (New York, 1910).

72. Baudelaire (as in n. 19), 105. "Une immense défilade de croque-morts, croque-morts politiques, croque-morts amoureux, croque-morts bourgeois." Baudelaire (as in n. 20), 260.

73. André Malraux, *The Voices of Silence* (London, 1954), originally published as *Les Voix du Silence* (Paris, 1954). "Au chant des formes et des couleurs." Bataille (as in n. 6), 35.

Privilege and the Illusion of the Real

JAMES D. HERBERT

As measured by the amount of attention garnered from art historians, Manet's *Bar at the Folies-Bergère* of 1881–82 (frontispiece) has been, especially of late, a privileged painting.[1] The canvas has elicited repeated consideration, in large part, because it has forestalled resolution on a crucial issue: is this picture a transcription of actual happenings at a certain Parisian music hall, or is this surface an accumulation of the traces of Manet's sophisticated manipulations of the illusions of painting? I will argue in this essay that the interaction between these two basic interpretative approaches to *A Bar at the Folies-Bergère*—regarding the painting as a record of the real and deeming it an illusion—generates privilege not only for the painting, not only for the painter and certain of the social types he portrayed, but also for the art historians who analyze the picture and interpret the words that their colleagues write about it. I can hardly claim to step outside this system for the production of rank; my essay appears in a book, after all, that both declares Manet's picture worthy of monographic attention and provides a forum for exchange among scholars. From the inside, then, I would like to examine the mechanisms of privilege that have been enacted through and around *A Bar at the Folies-Bergère;* enacted in the painting, in its critical and art historical reception, and in the historiographic assessment of that reception.

What is *A Bar at the Folies-Bergère* about? The title points toward a plausible answer: it is about a bar at the Folies-Bergère. Critics who discussed the painting at the time of its first exhibition in 1882 often worked to realize this interpretive possibility. Consider the meticulous inventory of details penned by Paul Alexis when he previewed Manet's canvas for the readers of *Le Réveil* a month before the work was shown at the Salon of 1882. Alexis commenced with the "beautiful girl, truly alive, truly modern, truly 'Folies-Bergère,'" moved on to elements of the scene reflected in the mirror, "[the] candelabra, the

busy, teeming crowd, and far away in the background a redness which is the red velvet of the boxes," and finished up with the "amusing and varied wares" on the counter in the foreground, "liqueur decanters, bottles of champagne, mandarin oranges in a crystal bowl, flowers in a vase, etc."[2] The critic, with great thoroughness, articulated a set of correspondences between strokes of paint on canvas and what he took to be the actual site of the Folies-Bergère; he insisted on a one-to-one matching directed toward tying each signifying element in Manet's image down to the real.

The painting, however, resists such a direct correlation. Manet's loose handling of paint and the perspectival inconsistencies of the reflection in the mirror—aspects of *A Bar at the Folies-Bergère* that have been thoroughly rehearsed in the literature on the picture—defy established conventions of mimesis. The image both exceeds and falls short of the responsibilities of iconic representation: corpulent brush strokes seem in their fullness to represent something more than the sparkle of glass or the play of light through lace, while the composition nevertheless fails to provide sufficient information about the spatial order of the place portrayed. Maurice du Seigneur protested in the pages of *L'Artiste* after the exhibition opened: "Manet's *Bar* almost makes one want to go [to the Folies-Bergère], one of these evenings, in order to understand the truth of the room's reflection in the mirror on the spot, in front of nature."[3] For du Seigneur, a glimpse of the actual music hall promised to resolve the ambiguities and trim the superfluities of Manet's picture. Measured in this manner against the real, Manet's image takes on the status of illusion.

Thus the matter stood for many years: critics and scholars, art historians and *amateurs* debated amongst themselves whether *A Bar at the Folies-Bergère* captured the real or, to the contrary, displayed illusion. (Illusion has been given a variety of names in accounts of Manet's painting, but over the past half-century it has perhaps most frequently been cast as a form of proto-abstraction that led the way toward the abstract schools of the twentieth century.) Those speaking from a historiographic perspective—my text for the preceding several paragraphs may serve as an abbreviated sample of the practice—find themselves, in assessing the acquired knowledge on Manet's picture, balancing the real against the illusory.

Only quite recently has T. J. Clark formulated a strikingly new assessment of reality and illusion in Manet's canvas. The café-concert

and the music hall, according to Clark, were sites for the production of the illusion that went by the name of the "popular," an illusion that served to obscure the "definite set of class relations" taking shape in the rapidly modernizing city of Paris. *A Bar at the Folies-Bergère* concerns itself with precisely this production of an illusion. Hence, argues Clark, the explanation offered by the painting for the world it portrays,

> consists . . . in the "actual social circumstances" barely appearing to be any such thing—to be either actual or social—to us or the actors involved in them. A curious balance must thus be struck. The circumstances must all be *there* in the picture, but somehow not quite convincingly. They must be seen to apply to the barmaid, but at one remove, as if they came to her—to us—as things slightly insubstantial, not wholly real.[4]

In essence, the artist in Clark's account adopts the position previously occupied by the historiographer. Manet, in painting his picture about class relations and their effacement, explored and assessed the interplay between reality and illusion.

And yet, curiously, Clark insists on the reality of Manet's balancing act of the illusory and the real. The "kinds of matching . . . between [the] formal arrangement [of the painting] and the actual subject, the bar and the barmaid," are explained and underwritten, in Clark's argument, by "the plausible hypothesis . . . that inconsistencies so carefully contrived must have been felt to be somehow appropriate to the social forms the painter had chosen to show."[5] Clark here posits a metalevel of reality: the "social forms" to which *A Bar at the Folies-Bergère* corresponded are not Clark's "definite set of class relations" but rather the interactions he describes between those relations and the music hall's illusions. And just as the critic Alexis strove to tie Manet's picture down to the physical site of the Folies-Bergère detail by detail, Clark's essay works to establish a "kind of matching," between *A Bar at the Folies-Bergère* and the metareality of modernity's complex and inconsistent "social forms."[6]

Clark thus positions *A Bar at the Folies-Bergère* as a rather special painting. If, according to Clark, contemporary painting "was mostly a complaisant spectator of [the] spectacle" of "popular culture" as that culture "provided the petit-bourgeois aficionado with . . . forms of illusory 'class,'" Manet's canvas "suggest[s] the unease and duplicity involved in this attaining to a new class."[7] Inferior paintings, in other

words, blindly reiterated the illusions performed by popular culture and thereby concealed the reality of a "definite set of class relations," while *A Bar at the Folies-Bergère* disclosed the metareality of the music hall's interplay of illusion and the real.

Yet to perceive an engagement between the real and illusion in Paris during the second half of the nineteenth century was not a neutral act, grounded in and authorized by its correspondence to the metareal. Rather, the position from which the balance could be observed was a social construct, and one that granted great privilege to the observer. Not everyone could see the places where reality and illusion intersected—indeed, I would argue, reality and illusion thus perceived existed only for the chosen few.

In a particularly lucid manner, Edgar Degas' *Rehearsal of the Ballet on the Stage* of 1874 (fig. 29) manifests just this sort of privilege. To paint this picture, it would seem, the artist took himself to the stage of the Opéra, the site of that most mannered and artificial of the corporeal arts, the ballet. The painting, however, positions the artist not as witness to the public spectacle offered by the ballet, the polished performance presented to ticket holders seated in the house. Rather, the artist views the ballet from the wings and after hours, from much the same position as do the two gentlemen seated across the way. From such a vantage, Degas ostensibly perceives both the product and the production of the ballet's artifices. The picture purports to reveal not only the ballet's illusions of grace and effortlessness—the dancer *en point*, say, or the ballerina in fourth position further upstage—but also its realities—sore muscles in need of a rub and backs awkwardly scratched among those freed for a moment from the rigors of the drill. The ballet master, around whom the action swirls in Degas' depicted scene, exerts the discipline necessary to transform painful reality into artful illusion.

In the most obvious of senses, Degas' access to the stage of the Opéra involved the exercise of a prerogative. Eugène Chapus, author of popular guidebooks, expostulated in his book *Le Sport à Paris* of 1854:

If only you are a financier, an investor wearing yellow gloves, a stockbroker, a rich foreigner, a diplomat, an embassy attaché, a man of the world in high repute; if only you have influence in powerful places; if only, again, you can fabricate for yourself a more or less real title . . . ; if you are something like the uncle of a dancer or her

protector, the tutor of a *panther* or her mahout, then the portals [to the backstage at the Opéra] become open to you.[8]

Degas certainly enjoyed the social standing of such *abonnés* at the Opéra, and fully exploited the license for free passage thus extended to him.

Yet rank realized itself not so much in having access to certain spaces as in possessing the capacity, within restricted social sancta such as the backstage of the Opéra, to perceive, comprehend, and ultimately master one's surroundings. A "man of the world," as Charles Baudelaire defined the term in 1863, was "a man who understands the world and the mysterious and lawful reasons for all its uses. . . . He wants to know, understand and appreciate everything that happens on the surface of our globe." Like the convalescent he "is possessed in the highest degree of the faculty of keenly interesting himself in things"; and if he has the gift of genius he can apply his "power of analysis which enables [him] to order the mass of raw material which [he] has involuntarily accumulated."[9] Hence, in Baudelaire's terms, a curiosity to know the world drove Degas to the Opéra, and once ensconced backstage he distinguished the subtle details of beauty and of ugliness—the perfect turn of an ankle, the ungainly jab of an elbow. When in the pages of the *Gazette des beaux-arts* the critic Charles Ephrussi reviewed Degas' pictures of the ballet at the fifth Impressionist exhibition in 1880, he enthused: "One really must praise . . . this shrewd observation directed uniformly over the secret miseries of these high priestesses of the harmonious art of the dance."[10] Degas' penetrating "observation," it would seem, could discern not only the illusions of the "harmonious art" but also the reality of its "secret miseries." The artist, in short, perceived and comprehended the difference between the real and the illusory, and reveled in exploring their interactions in places such as the ballet.

In social practice, not everyone enjoyed the attributes, as did Degas, of access and discriminating perception. With the obvious exception of the ballerinas (and their mothers), women could not venture backstage; ladies sufficiently equipped with cultural capital to be considered suitable observers of the productions of the stage (already a select group) did their observing from the loges or the orchestra. More important, to these worthy viewers was ascribed, to borrow a phrase from Mary Ann Doane, a "peculiar susceptibility to the image." The debutante in Renoir's *The First Outing* of 1875–76 (fig.

218

30) is rapt, absorbed in the performance. Though seated some distance from the stage in the house of the theater, she has been lured psychologically if not physically across the proscenium; the spectacle has taken her in. Doane's analysis of Hollywood cinema applies equally well, I believe, to Renoir's canvas: "There is a certain naiveté assigned to women in relation to systems of signification—a tendency to deny the processes of representation, to collapse the opposition between the sign (the image) and the real."[11] Engrossed by the events on stage, Renoir's young lady appears to have engaged her real emotions and forgotten that she is witnessing only a theatrical illusion.[12] Much the same fate befalls Flaubert's Emma when she visits the theater in *Madame Bovary:* "She gave herself up to the flow of the melodies, and felt all her being vibrate as if the violin bows were being drawn over her nerves. Her eyes could hardly take in all the costumes, the scenery, the actors." While for a moment Emma attempts to distance herself—"Striving for detachment, Emma resolved to see in this reproduction of her sorrows a mere formal fiction for the entertainment of the eye"—in the end she succumbs: "All her attempts at critical detachment were swept away by the poetic power of the acting."[13] The *abonnés* scouting backstage at the Opéra, the likes of Degas, would presumably never have made such categorical mistakes, conflating reality and illusion.

Renoir, in turn, seems rather taken in—dazzled, in fact—by the spectacle of feminine beauty in front of his eyes. Confined by his class rather than his sex to the public spaces of the Opéra—Renoir was no "man of the world"—this artist, by all appearances, also failed to distinguish seductive images from their production. More generally, there is a sense in which Renoir and (to a lesser extent) Monet, both provincials recently arrived in the big city, hopelessly confused illusion and reality as they strolled the urban *boulevards* and ventured out to the suburban *guinguettes.* They mistook—I speak here from a perspective that could be either Baudelaire's or Clark's—the façades of Second Empire society, as of Haussmann's Paris, for the substance hidden behind them. Degas' "powers of analysis" that ostensibly permitted him to understand the reality of the world rather than be deceived by its illusory appearances thus staked out a privilege of class just as surely as it marked out the prerogatives of gender.

In all of this, it is crucial to keep in mind that reality and illusion in Degas' pictures were as much social constructions, the products and

ciphers of privilege, as was the position of articulation from which they were perceived. Their interplay should not be mistaken by us for the actual state of affairs at the ballet. The dancer in fourth position in *The Rehearsal of the Ballet on the Stage,* for instance, may at first appear to be a real case of the ballet's creation of an illusion; Degas, we are lead to believe by the fiction of the picture, really saw her pose like this upon the stage. Yet in other paintings by Degas this same ballerina strikes this same pose seen from the same angle in entirely different settings, most notably in the rehearsal room depicted in the Orsay version of *The Dance Class* of 1873–76. She—or rather this collection of shapes and lines—served as one of Degas' stock figures, in the rhetorical sense of the term, for the representation of illusion, just as a different set of templates of the human body awkwardly posed repeatedly represented the real.

In conjunction, such rhetorical figures represented Degas' privileged vision, which is to say his ostensible capacity to perceive the metareality of the balance between the real and illusion. Degas' pictures, in essence, have the artist outflank the likes of Renoir: Degas can represent Renoir's sort of reality (the seductive spectacle) as illusion and grasp a seemingly deeper reality beyond it, while Renoir can perceive neither Degas' reality nor his metareality of the balance between illusion and the real. Through such mechanisms—it begs all questions to ask who got Paris right, whose real is more real—social rank was made.

The Manet of *A Bar at the Folies-Bergère* claims fraternity with the Degas of *The Rehearsal of the Ballet on the Stage* more than with the Renoir of *The First Outing.* The image places the artist on terrain that, in practice if not through explicit prohibition, remained nearly as exclusive as the corridors of the Opéra. "Manet's painting," explains Robert L. Herbert,

> evokes one of Paris's more expensive and *chic* places. It is true that a student, sales clerk, or prostitute could come to the Folies-Bergère, but only by dressing up and squandering a small fortune. If the Folies was a social mixing place, it was nonetheless quite dominated by the well-to-do. Manet's own society went there, urbane writers, critics, collectors, painters, actors, demi-mondaines, and members of the Jockey Club.[14]

This was, of course, the same circle that joined Degas backstage with the dancers of the ballet.

More importantly, *A Bar at the Folies-Bergère* casts its creator as a curious and perceptive "man of the world," assaying the interchange of reality and illusion. The real and illusion are here figured, most obviously, along the axis of depth, in the contrast between the foreground tableau—the counter and frontal barmaid—and the scene unfolding in the reflection. It is an illusory depth, certainly: that which at first appears to take place over there, behind the barmaid's back, may actually be happening over here, behind the viewer and Manet. Positioned as he is, Manet ostensibly takes it all in, discerning reality from illusion with a Baudelairean "keen interest." In contrast, the depicted barmaid—less privileged than the artist in terms both of class and of gender—faces away from the revealing mirror, and presents a countenance that speaks of something other than curiosity. The sophisticated artist, unlike his female foil within the painting, strives (here I alter Baudelaire's meaning with a tactical ellipsis) "to know, understand and appreciate everything that happens on the surface . . ." of the mirror. No wonder, then, that Manet stands as art history's—if not quite Baudelaire's—exemplary "painter of modern life."

It is rather tempting to locate the balance of reality and illusion in *A Bar at the Folies-Bergère* in an actual entity within the picture, to locate it in the mirror. This reflecting surface, after all, stands both as a material object situated in the foreground (we can see the bottom edge of its golden frame behind the barmaid) and as a window onto the realm of reflection. Across this plane signs of the real—bottles, barmaid, and the like—encounter signs of illusion—the background crowd, frostiness and fuzziness, the loss of a sense of depth. The mirror, in short, can become the rhetorical figure in *A Bar at the Folies-Bergère* for the metareality of the site. Something quite like this occurs, I contend, in Degas' *Rehearsal of the Ballet on the Stage*. There the institution of the ballet orchestrates the interplay of reality and illusion: it built the stage flats viewed from the side, it prescribed the poses of the dancers. That institution in Degas' painting, like the mirror in Manet's canvas, is the figure of the interaction between the real and the illusory.

Yet the mirror in the music hall in *A Bar at the Folies-Bergère* does not manage reality and illusion as adeptly as does the institution of the ballet in *Rehearsal of the Ballet on the Stage*. Things happen in this picture for which the mirror offers no reasonable account: the problematic displacement of the barmaid's reflection to the right, the

subtle mismatch between the arrangement of bottles in the left fore-ground and that of the corresponding group in the mirror, and so forth. This set of illusions appears the product not of the distortions of the mirror—an actual entity at the music hall—but rather of the compositional manipulations of the artist. Manet the painter, it would seem, shifted the barmaid's reflection off to the side; Manet tucked the green bottle of ale in the reflection too far behind the wine and champagne.

The artist's thick, often unctuous brush strokes mark out the place where such manipulations occur: the picture plane of the canvas. If the mirror's surface embodies the metareal where foreground reality and background illusion meet, the paint-covered canvas correspondingly becomes Manet's figure of artistic metaillusion. The balance between foreground and background negotiated across the mirror's surface repeats itself, on a metalevel, in the negotiation between that surface and the picture plane. Nothing of this sort happens in *The Rehearsal of the Ballet on the Stage*, where Degas' more-or-less strict adherence to the conventions of Realism of the mid-nineteenth century effaces the status of the picture plane as a rhetorical figure: seemingly stripped of artistic metaillusions, it appears for the most part a transparent window onto the metareality of the ballet. In *A Bar at the Folies-Bergère* the perfect correspondence between the figure of the metareal (the mirror) and that of metaillusion (the surface of the canvas) cannot thus be taken for granted. The picture balances the one against the other.

This balance, like the first between reality and illusion, serves as a device of privilege. In casting Manet as the negotiator of metareality and metaillusion—it is he, after all, who plays mirrored surface against the picture plane—*A Bar at the Folies-Bergère* posits a third level, above metareality and metaillusion, as the position from which its author speaks. Any "man of the world" can look into the mirror at the Folies-Bergère; only the artist can balance the metaillusions of the canvas against the metareality of the interaction of the real and the illusory taking place in that mirror. "Few men are gifted with the capacity of seeing," wrote Baudelaire about the painter of modern life; "there are fewer still who possess the power of expression."[15]

Again, Degas—this time the later Degas—provides an instructive parallel case. In Degas' late canvases and pastels of the ballet—virtually any image from the 1880s until Degas' death in 1917 will serve to make the point—thick skeins of pigment and medium build

up on the surface to disrupt the ostensible transparency of the Realist picture plane. Lines and patches of color, moreover, appear to break free of the object they are meant to portray to assume a life of their own. Degas the painter, not Degas the *abonné*, balances this level of artistic metaillusion against the metareality of the ballet. Where *The Rehearsal of the Ballet on the Stage* formulates prerogatives of gender and class for the "man of the world," Degas' later pictures—and Manet's *Bar at the Folies-Bergère*—establish the rank of the artist over even these highly privileged gentlemen. The pictures of the late Impressionists—I would generalize this argument to include Monet, Cézanne, and others—thus attribute to their creators access to a higher, artistic knowledge founded not on the painters' plunge into absolute abstraction (as it is often described in conventional teleological accounts of the progress of modernism) but on their skillful negotiation of art and reality, both ostensibly perceived profoundly. That attribution is as much a social formulation of prerogative as was the granting of perquisites to the *abonnés* at the Opéra.

The production of privilege in *A Bar at the Folies-Bergère* through the conferral of control over a balance between reality and illusion (at whatever level) has continued after the completion of Manet's picture in 1882. As we have seen, critics, in writing about the painting, asserted their capacity to discern the real from the illusory. Du Seigneur's desire to go to the Folies-Bergère to "understand the truth of the room's reflection" takes for granted the writer's aptitude to make sense of the site and subsequently to name Manet's distortions; and even Alexis' catalogue of details implicitly credits the critic with the ability to separate significant wheat from meaningless chaff. Art historians, no less than art critics, resist being outranked by artists on matters concerning the discrimination of reality and illusion.[16] Clark "understands . . . the mysterious and lawful reasons" of *A Bar at the Folies-Bergère* and uses his considerable "powers of analysis" to tie it down to the metareal. No one wants to play Renoir's naïf to Manet's sophisticated "man of the world"; if Alexis and du Seigneur can distinguish reality from illusion, Clark can differentiate metareality from metaillusion in Manet's painting.

Art historians, moreover, often turn themselves into art historiographers in order to assert the reality of their interpretations over the illusions of those of others. When Françoise Cachin condemns a preliminary version of Clark's analysis of *A Bar at the Folies-Bergère* as "an ideological mirage, imposed on a work even in spite of itself," she

asserts not only the illusory nature of Clark's text, but also her capacity, from a position seemingly above the fray, to differentiate the illusions of Clark from the reality of Manet.[17] Cachin attempts to outflank Clark—she considers his reality to be illusory—and Clark, in turn, might well wish to outflank Cachin by treating her reality as an illusion. In so doing each claims a privileged position of analysis—and such claims are potentially as ripe with social implications as were Manet's and Degas' assertions of the power to apprehend.

Now, there are several ways in which you, the reader, can take this argument. As you may have noticed, I have shifted registers twice over the last several paragraphs, first from art history to art historiography, then from historiography to an analysis of historiographic activity. You can accept my metahistoriographic account—my presentation of Cachin's assessment of Clark (a real event) and Clark's assessment of Cachin (my illusion)—as an accurate description of the real state of historiographic affairs. Or you may decide that I have produced a metahistoriographic illusion, which you, from a meta-metahistoriographic plateau, can balance against the real metahistoriographic situation.

Clearly we are launched here on an unproductive track of infinite regress. Rather than extend the practice (I, for instance, might consider your metametahistoriographic assessment of my metahistoriography to be illusory, and so on), I would like to highlight its political function. Each time a social actor—Degas the *abonné*, Manet the painter, Clark the art historian, Cachin the historiographer, me the metahistoriographer, you the metametahistoriographer—negotiates an interaction between reality and illusion, he or she constructs a further metalevel from which to conduct that negotiation. Every time such actors ferret out the illusions of others, they figure their own metapositions of articulation as the real. These operations create privilege. When scholarship reiterates rather than examines the capacity to sort out the real from the illusory in *A Bar at the Folies-Bergère* (or in the literature on *A Bar at the Folies-Bergère*, and so on *ad infinitum*), it brackets and thus removes from analysis a principal mechanism of privilege exercised by the painting. In this sense the infinite regress is far from unproductive, for it produces, over and again, the reality effect that legitimates a system of social ranking.

This process hardly comes to an end with my description of it: the preceding paragraphs are not meant to reveal the making of privilege

as an illusion. Moreover, we cannot disown privilege; nor would we want to do so. Interests are served, benefits derived all up and down this ladder of balances and metabalances. There are advantages, however, to figuring privilege as the function of the dialectic of reality and illusion, rather than inscribing it in the real (or, more precisely, in the highest level of the real yet staked out). To analyze privilege, and reality and illusion, as social products means that we need not accept prerogatives already formulated as givens, as real. We can make some choices about positions of articulation we would like to see privileged—and not only in our present moment.

By way of example, I return to *A Bar at the Folies-Bergère*. In the account above certain actors—men, members of a certain class, Manet the artist—have privileged vision. But need it be so? Can we not imagine a subject figured female for this painting?[18] Can we not imagine, that is, a subject that reflects on herself rather than serving as the unreflecting object of someone else's vision? It is a principal conceit of the painting, after all, that it depicts a mirror. We can figure the relation between mirrored surface and picture plane not as a metaphoric balance—the picture plane is like a mirror in some respects and unlike it in others—but as a metonymic transference: the picture plane, running parallel to the mirror, assumes its characteristic of reflexivity. Suddenly the starkly frontal image of the barmaid takes on an entirely new meaning. Her unflinching yet diffused gaze becomes, convincingly, the look of someone examining her reflection—the reflection not just of her eyes but of her whole corporeal presence— in a mirror. Indeed the dimensions of the painted image of the barmaid's body, almost precisely half life-size, correspond to the proportions a woman would see when viewing herself in a mirror (regardless of her distance from the reflecting surface, I should add, for the image on the surface of a mirror always lies exactly half the distance between the perceiving eye and the reflected body of which that eye is part).

"The traditional view of a mirror," writes Jane Gallop in a conveniently succinct gloss of Lacanian theory, "is that it reflects a self, that it produces a secondary, more or less faithful likeness, an imitation, a translation of an already constituted original self. But Lacan posits that the mirror constructs the self, that the self as organized entity is actually an imitation of the cohesiveness of the mirror image."[19] Accordingly, *A Bar at the Folies-Bergère* offers a mechanism for the formation of a subjectivity, for the granting of a position of articula-

tion to a subject figured female. We as viewers can identify with that subject position as readily as we identify with that alternative subject position articulated by the painting, that of the artist Manet. Thus my statement above, "[she] examin[es] her reflection . . . in a mirror," can authorize for us a viewing position figured female—we see ourselves reflected in this body—just as statements by previous art historians have authorized our viewing the painting through the eyes of Manet, or rather through the subject position that goes by the name of Manet.

Another subject, by this analysis, is also formulated by the mirror: the dapper fellow—let us call him the dandy—appearing in the reflection along the right edge of the canvas. Manet's picture thus sets up an interplay between two self-reflexive subject positions, each with its own vantage point, and each with its own perspectival vanishing point directly across the way in the parallel plane of the mirror. Virtually all of the compositional discrepancies in *A Bar at the Folies-Bergère*, in fact, can be accounted for as the products of Manet's rather systematic intermingling of perceptions from these two vantage points. The position directly in front of the canvas makes perfect sense of the frontal image of the barmaid, for instance, but not of her reflection; the dandy's vantage easily accommodates the reflected barmaid in relation to the foreground body but not the uncompromising frontality of that foreground figure. The bottles in the reflection need no longer match the arrangement of the foreground collection if we imagine that we are viewing a different set of bottles, further down the counter to our left, from the dandy's radically raking angle; the short end of the marble counter next to them, nevertheless, points as an orthogonal to a spot only minutely to our right of the barmaid's left eye, affirming the central viewpoint as the operative vantage.

That central location, of course, need not be granted to the barmaid. When the subject position directly in front of the canvas is taken to be Manet's, a matching of gender occurs between the two vantage points, reinforced by the perception of Manet as himself a rakish fellow taken to frequenting such locales as the Folies-Bergère. These two positions, not identical, can appear to develop narratively the one into the other. *A Bar at the Folies-Bergère* can be read, given these terms, as the telling of a masculine tale. Robert L. Herbert, implicitly placing us as viewers in the shoes of Manet in his role as a dandy, articulates one of the various forms this narrative can take:

Manet makes us consider this woman's actual role as professional barmaid, and her potential role as envisioned by that man. Her frontal image is correct, even distant from us; nothing hints at her availability after hours. In the mirror, her more yielding nature is revealed, detached as it were from her body by the man's powers of wish-fulfillment. . . . We can't really be that man, yet because we are in the position he would occupy in front of the bar, he becomes our second self. His disembodied image seems to stand for a male client's hidden thoughts when facing such an attractive woman.[20]

This is an archetypal narrative structure, moving from dramatic conflict (can man get woman?) to dramatic resolution (man gets woman). Interpreted in this manner, *A Bar at the Folies-Bergère* figures subjectivity as male twice over: man is the subject not only of the look but also of the story. In the words of Teresa de Lauretis, such a placing of "male-hero-human on the side of the subject and female-obstacle-boundary-space on the other," which dates at least from the myth of Oedipus, sets up a drama that "has the movement of a passage, a crossing, an actively experienced transformation of the human being into—man."[21]

When, however, we do allow the picture plane to reflect back in the central location a subjectivity figured female, the lack of a match of gender between central vantage and right-edge vantage disrupts such privileging narratives. We can no longer imagine a smooth dramatic development between these two subject positions, or fantasize a successful resolution to the story. De Lauretis contends that such narrative dislocations can produce fissures where a female subjectivity can begin to be defined in relation to the operations of narrative:

If the spectator's identification is engaged and directed . . . by specific . . . narrative codes (the place of the look, the figures of narrative), it should be possible to work through those codes in order to shift or redirect identification toward the two positionalities of desire that define the female's Oedipal situation; and if the alternation between them is protracted long enough . . . the viewer may come to suspect that such duplicity, such contradiction cannot and perhaps even need not be resolved. . . . What I am arguing for . . . is an interruption of the triple track by which narrative, meaning, and pleasure are constructed from his [Oedipus's] point of view.[22]

A reading of *A Bar at the Folies-Bergère* along these lines promises to challenge the automatic presumption that the subject of Manet's narrative is male, just as the interpretation of the picture plane as a reflecting surface opened the possibility that woman as well as man can be the subject of vision.

Thus we need not accept as givens the structures of privilege that seem at first to be the only ones articulated by a painting such as *A Bar at the Folies-Bergère*. Even this canvas, seemingly so assured in its placement of the "man of the world" in control of the Folies-Bergère and of Manet in control of the production of art, can become a means for the assignation of subject positions figured female and for the breaking down of masculine narratives. Presumably similar reformulations of *A Bar at the Folies-Bergère* could be accomplished involving the privileges of class.

It could be objected, in response to the preceding several paragraphs, that I am imposing my ideas onto *A Bar at the Folies-Bergère*, conjuring up meanings that otherwise simply would not exist. This challenge could be phrased in several ways. It could be said that I allow concerns of the "present" to shape the historical "past." That I allow "interpretation" to ride rough-shod over "description." Or that I force "politics," in this case the politics of gender, onto "art."[23] To this objection, variously formulated, I have three responses.

First: No, I do not. The privileging of the "men of the world" was an operation actively performed in the nineteenth century and in paintings such as *A Bar at the Folies-Bergère*. The power thereby asserted (here I use terms derived from the later Foucault) depended fundamentally on a reciprocal resistance against which to exert itself; without the "agonism" of an ongoing struggle of gender there would have been no exigency compelling the *Bar*'s quite forceful privileging of male subjectivity.[24] The caricature from 1882 by Stop of Manet's painting (fig. 8) draws its laugh precisely by demonstrating how much the composition of the canvas leaves open the space before the barmaid. With a jesting spirit that may be covering for a deeper anxiety, the caricature rushes forward to fill the lack: the caption reads "Her back is reflected in the mirror; but, no doubt because the painter was distracted, a gentleman with whom she is chatting and whose image one sees in the glass, does not exist in the picture itself.—We thought we should repair the omission."[25] Seen in this light, Manet's painting may indeed have produced the possibility of alternative viewers, but only for the purpose of recasting male sub-

jectivity as the filling of a need, the solution to the picture's problem. Female subjectivity existed in the art of the past if in no other form as that which had to be suppressed in the making of male privilege.

Second: Yes, I do. The analysis I have pursued above relies heavily on intellectual resources—Lacan, Gallop's feminist appropriation of Lacan, de Lauretis, Foucault, and many others—developed only over the past several decades for the investigation (to use de Lauretis' phrase) of "technologies of gender." My articulation of a privileged subjectivity figured female in *A Bar at the Folies-Bergère* could hardly have taken place—or at the very least would not have taken the shape that it did—without my access to these tools of interpretation dating, for the most part, from the later part of the twentieth century.

Third: Yes and no; I balance motivated interpretation in the present and impartial description of the past. To insist that the practice of art history must dismiss all of the former in favor of the purity of the latter is nothing other than a reformulation of the idea that one should see through illusions to discover the real. To place oneself thus in charge of resolving the interplay between reality and illusion from the plateau of one's own metareality, I have been arguing, replicates rather than explicates an important political operation performed by Manet's painting. Only by recognizing the contingency of our own position of articulation, by acknowledging that we (like all others) construct our truths through a negotiation between illusion and reality, can we bring that mechanism under scrutiny. To fail to do so, I could counter to the objection above, brackets from "description" a "real" aspect of the "past" of *A Bar at the Folies-Bergère*. In the end, the feminist reading above is no more "an ideological mirage" (to repeat Cachin's dismissive phrase) than is the demand that we constrain ourselves to Manet's reality.

Thus alternative readings of Manet's painting no more consign art and art history to the realm of pure illusion than established accounts succeed in matching themselves to the real. Let us therefore ask of the texts of art history, as of paintings, not whether they meet the impossible standard of correspondence to reality (a question of ontology), but rather what interests they serve through their interplay of the real and the illusory (a question of politics). As viewers of *A Bar at the Folies-Bergère,* as authors and audience of the art history written about it, we should not be lulled into taking for granted either Manet's privileges or our own by subscribing to the illusion of the real.

Notes

My thanks to Stephen Eisenman and Cécile Whiting for reading drafts of this essay and offering suggestions toward its improvement.

1. In composing this essay, I am much beholden to the extensive work performed by others in investigating the critical response to Manet's painting, the nature of the Folies-Bergère and the cafés-concerts, and the social dynamics at the Parisian Opera. While I will attempt to give credit where it is due throughout the essay, my debt to two art historians is large enough that I should acknowledge them right away: T. J. Clark, whose chapter on Manet's *Bar at the Folies-Bergère* from *The Painting of Modern Life: Paris in the Art of Manet and his Followers* (New York, 1985) underlies many essays in this volume, and Robert L. Herbert, whose chapters on the café-concert and on the Opera from *Impressionism: Art, Leisure and Parisian Society* (New Haven, 1988) greatly inform my argument here.

2. Translation from Clark, 239.

3. Translation from Clark, 240.

4. Clark, 254.

5. Clark, 252.

6. To be sure, the metareality of "social forms" in Clark's account is no simple material entity; it, like the realities and illusions of the Folies-Bergère, is the product of representations. "It does not seem to me to trivialize the concept of 'social formation'—or necessarily to give it an idealist as opposed to a materialist gloss—to describe it as a hierarchy of representations. That way one avoids the worst pitfalls of vulgar Marxism, in particular the difficulties involved in claiming that the base of any social formation is some brute facticity made of sterner and solider stuff than signs—for instance, the stuff of economic life." Yet in his desire to remain "within the orbit of historical materialism," Clark privileges one set of representations—in the terminology of mathematics, the full set—over all others: "Everything depends on how we picture the links between any one set of representations and the totality which Marx called 'social practice.'" Thus, "it makes sense to say that representations are continually subject to the test of a reality more basic than themselves—the test of social practice. Social practice *is* that complexity which always outruns the constraints of a given discourse; it is the overlap and interference of representations; it is their rearrangement in use." To posit such a "totality," I would insist, reconstitutes "reality" (a complex reality, certainly, a reality not strictly material and undoubtedly "analyzable, at least in its overall structures and tendencies") in such a manner that it still serves as the standard for final analytic appeal. All citations from Clark, 6.

7. Clark, 205.

8. Translation from Herbert (as in n. 1), 106–7.

9. Charles Baudelaire, "The Painter of Modern Life," in *The Painter of Modern Life and Other Essays,* trans. and ed. Jonathan Mayne (London, 1964), 6–7, 8.

10. Translation from *The New Painting: Impressionism 1874–1886,* ed. Charles S. Moffett, exh. cat. (San Francisco, 1986), 323.

11. Mary Ann Doane, *The Desire to Desire: The Woman's Film of the 1940s* (Bloomington, 1987), 1.

12. Mary Cassatt's *Woman in Black at the Opera* of 1879, a painting of remarkable compositional congruence to Renoir's *First Outing,* has emerged in the recent literature as something of a counter case, as an emblem of sophisticated viewing by a woman in control of her own vision. (Two women in control, actually: the depicted sitter and the painter herself, who assumed the artistic gaze when she seized the means of production of the painted image.) Nevertheless, Cassatt's canvas, like Renoir's, depicts a woman in the house of the theater, not backstage. Moreover, the binoculars used by the woman, rather than constituting an unequivocal sign of her scopic prowess, can alternatively be considered a device that distorts vision, specifically by collapsing the distance between the woman and that which she views with such absorption.

13. Gustave Flaubert, *Madame Bovary* (1856), part 2, chapter 15; trans. Paul de Man.

14. Herbert (as in n. 1), 80.

15. Baudelaire (as in n. 9), 12.

16. Richard Shiff has written on this point: "It is something of a cliché to say that 'few if any artists are entirely conscious of their enterprise, and therefore of the manner in which the changing directions in their art may transcend the frames of reference imposed by their moment in time' [William Rubin]. Like all clichés, this one has repeatedly been put to productive use: it has allowed the art historian to attribute a complex level of system and signification to a given work and to explain it in a sophisticated fashion, while viewing its creator as a relatively naïve finder, someone unaware of his own accomplishments. . . . The art historian thereby establish[es] his own professional territory of 'original' interpretation." Richard Shiff, *Cézanne and the End of Impressionism: A Study of the Theory, Technique, and Critical Evaluation of Modern Art* (Chicago, 1984), 218.

17. Françoise Cachin, "Un bar aux Folies-Bergère," in *Manet: 1832–1883,* exh. cat. (Paris, 1983), 478. The translation provided in the English edition of the catalogue—"an ideological mirage, willfully imposed on the work"— somewhat alters the sense of the French phrase: "un mirage idéologique, plaqué sur une œuvre bien malgré elle."

18. For me as a male to articulate a position of female subjectivity for *A Bar at the Folies-Bergère,* some writers might remonstrate, simply reinscribes the privilege of a male act of viewing. See, for example, Teresa de Lauretis' dis-

cussion of Jonathan Culler in *Technologies of Gender: Essays on Theory, Film and Fiction* (Bloomington, 1987), 21–23. By such lights, the "we" in my sentence becomes highly suspect; for whom, after all, am I speaking? At the risk of repetition I would respond that I do not (cannot) disown my own privilege. I would locate that privilege, however, not in a capacity to read as a woman but—as will be become evident in the paragraphs to follow—in the effort to measure viewership positions figured male and female against each other. The question then arises: who benefits from this sort of privilege? My personal interests as a scholar are certainly of little moment from a historiographic perspective, but I would like to imagine that communities larger than myself—feminists, perhaps, or more narrowly those interested in the place of men within feminism—could profit from my explorations.

19. Jane Gallop, *Reading Lacan* (Ithaca, 1985), 38.

20. Herbert (as in n. 1), 80–81.

21. Teresa de Lauretis, *Alice Doesn't: Feminism, Semiotics, Cinema* (Bloomington, 1984), 121. I have altered de Lauretis' punctuation slightly.

22. De Lauretis, 153, 157.

23. In its most recent form, this last attack would be articulated: I force "political correctness" onto the "eternal truth" of art. A great deal of disingenuousness marks this critique, for what could be more "political" than the insistence that a painting depicting an interaction between a dandy and a barmaid is about nothing other than the "eternal" verities of art? By now, it should be clear which political concerns in the present are being served by interpretations such as this that bracket the troublesome issues of gender and class.

24. See Michel Foucault, "The Subject and Power" [Afterward], in Hubert L. Dreyfus and Paul Rabinow, *Michel Foucault: Beyond Structuralism and Hermeneutics* (Chicago, 1982), 221–3.

25. Translation from Clark (as in n. 1), 241.

In Front of Manet's *Bar:*
Subverting the "Natural"

JOHN HOUSE

THE FIGURE confronts the viewer frontally, directly. Centered in the image, the barmaid's gaze engages our space, grasps our attention. Yet this is not the gaze of the classic portrait image which, Mona-Lisa-like, follows us around the room, confidently positing the sitter as the viewer's equal, or superior. Our engagement with the figure is more oblique, more uncertain, more equivocal.

Hung as the picture now is, we can move up close to it, and momentarily imagine ourselves at the bar, the objects of the barmaid's half-attention. But as soon as we step back to view the image as a whole, we are irrevocably distanced from that gaze, and the complexities and oddities of the representation as a whole come into focus—the illegibility of the space and the incongruities of the famous mirror image.

However, this "we" is problematic, in two ways. If we identify the viewer with the client at the bar, he is immediately gendered, defined in terms of male social spaces and social rituals; the male figure seen in the mirror image endorses this identification. And yet the picture was made to be seen as fine art and in an exhibition context, by a different public, of both women and men, who would approach the image with a quite different agenda.

Moreover, for the picture's first viewers, at the Paris Salon in 1882, its imagery would have been far more complex and problematic than it seems now, raising as it did a set of issues that were central in contemporary debates about the city and its social rituals and morality—about "modernity." Likewise the picture's formal oddities would have seemed far more pointed in 1882. The late twentieth-century viewer can readily accommodate the picture's forms within a "modernist" aesthetic which has come to legitimize far more extreme dislocations of perceived reality. In its original context and for its

original viewers the picture's distortions had no such sanction: both its imagery and its form challenged contemporary notions of coherence and legibility.

Any historical reading of the picture has to tackle both the imagery and the way in which it was presented in a fine art context, and to bring these two issues together, so as to explore what it meant to treat that subject in painting in that way, at that particular moment.

Contemporary accounts show that the Folies-Bergère was, in the broadest terms, a middle class place of entertainment. The fact that it levied admission charges, rather than simply charge for drinks consumed, set it apart from most of the other cafés-concerts in Paris at the time. The entertainments it offered in a sense aped working class forms, but processed them, re-presented them for middle class viewers, seeking to harness their earthiness and sense of surprise and spectacle to the expectations of a different audience, used to greater professionalism and a more lavish ambiance. Yet, from the viewpoints of urban "high" culture, the Folies-Bergère emphatically represented the "popular." For Huysmans, the place was unique in its *cachet boulevardier.*[1]

These issues came sharply into focus in 1881. In May, Léon Sari, proprietor of the Folies-Bergère since 1871, reopened the place as the Concert de Paris, presenting ambitious programs of Classical music, with a distinguished *comité d'honneur.* However, the experiment was an immediate failure, and Sari quickly decided to return to his previous successful formula; a satirical playlet presented this decision as the victory of popular *phénomènes* over high "Art."[2] This victory would have been fresh in the viewers' minds in 1882, when Manet presented his image of the place at the Salon, bastion of high art.

Three key issues were at stake in the image of the café and the café-concert in the 1870s and 1880s: politics, alcohol, and sexuality. However, these issues have a complex and in some ways oblique relevance to Manet's painting; both the status of the Folies-Bergère itself, and the political circumstances at the moment when Manet exhibited the picture, mean that it cannot be discussed in the same terms as the images of lower-class places of entertainment painted by members of the Impressionist group and their associates in the later 1870s.

The most immediate causes for official concern about cafés were political. Throughout the century, the authorities regarded cafés as

the primary forums of political opposition, particularly in phases when the tightest controls were imposed on political debates and public meetings. In the severe repression of President MacMahon's "moral order" régime of the mid-1870s, cafés were a particular object of surveillance and controls, notably in a draconian round of closures of cafés which were suspected of being centers of republican opinion in summer 1877, after the government upheavals of the *seize mai*. However, the climate changed with the establishment of a firmly based republican government in the elections of 1877–79, and the law of 17 July 1880 transformed the position of the café, allowing free political activity and retaining only controls in the interests of law and order. The result was a vast increase in the number of cafés.[3]

The significance of the changes in political and social climate introduced by the "opportunist" Republican administration under the presidency of Jules Grévy from 1879 onwards cannot be over-emphasized. The rigorous controls and governmental paranoia of the 1870s gave way to an extended period of open economic expansion and social debate, encouraged most notably by the amnesty offered to the former communards in 1880 and the press laws of 29 July 1881, which finally gave France an effectively free political press.

These changes gave rise to a wholesale shift in contemporary perceptions of the city. Under the "moral order" régime of the 1870s, the city, as potential hotbed of political radicalism, had to be strictly policed; by contrast, the Grévy government gave considerable latitude to urban culture, building on notions of industrial and commercial progress, and instituting the 14 July celebrations as talisman of "freedom." This effective endorsement of the modern city precipitated a flood of critiques from the erstwhile protagonists of "moral order," attributing the evils of modern society to the city and its influence. These attacks focused in particular on notions of moral and physical disease—a Pandora's box of infections, notably sexual license, alcoholism, and social anarchy, which threatened the very structure of society. The roots of these attacks can be traced back to the Second Empire and beyond; but the liberalization of the early 1880s forced conservative moralists into vociferous opposition.[4]

The new official view of modern Paris emerges vividly in Alfred Roll's *14 July 1880* (fig. 31), a vast tableau of the first official 14 July celebrations of the Third Republic, purchased by the State at the 1882 Salon—the year that Manet exhibited *A Bar at the Folies-Bergère*. The picture includes many of the emblems of the city that had seemed so

threatening under the previous régime—the public sale of alcohol, drunken revelers, the comprehensive mixing of classes, and, just to the right of the bandstand, the figure of a single woman in a public space; in the foreground, even the *gamin de Paris*, traditional emblem of anti-authoritarian revolt, is co-opted to sell Republican buttonholes. All this can be accommodated, controlled, by the dual forces of Republic and army, of peace and war, which enclose and contain the revelers: the moment shown is when the crowd stops to salute the parading of a newly presented regimental flag, framed by the monument to the Republic and the banner on the flagpole declaring *PAX*. This presentation of flags symbolized the regeneration of the French army after the disasters of the Franco-Prussian War.[5]

The restrictions on cafés of the mid- to later 1870s give an immediate context to the sequence of paintings of café subjects by the artists of the Impressionist group, painted, as Robert Herbert has noted, only between 1875 and 1880.[6] The sites they chose to depict were generally establishments with very mixed clienteles, and they tackled these themes only so long as the subjects themselves carried subversive associations in official discourse. Manet's previous pictures of cafés and brasseries, such as his planned major painting of the Brasserie Reichshoffen, belong firmly in this group; indeed, as Paul van den Abeel and Juliet Wilson-Bareau have recently shown, his *Au café* drawing was published in 1874 in an overtly subversive, and censored, journal, and was accompanied by a text that marked out the café as a locus of political debate.[7]

However, *A Bar at the Folies-Bergère* does not fit neatly into this framework. First, it postdates the liberalization of café laws; second, the Folies-Bergère itself, so far as is known, had not suffered at the hands of the authorities (of major forms of censorship, only the prior approval of theatrical performances was maintained after the reforms of 1880–81);[8] and, as a middle class place of entertainment, it was not the focus of the anti-alcohol campaigners, who saw peril only in working class forms of alcoholic consumption and drinking habits. Indeed, the juxtaposition of champagne, vin rosé, crème de menthe, and Bass ale (all fashionable and comparatively expensive drinks) on the bar in Manet's painting reinforced its image as a fashionable milieu, as did the mandarin oranges (something of a luxury) in the bowl.[9]

The most complex network of debates around the place and around Manet's picture of it concern sexuality. The Folies-Bergère

itself had a complex sexual geography. The orchestra stalls were characterized as the territory of those ordinary bourgeois families who wanted to see the show,[10] while the boxes and the *promenoir* which surrounded them, together with the lavish winter garden, were the unequivocal province of the *flâneur* and the prostitute; it was this, wrote Elie Frébault in 1878, that made the Folies-Bergère into "*le véritable turff* [sic] *de la galanterie parisienne.*"[11] The site of Manet's picture was the gallery with its *promenoir;* though less often described, this seems to have been a continuation of the *promenoir* below.[12]

Throughout the Folies-Bergère there were bars with mirrors behind them—in the entrance corridor, in the *promenoirs* upstairs and downstairs, and in the winter garden. For Maupassant, the barmaids there were "merchants of drinks and love." A cartoon of 1878 (fig. 24) shows that their potential sexual availability was a humorist's cliché; and Stop's caricature of Manet's painting (fig. 8) calls the barmaid a "merchant of consolation."[13] Yet their status was crucially different from that of the women who plied their trade in the *promenoirs,* for, unlike them, the barmaids were able to choose their sexual partners. Certainly, as the 1878 cartoon shows, their clients might dream of becoming their lovers, but the seeming modesty and hesitation of the client here only makes sense if they were *not* perceived as automatically available. In contemporary writing on clandestine prostitution, much is made of the distinction between those who could choose and those who could not.[14] Moreover, Carel's pamphlet on the peril facing the waitresses in *brasseries à femmes*—a central issue in the literature of moral fear at the time—saw no problem in women serving from behind a bar, with "their virtue protected by a broad and impassable counter."[15] The uncertainty of the barmaid's position vis-à-vis her client is crucial to Manet's picture.

This uncertainty is only one of many ways in which the picture undermined conventional notions of pictorial legibility. To see how central this challenge to legibility was to Manet's project, we must return to the canvas itself, and to the way in which he worked up the final image.

In his sketch for *A Bar at the Folies-Bergère* (fig. 1), the space is relatively coherent, with bar, barmaid, and mirror seen from an angle; the viewer is invited to imagine himself in the place of the man with a cane raised to his chin seen in the reflection at the far right, rather below the barmaid. In the final version the barmaid is pre-

sented frontally; bar and mirror, too, seem more or less frontal. Yet the reflection of barmaid and customer is displaced to the extreme right, and the customer seen in the reflection stands face to face with the barmaid and a little taller than her, whereas we—the viewers of the picture—seem to be at a greater distance from the image that looks out of the picture. Moreover, the bottles in the reflection do not correspond to those on the bar—they are placed on the "wrong" edge of the bar; and, in the reflection, a wide space opens out between bottles and barmaid, while the reflection of the little glass of flowers is displaced to the right margin.

An x-ray photograph (fig. 15) shows that the final picture, as initially laid in, corresponded closely with the sketch. The figure of the barmaid seems to have faced the viewer from the outset, but otherwise the forms were as in the sketch: the barmaid's hands folded, and the reflection of her head in front of the pillar just right of center, with the man in a round-topped hat with cane to his chin clearly seen at the right. The barmaid's reflection was then shifted not once but twice: first to a position to the right of the pillar, directly above the bowl of mandarin oranges (in this position it would already have partly obscured the original male figure), and then to its present location; the reflection of the top-hatted man was inserted at a very late stage.[16]

The incongruities between image and reflection are not the only problem that the final picture raises. The reflection on the left presents a further puzzle: all that we can see beyond the reflected bar top is the opposite balcony, with the columns supporting it; even at far left, to the left of the end of the bar in the reflection, we see only the column opposite and a dark space around it. There is no indication in the part of the balcony on which the customer, and implicitly we ourselves, are placed. We have still less foothold than the green-shoed acrobat who swings above the audience at the top left.

It was not only in its spatial incongruities that the picture transgressed contemporary conventions of representation. Anomalies arise, too, in the ways in which the brushwork and facture direct the viewer's attention. As we should expect, the principal image is more sharply focused than the reflection, and the figure of the barmaid stands out boldly from the flurry of seemingly improvised marks that evoke the audience on the opposite balcony. Yet this principal figure is not the most sharply focused element in the picture: the bottles and fruit bowl are treated with great richness and finesse, while the barmaid is more broadly and simply treated.

Throughout his career, critics had accused Manet of failing to differ-entiate the salient points of his compositions, of showing "a sort of pantheism that places no higher value on a head than a slipper, which sometimes gives more importance to a bunch of flowers than a woman's face . . . which paints everything almost uniformly."[17] Yet, in *A Bar at the Folies-Bergère,* the execution seems more positively to invert expected values. The focus on the barmaid's merchandise upgrades still life elements—traditionally treated as accessories—as if to emphasize that they are the primary reason for her presence behind the bar. And at the same time one expected focus is unobtrusively denied. As the 1878 cartoon of barmaid and client shows (fig. 24), a stereotype of such imagery was the client's fixation on the barmaid's bosom. In Manet's canvas the décolletage initially attracts the viewer's eye; but the little bouquet of flowers, summarily sketched directly onto the canvas priming, is by far the least highly worked part of the figure, and there is not a hint of modeling in the flesh painting around it. The viewer's attempt to become a voyeur is balked.

The viewer's relationship to the image is complicated, too, by the gaze of the barmaid. The presence of a figure looking straight out from a picture invites a direct response from the viewer, particularly if that figure is central. Yet the seeming distance and abstractedness of the barmaid's expression thwarts any attempt at empathetic engagement. Ernest Duez's canvas *In the Restaurant Le Doyen* (fig. 32) illustrates the type of direct appeal that Manet's picture so care-fully avoids, with the added aid to the viewer of the attentive male figures seen at the table at back right.[18]

Manet's concern to distance himself from the conventional rheto-ric of sexual appeal is also revealed by the very different ways in which the female figure is treated in the sketch and the final picture. The piled-high blonde hair and pert expression of the figure in the sketch give way to the far less elaborated hairstyle and less flirtatious demeanor of the final figure, for which he used a different model.

The distancing in *A Bar at the Folies-Bergère* is further complicated by the apparently closer and more engaged interchange seen in the mirror reflection, between the woman and the man whom we seek to read as our alter ego. Stop's caricature (fig. 8) resolved this discrep-ancy between image and reflection with wit and concision, simply by slipping the back view of a top-hatted man into the image, between the viewer and the bar. But the picture itself makes no such conces-sions to spatial and psychological legibility.

The x-ray evidence shows how deliberately Manet introduced the discrepancies between image and reflection in the picture. The rupture of a literal spatial coherence emerged, step by step, as he worked on the final canvas. How should these dislocations be viewed? From the start of his career, Manet's critics accused him of willful subversion of academic values; yet his apologists, from Zola onwards, emphasized the aesthetic dimensions of his enterprise, his concern for the effect of the *tache* of color. In 1882, Georges Jeanniot visited Manet's studio while he was at work on *A Bar at the Folies-Bergère*, with the model posed behind a marble slab laden with bottles and foodstuffs: "Although he worked from the model, he did not copy nature at all closely; I noted his masterly simplifications. . . . Everything was abbreviated; the tones were made lighter, the colors brighter; the values were more closely related to each other, the tones more contrasting." Manet insisted that "concision is everything."[19] Yet such formalist accounts seem quite inadequate to account for the positive dislocations of the picture.

The initial responses to *A Bar at the Folies-Bergère* upon its appearance at the 1882 Salon give some insight into the ways in which it invited and yet thwarted conventional modes of reading images, and how the issues it raised related to wider contemporary social and moral debates. T. J. Clark has explored a number of the key themes in the criticism of the picture, and in particular the discussions of the barmaid—her beauty or ugliness, her modernity, and her presumed moral status—and the widespread concern with the truthfulness of the mirror reflection and the accuracy of the lighting.[20]

Most immediately, there was no agreement about how to read the barmaid's expression. She could be characterized as beautiful and lively—the archetypal modern *fille;*[21] but she could also be seen as bored and paralyzed.[22] One critic, Louis de Fourcaud, could elaborate on her pouting and disgusted turn of the lip as her response to the attentions of her "gross, blasé, idle" client.[23]

The discussions of the picture are inseparable from wider contemporary debates. Running through the commentaries is an underlying concern that seems fundamental to Manet's project in the context of its initial reception in 1882: this is the relationship between "nature" and "artifice" within contemporary culture. The picture raised this issue in two distinct ways, both in terms of the question of verisimilitude in painting, and in relation to notions of modernity in the city.

These issues appear most obviously in the criticisms of the mirror reflection and the lighting in Manet's picture. The discrepancies between image and reflection were the most blatant challenge to representational coherence, but the criticisms of the lighting also point to Manet's rejection of the notion of literal lifelikeness: the barmaid, ostensibly working in an artificially lit interior, is depicted in the cool clear daylight of a north-facing artist's studio. In a sense, this expressed the artist's power to transform his raw material, which Jeanniot's account stressed. But, in more practical terms, it also reflected the circumstances in which Manet expected the picture to be seen—amid a mass of other pictures, and maybe hung high, on the walls of the Salon. Just as the viewers of the picture must be distinguished from the imagined client at the Folies-Bergère, so the "reality" of the picture itself was conceived in terms of the circumstances in which it was to be seen, not of the scene it represented.

But the question of naturalness is also central to the critics' discussions of the social milieu depicted, more specifically in their characterizations of the barmaid. Her appearance was viewed in contrary ways, ranging, as Clark has noted, from Henri Houssaye's criticism of the "cardboard head" to Emile Bergerat's praise of the figure as "natural in pose and altogether full of character."[24]

How should we explain such contradictions? What is at stake seems to be the definition of the "natural" itself—whether it is the raw material which then may be overlaid, obscured, distorted by "culture," and specifically by the fashions and artifice of the city, or whether the "natural" itself is forged by environment. This tension is most vividly shown in the comment of La Senne, who displaces his concern about the barmaid onto her anatomy, which is "mediocre and all the more Parisian for that."[25]

One recurrent theme in the criticism of the picture was the question of make-up. This picked up on a type of imagery that was already current in descriptions of the Folies-Bergère itself. Huysmans, for instance, in his 1879 account of the Folies-Bergère, used *maquillage* by metonymy as a sign of the corruption for which the place stood.[26] But the question of make-up was part of a wider debate about the state of urban society.

Contemporary accounts of cosmetics, mostly directed towards potential consumers, were generally very positive about the benefits of make-up and face powder, though with salutary warnings about the dangers of poor quality goods which might contain dangerous

additives (none of the ironic paradoxes here of Baudelaire's cele-brated "Eloge du maquillage" in *Le Peintre de la vie moderne*, in which face-painting allows woman to transcend the imperfections of nature). However, tracts of social morality took a different position; Maxime du Camp, writing in the 1870s, adopted an overtly moralistic tone in attacking make-up, while Paul Lacroix in 1858 developed this argument into a starkly misogynistic image of make-up being used to conceal underlying physical decay which will finally burst through in all its ruin—another sudden leap from the sphere of "culture" to the sphere of "nature." Lacroix's account was given wide circulation in Larousse's *Dictionnaire* in 1869.[27]

At first sight, the critics' invocations of make-up in their discus-sions of Manet's picture relate simply to the way in which the bar-maid is described; but notions of cosmetic concealment and deceit seem to act also as metaphors for deeper anxieties. For Paul Alexis, make-up was just one ingredient in his wholly unproblematic cele-bration of the "modernity" of the image, published before the exhibi-tion opened. Houssaye's account, by contrast, moved from "the flat, plastered face of the girl" to the mirror, whose presence is conveyed by "a little white dust spread on the back of the young woman."[28] Thus the flaws in the mirror image, its imperfect, blurred, frosted image of the place, are evoked by the metaphor of face powder, as if cosmetics were the root of Houssaye's evident anxiety at the culture that the place represented.

Many of these issues came together in a review of *A Bar at the Folies-Bergère*, published under the name Jules Fleurichamp.[29] After evoking the "seething, powdery" background, and insisting that it does, despite the uncertainties, represent a mirror, the author invokes the obligatory mention of Impressionist sketch-like tech-nique; the core of the account, though, insists on a necessary con-nection between subject and treatment, switching rapidly between evocation of the scene and characterization of the *facture*, in a sequence of staccato (and untranslatable) paragraphs which itemize in turn the barmaid's face, clothing, and jewelry, the items on the bar and in the background, insisting at one moment that there is "not a trace of beauty" here, but rather "naturalness, gaiety, light and skill," and at the same time reiterating all the elements of studied artifice which form the overall tableau, from the barmaid's makeup to the lighting and the trapeze artist's legs.

Two other pictures at the 1882 Salon vividly posed the problem of

the nature of the "natural" in modern society: Roll's *14 July 1880* (fig. 31) and Léon Lhermitte's *The Wages of the Harvesters* (fig. 33). In a sense the two presented decisively different versions—Lhermitte's in terms of due rewards for honest toil in the countryside, Roll's in terms of the peaceful coexistence of classes in urban, republican festivities. The bases of order in Lhermitte's are ostensibly natural; despite the presence of the paymaster, all the figures know their rightful, "natural" place. In Roll's, the order is unequivocally social and cultural. Yet, in the context of the politics of 1882, both could be assimilated into an overriding discourse of the "natural": the city as an organism could accommodate class diversity to the mutual benefit of all, while rural labor offered its due rewards. Indeed, Louis de Fourcaud insisted that both pictures should be seen in the same terms, as being "so logically and so freely composed that [they seem] to have come into being all on [their] own"; standing in front of Lhermitte's picture, "it seems as if one has reality itself before one, the composition is so natural and the painter has taken such care to conceal himself."[30]

Of course both of these visions of order were fictions. The proclaimed order of Paris obscured the ever-present threats of unemployment, poverty, and homelessness,[31] and the propagandist image of rural stability was an increasingly ineffective attempt to counteract the effects of migration to the towns and cities in the face of the developing "great agricultural depression," a result of agricultural diseases at home and increased competition from overseas.[32] Nor was there any security in the world of high capitalism on which Grévy's Republican government had pinned its faith: in February 1882 one of France's leading banks, the Union Générale, had crashed, involving other banks and ruining many businesses and investors.

Manet's *A Bar at the Folies-Bergère* occupies a complex position in relation to these debates. As we have seen, the liberalization of political activity and drinking laws of 1880–81 meant that the subject of urban popular entertainments, as a whole, had lost its radical edge; and the Folies-Bergère itself had no special reputation as a radical forum. The Paris entertainments world was the object of increasingly vocal condemnation by the "moral order" conservatives in the 1880s, and the success of the Folies-Bergère among the middle classes and as a tourist attraction could be seen as evidence of how thoroughly compromised bourgeois culture itself was—as evidenced by Sari's failure to turn the place into a concert hall. But Manet's painting, through its very open-endedness, had nothing in common with the

"moral order" imagery of decay and degeneration threatening bourgeois ascendancy. In the sense that it could be seen to celebrate the collective social rituals of the city, the picture could even be viewed within the same ideological frame as Roll's *14 July 1880*. Yet it evidently could not be co-opted for the government ideology, and Manet's old friend Antonin Proust, so recently Minister of Arts under Gambetta's short-lived ministry, could find absolutely nothing to say about it in his review of the 1882 Salon.[33] It was in its resistance to co-option by either government or conservative opposition, in its rejection of the closures of spatial or psychological narrative, that the picture found its subversive force.

Throughout his career, Manet's art had posed great problems of classification. Often it was unclear to which genre his exhibition pictures belonged; and sometimes a theme was treated in a manner or on a scale that, by traditional standards, was considered inappropriate to the genre to which its subject linked it. Scenes of everyday life were treated on an unduly large scale, or included figures that looked puzzlingly like portraits.

Beyond this, his treatment of his subjects recurrently defied the standard modes of reading and interpretation deployed by contemporary viewers: figure groups did not cohere, figures looked straight out of the picture, gestures could not be clearly understood, figure types could not readily be classified, and settings were often ambiguous.

In the face of these challenges, most critics adjudged his exhibition pictures by purely artistic criteria. Many condemned him for simple incompetence—for his failure to draw and model his figures adequately, to make expressions and gestures legible and figure groups coherent. Others, as we have seen, attributed the failure of his pictures to make sense in conventional terms to his preoccupation with the *tache* of color. Whether in the hands of supporters such as Zola, or of critics who wished to belittle his work, such commentaries played down the significance of his subjects and the way he presented them.

Yet these subjects, throughout his career, engaged with themes that were of central significance in contemporary debates. Only once, with *The Execution of the Emperor Maximilian,* did he tackle an overtly political subject, and met official censorship for his pains.[34] Otherwise, his subjects mainly dealt with contemporary social life, in Paris and its environs; they consistently explored boundaries and frontiers—

between private and public spaces, between city and country, between classes, between respectability and moral uncertainty. And these uncertainties consistently engaged with, and challenged, the conventional, normative distinctions between the "natural" and the "artificial."

There was no consistency about which of his paintings were accepted and which rejected at the Salon. An overt image of prostitution, *Nana,* was rejected in 1877, but *Olympia* was accepted in 1865, and subjects as innocuous as *The Fifer* and *The Artist* were rejected in 1866 and 1876. In the main, the rejections seem to have been the result of the aesthetic or personal prejudices of a particular year's jury. Neither the artistic authorities nor the formal censors found any consistent cause to suppress his work, and hostile critics could defuse its effect by actual or strategic incomprehension.

Yet it can be argued that, in his consistent subversion of the normative categorization of contemporary life, he was posing a more searching challenge to the dominant social order than any act of direct confrontation and defiance.[35] The consistency and complexity of these subversions suggests that this was quite deliberate on Manet's part. Neither his supporters nor his critics defined his enterprise in any sustained way in these terms; yet his art consistently generated a combination of fascination and anxiety in its viewers, attracting a surprising level of attention even from those who argued that his paintings were fatally flawed. At some level, this was a response to the challenge the pictures posed, both in the immediacy and frontality of their imagery, and in their disconcerting challenge to the vision of an ordered world in which everyone could readily be located.

Classification and type-casting are central to any form of social control; the unclassifiable and the illegible pose a fundamental threat to the order that the dominant categories purvey. Such challenges are at their most cogent when they undermine a society's notion of the "natural," since it is on just such definitions of "nature" that justifications for the most basic social inequalities are based. Certainly, as I have argued, there was an important shift in government ideology around 1880, with the emergence of the "opportunist" republic; and this was accompanied by a significant realignment of social values. Yet the new régime, just as much as the old one, justified its policy by a notion of a rightful, "natural" order, in which everyone occupied a definable place.

In this context *A Bar at the Folies-Bergère* attacked the norms in complex and far-reaching ways. Most evidently, it denied a coherent, legible authorial position, by denying empathetic access to the image of the barmaid and yet juxtaposing it with a provocatively engaged image in the reflection, and furthermore, in the most basic terms, by denying the author/viewer any secure foothold within the pictorial space. Beyond this, the stereotype of the barmaid's sexuality is questioned by the way in which the image is painted. The gaze of the figure, penetrating deep into our space, is counteracted by the barrier of the bar and its contents, whose palpable physicality creates a problematic threshold. The mirror reflection challenges any attempt to read the picture anecdotally or to define the "nature" of the barmaid. Its anomalies propose an alternative "reality" and its markings and disfigurements challenge the integrity of the principal image.

The forum for these challenges was the walls of the Salon. The picture was made to be seen and judged as art; on an immediate level, its transgressions were artistic. By its insistent frontality and its clear, luminous tonality, it proclaimed its difference from the measured spatial organization and mellow tonality of the pictures around it. But these transgressions also, and more fundamentally, challenged the values that underpinned the normative vision of a legible and coherent universe. As a whole, in its form as well as its subject, *A Bar at the Folies-Bergère,* in its complexities and calculated inconsistencies, presented a social world—the promiscuous world of boulevard entertainments—which was an epitome of the uncertainties of modernity in the city.

Notes

I am indebted to Kathleen Adler, Juliet Wilson-Bareau, Kate Flint, and Suzanne G. Lindsay for their searching comments on the first draft of this essay; they are not accountable for the results. Among recent accounts of Manet's picture, the following have been particularly useful: T. J. Clark, *The Painting of Modern Life: Paris in the Art of Manet and His Followers* (New York, 1984); Juliet Wilson Bareau, "The Hidden Face of Manet," supplement to *Burlington Magazine,* April 1986; and Robert L. Herbert, *Impressionism: Art, Leisure and Parisian Society* (New Haven and London, 1988). These are hereafter abbreviated as Clark 1984, Wilson Bareau 1986, Herbert 1988.

1. Joris-Karl Huysmans, "Les Folies-Bergère en 1879," in *Croquis Parisiens* (Paris, 1880, 1976 edition), 347. The ambivalent status of the Folies-Bergère is vividly shown by the uncertainty about how it should be classified in Karl Baedeker's *Handbook for Paris*. In the 1876 edition (50) it was listed as a distinct item at the end of the listing of legitimate theaters, while in 1878 (56) it appeared at the end of the Cafés Chantants, with an indication that it alone of them charged an admission fee.

Among contemporary accounts, the following are particularly useful, in addition to Huysmans': "Le Jardin des Folies-Bergère," *La Vie parisienne*, 24 August 1878, 500, cited by Novelene Ross, *Manet's Bar at the Folies-Bergère and the Myths of Popular Illustration* (Ann Arbor, 1982), 75; [Arnold Mortier], *Les Soirées parisiennes*, I (Paris, 1875), 283–85, and IV (Paris, 1878), 140–42 (cited by Herbert); Pierre Larousse, *Grand dictionnaire universel du XIXe siècle*, premier supplément (Paris, [1877]), 828; Arthur Pougin, "Folies-Bergère," in *La grande encyclopédie*, XVII (c.1891), 690–91.

For discussions of the complexities of the notions of "popular" and "working class" culture in these years, see Jacques Rancière, "Good times or pleasure at the barriers," in Adrian Rifkin and Roger Thomas, eds., *Voices of the People* (London, 1988), and Adrian Rifkin, "Cultural Movement and the Paris Commune," *Art History* (June 1979). Concetta Condemi, *Les Cafés-Concerts: Histoire d'un divertissement (1849–1914)* (Paris, 1992) offers a valuable account of the emergence and organization of the café concert.

2. [Arnold Mortier], "25 mai—la revanche des phénomènes," in *Les Soirées parisiennes de 1881* (Paris, 1882), 209–12; on Sari's experiment with Classical music, see also ibid., 141–44, 193–95 (a serious review of the first Classical concert), and H. Gourdon de Genouillac, *Paris à travers les siècles*, 5 (Paris, 1882), 298 (listing the *comité d'honneur*).

3. See Susanna Barrows, "Nineteenth-Century Cafés: Arenas of Everyday Life," in *Pleasures of Paris: Daumier to Picasso*, exh. cat. (Boston, Mass., 1991), 17–26, and Susanna Barrows, "After the Commune: Alcoholism, Temperance, and Literature in the Early Third Republic," in John M. Merriman, ed., *Consciousness and Class Experience in Nineteenth-Century Europe* (New York, 1979), 205–18; on the 1880 reforms, see also Larousse, *Grand dictionnaire*, deuxième supplément (Paris, [c.1891]), 694, 697 (s.v. *cabaret* and *café*).

4. See for instance Daniel Pick, *Faces of Degeneration* (Cambridge, 1989), and Robert A. Nye, *Crime, Madness and Politics in Modern France: The Medical Concept of National Decline* (Princeton, 1984).

5. The significance of the flag is explained by [Louis de] Fourcaud, "Le Salon, II (suite)," *Le Gaulois*, 8 May 1882.

6. Herbert 1988 (87 and especially 310n.62) says that their concentration on these subjects is a "mystery," despite noting the conjunction with contemporary repression; he suggests a connection with euphoria at the 1878 Paris Exposition Universelle, although many of the pictures preceded this.

7. Paul van den Abeel and Juliet Wilson-Bareau, "Manet's 'Au Café' in a Banned Brussels Paper," *Burlington Magazine* (April 1989), 283–88; on his Brasserie Reichshoffen project, see Wilson Bareau 1986, 65–76.

8. For a valuable recent discussion of the regulation and censorship of café concert performances, see Condémi 1992 (as in n. 1).

9. On the positive values of champagne, "the wine of youth," see Armand Husson, *Les Consommations de Paris* (Paris, 1875 edition), 265–66; on different qualities of liqueur, see ibid., 404–45; on vin rosé (or *clairet*), "the desert and dinner wine that is most fashionable on the best tables," see Arsenne Thiébault de Berneaud, *Nouveau manuel complet du vigneron,* new edition by F. Malpeyre (Paris, 1873), 355–56; in 1872–85, English beer constituted less than 0.25% of beer consumption in France (Larousse, *Grand dictionnaire,* deuxième supplément [Paris, c.1891], 561); the celebrated red triangle, trademark of Bass Ale, marked it out as a quality beer (for praise of the perfection of English *malterie,* see Dr. Hipp. Barella, *Les Alcools et l'alcoolisme* [Paris, 1880], 91, quoting A. Laurent, *La Bière de l'avenir*); on the vogue for *mandarines,* see Larousse, *Grand dictionnaire,* XI (Paris, 1874), 1406 (s.v. orange).

10. The account given in Chapter I of Maupassant's *Bel-Ami* is confirmed by Larousse 1877 and Pougin [c.1891] (both as in n. 1).

11. Elie Frébault, *La Vie de Paris: Guide pittoresque et pratique* (Paris, 1878), 257; almost all accounts of the place characterize the *promenoir;* on the *jardin d'hiver,* see *La Vie parisienne,* 24 August 1878, and Huysmans 1879 (1976 edition, 347; both as in n. 1).

12. On the gallery, see Huysmans 1879 (as in n. 1), 1976 edition, 335. The gallery is depicted, with more or less exactitude, in Chéret's 1875 poster (fig. 10), and in a seating diagram and a wood engraving of the 1870s (both reproduced in Wilson Bareau 1986, 79).

13. The 1878 cartoon was reproduced by Joel Isaacson, "Impressionism and Journalistic Illustration," *Arts Magazine* (June 1982), 112, and Stop's caricature in *Manet,* exh. cat. (Grand Palais, Paris, and Metropolitan Museum of Art, New York, 1983), 481, and in Clark 1984, 241.

14. Dr. L. Martineau, *La Prostitution clandestine* (Paris, 1885), 36–37, 84.

15. A. Carel, *Les Brasseries à femmes à Paris* (Paris, 1884), 2. On the *brasseries à femmes,* see also Theresa Ann Gronberg, "Femmes de brasserie," *Art History* (September 1984).

16. For further discussion of the x-ray, see Robert Bruce-Gardiner, Gerry Hedley, and Caroline Villers, "Impressions of Change," in *Impressionist and Post-Impressionist Masterpieces: The Courtauld Collection* (London and New Haven, 1987), 30–32, and Wilson Bareau 1986, 78–82.

17. Théophile Thoré, "Salon de 1868," in *Salons de W. Burger, 1861 à 1868* (Paris, 1870), II, 531–32; Thoré had voiced similar criticisms of Manet in 1863 (ibid., I, 424–25).

18. Duez's canvas is reproduced in Herbert 1988, 72.

19. Georges Jeanniot, "En souvenir de Manet," *La grande revue,* 10 August 1907, 853. The primacy of the *tache* was central to Zola's 1867 analysis of Manet's work (see Emile Zola, *Mon Salon: Manet: Ecrits sur l'art,* ed. Antoinette Ehrard [Paris, 1970], 100–101).

20. Clark 1984, 239–243, and 310–14nn.65–84, where most of the key texts are reprinted in full, in French; I am much indebted to this compilation.

21. Alexis and Chesneau, quoted by Clark 1984, 311n.66, 313n.82.

22. Du Seigneur and Beaulieu, quoted by Clark 1984, 312n.71, 313n.77.

23. [Louis de] Fourcaud, "Le Salon, I," *Le Gaulois,* 4 May 1882.

24. Houssaye and Bergerat, quoted by Clark 1984, 242–43, 312n.73, 313n.81.

25. Clark 1984, 242, 312n.70.

26. Huysmans (1976 edition; as in n. 1), 347.

27. Maxime du Camp, *Paris: ses organes, ses fonctions et sa vie dans la seconde moitié du XIXe siècle,* 6 (Paris, 1876), 241–42; *bibliophile* Jacob (i.e., Paul Lacroix), *L'Art de conserver la beauté* (Paris, 1858), quoted by Larousse, *Grand dictionnaire,* V (Paris, 1869), 226.

28. Clark 1984, 239, 243, 311n.66, 313n.81.

29. Jules Fleurichamp, "Manet," in *L'Exposition des beaux-arts: Troisième année (Salon de 1882)* (Paris, 1882), 124–27. The author is listed as "un amateur" in the contents, but as "Jules Fleurichamp" on the title page; the section is signed, at the end of the section on 127, with a seal inscribed "Jules Paton Fleurichamp."

30. [Louis de] Fourcaud, "Le Salon, III (suite)," *Le Gaulois,* 12 May 1882, quoted in Monique Le Pelley Fonteney, *Léon Lhermitte et "La Paye des moissonneurs,"* Les Dossiers du Musée d'Orsay, 44 (Paris, 1991), 29–31; this publication contains a valuable anthology of contemporary criticisms of Lhermitte's canvas. See n. 5 above for reference to Fourcaud's comments on the Roll.

31. For a contemporary anatomy of social problems in Paris, see Othenin d'Haussonville, "La Misère à Paris, I: La Population indigente et les quartiers pauvres," and "II: La Population nomade, les asiles de nuit et la vie populaire," *Revue des deux mondes,* 15 June and 1 October 1881.

32. See Maurice Agulhon, Gabriel Désert, and Robert Specklin, *Histoire de la France rurale,* III (Paris 1976), 387ff.

33. Antonin Proust, "Le Salon de 1882," *Gazette des Beaux-Arts* (June and August 1882); brief and entirely unspecific comments on Manet appear in the first article, 547.

34. See essays by Juliet Wilson-Bareau and John House in *Manet and the Execution of Maximilian: Painting, Politics and Censorship,* exh. cat. (London, 1992).

35. In this analysis I am indebted to Dominick LaCapra's study of Flaubert, *"Madame Bovary" on Trial* (Ithaca and London, 1982).

Manet's Man Meets the Gleam of Her Gaze:
A Psychoanalytic Novel

STEVEN Z. LEVINE

> I must, to begin with, insist on the following: in the scopic
> field, the gaze is outside, I am looked at, that is to say,
> I am a picture.[1]
> —*Jacques Lacan, "What is a Picture?"*

WHO IS PICTURED here? A middle-aged, middle-class, suburban
Jew from Harvard who studied with Freedberg and Fried and, years
later during a divorce at Bryn Mawr, began to read some Freud.
Freud's name in Hebrew and his are the same, at least he thinks so. A
son of these fathers, he has written mostly on Monet, Manet having
been preempted by Fried, the subject he is here trying to confront
like a man: "In Manet's last ambitious work, *A Bar at the Folies-
Bergère* (1882), the preemption of beholding is made explicit by the
reflection in the bar mirror of a male customer standing directly in
front of the barmaid, or rather by the unresolvable conflict between
the tendency of the composition to position the actual beholder pre-
cisely there and the laws of optics ostensibly governing the reflection
in the mirror that would have the beholder stand well over to the
right." An alternative reading, Fried notes, "'that inconsistencies so
carefully contrived must have been felt to be somehow appropriate
to the social forms the painter had chosen to show,'" is T. J. Clark's,
the Other/Author who presides here in the name of the totemic
father, whose tribal law largely regulates today's licit intercourse with
Manet's maid, the goal, in spite of this manifold preemption, of the
son's avid gaze.[2]

Once, at the Metropolitan Museum, he briefly shared the same
podium as Clark and Fried and made remarks he has since forgotten
on Freud's "Family Romances."[3] There the son enacted his Oedipal

ambivalence in choosing in fantasy, by way of parricide and homo-erotic love, the father(s) of his desire. Fried is absent from this volume; Clark is too. These filial words are for them—and manifestly against them too. Now he tries to write like a man, but as yet he has said nothing of mothers.

He imagines that Freud's infamous parricide sanctions his own, Lacan's as well, for he was dazzled by the glittering Parisian revision of Freud before daring to expose himself in the mirror of Freud's own texts, some of them written in Charcot's Paris only three years or so after the exhibition of Manet's *Bar.* Indeed something like the hysterical paralysis of Charcot's female patients is evoked in Caroline de Beaulieu's joke at Manet's expense: "M. Manet himself has truly painted with a remarkable assurance and truth of tone a number of very well distributed bottles and a very successful compote of tangerines; the merchantess is so surprised at this that she is paralysed on the spot."[4] The paralysis of her surprise is a function of the immobilizing power of illusion: "What is it that attracts and satisfies us in *trompe-l'oeil?* When is it that it captures our attention and delights us? At the moment when, by a mere shift of our gaze, we are able to realize that the representation does not move with the gaze and that it is merely a *trompe-l'oeil.*"[5] The immaterial picture that momentarily transfixes the critic's gaze thus loses its paralysing appearance of truth when she resumes the mobility of her gait. To fend off the arresting allure of the picture and to find the mobile painting in its place is the moral of this story as well.

For the narrator of this story—the abject, blinking, tearing eye who will at times succumb to the seductive *trompe l'oeil* of the disembodied ego—the Lacanian Freud of inescapable self-division first entered the discourse of art history at a summer film institute in Scotland staffed by a cohort from *Screen,* the magazine of politics and theory where Clark's "Preliminaries to a Possible Treatment of 'Olympia'" later appeared.[6] The Lacanian parable of the mirror-stage of narcissistic mis-recognition (in which modern Western selfhood is seen as the illusory and delusive reflex of an alluring and alienating image) soon put paid to the unreflective formalism of his graduate training at the Fogg.[7] He dutifully purchased Christian Metz's psycho-semiotic theory of the cinematic gaze as well as Laura Mulvey's deconstruction of its allegedly masculine impetus at the London offices of *Screen;*[8] and then he took the bus to the Courtauld's *Bar.*

251

Years earlier he had stood before the *Bar* in the lonely last weeks of his first European trip after a year in Jerusalem where he had first read about Manet. His girlfriend had returned to the States and he found himself alone in London, alone with Manet and his first manhood, "alone with the barmaid and her elusively averted gaze."[9] He no longer knows what he saw then, but years later in New York he subjected himself to the manacles of the barmaid's gaze—her "absent gaze," her "impassive gaze," her "inscrutable gaze," her "vacant gaze."[10] Again a husband but not yet a father, his manliness seemed to him still there to be made out in the mirror of her eyes. As he now knows, that place where he would manfully stand was and is already taken, *occupé, besetzt,* preempted, by Manet and his dandy, by his own daddy, by Fried and Clark and all those women and men caught up as is he in the mortgaged transfer of tradition's tenancy in that troubled place before the *Bar.*

Indeed Manet was "only the first in the decrepitude of [his] art," as Baudelaire's famous letter to him put it, for there was precisely no uncontested place there, in the face of Manet's painting, for Manet the painter, for Manet the man.[11] But let us say, nevertheless, that Manet once was there, in his studio, facing both Suzon the model paid to act as a focus for his gaze and the canvas of the barmaid painted to be beheld not only by himself but also by all those others at the Salon of 1882 or the blockbusters of 1983 into whose blinding gaze I can now only squintingly look.[12] If Manet once was there, then, his attention was stretched and split not only across the perceptual space between the canvas and the model but also across the internalized gap between "the eye and the gaze," between the embodied desires of pictorial looking and the conventional determinations that unconsciously came to weigh upon that look.[13]

So if I am to imagine that the man Manet once painted the *Bar,* who do I imagine that man to be? Born in 1832 in Paris, an eldest son with brothers two and three years younger, he died in 1883 with no son of his own, although his residual legatee, Léon Leenhoff, born in 1852, has been taken to be his son and his wife Suzanne's—or the son of his wife Suzanne and someone else, perhaps even his father Auguste.[14] As my story is an august tale of fathers and sons, real and imagined, the biography here will fitfully attend to the putative traces in Manet's work of *les noms du père,* a Lacanian romance of the errant paternal phallus ("Les Non-dupes errent"), a revised Freudian novella of the inferential dynamic of paternity which annihilates (and

252

hence enculturates) through the deferred introduction of the third term of insemination the phenomenologically irreducible dyad of the mother and child.[15]

So who is this man Manet, son of his father, perhaps father of his son, necessarily his mother's child, as he gazes into the gazes of those whose knowledge of him lies occluded on the surfaces of the canvases that gaze at us? For Clark, "the same dead-pan face confronts us, the same frozen posture, the same compacted space. . . . It is the face, to paraphrase a remark of Michael Fried's, of the painting itself, in which the painting stares at us. . . . 'In this sense it is as though the painting itself looks or gazes or stares at one—it is as though it confronts, fixes, even freezes one.'"[16] How is the professor to elude this Medusa, to refuse its immobilizing gaze, to restore its physicality and temporality, to move?

Manet's father was a high official in the Ministry of Justice and a bearer of the cross of the Legion of Honor; his mother was the daughter of a diplomat stationed in Stockholm and a god-daughter of the elected king of Sweden. Manet painted a double portrait of his parents in 1860, two years after the onset of his father's partial syphilitic paralysis (fig. 34). He exhibited their portrait at his first Salon in 1861 (RW30): a year later his father died and he painted his mother in mourning (RW62), her gaze already congealed into that frontal disposition which the barmaid would repeat, her right wrist apparently encircled by the bracelet containing a lock of Manet's baby hair which Olympia would don in the following year (RW69) and which Suzon may still be wearing twenty years later in the *Bar*. With the traces of desire ostensibly painted out of her downcast eyes in the double portrait with her husband, Eugénie-Désirée Manet may be seen to cede her role as the imperious mirror of her son's desire to an Italian model (RW29), who first incarnates in Manet's work the braceleted arm, proferred breasts, banded neck, and overt gaze later attributed to Olympia and Suzon. Suzanne, as model alongside Manet for the Rubensian conjugal couple in the corner of *La Pêche* (RW36), repeats in 1861 the Italian model's bosom-revealing cross-clasping of her arms rather as the sketched barmaid of 1882 (RW387) later also will do, but in Suzanne's principal pictorial role in *The Nymph Surprised* (RW40), she plays out at right angle the Italian and French models' scenario of frontal display, turning her gaze full upon the dyadic space between herself and the painter-spectator yet at the same time barring the traversal of this intermediate gap through

the closing of her naked legs across her sex and the clasping of her arms across her unseen breasts.[17] Recalling in Suzanne's name and pose the Biblical iconography of Susannah and the Elders, this tabooed access to the female body is underscored by contrast to the contemporaneous fantasy of the openly nursing gypsy mother (RW41), itself a transformed repetition of Titian's holy family copied at the Louvre in 1854 (RW5), itself the sacramental guarantor of a desexualized femininity (and a marginalized masculinity: note Joseph at the rear) whose libidinous face (and braceleted wrist) is turned to the fore in Titian's *Venus of Urbino* copied in Florence in 1856 (RW7), itself the antithetical sign of the masculine corpse that is clinically laid bare in Rembrandt's *Anatomy Lesson* copied in Holland around 1856 (RW8), where the naked male body is overseen by the "same" hatted, collared, and mustachioed man who later presides in the upper-right corner of the *Bar at the Folies-Bergère,* itself the scene of anatomy lessons of a not altogether different sort as in the ostentatiously displayed décolletage of the barmaid or the frame-amputated trapezist's legs whose *corps morcelé* might already intimate the amputation of Manet's syphilitic and gangrenous leg in 1883.[18] Something of the eviscerating mien of Rembrandt's surgeon abides in Manet's father's penetrating gaze, more clearly in the effaced underlayment of the painting of 1860 than upon its outward face.[19]

In his parents' joint portrait Manet cannot bring either his father or his mother to look into his eyes, although an etching of his father and a preparatory drawing for the composition suggest that this may not have been initially the case. The old-masterly eyes of Tintoretto's copied self-portrait may offer an alternative parental gaze to the mirror-seeking eyes of the twenty-two-year-old artist in 1854 (RW6), but the abjuring *noli-me-tangere*-eyes of Manet's resurrected Christ from this period (RW14) appear to reinforce the paternal law of scopic interdiction. In contrast, the not-yet-dead eyes of the young model who later hanged himself in Manet's studio openly permit an unfettered scrutiny of his androgynous features in 1859 (RW18), while his hands finger the ripe cherries whose lush avatars will reappear in the languid clutch of the street singer of 1862 (RW50), in the lurid tangerines on the barmaid's counter in 1882, and in the numerous *natures mortes* of flowers and fruit which precede and prolong the *Bar*'s execution up until the weeks just prior to Manet's death.

Manet repeatedly stages situations in which a gaze, alternatively

masculine or feminine, might be seen fully to reciprocate his own: "When, in love, I solicit a look, what is profoundly unsatisfying and always missing is that—*You never look at me from the place from which I see you.* Conversely, *what I look at is never what I wish to see.*"[20] Manet's mother in 1860 does not look out at her son but the young wife of a friend, Mme Brunet, does (RW31); Manet's father in 1860 does not look out either, but in the following year the nine-year-old Léon does (RW37), and thus the son becomes father to the man. Like a broken fragment of Velasquez appropriated from the corporate history of art, Léon bears the sword of patriarchal power: but is his father the unknown Koëlla whose name he was given; is it his mother's father Leenhoff whose son he was later said to be; is it his mother's lover Manet who made her a wife after his father's death but never made him a son; or is it his mother's lover's father, also her lover, who acknowledged no illegitimate son but whose other sons, Manet's two brothers, were later presumed by the artist to be in accord with his testamentary dispositions in Léon's favor rather than in their own? Does it matter to us whether we think of Manet looking into Léon's eyes looking into his own as the facing off of brothers-in-law or half-brothers by blood, of father and stepson by marriage or father and son by birth? In a note to "Manet's Sources" in reference to a later appearance of Léon in Manet's art, Fried briefly wonders whether a "relation" might obtain between *The Luncheon in the Studio* of 1868–69 (RW135) and "the theme of domestic tragedy" in paintings of *Andromache Mourning Hector* (1783) and *The Return of Marcus Sextus* (1799) by David and Guérin. "Almost certainly Manet's son," Léon's paternity is not further speculated upon by Fried; torn between Fried and Freud and uncertain of my own paternal sources in art history, I wonder whether it is an anxiety of genealogical doubt that lurks in Léon's look.[21] Might Suzanne herself not have known the father of her son?

Whatever there was for Manet in Léon's look, he looks for this look again and again. His notorious model, Victorine Meurend, manifests the look most Léon-ishly in her mannish guise as a cross-dressed *espada* or sword-bearer at the bullfight (RW58). Does her sado-masochistic image threaten to avenge the crime of Léon's unacknowledged paternity, and if so is the allotted victim to be understood as Manet's father, perhaps not yet dead at the time of the painting's execution in 1862, or is the ritual taurine victim Manet himself, the matador whose mutilated body the painter later severed

from the critically spurned *Episode in a Bullfight* of 1864 (RW71–73)? These questions have no simple answers of course, but the unforgotten confrontation with Léon's and Victorine's face continues to reverberate within the frame both of Manet's twenty-year obsession to master that look as well as art history's century-long struggle to master his art.

As Olympia, Victorine bears the flowers and wears the bracelet and velvet band which rather differently set off the unseen but no less indicated nakedness of Suzon. "The progressive concealment of the body which goes along with civilization keeps sexual curiosity awake. This curiosity seeks to complete the sexual object by revealing its hidden parts. It can, however, be directed ('sublimated') in the direction of art, if its interest can be shifted away from the genitals onto the shape of the body as a whole."[22] As one recent commentator puts it, "Manet has emphasized the barmaid's vagina through the arrow-like cut of her vest, and through the echoing outlines of the compote on the right and the other objects lined up on the bar."[23] As the intimately sheathed *Young Woman of 1866* (RW115) Victorine wears nearly the very brooch and band that Suzon later so prominently displays, the "same" worn by his wife Suzanne in a contemporaneous bust-portrait (RW116; fig. 35). Victorine yields back to Léon her surrogate's role as the baited trap for Manet's avid eyes in *The Luncheon in the Studio,* where the top-hatted mustachioed man of the *Anatomy Lesson, Music in the Tuileries* (RW51; where it is Manet), *The Old Musician* (RW52; where it is the *Absinthe Drinker* of 1859), *The Masked Ball at the Opera* (RW216; where it is Manet), *Nana* (RW259; where it is Zola's Muffat), and the *Bar* (where it is the painter Gaston Latouche) surveys not the serving maid, here placed to the left rear, but rather Léon's rear or at least some indeterminate space where just such homoerotic anal fantasies of incestuous sex and violence can be safely conjured up, and just as safely set aside, amidst a displaced, oneiric tangle of knives, armor, oysters, and black cat. The Bass ale of the *Bar* finds a near-counterpart here too, a manly brand whose continued commercial availability can still provide the her-men-eutic occasion for experiencing the heady incorporation of Manet's maid's gaze.

The horizontal disposition of the *Luncheon* echoes the format of the *Bar,* a lateral slice of space whose precise dimensions (96 × 130 cm) are repeated in only one other painting by Manet, *Boating* of 1875 (RW223), in which Suzanne's brother Rodolphe takes up the

out-gazing role previously passed back and forth within the intimate Manet-Leenhoff circle. Like the *Bar*, *Boating* displays a gleaming mirage of dyadic male-female relations, in which, however, the artist's absent gaze is now mirrored by the male rather than female character. This lability of identification across the uncertain threshold of gender extends to Manet's depictions of children as well, with not only Léon in 1861 but little Henry Bernstein twenty years later (RW371) striking poses otherwise taken up by Manet himself. Léon precariously proffers his manly sword rather as Manet ceremoniously displays his palette and brushes in imitation of Velasquez (RW276), and Henry manfully thrusts his hands in his pockets in a flat-footed frontal stance (RW371) that recalls Manet's other Velasquez-like self-portrait (RW277), in which the bearded and jacketed painter wears a skull cap not unlike the one his deceased father had worn in the double portrait eighteen years before.

Given this knotted web of gendered and generational self-representations, whose face(s) shall I take it that Manet paints when he looks into Suzon's face in 1882? From Rio de Janeiro thirty-three years earlier the seventeen-year-old naval recruit writes to his mother as follows: "In the street you encounter only Negroes and Negresses; Brazilian men don't go out much and ladies even less. . . . I saw a slave market, a rather revolting spectacle for people like us; the Negroes wear trousers, sometimes a cotton jacket, but as slaves they're not allowed to wear shoes [see the shoeless Christs, RW74, 102]. The Negresses are generally naked to the waist, some with a scarf tied at the neck and falling over their breasts, they are usually ugly, though I have seen some quite pretty ones [see the nude busts, RW176, 240–41, 287, 318]. . . . Some wear turbans, others do their frizzy hair in elaborate styles and almost all wear petticoats adorned with monstrous flounces [see Olympia's maid, Laure, RW68–69]. Most Brazilian women are very pretty; they have superb dark eyes and hair to match [see Manet's dark-eyed ladies, e.g., *The Spanish Lady with a Cross*, RW34; Jeanne Duval, Baudelaire's mulatto mistress, RW48; Lola de Valence, RW53; Nadar's mistress or *Young Woman Reclining in Spanish Costume*, RW59; Eva Gonzalès, RW154; Berthe Morisot, until she became his brother's wife, RW158, 177–79, 181, 209, 228–29; *Emilie Ambre in the Role of Carmen*, RW334; *The Amazon*, RW394–96] . . . they never go out alone but are always followed by their black maid or accompanied by their children [see Victorine Meurend with maid and child, RW69, 207; Edma Pontillon-

Morisot and Camille Monet with marginalized husband and child, RW155, 227; *Skating,* or Henriette Hauser and child, RW260]. . . . The carnival of Rio is something quite special. . . . All the Brazilian ladies are at their front doors or on their balconies, bombarding every gentleman who passes with multicolored wax balls" (see *Angélina,* RW105; *The Balcony,* RW133–34, Léon Leenhoff on the balcony at Oloron, RW163; Suzanne Manet on the balcony at Berck, RW202; Méry Laurent, Jeanne Demarsy, et al. on the balcony at the Folies-Bergère). Manet insists, "I gave as good as I got"; but "unfortunately there are enormous quantities of snakes and you have to take great care."[24] Even in Paris, it seems there are snakes (see *The Dead Christ with Angels,* RW74, and the still lifes with eels, RW80–81), as well there might be for someone who re-envisions in each new encounter the manning and unmanning sights of the past.

The young man Manet displays his libidinal and aggressive cathexes more overtly to his cousin, Jules de Jouy, than to his mother: "As for the Brazilians, they are spineless and seem to have little energy, their women are generally very good-looking but don't deserve the reputation for looseness they've acquired in France; there's nothing so prudish or stupid as a Brazilian lady." After Brazil it is Spain in 1865 which remobilizes Manet's recuperative scopic drive, and he reenacts the visual fascination of his earlier experience in several letters to friends. To Fantin-Latour he writes, "Madrid is a pleasant town, full of entertaining things to do. The Prado, a charming promenade full of pretty women all in mantillas [see the earlier etching *At the Prado,* ca. 1863, and the later etching, *Exotic Flower,* 1868; Angélina at her window in 1865, RW105; Berthe Morisot with a fan, RW181]. . . . In the street one still sees a lot of local costumes, and the bullfighters are also strikingly dressed" (see the numerous cavaliers, musicians, dancers, and bullfighters already present in Manet's work for a number of years prior to his visit to Spain, RW21, 25–26, 32, 34, 37, 53–56, 58–60, 70–73). In letters to Astruc and Baudelaire written upon his return to France, Manet reiterates his impressions and projects a painting as well: "I stayed a week in Madrid and had plenty of time to see everything, the Prado with all those mantillas was absolutely delightful, but the outstanding sight is the bullfight. I saw a magnificent one, and when I get back to Paris I plan to put a quick impression on canvas: the colorful crowd, and the dramatic aspect as well, the picador and horse overturned, with the bull's horns ploughing into them and the horde of *chulos* trying to draw the furious beast

away" (see RW107–11). "One of the finest, most curious and most terrifying sights to be seen is a bullfight. When I get back I hope to put on canvas the brilliant, glittering effect and also the drama of the *corrida* I saw. And the *Prado,* too, where every evening one can see the most attractive women in Madrid, all wearing mantillas over their hair."[25]

What Manet sees in Spain is above all himself, himself as he would wish to be, as his own feared and beloved manly ideal, as his own father perhaps. He expresses his eagerness to depart to Astruc who has advised him on the trip: "I simply can't wait to see all those wonderful things and go to *Maître* Velasquez for advice"; as a judge Manet's father would have been addressed as *Maître* as well. Once in Spain Manet confirms his expectations for Velasquez, "who all by himself makes the journey worthwhile; the artists of all the other schools around him in the museum of Madrid, who are extremely well represented, all look like shams." "He is the supreme artist; he didn't surprise me, he enchanted me," he writes to Fantin-Latour from Spain; and upon his return to France he immediately repeats this judgment: "At last, my dear Baudelaire, I've really come to know Velasquez and I tell you he's the greatest artist there has ever been." And to Astruc: "He's the greatest artist of all; he came as no surprise, however, for I discovered in his work the fulfillment of my own ideals in painting, and the sight of those masterpieces gave me enormous hope and courage."[26] With its gleaming mirror, its rhetorically arrested, black-suited, mustachioed, and marginalized gentleman, and its centralized, cinch-waisted, black-and-gray dressed, beflowered, out-gazing blonde, the *Bar* will become Manet's *Meninas* at the Folies-Bergère.

On the lookout for a father's confirming gaze, his own parent now dead since 1862 and his painting teacher Couture no longer of any idealizing use to him, Manet finds that manly orthoscopic gaze in Velasquez's work, most notably in "the most extraordinary piece in this splendid *oeuvre* and possibly the most extraordinary piece of painting that has ever been done . . . a portrait of a famous actor at the time of Philip IV; the background disappears, there's nothing but air surrounding the fellow, who is all in black and appears alive" (see the copy of the portrait of Philip's fool, Pablillos de Valladolid, RW103, and the portraits of the actors Rouvière and Faure as the father-bereft and guilt-ridden Hamlet, RW106, 256–57). Further insisting on the living power of painting to overcome the paralysis of death, Manet

also notes "the fine portrait of Alonso Cano; *las Meninas* (the dwarfs), another extraordinary picture; the philosophers, both amazing pieces [see RW99–100]; all the dwarfs, one in particular seen sitting full face with his hands on his hips, a choice picture for a true connoisseur [for hands on hips see Manet's standing self-portrait, RW277]; his magnificent portraits—one would have to go through them all, they are all masterpieces." In this romance of patriarchal over-valuation, Manet finds the portrait of Philip IV's great-grandfather Charles V painted by Velasquez's art-historical grand-parent Titian inferior to the work of the later-coming artist, but at the same time he denies this capacity of generational surpassment to Goya, "the most original next to the master whom he imitated too closely in the most servile sense of imitation." Manet may imagine that he will avoid this filial trap into which Goya falls, just as Velas-quez himself had done vis-à-vis Titian. This essay is obviously telling a similar institutional tale about Freud, Fried, and Levine. Like the professor, Manet admires his art-historical mentor but through the interlocking merger-fantasies of idealization and identification he will incorporate him too, become his father's father, swallow him even though this sacramental killing-meal brings him distress: "But although this country provides a feast for the eyes, one's stomach suffers tortures. When you sit down at table you want to vomit rather than eat."[27]

In the Louvre "only the *Infanta* is indisputable," the only painting in Paris that Manet accepts as bearing the physical trace of the mas-ter's own hand (fig. 36). In the gaze of the young princess Manet sees reflected Velasquez's look; in looking at the painting with Velasquez's eyes Manet transfers upon himself the vivid indexical vector of his master's lady's gaze. This then is his mother's gaze too, accessible in fantasy without paternal or sibling interference even though his father and his after-born brothers had from the first taken away the sole proprietorship of that maternal gaze which once might have seemed all his own. Now married to Suzanne but since 1867 living at his mother's home, it is through his wife that his mother's gaze makes its circuit to his eyes; later it will be through Suzon that Suzanne will look at him. From Prussian-besieged Paris in 1870 he writes via bal-loon to Suzanne who has been sent to the Pyrenees to be out of harm's way: "My regards to you all, give mother a kiss for me. Tell Léon to behave like a man. . . . I hope this won't last long."[28]

The siege of Paris lasts for more than four months. "A lot of cow-

ards have left, among them, I'm afraid, our friends Zola, Fantin, etc."
Manet writes to Eva Gonzalès in safety at Dieppe at a time when he
can still say "that of all the privations the siege is inflicting on us, that
of not seeing you any more is certainly one of the hardest to bear."
Not seeing Suzanne is harder still: "I spent a long time, my dear Suz-
anne, looking for your photograph—I eventually found the album in
the table in the drawing room, so I can look at your comforting face
from time to time. I woke up last night thinking I heard you calling
me. . . . People who have stayed in Paris see very little of each
other—one becomes dreadfully self-centered." Seeing takes Manet
out of himself; during the siege he attends a public meeting with his
brother and Degas at the Folies-Bergère and continues for a time to
go to the Café Guerbois. In spite of such visual stimulation, in his
egocentric isolation he looks to the absent gaze of Suzanne: "I think
of you all the time and have filled the bedroom with your portraits"
(see RW20, 36, 38–40, 116–17, 131, 136). In a letter written to Suzanne
on Christmas, the one-hundreth day of the siege, Manet adopts the
same diminutive form of her name that will later return in the *Bar*:
"My dear Suzon, although it's been so long, I still can't get used to
coming back in the evening to this sad apartment. . . . What an end
to the year! . . . Good-bye my dear Suzanne, your portraits are hang-
ing in every corner of the bedroom, so I see you first and last thing."[29]
Me too; Susan, you see, is the name of my wife.

A stint with the cavalry of the National Guard soon consigns Manet
to spending more time at home: "I've had to stay in my room for the
last two days after riding gave me boils. . . . I hope they won't last
long, I get bored all alone in my room even though I'm surrounded by
pictures of you." Manet's besieged isolation in Paris contrasts with
the forced togetherness of his wife and mother at Oloron-Sainte-
Marie (see their later joint representations, RW190, 345–46): "Give
mother a kiss for me, I hope you're all getting on well together, you
have the same interests and anxieties and I should be unhappy to
think that there was anything less than perfect understanding
between you." Between them, in their exile, abides Léon, whatever it
is that he may be, the younger brother of Suzanne Manet or her ille-
gitimate son, the unavowable offspring of Désirée Manet's mortally
imperilled son or of her mourned late husband. In spite of this
enigma for us, Léon seems to play a clear enough role for them:
"There are many deaths in Paris. I hope you are pleased with Léon,
he must take good care of you and mother" (see *Reading*, RW136,

where Suzanne is centralized and Léon is marginalized, and RW163, 170–71). In his will Manet later commends Léon, "who has given me the most devoted care"; but in 1871 love and aggression seem fluidly bound together in the dual form of a solicitous threat: "I sent him along to look after you," he writes to Suzanne, "and he should remember that, because lots of boys of his age are sent into battle here."[30]

Any killing of Léon takes place not on the battlefield (where Manet's friend and colleague Frédéric Bazille soon died) but in paintings such as *Boy with the Sword* of 1862 and the sword-riven *Luncheon in the Studio* of 1868: "Unhappily, there have been many deaths here in Paris. Only we who have been through it can know what it's like." Only we who have been through the scopic mesh of Manet's lethal art can know what it is like, too, for art no less than war can leave us changed. To Berthe Morisot, Manet muses, "what terrible events, and will we ever recover from them";[31] the reference is to the civil violence of the Commune which followed hard upon the capitulation of Paris, but for the writer of this tale it is Manet's art that endlessly opens the wound of love and loss he has repeatedly suffered (and inflicted) in the face of both the male and female gaze.

In search of the self-confirmatory mirror of the admiring parental gaze, Manet finds himself instead in the face of an unsmiling public. In 1874 the Salon jury rejected a landscape-portrait of his mother and wife at Berck-sur-Mer (*The Swallows*, RW190) as well as his own self-representation in *The Masked Ball at the Opera*, but the poet Stéphane Mallarmé soon came to Manet's defense: "My dear friend, thanks, if I had a few supporters like you, I wouldn't give a f... about the jury" (see the portrait of Mallarmé, RW249).[32] Aggression and sexuality may have been on Manet's mind for other reasons just then, for later in the year his brother Eugène married Berthe Morisot whose still obscure special place in Manet's art and life soon enough came to be more overtly filled, or not, by a host of fashionable and/or notorious young women such as Ellen Andrée (see the barmaid-like frontally posed and cinch-waisted *La Parisienne*, RW236); Henriette Hauser (see the barmaid-like outwardly gazing and marginally observed *Nana*, RW259); Isabelle Lemonnier (see the barmaid-like bosom-flaring portrait, RW304, as well as RW299–303); Jeanne Demarsy (see the barmaid-like staring figure whose portrait-bust, RW374, is incorporated into the balcony of the *Bar* and whose allegorical profile-portrait as burgeoning *Spring*, RW372, accompanied

the full-face narrative of the *Bar* at the Salon of 1882); and the well-known *demi-mondaine* Méry Laurent (see the barmaid-like banged and blanched allegorical portrait *Autumn*, RW393, whose elegiac mood of senescence and resignation is perhaps also legible in the pastel portrait-bust, RW2:51, that is incorporated into the first row of the balcony in the *Bar* and in the variously oblique or direct portraits and nudes, such as RW2: 22–24, 52–53, 72–74, 76, which Manet made of her and for her in those years of his gradual succumbing to the effects of syphilis, eventually dying "of the same malady as his father").[33] Reputedly the sometimes-lover of both Mallarmé and Manet, Méry Laurent, née Anne-Rose-Suzanne Louviot, was one of the painter's most intimate correspondants during the period before and after the execution and exhibition of the *Bar:* "This silence, my dear Méry, is it laziness? Even that would be better than indifference. Has the most sensitive of hearts succumbed to some new passion? Quickly, tell me the latest about the life I hold so dear. My health continues to improve [he was at Bellevue outside of Paris for hydrotherapy and convalescence], apart from occasional bouts of depression [see the earlier *Suicide*, RW258]. . . . True the life I'm leading is not exactly varied. I don't even have much inclination to work and hope that will suddenly change." The *Bar,* in which Méry Laurent may have played both a muse-like and emblematic role, is the principal product of Manet's renewed activity in 1881, but in the increasingly incapacitated months after its exhibition in the following year Manet confides to her that "to feel really well and happy I have to be able to work." In the previous week the newspaper *L'Evénement* had published "a deplorable bulletin about my health," and if he does not entirely hide the truth of his decline from Laurent and Mallarmé to whom he also writes at this time, to the offending journalist he simply lies: "I am not in the least ill. I simply sprained my foot before leaving Paris."[34] Within nine and a half months his left leg was amputated; ten days later Manet was dead. Claude Monet was one of the pall bearers at the funeral, and I have also come here to bury the Man.

With Manet dead and buried, henceforward Suzon will look only at the professor, yet between her gaze and his are interposed the manifold screens of vision of the preemptive art-historical past. For Manet's friend Paul Alexis back in 1882 the barmaid is "a beautiful girl, quite lively, quite modern, quite Folies-Bergère in the expression of her made-up face." In the mirror she chats with a client, "a serious

adorer perhaps"; and she chats or flirts with this mustachioed gent in the writings of a number of other male critics at the Salon.[35] Although she could not be more "*fille*" for Ernest Chesneau, for Henry Houssaye she is not more than a cardboard mannikin: "In good faith must we admire the flat and plastered face of the bar-girl, her bust without relief, her offensive color? . . . No. . . . No. . . . No."[36] This triple negation points to an anxiety, scarcely repressed then and to which the middle-aged professor is still prey, provoked by the sight of that face, those breasts, that paint: "To love the little blue merchantess selling oranges at the Folies-Bergère we would have to learn to cherish cardboard women."[37] The "brutality" of her pose, "cut off at the belly" by the counter, above which she "seems to rise like an expiatory victim," may preserve some of the castration anxiety and counter-phobic sadism of Houssaye's defensive repetition of disavowal, but elsewhere we find an idealization of "la belle fille."[38] Whether in admiration or anxiety "this lady of the counter arrests everyone" who walks by; she is a "fantasy" or a "dare," eliciting "stupified" and "disoriented" comments from the pressing throng.[39] This manic dysphoria yields the split-screen scenario that she is putting on "a most innocent face in order to pretend that she does not know that her twin sister is being chatted up behind her by a man of substance." Notwithstanding the probable irony of this doubling of the female *dramatis personae,* what most other writers take as the background mirror-image of the one and same barmaid repeatedly provokes similar expressions of lack: "The whole picture transpires in a mirror, and there is no mirror. As for the incorrectness of the drawing, as for the absolute insufficiency of the figure of the woman who is, in sum, the only personage, as for the lack of correspondence between the reflected objects and their image, we will not insist upon it."[40] But of course they did, and we still do: "If that *is* a mirror behind the barmaid, then what exactly is being reflected in it? If it is a mirror, then the second young woman, towards the right, must be the mirror image of the one who looks out towards us. She must be, and she cannot be."[41] To be *and* not to be, is that the Lacanian lesson? Who am I? Who am I not? "Je est un autre."[42]

One critic notes in 1882 that the barmaid takes on a "bored air," whereas another makes out "the gleam of [her] gaze."[43] This antiphonal response repeats itself down to our own day, a function of the affective ambiguity of the barmaid's gaze as well as our own ambivalence (the professor's at least). Edmond Bazire, who reputedly

became Suzon's lover, insists in his 1884 monograph on Manet that "she listens without emotion, to the words of the gallant drinker," but in a report on the posthumous sale of Manet's works in that same year the barmaid is said to be chatting with a gentleman "at whom she makes eyes."[44] Manet's testamentary trustee and biographer, Théodore Duret (see RW132), later describes the barmaid as doing nothing but waiting for a customer, with "her vacant eye and placid face," and this would-be authoritative interpretation is in turn repeated in the *catalogue raisonné* of 1932: "A pretty blond girl, wasp-waist, black ribbon at the neck, bodice of blue velvet largely cut out upon a white chest that bends over, framed by a border of lace and a bouquet of roses, is there, in her professional amiability and inexhaustible indifference." In Jamot's paradigmatic passage the barmaid is further described as "this melancholy, made-up and dressed-up youth," and thereafter echoes of her melancholic indifference reverberate in many later texts.[45]

In Janson's *History of Art* "the barmaid's attitude, detached and touched with melancholy, contrasts poignantly with the gaiety of her setting, which she is not permitted to share." Hofmann similarly sees that "her eyes, which seem to be looking at nothing in particular, have the emptiness that goes with melancholy." In the catalogue of the retrospective exhibition of 1983 Cachin sees "melancholy in the absent gaze of the serving girl," and her "indifferent" look is viewed as "more aloof than flirtatious." To Wivel she also "seems quite indifferent," and Adler finds her face "a mask of indifference and boredom."[46] This indifferent mood is understood either as an effect of the actual model's "deadly boredom familiar to everyone who has sat to a painter for hour after dismal hour," or as the affect of the depicted barmaid who stands "strangely lusterless, her eyes clouded with fatigue or boredom beneath her blond bangs." Courthion sees her as "tired yet still attentive to the customers," but Schneider, annulling the "inexhaustibility" of 1932, finds that her "professional attentiveness barely hides exhaustion." Elsewhere in Schneider's book, an editorial caption silently echoes Mortimer's opinion that "her tired and rather bored expression may be the result of posing for long hours in Manet's studio."[47] Throughout the art-historical literature a polymorphous Suzon slips in and out of Manet's painted narrative as though in a recurrent, collective dream.

In Richardson's allegorical interpretation the barmaid is "an impassively pretty *fille du peuple* [who] epitomize[s] the spirit of the

period," whereas in Canaday's formalist account the barmaid's face is nothing other than "a passage of flat tone given its third dimension by the brushing in of a few small, sudden concentrations of dark." *Gardner's Art through the Ages* repeats even in its most recent edition that "the barmaid is only another *motif*—another still life amid the bottles on the counter," whereas in Rosenblum's post-formalist survey text the barmaid is seen as "usurping the traditional role of a frontal, centralized Madonna." For him "the barmaid's expression of loneliness or apathy completely denies the ambience of communal pleasure and bustle," an incarnation of "the alienation of the individual in the modern city."[48] "Perhaps the most poignant image of alienation ever painted," according to Nochlin, this reading of the barmaid's "empty stare" is widely disseminated by text-book writers Honour and Fleming who see in her "something of the loneliness and disillusion of city life, of that sense of isolation and alienation so typical of the modern sensibility." For Hanson she is "the lonely modern individual isolated by her firm contours and her own reverie from the activity which surrounds her"; for Herbert she embodies "the anonymity and loneliness inherent in the arbitrary encounters of modern life," but her "statuesque" figure retains "an immense dignity and self-containment": "She is also a disconcerting figure because her matter-of-fact, cool glance seems to lack expression."[49]

Suzon's lack is repeated in a monograph on the painting by Novelene Ross where "the barmaid's sensuous face with large features betrays no expression." In contrast to this view, a recent allegorical account suggests that "the girl stands behind the bar like some sibyl and stares out, not expressionlessly, but absently, as if preoccupied, at *Life* and at us—who watch both her, and it, as it unfolds in all its evanescent splendour in the mirror behind her."[50]

Who then are we for her to stare in these ways at us? In the mirror "she seems to address a customer whose reflection appears in the mirror and it has often been suggested that the spectator of the painting becomes a kind of substitute for the missing image of this man. . . . Who is this man? It has been suggested more than once that he is *you*, the spectator."[51] According to this phenomenological interpretation of the painting the play of reflections "forces us to see ourselves mirrored irrationally as another person, a dapper Parisian who holds a walking stick and is possibly propositioning the recalcitrant barmaid." So it is not just drink that is on his/our mind: "Is the woman's glance not just the barmaid meeting the customer's

gaze, but the whore appraising the client, offering herself for appraisal? Is the look—the famous stare—a commodity? Of course we cannot be sure."[52]

In spite of Clark's admirably Freudian disclaimer—"What if we have shared the fate of so many interpreters who have thought to see quite clearly things which the artist did not intend either consciously or unconsciously? I cannot tell,"[53] the professional field has subsequently become divided between proponents and opponents of the Clarkian view. For Nochlin the barmaid is "both seller and sold"; for Howard her "pudendum (inverted and disguised but centrally placed in the painting) was for sale like its other sensual delights." Resisting Clark's seminal interpretation, Cachin protests that "Manet surely had no intention of portraying the degradation of a fallen woman, the corruption of a working girl by the bourgeoisie; that is an ideological mirage willfully imposed upon the work." In a review of the revised 1985 version of Clark's account (in which he now maintains that the *Bar* "is a picture of a woman in a café-concert, selling drinks and oranges, and most probably for sale herself—or believed to be so by some of her customers"), Cachin argues that the barmaid's "place behind the counter is surely proof, if anything, of her respectability, for she could easily have earned more money as a prostitute than tending bar"; that the cited phrase "*marchande de consolation,*" far from being a reference to prostitution, neither directly denotes nor indirectly connotes anything other than a dispenser of consoling alcoholic spirits; and that, in any event, Manet repeatedly endowed depictions of his wife and many other fashionable women "with that same sleepy look." Cachin's highly public challenge to Clark's professional authority (in a subsequent rejoinder letter she calls him a typical "campus mandarin who resents criticism or discussion") has been taken up in other recent work: "The barmaid may or may not be a prostitute, but nothing in the gaze or attitude suggests her availability, and the contrast between her remoteness and the obvious body language of the women in the *Masked Ball* makes such a reading of her unconvincing."[54] "We can be sure that . . . Suzon lived [a] less conventional [life] than a proper bourgeoise, and that [she] might well have had lovers, or occasionally slept with a theater manager. But between this and prostitution there is an enormous gap. . . . Nothing hints at her availability after hours."[55] Touché, T. J.

Whore or Madonna, alienated *petit-bourgeoise* or "heroic agent of coherence," Manet's barmaid is the "blank" face upon whose "neutral,

undifferentiated expression" art historians persist in unconsciously projecting their own mirror-images.[56] "Her gaze resists interpretation," Clark memorably says; and years later he soberly adds, "I think the viewer ends by accepting—or at least by recognizing—that no one relation with this face and pose and way of looking will ever quite seem the right one." For the analyst / analysand who writes here, these words would be among the most productive in the *corpus* of the *Bar's* recorded responses were it not for the dark shadow of positivist faith that nostalgically lurks in Clark's hyper-contextualization of the prostitutional scenario and in the deadly rightness of the looking that is imagined even if only as beyond his grasp. Clark knows that in 1882 "the critics were strikingly lacking in unanimity when it came to saying something about the pose and expression of the barmaid";[57] the situation is no different today yet art history has not notably sought to acknowledge the institutional implications of our historically discontinuous and affectually particularized encounters with Manet's *Bar*.[58]

For now let me conclude by acknowledging that the man Manet (whoever *he* was) once painted the *Bar*, and that the man who writes here (and any other woman or man who will be his reader) must somehow bear up to the task of confronting the transindividual context of interpretation which she or he has mobilized from among the innumerable such contexts (formalism, Marxism, psychoanalysis, feminism, deconstruction, etc.) already or not yet sanctioned by our common disciplinary practice. If Manet were here, the balding and bearded Jewish professor might ask him to tell his story of the *Bar* in his own words, in whatever words came in to his mind; but of course he is not here. As we have seen, however, others have written as though he were: but even if Manet were present, the would-be authority of his own narrative would still have to yield in the face of other viewers' imperative desire to look (and not to see). "Do not ask, finally, how much of this Manet intended."[59] Ask instead how much of this Clark intended; ask instead of the devices and desires that are brought manifoldly to bear in each and every one of our own presumptive preemptions of Manet's intention: "He / We painted the *Bar* in order to place some spots of light in a darkened field"; "He / We painted the *Bar* as a critical exposé of the libertine rapacity of masculinist-capitalist power in its commodification of leisure for monetary gain, in its sham mixing of the classes for ideological diversion, and in its exploitation of women's bodies as objects of sexual

display and reckless libidinous use"; "He/We painted the *Bar* in lov-ing celebration of female fecundity and from an anguished sense of the impotent masculine pretense of so-called artistic creativity"; "He/We painted the *Bar* as revenge against all the loveless looks encountered in the bedroom, the academy, the gallery, and the street"; "He/We painted the *Bar* in acknowledgment of the ineluct-able formal modalities of the flattened, framed, and factured picture plane"; "He/We painted the *Bar* in order to acknowledge the primor-dial convention that paintings are made to be beheld in a solemn attitude of reciprocal facing, an attitude which fleetingly ratifies in the purified register of art the otherwise socially perturbed recogni-tion of the embodied subjectivity of the self and its counterparts"; "He/We painted the *Bar* to celebrate nocturnal Paris"; "He/We painted the *Bar* in repudiation of, and/or in solidarity with, quite particular trends in the art-historical present and past"; "He/We painted the *Bar* to stave off the imminent encroachment of death"; "He/We painted the *Bar* for fame, fortune, and the love of beautiful women"; "He/We painted the *Bar* as a memorial to Mother's smile and as a talisman against Father's awesome gaze"; "He/We painted the *Bar* as a joke"; "He/We painted the *Bar* to make the family proud"; "He/We painted the *Bar* because he/we did or did not, could or could not, would or would not have sex with Suzon/Suzanne."

My uncanny Jewish fathers Fried, Freedberg, and Freud are ambiv-alently aped here along with their Gentile counterparts Hanson, Her-bert, Cachin, Clark, et al.; here they become the issue of my text, no longer the *Bar*'s originary and knowing analysts but rather its belated though not belittled analysands. Shuddering and stuttering beneath the impact of Manet's barmaid's gaze, in their textual mirrors they reveal and conceal their own seeing and unseeing face: "The process that made them think they were the analysts applying their master code to the work can be called transference, a projection on the work-analyst of roles the critic-patient needs to work through."[60] Nor does the transferentially entrapped Jewish narrator manifestly know what he sees and shows in the gleam and glitter of that gaze: "I see better now what has led me the length of this uncertain stroll, igno-rant of any straight line and in which I have cited texts, books of philosophers, writers, painters as if they were my patients or I theirs."[61] This Man of Sorrows wanly notes that unlike Manet's Man of the World he sports no top hat, goatee, cravate, or cane: "We can't really be that man, yet because we are in the position he would

occupy in front of the bar, he becomes our second self."[62] Not, however, if we refuse to occupy the imaginary site, the empty grave, of his gaze. We have but to resume our gait.

For much of the professor's remembrance of time past, he has been trying to occupy the grave, unitary, centralized place of just this bourgeois, Christian, Cartesian *alter ego.* But like Freud, Marcel Proust was a Jew: perhaps Manet's friend Antonin Proust was secretly one too, the man who, as Minister of Fine Arts in 1881, decorated Manet with the Legionnaire's cross and whose gentlemanly portrait (RW331) Manet reportedly and perhaps obsessively and blasphemously spoke of "as Christ wearing a hat, in your frock coat with a rose in the buttonhole—as Christ on his way to visit Mary Magdalene."[63] Perhaps, *mirabile dictu,* even Manet was Jewish, a hidden Marrano, hence his atavistic interest in the dark-eyed women of Brazil, Spain, and the Levant, from *The Sultane* of 1871 (RW175) to Mme Michel-Lévy, whose portrait-pastels of 1882 (RW2: 70–71; fig. 37) more nearly recall the barmaid's blunt bangs and corseted bodice than any other images the painter produced. The Jewish painter Alphonse Hirsch introduced Méry Laurent to Manet in 1876; the Jewish painter Emile Lévy voted for Manet's medal at the Salon of 1881; perhaps, after all, this unpriestly professorial Levite can belatedly insert himself into the endless transferential economy of Manet's Gentile gaze and become an Apocryphal elder in his own turn in the face of the painter's un-Biblical Susannah, alias Suzon/Suzanne. Longing for sexual knowledge, the enraged elders violently thrust themselves upon the beautiful body they do not know; and they die for their desire: "At the scopic level we are no longer at the level of demand, but of desire, of the desire of the Other."[64] For the Jewish professor and not-so-newish father similarly seeking the transmission to the future of his seed, his text, his genetic code, the plaintive "O Susannah" of erotic coupling, the academic fantasy of the copula *is,* can only be a delusory detour through the looking-glass on the individual's way to death. If for the flicker of an instant the gleam of her gaze animates the illusion that she is looking at him—not at him in the mirror, not at him at the easel, not at him or her at Harvard, Hopkins, Berkeley, Orsay, or Yale, not at any of you others, but at him here at Bryn Mawr, at me—then his being there for her, supplying her with what she lacks, being supplied with what he craves, will abide and arrest the relentless trajectory toward death. But alas, "she activates the male gaze but is demonstrably not activated by it. . . .

Concentration on one person staves off dispersion"; but concentration flags, the nourishing breast moves on, the stabilizing phallus limps, one brushstroke parries another, the frame cuts the whole, a leg is lost, and the gaze fades to black.[65]

Perceiving himself now in the Manet-pulated mirror of the *Bar*, Professor Narcissus imagines that in this mirror of his text he will abide; but of such illusions Narcissus died at the well. Casting himself now as an Apocryphal elder, he abides unmanned, Actaeonized beneath the goddess's horn-rimmed gaze, for he knows too (or claims to, at least) that this is only a Jewish joke.[66] His trick, hereafter, is manfully to assume his symbolic castration, refusing to mourn the lack of some imaginary discourse on Manet that might seem more manly than his own emasculated joke.

Manet's "enigmatic central figure is a Mona Lisa of barmaids. . . . He met the woman who awakened his memory of his mother's happy smile of sensual rapture, and, influenced by this revived memory, he recovered the stimulus that guided him at the beginning of his artistic endeavors. . . . With the help of the oldest of all his erotic impulses he enjoyed the triumph of once more conquering the inhibition in his art. . . . If in making these statements I have provoked the criticism, even from friends of psychoanalysis and from those who are expert in it, that I have merely written a psycho-analytic novel, I shall reply that I am far from over-estimating the certainty of these results. . . . At the same time we are all too ready to forget that in fact everything to do with our life is chance, from our origin out of the meeting of spermatozoon and ovum onwards—chance which nevertheless has a share in the law and necessity of nature, and which merely lacks any connection with our wishes and illusions."[67]

Notes

1. Jacques Lacan, "What is a Picture?" (1964), in *The Four Fundamental Concepts of Psychoanalysis*, trans. Alan Sheridan (New York, 1978), 106. On the gaze in Lacan, see Jonathan Scott Lee, *Jacques Lacan* (Amherst, 1990), 154–61.

2. Michael Fried, *Courbet's Realism* (Chicago and London, 1990), 338n.28.

3. Sigmund Freud, "Family Romances" (1909), in *Standard Edition of the Complete Psychological Works of Sigmund Freud*, trans. and ed. James Strachey et al., 24 vols. (London, 1953–75), 9:237–41. Hereafter *S.E.*

4. Caroline de Beaulieu, *Salon de 1882: Publié dans la Mode Actuelle* (Versailles, 1882), in T. J. Clark, *The Painting of Modern Life: Paris in the Art of Manet and His Followers* (New York, 1985), 313n.77. Clark's book, like the memory of his conversation, has been an indispensable resource for this essay, both in its interpretation of the barmaid's gaze and in its extensive excerption of contemporary critical texts. All translations from the French not provided by Clark and others are the author's. On Charcot, Freud, and hysterical paralysis, see Stephen Heath, "Difference," *Screen* 19 (Autumn 1978), 51–112, in *The Sexual Subject: A "Screen" Reader in Sexuality* (London and New York, 1992), 47–106, an essay that Clark acknowledges as using only partially and unadventurously on page 296n.143 of his book.

5. Lacan (as in n.1), 112.

6. Timothy J. Clark, "Preliminaries to a Possible Treatment of 'Olympia' in 1865," *Screen* 21 (Spring 1980), 18–51.

7. Jacques Lacan, "The Mirror Stage as Formative of the Function of the I as Revealed in Psychoanalytic Experience" (1949), in *Écrits: A Selection*, trans. Alan Sheridan (New York and London, 1977), 1–7. Narcissism, or the repeated, death-deferring suspension of the subject in the face of an illusorily ideal image of the self, is the theme of both this essay as well as Steven Z. Levine, *Monet, Narcissus, and Self-Reflection* (Chicago and London, 1994).

8. For the conjugation of visual semiotics and Lacanian psychoanalysis, see Christian Metz, "The Imaginary Signifier," *Screen* 16 (Summer 1975): 14–76; it is this intersection of a general psychoanalytic theory of desire and a specific pictorial practice of the gaze that is problematized in Laura Mulvey's often-cited feminist intervention, "Visual Pleasure and Narrative Cinema," *Screen* 16 (Autumn 1975), 6–18, in *The Sexual Subject* (as in n.4), 22–34.

9. Juliet Wilson Bareau, *The Hidden Face of Manet: An Investigation of the Artist's Working Processes* (London, 1986), 96n.62.

10. Françoise Cachin, *Manet 1832–1883*, exh. cat. (Paris and New York, 1983), 478; Robert Herbert, *Impressionism: Art, Leisure, and Parisian Society* (New Haven and London, 1988), 80; Bareau (as in n. 9), 83; Jeanne Wolff Bernstein, "A Psychoanalytic Exploration of Manet's Work" (Ph.D. diss., The Wright Institute, Berkeley, 1985), 324: "The barmaid's vacant gaze seems to pass right through the spectator, disorganizing his attempt to accomodate himself according to her look." Dr. Bernstein presented an excerpt of her Lacanian reading of Manet at the 1987 College Art Association panel on art history and psychoanalysis which the author chaired in Boston.

11. Charles Baudelaire to Manet, 11 May 1865, in *Manet raconté par lui-même et par ses amis*, ed. Pierre Courthion and Pierre Cailler, 2 vols. (Geneva, 1953), 1:116.

12. For provenance, bibliography, and exhibition history, see Denis Rouart and Daniel Wildenstein, *Edouard Manet: Catalogue raisonné*, 2 vols.

(Lausanne and Paris, 1975), 1:286, no. 388 (hereafter abbreviated as RW in the text). Also see *Manet* (as in n.10), no. 211.

13. Lacan (as in n. 1), 72–73: "What we have to circumscribe, by means of the path [Merleau-Ponty] indicates for us, is the pre-existence of a gaze—I see only from one point, but in my existence I am looked at from all sides. . . . The gaze is presented to us only in the form of a strange contingency, symbolic of what we find on the horizon, as the thrust of our experience, namely the lack that constitutes castration anxiety. The eye and the gaze—this is for us the split in which the drive is manifested at the level of the scopic field."

14. On Léon's paternity, see Steven Kovács, "Manet and His Son in 'Déjeuner dans l'atelier,'" *Connoisseur* 181 (November 1972), 196–202, and Kathleen Adler, *Manet* (Oxford, 1986), 229n.6.

15. In "Family Romances" Freud quotes the old legal saw "paternity is always uncertain, maternity is most certain," in *S.E.*, 9:239. Lacan adapts the term Name-of-the-Father ("le nom du père") from Freud's characterization of the paternal figure of instinctual prohibition ("le non du père") in *Totem and Taboo* (1912–13; *S.E.*, 13:140–46). In his unpublished seminar of 1973–74, Lacan further submits the punning term to the self-exceeding annihilation ("les non-dupes errent") which for him constitutes the inevitable if unacknowledged fate of the self-deluded paternal ego mockingly cast adrift upon the endlessly transformative expanse of history and language.

16. Timothy J. Clark, "The Bar at the Folies-Bergère," in *The Wolf and the Lamb: Popular Culture in France from the Old Regime to the Twentieth Century*, ed. Jacques Beauroy, Marc Bertrand, and Edward T. Gargan (Saratoga, CA, 1977), 233, 237, and 237n.9.

17. A reference to this conjunctive/disjunctive space of "the viewer's own act of looking," symptomatically repressed in the first draft of this essay, is found in an early, provocative article by Rosalind Krauss, at the time of writing Michael Fried's graduate-student colleague and as such, in fantasy at least, the author's disavowed yet herein acknowledged art-historical Jewish mother. See Rosalind E. Krauss, "Manet's Nymph Surprised," *Burlington Magazine* 109 (November 1967), 624, and an unpublished paper for the Greater Philadelphia Philosophy Consortium by Steven Z. Levine, "Sons and Mothers: A Response to Svetlana Alpers and Rosalind Krauss" (1993).

18. The crucial Lacanian figure of the body-in-pieces is rooted in the biological prematurity and orthopedic insufficiency of the new-born, which is then provisionally stabilized in the ego-precipitating drama of the mirror-stage. "Inasmuch as it is formed on the basis of a unifying perceptual *Gestalt*, the ego is liable to anxiety in fantasies of the fragmented body, or *corps morcelé*. . . . As a specialized form of dismemberment, castration is a representative of the *corps morcelé* of prematurity over and against which the imaginary unity of the ego claimed its rights. . . . The superego effects a deconstruction

of the imaginary homogeneity of the ego, thereby introducing into the subjective economy a symbolic revival of the *corps morcelé* of prematurity. . . . In this way, the agency of death is positively installed in the subjective economy as a function of symbolic transformation"; see Richard Boothby, *Death and Desire: Psychoanalytic Theory in Lacan's Return to Freud* (New York and London, 1991), 143, 147, 172, 185. Hence the uncanny force of repetition, fragmentation, and transformation in Manet's thirty years of copying, cutting, and recontextualizing his own and the art-historical past.

19. For the x-ray of the portrait of Manet's parents, a preliminary compositional study, and an independent etching of his father's head, see *Manet* (as in n.10), nos. 3–4.

20. Lacan (as in n.1), 103.

21. Michael Fried, "Manet's Sources: Aspects of His Art, 1859–1865," *Artforum* 7 (March 1969), 77n.172.

22. Freud, *Three Essays on the Theory of Sexuality* (1905), in *S.E.,* 7:156–57.

23. Jeremy Gilbert-Rolfe, "Edouard Manet and the Pleasure Problematic," *Arts Magazine* 62 (February 1988), 43.

24. Manet to Mme Auguste Manet, 5 February 1849, in Juliet Wilson-Bareau, ed., *Manet By Himself: Correspondence & Conversation* (Boston, Toronto, and London, 1991), 23.

25. Manet to Jules de Jouy, 26 February 1849; to Henri Fantin-Latour, 3 September 1865; to Zacharic Astruc, 17 September 1865; to Charles Baudelaire, 14 September 1865, in ibid., 24, 35–37.

26. Manet to Astruc, 23? August 1865; to Fantin-Latour, 3 September 1865; to Baudelaire, 14 September 1865; to Astruc, 17 September 1865, in ibid., 34, 36.

27. Manet to Fantin-Latour, 3 September 1865; to Baudelaire, 14 September 1865, in ibid., 34–36.

28. Manet to Fantin-Latour, 3 September 1865; to Suzanne Manet, 10 September 1870, in ibid., 34, 55.

29. Manet to Eva Gonzalès, 19 November 1870; to Suzanne Manet, 23 October, 22 November, 25 December 1870, in ibid., 59–61, 63.

30. Manet to Suzanne Manet, 4, 12, and 15 January 1871; to his executors and heirs, 30 September 1882, in ibid., 63–64, 267.

31. Manet to Suzanne Manet, 30 January 1871; to Berthe Morisot, 10 June 1871, in ibid., 65, 161.

32. Manet to Stéphane Mallarmé, 12 April? 1874, in ibid., 167.

33. Philippe Burty, *La République française,* 3 May 1883, in *Manet* (as in n.10), 50. Also see Josette Raoul-Duval, "Méry Laurent," *L'Oeil* 77 (May 1961), 32–38, 80–82.

34. Manet to Méry Laurent, September? 1880, mid-July 1882; to "Sphinx" at *L'Evénement,* 8 July 1882, in *Manet By Himself* (as in n.24), 256, 266.

35. Paul Alexis, *Le Réveil,* 1 April 1882, in Clark (as in n.4), 311n.66. The

barmaid is also said to flirt or chat in commentaries by Jules Comte, Dubosc de Pesquidoux, Louis de Fourcaud, Saint-Juirs, and Stop.

36. Ernest Chesneau, *Annuaire illustré des Beaux-Arts: 1882*, and Henry Houssaye, *Revue des Deux-Mondes*, 1 June 1882, in Clark (as in n.4), 313nn.81–82.

37. Paul Mantz, *Le Temps*, 16 January 1884, in *Manet raconté par lui-même* (as in n.11), 2:139.

38. Charles Flor, *Le National de 1869*, 10 May 1882, in Clark (as in n.4), 313n.76; Joris-Karl Huysmans, "Appendice" (1882), in *L'Art Moderne/Certains* (Paris, 1975), 270; Pierre Schneider, *The World of Manet 1832–1883* (New York, 1968), 173; Emile Bergerat, *Le Voltaire*, 10 May 1882, in Clark (as in n.4), 312n.73.

39. Dubosc de Pesquidoux, *L'Union*, 15 June 1882, in Clark (as in n.4), 312n.69; Huysmans (as in n.38), 270.

40. Tamerlan, *Le Clairon*, 13 May 1882, and Jules Comte, *L'Illustration*, 20 May 1882, in Clark (as in n.4), 313n.83, 311n.68.

41. Clark (as in n.4), 249.

42. Arthur Rimbaud to Georges Izambard, 13 May 1871, in Lee (as in n.1), 28, 206n.29.

43. Maurice Du Seigneur, *L'Artiste*, June 1882, and C. Le Senne, *Le Telegraphe*, 2 May 1882, in Clark (as in n.4), 312nn.70–71.

44. Edmond Bazire, *Manet* (Paris, 1884), 109; Paul Eudel, *Le Figaro*, 5 February 1884, in *Manet raconté par lui-même* (as in n.11), 2:51.

45. Théodore Duret, *Histoire de Edouard Manet et de son oeuvre* (Paris, 1906), 241; Paul Jamot, Georges Wildenstein, and Marie-Louise Bataille, *Manet*, 2 vols. (Paris, 1932), 1:65.

46. H. W. Janson, with Dora Jane Janson, *History of Art: A Survey of the Major Visual Arts from the Dawn of History to the Present Day*, rev. ed. (Englewood Cliffs, N.J., and New York, 1969), 493; Werner Hofmann, *The Earthly Paradise: Art in the Nineteenth Century*, trans. Brian Battershaw (New York, 1961), 274; *Manet* (as in n.10), 478–79; Mikael Wivel, *Manet*, exh. cat. (Copenhagen, 1989), 41; Adler (as in n.14), 227.

47. Raymond Mortimer, *Manet's "Un Bar aux Folies-Bergere"* (London, 1944), 10; Georges Bataille, *Manet*, trans. Austryn Wainhouse and James Emmons (Lausanne, 1955), 99; Pierre Courthion, *Edouard Manet* (New York, 1961), 148; Schneider (as in n.38), 173, 176.

48. John Richardson, *Edouard Manet: Paintings and Drawings* (London, 1958), 131; John Canaday, *Mainstreams of Modern Art*, 2nd ed. (New York, 1981), 218; Horst de la Croix, Richard G. Tansey, and Diane Kirkpatrick, *Gardner's Art Through the Ages*, 9th ed. (San Diego and New York, 1991), 921; Robert Rosenblum and H. W. Janson, *19th-Century Art* (Englewood Cliffs, N.J., and New York, 1984), 370–71.

49. Linda Nochlin, *The Politics of Vision: Essays on Nineteenth-Century Art*

STEVEN Z. LEVINE

and Society (New York, 1989), 17; Hugh Honour and John Fleming, *The Visual Arts: A History* (Englewood Cliffs, N.J., 1982), 525; Anne Coffin Hanson, *Manet and the Modern Tradition* (New Haven and London, 1977), 205; Herbert (as in n.10), 80–81.

50. Novelene Ross, *Manet's "Bar at the Folies-Bergère" and the Myths of Popular Illustration* (Ann Arbor, 1982), 2; Wivel (as in n. 46), 41.

51. Anne Coffin Hanson, *Edouard Manet 1832–1883,* exh. cat. (Philadelphia and Chicago, 1966–67), 187; Hanson (as in n.49), 204.

52. Rosenblum (as in n.48), 371; Clark (as in n.16), 251.

53. Freud, "The Moses of Michelangelo" (1914), in *S.E.,* 13:236.

54. Nochlin (as in n.49), 89; Seymour Howard, "Manet's Men's Women," *Arts Magazine* 59 (January 1985), 80; *Manet* (as in n.10), 478; Clark (as in n.4), 253; Françoise Cachin, "The Impressionists on Trial," *New York Review of Books* 32 (30 May 1985), 45; Adler (as in n.14), 227.

55. Herbert (as in n.10), 80.

56. Ross (as in n.50), 92; Robert Baldwin, "'Condemned to See . . . Without Knowing'; Mirrors, Women, and the Lust of the Eye in Manet's Paris," *Arts Magazine* 60 (February 1986), 29; Penny Florence, *Mallarmé, Manet and Redon: Visual and Aural Signs and the Generation of Meaning* (Cambridge, 1986), 77.

57. Clark (as in n.16), 237; Clark (as in n.4), 241–42, 251.

58. An exception to this state of denial—though not one characterized by the psychoanalytic notions of conflict, ambivalence, or transference deployed here—is David Carrier, "Manet: Modernist Art, Postmodernist Artwriting," in *Principles of Art Historical Writing* (University Park, Pa., 1991), 201–17.

59. Clark (as in n.16), 232n.10. But regarding Manet's intentions, compare Clark (as in n.4), 252: "inconsistencies so carefully contrived must have been felt to be somehow appropriate to the social forms the painter had chosen to show."

60. Mieke Bal and Norman Bryson, "Semiotics and Art History," *Art Bulletin* 73 (June 1991), 196. In the section of their important article entitled "Psychoanalysis as a Semiotic Theory," the authors make a plea on behalf of a projective or transferential understanding of art historians' interpretations of works of art. The effort of this essay on the *Bar* is directed toward the intertextual and transferential structure of art-historical writing as a vexed genealogy of putatively legitimate and illegitimate progenitors and offspring. That their differing interpretations are metonymically linked in an unending process of deferred desire, and not metaphorically affixed to the *Bar an sich,* is analogous to the Lacanian understanding of signification which Bal and Bryson usefully explicate and according to which the individual art historian's deployment of the socially circulating linguistic signifiers of our trade is perpetually barred from intimate contact with the signified object of desire,

276

the painting, but is instead nakedly bared beneath the promiscuous effects of all those signifiers which follow it inexorably and unpredictably in the intra-psychic and interpersonal signifying chain. In other words, we are read. On the crucial role of transference in interpretation, see Steven Z. Levine, "Between Art History and Psychoanalysis: I / Eye-ing Monet with Freud and Lacan," in *Meaning and Methods in Art History,* ed. Mark A. Cheetham, Michael Holly, and Keith Moxey (Cambridge and New York: Cambridge University Press, forthcoming).

61. J.-B. Pontalis, "Perdre de vue," *Le Champ visuel, Nouvelle Revue de Psy-chanalyse* 35 (Spring 1987), 246.

62. Herbert (as in n.10), 81.

63. Antonin Proust, *Edouard Manet: Souvenirs* (Paris, 1913); in *Manet By Himself* (as in n.24), 247. On the repressed iconography of the Magdalene in Realist French painting, see Steven Z. Levine, "Courbet, Bronzino, and Blas-phemy," *New Literary History* 22 (Summer 1991), 677–714.

64. Lacan (as in n.1), 104.

65. Gilbert-Rolfe (as in n.23), 43; Schneider (as in n.38), 174.

66. On the Actaeon-like self-dismemberment of theoretical desire in Freud and himself, see Lacan (as in n.1), 188: "What I, Lacan, following the traces of the Freudian excavation, am telling you is that the subject as such is uncertain because he is divided by the effects of language. . . . The truth, in this sense, is that which runs after truth—and that is where I am running, where I am taking you, like Actaeon's hounds, after me. When I find the goddess's hiding place, I will no doubt be changed into a stag, and you can devour me, but we still have a little way to go yet." On the specular drama of Diana and Actaeon and its relation to that of Susannah and the Elders, see Steven Z. Levine: "To See or Not to See: The Myth of Diana and Actaeon in the Eigh-teenth Century," in Colin B. Bailey, *The Loves of the Gods: Mythological Paint-ing from Watteau to David,* exh. cat. (Paris, Philadelphia, and Fort Worth, 1991–92), 73–95. On Jewish jokes, see Samuel Weber, *The Legend of Freud* (Minneapolis, 1982), 100–17.

67. Sam Hunter, *Modern French Painting: Fifty Artists from Manet to Picasso* (New York, 1956), 40; Freud, *Leonardo da Vinci and a Memory of His Childhood* (1910), in *S.E.,* 11:134, 137. For assistance in the self-revising auto-mutilation of this manuscript, acknowledgments are due to Brad Collins, who more than adequately impersonated the Name of the Father and the Law of the Press; to a group of graduate students at Bryn Mawr College who challenged me on numerous points, especially Kathryn Casey, who offered a generous critique; and to Mary Campo, who saw and re-saw the text through the tortuous defiles of Word.

The "View from Elsewhere":
Extracts from a Semi-public Correspondence
about the Visibility of Desire

GRISELDA POLLOCK

I. LETTER TO A FAMOUS PROFESSOR, OR THROUGH THE LOOKING GLASS

Dear Sir,

I have been asked to write about A Bar at the Folies-Bergère *(frontispiece) by Edouard Manet (1881–82). One of the canonical images for modernist art history, the painting has a symbolic function in the social history of art as well. The way in which this painting is discussed exposes the limits within which all existing art histories operate with regard to questions of sexuality and representation, spectatorship and power. Given all that has been said about this painting, all the significance it has acquired, what is there to say about it?[1] Is there a* **feminist** *relation to this work and to the art historical practices that have defined its significance in all the existing histories of modernism?*

I do not know how familiar you are with feminist theory. Let me quote you a passage from Teresa de Lauretis which offers the possibility of such a "view from elsewhere."

> The problem, which is a problem for all feminist scholars and teachers, is . . . that most of the available theories of reading, writing, sexuality, ideology, or any other cultural production are built on male narratives of gender, whether Oedipal or anti-Oedipal, bound by the heterosexual contract; narratives which persistently reproduce themselves in feminist theories. They tend to, and will do so unless one constantly resists, suspicious of their drift. Which is why the critique of all discourses concerning gender, including those

278

promoted as feminist, continues to be as vital a part of feminism as the ongoing effort to create new spaces of discourse, to rewrite cultural narratives, and to define the terms of another perspective—a view from "elsewhere."[2]

I would much appreciate your response to what I have written so far as a possible beginning.

For Teresa de Lauretis *gender* is a semiotic construction which takes place through the interlaced processes of representation and self-representation. Gender is the effect of the constant play of material social practices, institutions, apparatuses, whose representations are absorbed subjectively by individuals as they are addressed by what she calls, borrowing and adapting from Foucault, the "technologies of gender." "All Western Art and high culture is the 'engraving' of the constructions of gender," she argues, while also asserting that the academy, and all other intellectual and artistic practices may equally be considered technologies producing gender. Such areas can also become a place for a radical deconstruction—once their function in the social process of gender formation is recognized and the implications for all practicing within their ambits is acknowledged.

The apparatuses of art history and the academy address me, as a potential participant, in terms that are the product of current gender constructions. Just as the cinema positions its spectators, so too the narratives of art history, in books and museums, propose modes of viewing and study, showing me how to look at paintings, how to see their meanings, how to be placed in front of art works. They define a position for knowing which is fundamentally a highly specific and selective form of gaze, itself a metaphor for knowledge.

Feminism has provided an "elsewhere." We have worked to produce different viewing positions which resist the relation to the image that is proposed in dominant discourses of art history. Feminisms provide other narratives to study and spaces to research, ways to look at the omitted and neglected work of artists who were women, as well as to reconsider the masculine canon, to name the ways in which gender is enacted in the practices of art-making and its reception. But, as De Lauretis suggests, there is no real outside of this process that can guarantee the value of the feminist discourses produced. Feminist analysis must be its own perpetual provocation and auto-criticism. Itself a construction of gender, a feminist dis-

course is vulnerable to the institutional spaces and ideological materials with which it works. De Lauretis paradoxically concludes that the elsewhere is, in fact, right here:

> For that "elsewhere" is not some distant mythic past or some utopian future history; it is the elsewhere of discourse here and now, the blind spots, or the space-off, of its representations. I think of it as the margins of hegemonic discourses, social spaces carved in the interstices of institutions and in the chinks and cracks of the power-knowledge apparati.[3]

This space-off is not outside of discourse, or, beyond ideology, a reality external to it. "What I mean instead," she writes, "is movement from the space represented by/in a representation, by/in a discourse, by/in a sex/gender system, to the space not represented yet implied (unseen) in them."[4]

What is it that we are looking for in this elsewhere? It is surely not some *real* notion of woman repressed in a dominant, white, patriarchal culture, and not merely the concrete realities of women in their cultural diversities to set against the monolithic and imperializing abstraction Woman. Nor is it a purely speculative or linguistically positioned femininity, such as French Feminist writing invokes. De Lauretis sees feminism as itself a new production of a critical subject in gender:

> By the phrase "the subject of feminism" I mean a conception or an understanding of the (female) subject as not only distinct from Woman with the capital letter, the *representation* of an essence inherent in all women (which has been seen as Nature, Mother, Mystery, Evil Incarnate, Object of [Masculine] Desire and Knowledge, Proper Womanhood, Femininity et cetera), but also distinct from women, the real historical beings and social subjects who are defined by the technology of gender and actually engendered social relations. The subject of feminism I have in mind is one not so defined, one whose definition or conception is in progress, in this and other feminist critical texts.[5]

The subject of feminism is a theoretical and political construct. Those of us living under the sign Woman and identifying as women through representation and self-representation in contemporary semiotics of gender, are engaged in a process of producing this "subject of feminism," through the discursive positions we create,

through the forms of address feminist writing can signify, through the look we cast over the spaces of representation, looking beyond and as much as into their centers.

What I want to write about the Bar *is, therefore, not a piece of feminist art history, not a demonstration of a feminist methodology and not an example of an orthodoxy. It will be a practice of reading and writing which will contribute to the production of a feminist subject—a position for viewing and seeing the painting in question and its cultural conditions of existence which will stretch the contradictions inherent in the technology of gender serviced by both modernist painting and modernist/social art history. In finding an elsewhere in the painting and an elsewhere in nineteenth-century feminist discourse from which to re-view the painting at work, I hope to open up the history of the nineteenth century to become a concrete—less mythic— historical field or archive. The point is not that gender is any more fundamental than the social relations of class, race, or sexuality. It is, however,* **as** *fundamental,* **as** *determining, and I would contend that feminism undergoing its own process of radical self-criticism around issues of class, race, and sexuality, is the political and discursive space wherein the fabric of textured inequalities and exploitations are at l(e)ast being comprehensively addressed. That is not a marginal "elsewhere," but the political necessity of this moment.*

Let me try an opening out on you.

The narratives of class and gender within which *A Bar at the Folies-Bergère* was produced in France in 1881–82 and those operative in present day art histories coincide on the body of the barmaid, the monumental figurative center of the painting. She provides the invitation to the presumed or, what should be called, the preferred spectator. A narrative reading of the painting defines her as a barmaid attending to a customer. "What do you want?," she asks, which, read metaphorically, clearly means "What do you desire?" Yet this impassive, still figure balks any confident knowledge. She remains an enigma that only further incites repeated art historical attention to the play of mirrors and reflections to generate the possibility that *she* is what the viewer desires.

 T. J. Clark's compelling reading of the historical specificity of this social space of the café-concert as paradigmatic of the *populaire,* as

the bourgeoisie consumed it and the petit bourgeoisie performed it, defines the painting as a tissue of uncertainties which never merely become a matter of pure ambiguity. The barmaid is calculated to function as "detached," in a way that allows the customer to think, "she is one more such object which money can buy, and in a sense it is part of her duties to maintain that illusion."[6] In his study of Impressionism, Robert Herbert reads the impossible reflection as an explicit sexual fantasy. The reflected barmaid's more responsive pose signifies the potential acquiescence envisioned by the desiring man: "In the mirror, her more yielding nature is revealed, detached as it were from her body by the man's power of wish-fulfillment. . . . We can't really be that man, yet because we are in the position he would occupy in front of the bar, he becomes our second self." At the point at which the regimes of representation of the commodity and the desire historically interpenetrate, these interpretations work within a gender ideology. The "we" of the texts is the collectivity of men who can in fantasy and in scholarship identify with the "*Homme du Monde,*" man of the world, *flâneur* and dandy who painted it and whose surrogate stands ominously in the extreme right-hand side of the painting, offering his implied place for the viewer to occupy.

I cannot be where he is, or might be. I can belong only to the "you" and the "her," like the audience for Freud's undelivered lecture on "Femininity" of 1933:

> Throughout history people have knocked their head against the riddle of the nature of femininity—
>> *Heads in hieroglyphic bonnets,*
>> *Heads in turbans and black birettas,*
>> *Heads in wigs and a thousand others*
>> *Wretched, sweating heads of humans*
> Nor will you have escaped worrying over this problem—those of you who are men; to those of you who are women this will not apply—you are yourselves the problem.[7]

The painting is apparently a full sign, promising meaning—about Manet's art, about avant-garde painting, and above all, about Paris. It offers an image of a social space catering to masculine desire. It is also, however, an ambiguous sign, defaulting on its semiotic promise. Only through the complex of significations projected onto and by this historically and socially constituted female body can its discomforting dissonances be contained. A painting that writers confidently

proclaim offers the essence of Paris does so precisely because of an ideological elision between the city, Paris, and a female image, *La Parisienne*. She is an embodiment of bourgeois men's fantasies about female availability in which woman is like a blank page upon which is inscribed a masculine script through the social hieroglyphics of fashion. As a historical articulation of the accelerating temporality characteristic of modernity, fashion then, as now, contains within it notions of both commodity and masquerade—indeed it is a precise formulation of the one as the other, and vice-versa.

Furthermore, City and Woman are conflated through the signifying relations of sex and money for which the body of *La Parisienne* was both sign and conduit. These relations constitute the semiotic, and gendered, mastery of the masculine bourgeois subject—fictionalized as MAN and given a specifically modern garb as the man of the world. The myth of Paris was produced by men such as Baudelaire, Zola, Dumas, the Goncourts, Houssaye, Proust, Degas, Grevin, Huysmans, Mallarmé, and Manet. It has been adopted as the myth of modernist and social art history. Doing the latter provides vicarious access to the former—access to a world through vicarious consumption of its principle image and fantasy: the available and desirable *Parisienne*. Clark was right, and more precise than Herbert: that sexual fantasy is riven with the matter of class.

I have never written much on Manet before. He belongs to them, the art historians, the big Others. These are men, for the most part, who seem to feel at home in the world of late nineteenth-century French culture. They make it their own professional territory. It feeds and satisfies their fantasies of a society of men of the world, dandies, and of women of the demi-monde. Doing something on Manet, a colleague commented to me, when I first mentioned I was going to write about A Bar at the Folies-Bergère, *is like a trip to a brothel: it is a rite of passage. This has become even more insistent and problematic in the aftermath of writers on Manet and modernity like Clark (and Herbert). I have literally never dared to conceive of writing—going public—with one of "their" prize and paradigmatic names who belongs in those grand schemes that run from Manet to (another) Pollock. Such a confession is no mere feint or device. My anxiety at dealing with this artist and this painting is genuine, because it is ultimately political. It is important not to underestimate the level at which women experience the conflicts between feminism and art his-*

tory. I have introjected a lack which stems from misunderstanding why I did not "naturally" understand the goings-on and fantasies of early modernist Paris and its paintings. What could I identify with when that culture made women its badge, not the agents of its meaning, but the cipher for those produced by the "men of the world?"

Women art historians have of course written about Manet.[8] In borrowed clothes we have masqueraded as men, and lent our considerable scholarship to the perpetuation of the mythologies of modernism. We are well-schooled in the professional transvestitism that the discipline requires of us—so that we either adopt the positions of viewing offered by the works of art and assumed in art history, or we masochistically accept our objectification by identifying with the image. Through this may come the pleasure of formal appreciation of the painting's masterful performance as a piece of painting. Seduced by the beauty of art, we accede to an image of femininity or femininity as an image. Or else we can divest ourselves of that femininity and internalize the viewpoint of the father. Feminism interrupts this spectatorship by providing a language in which to critique the image and to acknowledge and invite the sexual differentiation of spectatorship.[9]

Censored by the hegemony of modernist art histories, I have found an indirect way to have some access to nineteenth-century French culture by looking to (what seemed like) its margins. There, overlooked by the Rewalds, Clarks, and to a lesser extent the Herberts, were women modernists, notably Mary Cassatt and Berthe Morisot. They made me bold. To begin to understand their practice, I had to come to terms with what the big Others had made their own, modernism. Once I looked at modernism from the vantage point of women modernists, of women **and** modernity, modernism looked very different. It was not nearly so monolithic and alien. It could contain elements of my own imagination, my own experiences of urban life, with its prohibited spaces, its dread of that ubiquitous, proprietorial, and offensive male gaze, but also its specific pleasures of female sociability, fashion, public entertainment, travel, science, education, and so forth.

Such a re-vision of modernism and modernity was made possible by the re-vitalization of feminism rooted in that nineteenth-century moment of modernity. The emergent bourgeoisie produced a particularly vicious and confining concept of femininity but its triumph incited the challenge to it in the form of women's social movements and the intellectual and artistic developments collectively known as feminism. Never merely a struggle about the voting rights of women,

feminism in its largest intellectual sense was and is a struggle around enunciations of femininity.[10] Ignored or overlooked by the keenest scholars of modernity, we are obliged to recognize belatedly that feminism was one of the major symptoms of modernity, deeply rooted in the discourses and politics of which modernism as cultural form was the product.

In several earlier texts, I have focused on the formations of femininity within modern bourgeois culture, exploring its resources for women producers of that class to enunciate the specificity of their social and psychic positioning within a critical engagement with the consciousness and social practices of bourgeois modernity.[11] In this paper, I want to confront art history's submission to a mythic—a classed and gendered—version of modernity by shadowing A Bar at the Folies-Bergère, Manet, *and art history with the discourses of historical feminism which all three repressed. I'm off to the BM to do some more reading.*

Yours sincerely,

II. Letter to a Feminist Scholar, or What do Women Want?

Dear Friend,

I was at the British Library the other day doing some research for a paper I have agreed to do about Manet's A Bar at the Folies-Bergère. *Yes, I can well imagine, you are shocked. I never thought I would come to this, doing "real art history" again after so long in the polemics and pleasures of feminist theory, writing always about art history, not talking about the pictures like you're supposed to. Besides, I always felt bad that I did not do any real research, you know, like you do at the Bibliothèque Nationale and so forth. So here I am in the British Library Reading Room, sitting at the computer, doing a search for books about women and especially feminism in France in the nineteenth century. I'm getting very frustrated. None of the key words I try bring up any titles. Do they have no books on women and feminism? Eventually I get angry and in a fit of clearly Freudian rage I stamp out on the keys:* **What do Women Want?** *To my complete amazement, up comes one item, a book with exactly that title.*

On 10 April 1869, a liberal bourgeois feminist Maria Desraimes published a lecture titled *"Qu'est-ce que veulent les femmes?"* Desraimes, born in 1828, four years before Manet, was the daughter of republican, anti-clerical parents who were keen followers of Voltaire's rationalism. From them, she received a "modern" education. In this formation she typifies the forces that made possible the altered relation between the terms, "women," and, "modernity." Desraimes' question predates Freud's famous formulation of his own perplexity about "what a woman wants" by more than half a century and shows that his blindness to women's desire was partly self-inflicted. By the 1930s there was plenty of evidence from the women's movement of what women desired.[12] It is a coincidence of considerable significance that Berthe Pappenheim, the real name of the hysteric "Anna O.," attended by Freud's colleague Josef Breuer, underwent a form of proto-analysis in 1880–81, the very year in which Manet was painting the *Bar.* Berthe Pappenheim formulated the therapeutic process she named the "talking cure," now a synonym for psychoanalysis itself. Breuer listened to her. In that acoustic haven she gradually overcame her hysteria, socially induced, psychically experienced, and physically manifested, by being able to articulate the emotional excess created by her situation as a woman denied outlet for what she wanted. Indeed her case poses the important question: is feminism itself the "talking cure" for women, the means to give voice to what our cultures repress, leaving us all, like the hysterics, bodies in trouble with patriarchal language? Berthe Pappenheim spoke four languages and Breuer commented that she was "markedly intelligent with an astonishingly quick grasp of things and a penetrating intuition" as well having "great poetic and imaginative gifts."[13] All of these were repressed by the closed horizons offered to the middle class woman of a wealthy Orthodox Jewish family in Vienna in the late nineteenth century. The crisis of her illness manifested itself eventually in an inability to speak at all. After her "self"-treatment, she became a feminist activist, a worker on behalf of abandoned, homeless, or sexually exploited women, a founder of the German League of Jewish Women, and the German translator of Mary Wollstonecraft's *Vindication of the Rights of Women* (1792).[14]

Maria Desraimes' answer to her own question, "What do women want?," derived from that same lineage of the feminist appropriation of the Enlightenment discourse of natural rights: women want "*le droit et la liberté.*" Significantly, her concept of liberty included free-

dom from the fate of *being represented*. Women desire to represent themselves, she insisted:[15]

> What women want, is that men stop building their own elevated status on the systematic debasement of women; what women want is not to be brought up, instructed, and fashioned according to a convention, a type conceived in the brains of poets, novelists, artists, and as a result, entirely unrelated to reality.[16]

Maria Desraimes had participated in the foundation in 1866 of the first feminist organization in France, La Société pour la Revendication des Droits de la Femme, whose chief purpose was to foster women's education. In 1870 she co-founded the Association pour le Droit des Femmes and was part of the Congrès Français International du Droit des Femmes which coincided with the International Exhibition held in Paris in 1878. It was over the question of the vote that this congress was split and Hubertine Auclert withdrew to found her own magazine and promote the political rights of women. During the elections of 1881, while the *Bar* was being painted and exhibited, French women campaigned for the vote. In 1884 three women were actually elected, but the election was later deemed unconstitutional. The debate in France over women's voting rights was complicated by continual anxieties about the security of the republican cause, and thus opposition to female suffrage was often posed in the name of a defense of the republic against *unenlightened* women under the sway of the priests.[17] These were women not yet reformed by modernity, and it was feared that they would sustain an antithetical, that is a fixed and Catholic, concept of femininity. For the modernist feminists of this liberal bourgeois constituency, education and, thus, rationality and modernity were the necessary prerequisites for women's rights and their "intellectual" liberty. Socialist feminists like Hubertine Auclert maintained a commitment to political enfranchisement as the means to achieve the legislative changes to alter women's economic unfreedom. Working women gave formal political liberation a lower priority, and campaigned to secure concrete necessities in relation to wages, work conditions, and legal rights. The radical communards and socialists, like Paule Minck, resisted female suffrage and encouraged women to work inside mixed revolutionary groups so as to challenge domestic slavery and the authority of all men in their own homes as much as at work and in relation to the State. The critical point, however, is that women were in need of a

change in their status vis-à-vis representation, whether we use the term politically or discursively. Some wanted to represent themselves through the vote and political activity; others through the word and the image. The condition for both was the product of the conjunction of women's interests and the possibilities offered by modernity. Orators and writers like Hubertine Auclert, Paule Minck, Louise Michel, and Maria Desraimes took an active part in both class and gender struggle on this battlefield of *representation.*

The feminist movement, its debates, publications, and conferences have been largely erased by the typical histories of modernity. Yet feminism was very much a force and an issue in the history of modernity and women, as with Mary Cassatt, in her politicized program of work and exhibition. Feminism is evident in her support of "independence" in art, and of women's suffrage in politics.[18] Feminism is there in her mural *Modern Woman,* for the Women's Pavilion of the Colombian World Fair in Chicago in 1893.[19] It is there in the uncensored entries in the diaries of Marie Bashkirtseva about her meetings with Hubertine Auclert and in her art reviews for Auclert's feminist journal *La Citoyenne.*[20] These women: Cassatt, Auclert, Bashkirsteva, Séverine, and many more are the *other* Parisiennes. They are the women intellectuals who campaigned against economic, political, professional, and educational limitations on women, oppressions that made working women vulnerable to the sexual exploitation that modernist culture mythologized with its endless parade of *grisettes, lorettes, cocottes,* its *La Parisienne.*

In sisterhood . . .

III. Letter to a Famous Professor, or Looking Off

Dear Sir,

Against the mythic image of Paris and Parisiennes, circulated by all the masculinist art histories, I have found that I can interpose the feminist movement which equally forms part of the historical possibilities of modernist culture. Feminism constitutes the content of a "space off," placed beyond the frame of these modernist discourses, none the less implied by them. The challenge to the class and gender power of bourgeois men posed by feminism in the nineteenth century is the phantom that shadows the works and images of those "men of

288

the world"; it was the structuring absence. To be ignorant of this is to consume uncritically the mythology they produced in that intense period of gender struggle.

Viewed from the "elsewhere" of feminism, La Parisienne is, therefore, only a fragment of the history of women in the nineteenth century. The women who played this role were culled from those precarious professions available to pretty working class women where they sold not only their labor power but also their appearance and their bodies—as prostitutes as well as mannequins, as kept women who were also walking advertisements for couturiers and the fashions of the grands magasins, as barmaids and waitresses, as performers who appeared as naked as the Venus that made the fame of the heroine of Zola's eponymous novel, Nana.[21]

Novelene Ross' study of *A Bar at the Folies-Bergère* concludes with "the most significant dimension of the painting—the provocative mystique of the barmaid."[22] I cannot contest the fact that the monumental figure in the foreground is an arresting figure. Her position and purpose must be central to any understanding of the painting's project and effect. That she is a female figure, coded as a barmaid in that environment of potential as well as actual sexual commerce, provides the grounds for our reading of the painting's complex representation of the spaces of modernity, which we have classified as those socially ambivalent and interstitial places of cross-class sexual exchange and fantasy.[23] In her chapter on the painting itself, significantly titled "The Woman at the Counter," Ross says everything very clearly:

> In the last major painting of his career, Manet paid eloquent tribute to *La Parisienne*, who was the chief deity of that world. *Un Bar aux Folies-Bergère* could not have been more modern, for it distilled that element of the myth which sustained the clichés of popular art, motivated the naturalism of the avant-garde, and confirmed Manet's personal delight at being a man of his own time. The girl at the bar is a descendent of Monier's *grisette,* and the kingdom over which she presides bears a name that still evokes the promise of that delicious wickedness which is the secret charm of every great city, but most especially of Paris. When Manet decided to paint the subject of the *Folies-Bergère,* it had already become synonymous with the seductions of *la Parisienne* and the boulevards.[24]

To the "*hommes du monde*" like Charles Baudelaire or Manet Paris was a City of Women. But the inversion is also appropriate: Woman was like the city, a sexual geography, with each part of the body, from face to pudenda, having an equivalent social location—from the Bois and the loges at the Opera via the *coulisses* and the café-concert to the brothels and stews.[25] This kind of conflation was current in the discourse and fantasies of the masculine literati of the time. Archival work in popular journalism of the time finds appropriate evidence. Ross cites the newly founded journal *La Vie Moderne* for 24 August 1874, where the reporter in an article on the *Folies-Bergère* asserts that the place is the "microcosm of Paris," "where sophisticated men of all cultures felt *at home*": "Everyone understands the universal language spoken at the *Folies-Bergère*, because it is the *language [my emphasis]* of pleasure."[26] Whether actual or fantastic, this pleasure was erotic for heterosexual men. It was projected onto the architecture of display and consumption which was not only the pathway for the circulation of commodities and the site where capital accumulated into spectacle, but precisely the spaces for a complex economy of subjectivities and sexualities for which the body of Woman was the key currency.[27]

Enough of me for now.

Yours etc.,

IV. Letter to a Feminist Scholar, or Men Never Make Passes at Girls Who Use Glasses

Dear Friend,

I have made quite a breakthrough in my work on women and modernity.

Woman was the major sign of the masculine bourgeois relation to urbanity and pleasure. We know too well that "Woman" was the object of male exchanges taking place in the spaces of entertainment and recreation. Bourgeois women were, however, themselves consumers and participants in this spectacle. If we ask if a bourgeois woman could have painted the *Bar*, or conceived of it as a representation of her relation to modernity, the answer must be no.[28] But like others before me, when I stand in front of the *Bar* I am now drawn

into that play of peripheral reflections and find my look attracted to the margins and background of this canonical image. There are many women present in this crowd, summarily sketched, glimpsed only through the looking glass, made secondary to the barmaid who fills both the foreground of the painting and imaginations of scholars to the exclusion of all else. Like the Afro-Caribbean maidservant (modeled by a woman we know as Laure) in *Olympia* of 1863, the fact that there are several signifying female figures in the painting seems invisible to many commentators.[29] Only certain bodies, it seems, achieve art historical acknowledgment and arrest the desiring masculine gaze, while others fall below the threshold of masculine interest and become invisible.

There in the background are some clues about how a nineteenth-century bourgeois woman might relate to the elements of this space on the edges of femininity. Over the shoulder of the barmaid, beyond her in the reflected space of the audience, set amidst the glitter of chandeliers and glowing gas-lit globes, are at least three women. One is painted in striking whites, her pale face and blond hair set off with a rakishly angled black hat. Leaning on the balustrade, her arms are encased in elegant lemon-colored gloves. She has been identified by the Manet archivist, Adolphe Tabarant, as Méry Laurent, now more fully dressed than at her debut.

> Méry Laurent. She was one of the most captivating young beauties of the end of the Empire. Born in Nancy in 1851, her doorway to the world of gallantry was through the stage. In 1867, as the Universal Exposition made Paris one vast brothel, she appeared at the Varieties in the very scantily clad role of Venus in the play, *La Belle Hélène*. She was just seventeen. How gorgeously seductive she was! The famous American dentist Thomas Evans made her his mistress and their arrangement lasted quite a while.[30]

Just behind Méry Laurent, even more sketchily annotated, are the head and shoulders of a woman in a tawny jacket and black hat. This figure Tabarant names as Jeanne de Marsy.

There is a third, unidentified woman dressed in black wearing muted gray gloves. She is looking towards the stage through a *lorgnette*. I shall name her the metaphorical female spectator with whom I—a feminist in the present—can identify in this representation of modernity. I think she is a quotation from, and overt reference

to, a painting by Mary Cassatt, generating an unexpected dialogic moment between class and gender in the background of this image of modernity.

More later,

In sisterhood . . .

V. Letter to a Historical Person, or Now, but also Then

Dear Miss Cassatt,

I do hope you don't mind my presumption in writing to you after all these years. I have had many imaginary conversations with you. I keep coming back to one of your paintings, At the Opera *(1879; fig. 38). It has come to me again, from a most surprising place, and I want to run a few thoughts by you to see if what I am finding in your painting, as a feminist in my reading present, means anything to you in yours.*

Just to the left of the barmaid's left shoulder in M. Manet's A Bar at the Folies-Bergère *is a fragment of a woman, looking through her lorgnette at the stage. Her presence is both incidental and highly relevant. She seems to signify a third point in a game played in your artistic community between two men, MM. Manet and Degas, competing for the definitive realization of a painting of modern life. You will remember that in the mid-1860s M. Degas sketched a scene at the race course, showing M. Manet—easily recognizable—standing beside a woman holding a lorgnette (now in British Museum, London). His female companion is but a vague outline. None the less, it was she and not the Manet figure who became an obsessive object for Degas, who began the composition* At The Races *(Weill Bros. Inc., Montgomery, Alabama) in the later 1860s and left it much repainted and badly conserved in his studio where it was found at his death in 1917. That painting reveals an attempt to make a big modern subject picture out of the little sketch. But it seems that compositionally and psychologically, Degas could not sustain the Oedipal triangulation (forgive this rather twentieth-century jargon) which this composition created between Manet, the woman, and himself. Psychically freighted as this single female figure became, for Degas, it could never lead to a solution to the big painting; it remained a powerful fragment, a little bit of a "corps morcelé."[31] M. Manet's* A Bar at the Folies-Bergère *was, in part, his answer to M. Degas' abortive exploration of a way to locate the trope of a woman's gaze within the ambit of an utterly modern sce-*

292

nario. Once the Bar *was produced, with so definitive a solution to a look that is both invitational and disarmed, no wonder M. Degas abandoned the project and turned his still wet canvas to the wall.*

But there was another artist who was party to this fascination and competition in the 1870s and 1880s. You, Miss Cassatt. You, however, inflected the question of woman and spectatorship within the spaces of modernity quite differently[32] in At the Opera *(fig. 38). A modern art historian, Novelene Ross, like others before her, has noted an important connection here. She writes: "Manet apparently appreciated Mary Cassatt's theater imagery to such an extent that he represented the principal figure of* At the Opera *among the spectators in the background scene of the* Bar.*"[33] But what she did not notice was the radical "translation" involved in taking your young bourgeois woman from the respectable opera and placing her among the demi-mondaines of the Folies-Bergère.*

In a paper on your painting,[34] I have argued that its composition of a woman looking obliquely out of the frame articulates a specifically feminine desire as a pressure against the limits of the spaces and frames of modernity. Like Degas' images, your work also articulates the dialectics of desire around both an active scopophilia (looking for the object of desire) and a passive exhibitionism (finding security and identity within the embrace of the [m]other's gaze). But I concluded that the differences between Degas' (and also Renoir's versions of this theme, as in La Loge *[1874, Courtauld Institute Galleries, London]) and yours, Miss Cassatt, could be read in terms of the specificity of the psychic formation of a historical bourgeois femininity. Notionally, the woman in the painting is looking at the stage. But the actual composition makes that act of looking imply much more. The direction of her gaze evokes a space not seen by the viewer, not fully included in the painting yet signified by that intense attention which turns so decisively against the direction of the spectator's look. Her pose bars entry to the picture and distracts the viewer. It denies the anticipated ease of looking proprietorially at a painting of a woman and it disrupts the expected relation of the masculine spectator to the woman whom, he hopes, will collude with his possessive gaze. I read your compositional structure as an allegory of women's desire, which thus appears as that which exceeds the frame or field of vision offered to women within a modern, western patriarchal culture. Your modern spectator looks across the space of the image to something beyond its frame which we, the viewers, cannot see. The painting gives us a figuration of "what*

women want." Whatever it is can only be implied. Of necessity, what women want falls outside the representational conventions against which Maria Desraimes was inveighing when she tells us that women want to be free of men's definitions and images. Women desire more than the existing social and semiotic frames permit to those they position in or under the rule of bourgeois femininity.

Was M. Manet, as it now seems, already there before us in grasping the possibilities of your At the Opera *when he inscribed into the background of his painting, not the eager male peering annoyingly at the matinee-goer in your parodic scene, Miss Cassatt, but a female viewer, who is not interested in the transaction between dandy and serveuse in the foreground. In this play of desire and looking, this citation from a bourgeois woman's painting becomes a subtle counterpoint to the ironic representation of masculine desire which occurs in the mirror on the other side of the barmaid. This feminine figure looking elsewhere installs in the painting an active and independent woman spectator who is, however, ultimately distanced and diminished by the compositional balance Manet has chosen. She is there, however, like you and your work, to be retrieved by contemporary feminist desire. She looks at that "elsewhere" which undermines the natural centrality of the interchange that fills the inverted foreground.*

M. Manet's appropriation of your "woman looking," can be read, however, in two quite different ways. On the one hand, looking to the "space off" signifies the inscription of female desire for "the more" for which feminism stands; on the other, she may be "just looking," part of the society of the spectacle.[35]

Yours with great respect,

VII. Letter to a Feminist Scholar, or Women's Pleasure and the Pleasures of Women

Dear Friend,

Of course we know that bourgeois women were participants in modernity's special forms of spectatorship and consumption. Rather than the brothel and the café, the street or the bar, shopping was its privileged site. I have just re-read Zola's novel, Au Bonheur des Dames *(echoes here of what women want/desire). This aptly named depart-*

ment store becomes a modern substitute for the Church, where the still unenlightened, unmodern feminine woman might spend her time in appropriate disciplines and devotions. The department store was the new "cathedral of modern commerce," a place where the new women could spend the entire day. This kind of "modern" woman, the consumer, replaced her submission to priest and Church, with her overstimulated desire for goods, for clothes, for the dispensing of money, or just for the pleasures of looking.

Rachel Bowlby's study of several late nineteenth-century novels, Just Looking, focuses on the relations of women to consumption through the new retail industries of the grands magasins.[36] Bowlby makes a historical link between shopping and cultural forms of spectatorship within the expansion of capital into areas of leisure. It is here that the distinctions, which appeared so critical then and remain so vivid to male art historians now, evaporate. For men it is, as it was then, vital to be able to distinguish between a woman who sells herself as a sexual commodity and one who is not part of the flow of money and commodities. But through the processes of mass expansion of fashion and shopping the division between women and commodities and looking and exhibition became faint indeed. Bowlby argues that "women's contradictory and crucial part in 'the oldest trade in the world'—at once commodity, worker and (sometimes) entrepreneur—can be taken as emblematic of their significance in the modern commercial revolution."[37] As Walter Benjamin has argued, the prostitute contains the ambiguities of social relations and relations between people and goods characteristic of the age of capital; she is both saleswoman and wares in one.[38] The prostitute is the paradigm, however, of a condition to which all women were being subjected, to which was added the further dimension "that it was above all to women that new commerce made its appeal."[39] Bowlby concludes: "They were to become in a sense like prostitutes in their active, commodified self-display; and also to take on the one role almost never theirs in actual prostitution: that of consumer."[40]

Participating through shopping in the covetous and eroticized looking that we now define paradigmatically as the modern condition of the capital of the nineteenth century, women were also solicited by the spectacles in the café-concerts and music halls. But through consumption it is easy to erase the distinction between the subject and the object. Women shopped the better to make themselves perform their spectacular role in the modern city, some through marriage or courtesanship, displaying someone else's wealth appropriated from other

women's labor, performing the rituals of fashion in which those relations of production were fetishized and celebrated. Women shopped the better to become the bearers of their culture's gendered meanings. They modeled it; their bodies were literally remodeled through fashion and its undergarments to emit the required signs of artifice and the infinite unnaturalism and inventiveness of the commodity.[41]

Yet the growth of shops and mass manufacture has also been identified with creating confusion in the city street. Fashion was no longer the badge of wealth—the sign of "distinction."[42] Clothes would disguise the social difference inscribed on the bodies of women of different classes at a moment when the sexual female body and the feminine body were categorically differentiated by the polarization in bourgeois ideology between la femme (unspoiled goods, purchased and privately possessed) and la fille (desiring, errant, free to be exploited). These are the divided figures of femininity and sexuality. Under the sign "Woman" fell opposing modes which masked any real social differences between women, and signified instead their common if various subjection to the dominant class and gender's divisive control and use of women. Consumption and spectacle were part of an erosion of the ideological distinctions, with the result that all women appeared "sexual," their desires incited through consumption. By the same token they were being eroticized through fashion. Thus the categories that should have been carefully kept apart, mingled. Women of the bourgeoisie slummed with their husbands in the café-concerts where other women's husbands kerbcrawled for sexual services amongst the range of working class women who labored in the entertainment industry or used it as a means of earning an extra living by servicing a bourgeois sexual economy.

Manet and his circle were fascinated by fashion. Never treating it as mere feminine frivolity, it was an important language or form of modernity. I have to come to formulate it thus: fashion was the point at which modernity and its uses of femininity converged as a spectacle for men while operating as a masquerade for women. Baudelaire's Painter of Modern Life *(1863) stresses the central role of fashion in the very definition of the modern.[43] Mallarmé founded a fashion journal,* La Dernière Mode, *in 1874, which lasted eight issues. He wrote fashion criticism under the pseudonym Miss Satin.[44] Antonin Proust's memoirs of his friend, Manet, include some anecdotes that reveal his engagement with women's clothes as a part of his artistic imaginary. Indeed Proust records Manet's plan to paint a pendant to his portrait*

of Jeanne de Marsy, exhibited at the Salon in 1882 with the Bar *under the title* Spring: Jeanne *(fig. 39). Proust recalls Manet saying: "I'm going to do* Autumn *using Méry Laurent. I went to talk to her about it yesterday. . . . She has had a pelisse made. What a garment, my friend, all tawny brown with a gold lining. I was stupefied."[45]*

Of Jeanne de Marsy, in the pendant, Spring: Jeanne, *who also appears in the* Bar, *Tabarant commented:[46]*

> *But another feminine face was going to enchant the studio in the following weeks and it was the face of Jeanne de Marsy, exquisite model of the exquisite allegorical portrait,* Spring. . . . *really beautiful, dainty, smartly dressed, shameless and impudent, a butterfly of the boulevards. . . . But what an outcome!* Spring: Jeanne de Marsy, *bustlength, in profile, her saucy face looking left, with its pert little nose. She wears a cream-colored bonnet, bordered with frills and surmounted with daisies and roses all mingled in with black ribbons {and so forth with a detailed fashion analysis}. . . . This painting is bewitching [or literally, an enchantress—cette peinture enchanteresse].[47]*

Tabarant was not atypical, writing his history of Manet. He was formed in a similar cultural and gender formation. Compare this review by Maurice Du Seigneur in L'Artiste *1 June, 1882:*

> *Since we are speaking of living flowers, let me introduce you to* Jeanne *by Edouard Manet [this was the title in the Salon livret]. She is not a woman, she is a bouquet, truly a visual perfume. Manet's defenders are delirious, his detractors stupefied, and Mlle. Jeanne strolls past them, proud and coquettish, in profile, her eyes alight, her nose turned up, her lips parted, with a winning air. A parasol, long suede gloves, not quite twenty years of age, and a full, fine figure. That describes her.[48]*

Here you will notice that common conflation of femininity and flowers,[49] and all the other rhetorical devices by which "Jeanne" does not signify a person, but an idea: a fantasy created as an effect of costume, of fashion. The grammar of the penultimate sentence is particularly striking. It lacks a verb, and metonymically conflates a commodity, a fashion accessory, a sexually desirable body shape, and the signifiers of youth to define and consume a her—a modern package of desirability.[50] But it is crucial not be taken in by the power of the fantasy. Manet's painting does not correspond to what is evoked by this prose. As Laura Mulvey pointed out to me the other day, the face in the

painting is not coquettish and her eyes are anything but alighted; her lips are not parted and her air is almost melancholy. The face is curiously similar to that of the barmaid in the Bar—*refusing to offer a fantasy of complicity, or an anecdotal physiognomy of a woman of her class, or any real indication of expression, character, personality, or type at all. As a whole, the set of the face stalemates the image of La Parisienne that the critic wants to see, which flowers and a fashionable figure seem to promise.*[51]
Yours, in haste, as time is running out,
In sisterhood,

VIII. Letter to a Historical Person, or Masquerade and Fetishism

Dear Miss Cassatt, may I call you Mary?

Sorry to bother you again with all these questions, but having access to someone on the spot, as it were, is really so helpful. Today we can hardly read the codes of fashion and etiquette that so ruled your lives. We think the body is so stable, so fundamental, that we can hardly imagine that it can change as much as it has historically. Or, shall we say, the semiotics of body language, gesture, and dress have altered dramatically over the last one hundred and fifty years. With it have changed the very meanings of femininity and masculinity as we live them through the body, or, as it were, as we embody the codes of our historical moment of sexual difference. Women now inhabit a quite different body and thus a different femininity. We have legs nowadays. We don't have to wear hats and hardly ever where gloves, except when it's really cold.

I have been reading the reviews of M. Manet's painting Spring: *that portrait of Jeanne de Marsy he showed with the* Bar *at the Salon of 1882. One reviewer makes a note of her gloves. I feel that is significant. I am wondering if details of fashion functioned in painting of yours and M. Manet's time to establish that nuance of class and identity—"distinction." They seem to create a distance which is at once a question of class in relation to the women in the painting, and an instatement of the male producer's class and gender interests. Fashionable dress seems to work both as a disguise for and a displacement of recognition of the status of the body who models it. Fashion clothed the*

working woman's sexualized body with the garments that were meant to function as a seamless unity with the feminine, bourgeois body. Fashion thus worked as a kind of fetish for men. One of your younger contemporaries, Sigmund Freud—perhaps you have read some of his book on dreams—developed an analysis of fetishism, rather after your time, so you will just have to take my word for it. In fetishism, the whole female body must be colonized by masculinity, so that it is refigured as total artifice, its specificity denied, just the way paintings such as Spring *work, where a socially coded femininity is used to signify the idea of the natural.[52]*

Fetishism is one of the prevailing structures of nineteenth-century representation and it has been invoked by art historians in regard to M. Manet's painting.[53] It is almost self-consciously evident in the Bar *in the other woman present, of whom I have not yet spoken. The trapeze artist, the actual performer who is truly marginalized, represented only by a fragment, her stunning lime green boots and carefully denaturalized legs, encased in the tights so beloved by Baudelaire. Fragmentary sketches from Manet's café-haunting days reveal a partiality for stockinged and booted female feet. A contemporary feminist art historian, Linda Nochlin, links the trapeze artist with Manet's preference for the use of synecdoche—in which the part of the woman stands for the whole.[54] But for male viewers, I am assured this feature works metonymically, that is, suggesting by means of contiguity what lies elsewhere, beyond the frame, at the top of her legs. The point here is to see how the language of M. Manet's painting constantly uses this device—synecdoche—in a fetishizing way, which must make us attend to the role of body parts in his overall signifying system.*

Other body parts, clothed and naked, are, therefore, critical to the semiotics in the Bar. *In the painting, the fashionable woman in white with her rakishly set black hat holds up her hands. They are gloved, as are those of the third spectator, the woman with opera glasses, the citation not from his own work, but from yours, Miss Cassatt. Your bourgeois lady who has been replaced by a fashionably masquerading woman also wears gloves.*

But there is one prominent woman in the painting who does not wear gloves. Her hands bring me to the "elsewhere" that is to be found at the very the center of the painting. I can now admit to a longstanding fascination with a detail in this painting, the starting point for a paper I am writing on the painting—the hands of the barmaid. Ungloved, these hands are pressed hard against the counter on which

the barmaid rests. This is no casual pose, but one full of significance syntagmatically within the composition itself, and paradigmatically in relation to Manet's long-standing obsession with hands,[55] and to hands as a signifier in the specific bourgeois semiotics of class, gender, and sexuality.

Do let me know your views on these hands.

Yours in friendship,

IX. Letter to a Famous Professor, or Looking Back, Again

Dear Sir,

Just to report some further progress on the Bar *paper: I have decided to focus on the hands of the barmaid.*

My attention to the semiotics of the hands—or their synecdoche (we see very little of an actual hand)—might seem a little perverse, given that attention normally focuses on quite other components of the female body, namely the face and figure of the barmaid. In contemporary interpretation much is made of the elegance of the barmaid's figure in her stylish and "of the moment" *Folies* uniform.[56] Another art historian has argued that fashion and cosmetics provide the disguise within which the barmaid's class eludes us, thereby enabling her to play the paradigmatic role in the "game of classlessness" in which lay the appeal of the "spaces of the *populaire*" for the bourgeoisie.

> [i]t is the face of fashion, first of all, made up to agree with others quite like it. . . . Fashion is a good and necessary disguise: it is hard to be sure of anything else about the barmaid, in particular what class she might belong to. . . . The face that she wears is the face of the popular . . It is face whose character derives from its not being bourgeois, and having that fact almost be hidden . . . fashion and reserve would keep one's face from having any identity, from identity in general.[57]

I am not sure that I concur. I agree that fashion was experienced in the nineteenth century as a kind of erosion of distinction between the bourgeoisie and those *nouvelles couches sociales* who could afford the mass produced replicas of the *haute couture*.[58] But men of Manet's class and social habits knew fashion as an anesthetization of

the commodity relations in which they actually, or in fantasy engaged with *La Parisienne*. Take for example the forthright Ernest Chesneau writing on the *Bar* in the *Annuaire Illustré des Beaux Arts*. He found no ambiguity at all in the figure of the barmaid. She was quite simply "*vulgaire*," that is, she did not perform the masquerade necessary to sustain the suspension of class which was the fiction of *La Parisienne*: "It is not permitted to be more of a *fille* than the creature installed behind the marble counter of the bar laden with fruits and bottles. It is not in this that you will see the essential merit of the work."[59]

Chesneau can only carry on from this point by treating the painting as a still life which Manet's skill as a painter has animated: "He surprises them [the objects on the counter] in their actual mobility." It is a curious move but signals a displacement of the disturbing impassivity of the barmaid—whose social gender within the bourgeois scheme from femininity to sexuality seems all too obvious to him—onto the objects with which she gratifies her customers' gustatory needs, which then come to life under the painter's energetic touch.

Nothing could be more different from the gloved, bonneted, made-up perfection of Jeanne, alias *Spring*, and her sisters in the audience in the celebratory feminine side of the painting's background, than the stark nakedness of the barmaid's hands plonked forcefully and gracelessly on the counter so that only the bulging mounds of Venus, as the fleshy parts below the thumb are named, ridge up against the counter's edge. In the paradoxical conventions of bourgeois society, women could bare their chests and upper arms in ball gowns, but their lower arms and hands had to be gloved, as a kind of compensation and permission for such display. Hands thus acquired a symbolic significance in a sexual topography of the female body totally unfamiliar to us today. To go about ungloved was akin to leaving your body physically naked. Such exposure was a classed sign which functioned metonymicaly for both nakedness and vulgarity, as Chesneau so roundly stated. We know from a wide range of literary and photographic evidence that for some bourgeois men, at least, the ungloved hand and an arm revealed by a rolled-up sleeve were erotic sights.[60] But the barmaid's "naked" hands would work to different effect in the context of a "painting of modern life." If Clark is right, the painting panders to the enigma of a sexual femininity that is available, and yet, is dressed in the mode of those fashionable women who are not

301

simply for sale. The painting uses this tease as its central semiotic device. With respect, to concur with Clark's reading would merely be to rehearse the fetishistic structure of feminine masquerade, which I have outlined above. The barmaid's hands—how they are painted as much as their position—disrupt that conflation and its negotiated pleasures, leading me to disagree finally with Clark's reading of this issue.

In her important work on Manet's working processes, Juliet Wilson Bareau uses X-rays of the painting to show how late the decision was made concerning the final position of the barmaid's hands (fig. 15). The small sketch of the composition (fig. 1) shows what has been called a "blowzy madame" with her hands crossed in front of her waist.[61] Perhaps that was an almost clichéd position for a saleswomen or *dame de comptoir,* waiting to attend to the request of the hatted gentleman at whom her gaze would seem to be directed.[62] As Clark has pointed out, the reflection and the figure match so well that the reflection provides a narrative explanation of her gaze off-screen. What is she looking at? She is looking at the customer who has just approached. Her arms express that patient subservience as well as an etiquette of neatness.

There can be no doubt that turning the barmaid's face to the front and thus dislocating the narrative was a very clever move on Manet's part. It is the gambit that lifted his final café painting from the anecdotal banality of a Béraud to that canonical pedestal as "modern," making it modern by turning it into spectacle, the central thesis of Clark's book. The "space off" into which the woman absently gazes is still, however, projected by what is shown on canvas, in its fictive space. The painting cannily implies and implicates the social spectator in front of the canvas at the place of exhibition, i.e., at the Salon, making that viewer part of the fictive space of exchange in front of the counter at the *Folies-Bergère,* rehearsing the similar device used before in *Olympia* in 1863. At the same time, the woman's lack of expression disarms her looking. She has no gaze; she embodies a "look" in the fashion sense. She appears but does not see. The dropped eyelids prevent her from looking at us in a way that would be brazen, like the stare of Olympia. She does not merely gaze absently or drunkenly off into space, like the figure in *The Prune* (1878, National Gallery, Washington) or the woman holding her cigarette in the foreground of the *Café-Concert* (1878, Walters Art Gallery, Baltimore). She does not seem to be looking at something as in the *At*

the Cafe (fig. 12). She does not let that gaze become tamed and explicable as that of the waitress in *The Waitress* (1879, Musée d'Orsay, Paris), who has just caught the eye of another customer, seemingly the viewer.

This guarded non-look may be Manet's solution to what he had been trying to do with the café as subject, and what he was trying to answer in Degas' race course settings, namely, a modern woman looking at the viewer. Manet's solution is much more subtle than Degas' device of obscuring the women's eyes with the monstrous extruberance of binoculars. Just over the barmaid's shoulder, to the left, is a little reminder of that other woman, of Mary Cassatt and her representation of looking as active feminine desire. With that figure which does not appear in the X-ray (fig. 15), and which, therefore, may be a late addition, Manet played a game of one-upmanship, marginalizing in one stroke both of his rivals, Degas and Cassatt.

When Manet reworked his sketch and dislocated the barmaid from the reflection's seeming explanation of her actions, he retained the crossed arms. From the X-ray, however, it seems that the clichéd pose of the sketch was already being worked on and the barmaid appears to be clasping her left hand with her right hand well above the wrist. The coding of this gesture within a semiotics of the sexual economy is suggested in a print by J. L. Forain, *At the Folies-Bergère,* in which a top-hatted gent accosts a fashionably dressed woman, significantly seen in profile with her head set off by a big-brimmed, black hat. Her right hand lightly flicks across her left arm as he asks, "What's your name, dearie?" She replies, "Zoë." Her hands, significantly, are encased in black gloves.[63] The use of a similar pose for the first draft of the barmaid in the final painting of the *Bar* makes her hand crossed over her body much more obtrusive. They also cover up the fetishism of her tightly corseted waist created by the new fashion silhouette of the costume she is wearing. The final position of the hands, away from that wasp-like figure, both pressing hard onto the edge of the counter so that the fleshy parts below the thumb are emphasized, dramatically alters both the meaning of the barmaid and the signification of the composition as a whole.

In the sketch, originally there was no counter and behind the barmaid was only the reflection of the gallery. In the final work, the barmaid's pose allows us to see through her arms to the reflected counter top and its contents, suspended, it seems, above the lower floor of the *Folies.* She who is at once most substantial becomes

almost transparent, sandwiched between the scintillating glasses and bottles and their ghostly doubles—were it not for the hands, that is. Multiplying the spatial oddities may have been served by changing the pose of the hands, but the figure itself becomes much less elegant, defiantly different from Jeanne's and Méry's poses here and nearby, in the other Manet painting at the Salon. While breaking away from the established iconography of the *dame de comptoir*, this figure acquires the kind of frankness which occurs, as John Tagg has argued, in contemporary photographic imagery of non-bourgeois people.[64]

The pose reads, therefore, within the semiotics both of gender and class, or rather precisely at the point of their historically overdetermined conjunction. The most important thing to recognize is that the barmaid's hands are working hands. Tinged with color, they are the counterpoint to the cosmetically induced pallor of her face and chest. And they give the game away. Masquerade as the imbrication of commodity and sexual fetishism is betrayed by these errant signs of the laboring class. Fetishism is disrupted by physical signs of manual labor. Perhaps Manet was again playing the game of reference and difference with his colleague and rival, Degas, who had tried his hand at the production of a modern representation of the most visible of working class women.[65] Toulouse-Lautrec would take up the challenge, combining Manet's pose with Degas' subject in his 1889 painting, *The Laundress* (fig. 40), and by turning it at an angle he heavyhandedly underlined the working class connotations of the pose and how it positioned the body. In Manet's *Bar*, the placing and detailing of the working class woman's hands arises out of an aesthetic of fidelity to the contradictions of the modern life which Manet lived as a "man of the world," but which he scrutinized as an artist in order to devise for it some telling, aesthetic form. This oddity at the center of the painting attracts my gaze but then directs it to those ardent feminist writers of the time. In their politicized social discourse on modernity, they emphasized the correlation between the exploitation of women in the labor process as unskilled, low-paid workers and their vulnerability to sexual exploitation through selling not their undervalued labor on the market, but their sexuality. Julie Daubié's crucial text *La Femme Pauvre aux Dix-Neuvième Siècle* was published in 1866 and went to a second edition in 1869–70. Writing in the 1860s, again concurrently with Manet's moves towards the production of a painting of modernity, Daubié argued that poverty and

not feminine weakness for money or love of finery drove women into regular or casual prostitution.[66]

And Paule Minck, writing one of her most famous essays, "Les Mouches et les Araignées" ("The Flies and the Spiders," 1869), charts the relations of gender exploitation between the male bourgeoisie and women workers across factory, home, and cafe:

> The fly is the modest young woman who wants to behave well and make an honest living at work, but who cannot find work but in yielding to the shameful desires of the overseer or her boss, who ultimately casts her aside and abandons her—often with a kid—as soon as he has had his fill or becomes afraid of scandal. The spider is the young dandy or *boulevardier,* the son of a cynical and impudent family, this *blasé,* depraved valetudinary, who mirthfully plunges a pure child into the mire, and plays with her, making it a point of honor to debauch honest women.[67]

By the barmaid's uncompromisingly proletarian hands, work is signified in the space of leisure, facade and social hieroglyphics at the Folies-Bergère. Work is their antithesis. It is what contradicts the fantasy of an effortlessly produced and perfect image, the fetish that the masquerade of femininity is meant to offer to men. Actresses like Méry Laurent and Jeanne de Marsy were adored because they could perform the myth of *La Parisienne* which Manet so obsessively rehearsed in his paintings in his last years. As his sexually contracted illness took its toll, he painted about twenty oil heads of women of the *demi-monde.* Suzon, the model for the barmaid, was also subjected to this regime of representation, appearing in her daytime clothes, in profile (fig. 23). But she was also employed to model in his last statement on modern life because she was an actual barmaid. She came in the daytime to Manet's studio to model the pose in which she worked at nighttime. Huysmans' criticism of the *Bar* was aimed precisely at the way the fact of its material production could not be avoided. He complained about Manet's painting in no uncertain terms. The Folies can only exist in the evening, he argued, a dream world made fairy tale with gas and electricity. Why, he fumes, must Manet ruin that dream with a painting so obviously produced in daylight, a mock-up, in the studio, a fabrication of a place, which is however, too real, too naked, too undressed? Thus the social relations that are the conditions of the erotic fantasy cannot be conjured out of sight. He concludes: "Treated in this unadulterated fashion it is

305

absurd."[68] Where there should be fantasy, there is a distressing prosaic actuality. The hands are the place where, I suggest, this negation occurs.

Most art historians have not, I feel, noticed the significance of the disjunction between the space represented—the Folies-Bergère—*and the space of representation which is both the fashioned space of an actual painting and its referent, the studio or working space of the producer/artist. The picture as text so pointedly provides an image and form for Paris, and yet it disjoins the social actuality of the conditions of its production and the social fantasy habitually erected through fetishism and masquerade in that myth of modernity. This dissonance is marked through the aberrant details of the working woman's hands, revealed by the cruel yet prosaic quality of studio daylight. Art historical versions/visions of this painting all too often simply confirm and delight in the myth of Paris which this image critically reworks for us. They use it to get close to Manet and vicariously enter the world he enjoyed socially as a bourgeois man of his time. But the painting is itself a site of work, as T. J. Clark argued in 1973 in his essay "On the Social History of Art."[69] Using heavily loaded ideological materials from* La Vie Moderne, *those resources are reworked in the painting, allowing me, the female spectator it does not address, to glimpse in both its margins and at its paradoxical center another history, one that enables me to make a* feminist *identification with its central female figure.*

I don't believe we can ascribe this foresight or intelligence simply to Manet. Perhaps a facet of the author "Manet," it has to be grasped as an element in meanings derived from a body of work by our critical and symptomatic reading practices. But beyond that, we know that historically a woman spectator was an inevitable part of the painting's possible audience at the institutional level in the actual Salon of 1882. And a woman viewer was also part of the painting's imagined public, foreshadowed by the female spectators in the painting itself. Manet knew Mary Cassatt and women like her, campaigning both for the vote and for independence in art. Once demythologized by attention to its own internal deconstructions, the conflation of painting and eroticized woman as object can be disowned and the text made to function as permeable to other histories and desires.

Yours, in hope of some useful comments, etc.,

X. Letter to a Feminist Scholar, or Looking Away

Dear Friend,

I am really excited by what I have been doing. I have looked away from their Manet and their visions of his painting, following the gaze of the woman with the lorgnette to Mary Cassatt but also to Maria Desraimes, Louise Michel, Hubertine Auclert, Séverine, Paule Minck, and to the women, like Suzon perhaps, with whom they campaigned to end the sexual exploitation of women by improving working women's access to other means of subsistence: well-paid work. The nineteenth-century women's movement was much more focused on the issue of women and work than on the politics of the body, which characterizes the theoretical originality of the contemporary discourses of feminism in the twentieth century. The right to work without sexual harassment, the right to adequate means of self-support, were then, and still are now, the basic conditions for women's rights and liberty. That's what is outside the frame of modernist mythologies. But it is there in the painting, obliquely and indirectly signified by the devices that Manet had made his very signature as an artist: the fact that a painting is the product of his labor and the paid labor of Suzon in a concrete social space. The mock-up of the bar in his studio on the rue d'Amsterdam, is an artifice, which, by being laconically depicted in the painting as such, undoes the myth of modern Paris—a little—for those who do not eagerly take their place in it, but wonder if there was something else for the barmaid to look at and for. Instead of addressing her customer and asking what he wanted, maybe she dreamed of his asking what she needed; what she as a working class woman actually desired: what her fantasies of pleasure, ease, and gratification might be.[70] If Suzon did not know, Maria Desraimes had published her suggestions in the year Suzon's current employer had exhibited at the Salon another working woman with her sleeves rolled up for work, in the background and shadows of a painting that celebrated his alter-ego, his son the dandy, also looking off into the urban space in which he would feel so much "at home"; I am thinking of Luncheon in the Studio *(1869; fig. 41).[71]*

When I was preparing my paper on the Bar, *I kept going back to Teresa de Lauretis and her argument that feminist theory provides a view from elsewhere, which is neither mythic nor utopian. It is the elsewhere of discourse here and now, the blind spots, the almost invisi-*

ble center, like the barmaid's hands, or the "space off" yet always-already inscribed within existing representations. I am still struggling with this paradox: a feminist viewpoint that is both immanent and transgressive of boundaries. I am looking to solve the riddle for the old Sphinx. In the mid-1970's feminist consciousness, Laura Mulvey imagined femininity as a "voice off," outside the city gates, at modernity's margins.[72] But perhaps that was wrong. I now view the dominant cultural discourses and practices, traditional and critical, from a politically and historically generated elsewhere which is at once right there. Neither center nor periphery, women's histories are complexly part of the fabric of historical discourses, institutions, and practices. But there are equally historical conditions for the (in)visibility of that presence, veiled or simply repressed by the hegemonic interests that dominate the apparatuses of power and knowledge. As part of the project of constructing the "subject of feminism," I want to write across the texts of art history the desire of women to be seen—in all the uncomfortable complexity of the pain and injuries of class, race, sexuality, and gender—as the subject of history and as subjects of desire in history. Manet, Freud, Maria Desraimes, Berthe Pappenheim, and Suzon, all wondering and arguing about what women want, shockingly shared a historical moment in the late nineteenth century. The archaeology of that coincidence, or rather, determined conjuncture, serves equally to articulate the questions of our desire and its visibility in this, our social present.

<div align="right">

In sisterhood and hope,

</div>

NOTES

1. Novelene Ross, *Manet's Bar at the Folies-Bergère and the Myths of Popular Illustration* (Ann Arbor, Michigan, 1982) provides a review of the interpretations of this painting up to 1980. In addition, it is worth noting several more readings of the painting. A. C. Hanson, *Manet and the Modern Tradition* (London and New Haven, 1977); T. J. Clark, "The *Bar at the Folies-Bergère*," in J. Beauroy et al., eds., *The Wolf and the Lamb: Popular Culture in France from the Old Regime to the Twentieth Century* (Saratoga, 1977); T. J. Clark, *The Painting of Modern Life: Paris in the Art of Manet and His Followers* (London and New Haven, 1988); P. Florence, *Mallarmé, Manet, and Redon: Visual and Aural Signs and the Generation of Meaning* (Cambridge, 1986); Jeremy Gilbert-Rolfe, "Edouard Manet and the Pleasure Problematic," *Arts Magazine* 62, no. 2 (Feb. 1988), 40–44; David Carrier, "Art History in the Mir-

ror Stage: Interpreting *Un Bar aux Folies-Bergère,*" *History and Theory* 29 (1990), 297–320.

2. T. de Lauretis, "Technologies of Gender," in *Technologies of Gender* (London, 1987), 25.

3. Ibid.

4. Ibid., 26.

5. Ibid., 9–10.

6. Clark (as in n. 1), *The Painting of Modern Life,* 254–55.

7. S. Freud, "Femininity," *New Introductory Lectures on Psychoanalysis* (1933), ed. J. Strachey (London, 1973), 2, 146. The quotation is from H. Heine, *Nordsee.*

8. See Hanson (as in n. 1).

9. There are some exceptions that date from the inception of the women's movement. Eunoce Lipton, for instance, provides a feminist re-evaluation of Manet in her important article, "Manet: A Radicalized Female Imagery," *Art Forum* 13 (March 1975), 48–53. She offered a reading, for women, of Manet's radical rupture with codes of representation, but one that still left the great artist central to the text of art history. See also Linda Nochlin, "A Thoroughly Modern Masked Ball," *Art in America* 71 (Nov. 1983), 188–201, for an important feminist reading of the relations between bourgeois men and working women in places of entertainment.

10. L. Tickner, *The Spectacle of Women Imagery of the Suffrage Campaign 1907–1914* (London, 1987) provides a superb analysis of women suffragists' relation to these debates, especially in Ch. 4, "Representation."

11. G. Pollock, "Modernity and the Spaces of Femininity," *Vision and Difference, Feminism, Femininity, and the Histories of Art* (London, 1988).

12. Freud's question occurs in a letter to Marie Bonaparte: "The great question that has not been answered and which I have not yet been able to answer, despite my thirty years' research in to the feminine soul, is 'What does a woman want?' [Was will das Weib?]." Cited in E. Jones, *The Life and Work of Sigmund Freud* (London, 1964), 474. Lacan devoted a seminar to this question, *Le Séminaire Livre XX* (Paris, 1975); see also S. Heath, "Difference," *Screen* 19, no. 3 (1978), 51–112.

13. Cited in E. Showalter, *The Female Malady: Women, Madness, and English Culture, 1830–1980* (London, 1987), 155.

14. D. Hunter, "Hysteria, Psychoanalysis, and Feminism: The Case of Anna O.," *Feminist Studies* 9 (1983), 465–88.

15. This point is made with intended reference to K. Marx, *The Eighteenth Brumaire of Louis Bonaparte* (1852), in *Marx and Engels Selected Works* (London, 1968), 171, writing of the peasantry of France, who suffered a uniform life, culture, and oppression, but did not constitute a class in themselves and therefore "cannot represent themselves but they must be represented."

16. M. Desraimes, *Ce que veulent les femmes: Articles et Conférences de*

1869–1894, ed. O. Krakavitch (Paris, 1981), xx: "Ce que less femmes veulent, c'est que les hommes cessent de baser leur grandeur sur l'amoindrissement systématique des femmes . . . c'est de ne point être elevées, enseignées, faconnées suivant un type de convention, type conçu dans la cervelle des poétes, des romanciers, des artistes, et par conséquent dépourvu de réalité."

17. Paule Minck, another leading feminist orator and organizer, but of more revolutionary and anarchist tendency, equally opposed Auclert and the suffrage campaigners because women's vote would be, "*le jeu du parti cléri-cal.*" See *Paule Minck Communarde et Féministe 1839–1901,* ed. A. Dalotel (Paris, 1981). I am grateful to Adrian Rifkin for bringing this text to my attention.

18. R. Rabinow, "The Suffrage Exhibition of 1915," *Splendid Legacy: The Havemeyer Collection,* ed. Alice Cooney Freylinghuysen et al. (New York, 1993), 89–99.

19. Significantly, it is now lost. Its central subject was *Women Plucking the Fruits of Knowledge and Science.* This painting is the subject of another paper, "Critical Critics and Historical Critiques: The Case of the Missing Women," *The Leeds University Review* 36 (1993/4), 211–46.

20. N. M. Mathews, *Cassatt and Her Circle* (New York, 1984); E. Le Garrec, ed., *Séverine: Choix de Papiers* (Paris, 1982); E. Le Garrec, *Séverine une Rebelle 1855–1929* (Paris, 1982); C. Goldberg Moses, *French Feminism in the Nineteenth Century* (New York, 1984); M. Blind, ed., *The Diaries of Marie Bashkirtseff,* intro. R. Parker and G. Pollock (London 1984).

21. In Emile Zola's novel, *Nana* (Paris, 1879), Ch. 1. In real life this was the fate of Méry Laurent, whose portrait appears as one of the three fashionably dressed women picked out in the crowd of spectators reflected in the mirror/background of the *Bar.* See text above.

22. Ross (as in n. 1), 13.

23. For discussion of prostitution on-site see P. Derval, *The Folies-Bergère,* trans. L. Hill (London, 1955); see also, F. Caradec and A. Weill, *Le Café Concert* (Paris, 1980).

24. Ross, 75.

25. See G. Pollock, "Modernity and the Spaces of Femininity" (as in n. 11). There is an important correspondence between what I am trying to construct here at the level of cultural myth and its puncturing and the work of feminist historians such as C. Stansell, whose book on the history of working women in New York in the nineteenth century is titled *City of Women* (New York, 1986).

26. Ibid., 75.

27. I am referring here both to T. J. Clark, *The Painting of Modern Life* (as in n. 1), and to the work of Marxist social geographer David Harvey, *Consciousness and the Urban Experience: Studies in the History and Theory of Capitalist Urbanization* (Oxford, 1985).

28. Pollock (as in n.11), 54–55.

29. H. Dawkins, *Sexuality, Degas, and Women's History* (Ph.D. diss., University of Leeds, 1991), Ch. 3, offers an important revision to the historical meanings of the two women in the painting, suggesting a perceived lesbian relationship and thus an exclusive, female sexuality signified by the painting.

30. A. Tabarant, *Manet et Ses Oeuvres* (Paris, 1947), 426–27. I must acknowledge Adrian Rifkin's unpublished papers given at the Toulouse-Lautrec Symposia at the Courtauld Institute, London, and University of Leeds, October and December 1991, in which he explained the way in which the early twentieth-century historians of the musical hall culture of late nineteenth- and early twentieth-century Paris used the texts they wrote both to reclaim and to distance themselves from their own beginnings. The ideas appear in his book *Street Noises* (Manchester, 1993).

31. See G. Pollock, "The Gaze and a Question of Difference: Woman with Lorgnette in the work of Degas and Cassatt," in *Dealing with Degas: Representations of Women and the Politics of Vision,* ed. R. Kendall and G. Pollock (London, 1991).

32. Ross (as in n.1), 6–7, suggests that Mary Cassatt's entry into the Impressionist circle through Degas in 1879 may have stimulated Manet's interest in theater scenes and use of mirrors. Cassatt exhibited *Lydia in a Loge Wearing a Pearl Necklace* at the fourth Impressionist exhibition. Ross cites N. Ramstedt, Jr., "Edouard Manet's *A Bar at the Folies-Bergère* (Ph.D. diss., University of California, Santa Barbara, 1971), as the scholar who first advanced the idea of Cassatt's influence on Manet.

33. Ross (as in n. 1), 7.

34. See note 31.

35. I am clearly indebted here to Clark, *The Painting of Modern Life* (as in n. 1).

36. R. Bowlby, *Just Looking* (London, 1985), 6.

37. Ibid., 10.

38. W. Benjamin, *Charles Baudelaire: Lyric Poet in the Era of High Capitalism,* trans. H. Zohn (London, 1973).

39. Bowlby (as in n. 36), 11.

40. Ibid.

41. D. Kunzle, *Fashion and Fetishism* (New Jersey, 1981), provides important material for taking these observations much further. His work confirms the possibilities of serious and theoretically informed analysis of fashion in relation to a semiotics and politics of the body and social fabrications of both image and identity. These themes have been richly taken up in feminist writings on fashion. See, for example, E. Wilson, *Adorned in Dreams* (London, 1988).

42. In Baudelaire's erotic itinerary through the night spots of Paris, narrated in his *The Painter of Modern Life* (1863), he writes of the mistress of a

spiv, who lacks nothing to become a grande dame, except that everything, which is "distinction," "that 'practically nothing being in fact practically everything,' for it is distinction." This is clearly a matter of class and hence of gender, since class determined the forms or exploitation to which men would feel free to subject women. See *The Painter of Modern Life,* ed. J. Mayne (Oxford, 1964), 35.

43. His essay begins with a chapter entitled, "Beauty, Fashion, and Happiness."

44. *La Dernière Mode* is reprinted in facsimile (Paris, Editions Ramsay, 1978).

45. A. Proust, *Edouard Manet: Souvenirs* (Paris, 1913), cited in T. A. Gronberg, *Manet: A Retrospective* (New York, 1988), 272.

46. Ross (as in n. 1), 8, citing Ramstedt (in n. 32).

47. Tabarant (as in n. 30), 44.

48. G. H. Hamilton, *Manet and His Critics* (New York, 1969), 249.

49. Compare Baudelaire's "No doubt woman is sometimes a light, a glance, an invitation to happiness, sometimes she is just a word" from *The Painter of Modern Life* (as in n. 42), 30. See also, L. LeGrange, *"Du Rang des Femmes dans l'Art," Gazette des Beaux Arts* 8 (1860), 39, for a famous analogy between women and flowers, where he concludes that women artists should confine themselves to painting flowers because they alone can compete with the grace and freshness of women themselves.

50. Tabarant (as in n. 30), 439, notes that from varnishing day there was a crowd around the painting.

51. I am grateful to Laura Mulvey for drawing my attention to this disjunction.

52. The special significance of the concept of masquerade for theories of femininity has been argued in feminist theory by M. A. Doane, in feminist philosophy by Luce Irigaray, in art history by Tamar Garb, see particularly, "Unpicking the Seams of Her Disguise: Self-Representation in the Case of Marie Bashkirtseff," *Block* 13 (1987–88), 79–86. This paper is particularly relevant here, but a full discussion of the psychoanalytical and later feminist thinking on this theme cannot be undertaken here.

53. P. Wollen, "Manet, Modernism and Avant-garde," *Screen* 21, no. 2 (1981), 21–22.

54. L. Nochlin, *Realism* (London, 1971), 164–65.

55. This is the topic of another paper. It involves a series of differences between the gloved hands, the crossed in the lap hands, the expressive hand gesture, the tumescent exposed arm. These differences are precise inscriptions of stratifications of class and sexuality.

56. This current fashion can also be seen in the contemporary portrait Manet painted of *Madame Michel-Lévy* (fig. 37). Devere's *Parisian Costumes for English Ladies* (London, October 1880), illustrates a Plate 90 which com-

pares directly with the costume of the barmaid. In editions of this guide for October 1881, the fashion is widespread.

57. T. J. Clark, *The Painting of Modern Life* (as in n. 1), 253.

58. R. Sennett, *The Fall of Public Man* (Cambridge, 1976).

59. Cited Tabarant (as in n. 30), 440.

60. The classic instance of this eroticization of working women's muscular arms, revealed by rolled up sleeves, comes from the archive of Arthur Munby, now in Trinity College, Cambridge. I am working on this area of interaction between bourgeois men's fantasies and the working woman's body in a forthcoming book, *Sexuality and Surveillance: Bourgeois Men and Working Women* (London, 1995). See a fine study of this from the perspective of a working class woman in Heather Dawkins, "The Diaries and Photographs of Hannah Cullwick," *Art History* 10, no. 2 (1987), 154–87.

61. Clark, *The Painting of Modern Life* (as in n. 1), 252.

62. Ross (as in n. 1), illustrates a print (fig. 46) of a man flirting with a *dame de comptoir* whose arms are folded neatly across her waist.

63. Illustrated in ibid., fig. 41.

64. J. Tagg, "A Democracy of the Image: Photographic Portraiture and Commodity Production," *The Burden of Representation* (London, 1988), 35–36.

65. See E. Lipton (as in n. 9), on Degas and laundresses.

66. J. V. Daubié, *La Femme Pauvre au XIXième Siècle* (Paris, 1866).

67. P. Minck (as in n. 17), 50–51: *"La mouche, c'est cette modeste fillette qui veut rester sage et vivre honnête en travaillant, mais qui ne peut trouver l'ouvrage qu'en cédant aux honteux désirs du contre-maître ou du patron qui l'occupe, et qui ensuite la jette loin de lui et l'abandonné—avec un enfant bien souvent—sitôt que la satiété ou la crainte du scandale se fait sentir. L'araignée, c'est le jeune dandy du boulevard, ce fils de famille impudent et cynique, ce valetudinaire blasé, déprave, qui plonge, en riant, une pure enfant dans la fange et se fait un jeu, un honneur de debaucher les femmes honnêtes."*

68. G. H. Hamilton (as in n. 48), 252; Huysmans' comments were appended to his book, *L'Art Moderne* which appeared in 1883.

69. I am constantly indebted to Clark, "On the Social History of Art," in *The Image of the People* (London 1973), for this important formulation.

70. We are all indebted to C. Steedman's book, *Landscape for a Goodwoman: A Story of Two Lives* (London, 1986) for her critique of both feminist and leftist literatures on working class lives that refuse to consider the complexity of working class subjectivity and desire.

71. S. Kovacs, "Manet and His Son in *Déjeuner dans l'Atelier*," *Connoisseur* CLXXXI (1972), 196–202.

72. I am referring here to Laura Mulvey's and Peter Wollen's film, *Riddles of the Sphinx* (London British Film Institute, 1976), script published in *Screen* 18, no. 2 (1977), 61–78.

A Select Bibliography for Methodological Issues in Art History

Ackerman, James S. "Toward a New Social History of Art." *New Literary History* 3, no. 3 (Spring 1972), 315–30.

Alpers, Svetlana. "Is Art History." *Daedalus* 106 (1977), 1–14.

Alpers, Svetlana and Paul. "Ut Pictura Noesis: Criticism in Literary Studies and Art History." *New Literary History* 3, no. 3 (Spring 1972), 437–58.

Bal, Mieke, and Norman Bryson. "Semiotics and Art History." *The Art Bulletin* LXXIII, no. 2 (June 1991), 174–208.

Bann, Stephen. *The Invention of History: Essays on the Representation of the Past.* Manchester, 1990.

Barthes, Roland. "From Work to Text." *Image—Music—Text,* trans. S. Heath, 155–164. New York, 1977.

———. "The Death of the Author." Ibid., 142–48.

Baxandall, Michael. *Patterns of Intention: On the Historical Explanation of Pictures.* New Haven and London, 1985.

Belting, Hans. *The End of the History of Art.* Chicago, 1987.

Berger, John. *Ways of Seeing.* New York, 1973.

Berman, Morris. "The Body of History." *Coming to Our Senses: Body and Spirit in the Hidden History of the West,* 107–35. New York, 1989.

Bryson, Norman. *Vision and Painting: The Logic of the Gaze.* New Haven, 1983.

———, ed. *Calligram: Essays in New Art History from France.* Cambridge, 1988.

———, Michael Ann Holly, and Keith Moxey, eds. *Visual Theory: Painting and Interpretation.* New York, 1991.

Bruns, Gerald. "Freud, Structuralism, and 'The Moses of Michaelangelo.'" *The Journal of Aesthetics and Art Criticism* 33 (1974), 13–18.

Carrier, David. *Principles of Art History Writing.* University Park, PA, 1991.

———. *Artwriting.* Amherst, MA, 1987.

Cheethamn, Mark A., Michael Ann Holly, and Keith Moxey, eds. *Meaning and Methods in Art History.* Cambridge and New York, 1995.

Clark, T. J., "On the Social History of Art." *Image of the People: Gustave Courbet and the 1848 Revolution,* 9–20. London, 1973.

Clifford, James. *The Predicament of Culture.* Cambridge, MA, 1988.

Collins, Bradford R. "What is Art History." *Art Education* 44, no. 1 (January 1991), 53–59.

Corn, Wanda. "Coming of Age: Historical Scholarship in American Art." *The Art Bulletin* LXX, no. 2 (June 1988), 188–207.

Cropper, Elizabeth, and Charles Dempsey. "The State of Research in Italian Painting of the Seventeenth Century." *The Art Bulletin* LXIX, no. 4 (Dec. 1987), 494–509.

Derrida, Jacques. "Structure, Sign, and Play in the Discourse of the Human Sciences." *Writing and Difference*, 278–93. Chicago, 1978.

———. "Restitutions of the Truth in Pointing (pointure)." *A Derrida Reader*, ed. Peggy Kamuf, 279–309. New York, 1991.

Eagleton, Terry. *Literary Theory: An Introduction*. Minneapolis, 1983.

Elkins, James. "Art History without Theory." *Critical Theory* 14 (Winter 1988), 354–78.

Forester, Kurt W. "Critical History of Art, or Transfiguration of Values?" *New Literary History* 3, no. 3 (Spring 1972), 459–70.

Freedberg, David, Oleg Grabar, Anne Higonnet, Cecilia F. Klein, Lisa Tickner, and Anthony Vidler. "A Range of Critical Perspectives: The Object of Art History." *The Art Bulletin* LXXVI, no. 3 (Sept. 1994), 394–410.

Freud, Sigmund. "The Moses of Michelangelo." *Collected Papers*, IV, 257–87. London, 1925.

Garrard, Mary D., and Norma Broude, eds., *Feminism and Art History: Questioning the Litany*. New York, 1982.

———. "Feminist Art History and the Academy: Where Are We Now?" *Women's Studies Quarterly* 15, nos. 1 and 2 (Spring/Summer 1987), 10–16.

Geertz, Clifford. "Art as a Cultural System." *Local Knowledge*, 94–120. New York, 1983.

Gouma-Peterson, Thalia, and Patricia Mathews, "The Feminist Critique of Art History." *The Art Bulletin* LXIX, no. 3 (Sept. 1987), 326–57.

Grabar, Oleg. "History of Art and History of Literature: Some Random Thoughts." *New Literary History* 3, no. 3 (Spring 1972), 559–68.

Hauser, Arnold. *The Philosophy of Art History*. New York, 1958.

Haverkamp-Begemann, Egbert. "The State of Research: Northern Baroque Art." *The Art Bulletin* LXXIX, no. 4 (Dec. 1987), 510–19.

Holly, Michael Ann. *Panofsky and the Foundations of Art History*. Ithaca, NY, 1984.

Hood, William. "The State of Research in Italian Renaissance Art." *The Art Bulletin* LXIX, no. 2 (June 1987), 174–86.

Johnson, W. McAllister. *Art History: Its Use and Abuse*. Toronto, 1988.

Kemal, Salim, and Ivan Gaskel, eds. *The Language of Art History*. Cambridge, 1991.

Kessler, Herbert. "On the State of Medieval Art History." *The Art Bulletin* LXX, no. 2 (June 1988), 166–87.

Kuspit, Donald. "Conflicting Logics: Twentieth-Century Studies at the Crossroads." *The Art Bulletin* LXIX, no. 1 (March 1987), 117–32.

Kleinbauer, W. Eugene. "What is Art History." *Modern Perspectives in Western Art History*, 1–105. New York, 1971.

Kultermann, Udo. *The History of Art History.* New York, 1993.

Michelson, Annette. "Art and the Structuralist Perspective." *On The Future of Art,* 37–59. New York, 1970.

Minor, Vernon Hyde. *Art History's History.* Englewood Cliffs, NJ, 1994.

Mulvey, Laura. "Visual Pleasure and Narrative Cinema." Reprinted in Laura Mulvey, *Visual and Other Pleasures,* 14–26. London, 1989.

Nochlin, Linda. "Why Have There Been No Great Women Artists?" *Women, Art, and Power and Other Essays,* 145–78. New York, 1988.

Nodelman, Sheldon. "Structural Analysis in Art and Anthropology." *Structuralism,* 79–93. New York, 1970.

Panofsky, Erwin. "The History of Art as a Humanistic Discipline." *Meaning in the Visual Arts,* 1–25. Garden City, NJ, 1955.

————. "Iconography and Iconology: An Introduction to the Study of Renaissance Art." Ibid., 26–54.

Podro, Michael. *The Critical Historians of Art.* New Haven and London, 1982.

Pollock, Griselda. *Vision & Difference: Femininity, Feminism and the Histories of Art.* London and New York, 1988.

Preziosi, Donald. *Rethinking Art History: Meditations on a Coy Science.* New Haven and London, 1989.

Prown, Jules David. "Mind in Matter: An Introduction to Material Culture Theory and Method." *Material Life in America, 1600–1800,* ed. Robert Blair St. George, 17–37. Boston, 1988.

Rees, A. L., and Frances Borzello, eds. *The New Art History.* Atlantic Highlands, NJ, 1988.

Richter, David H., ed. *The Critical Tradition: Classic Texts and Contemporary Trends,* Part 2, 551–1444. New York, 1989.

Ridgway, Brunilde Sismondo. "The State of Research on Ancient Art." *The Art Bulletin* LXVIII, no. 1 (March 1986), 7–23.

Roskill, Mark. *What is Art History.* New York, 1976.

————. *The Interpretation of Pictures.* Amherst, MA, 1989.

Shiff, Richard. "Art History and the Nineteenth Century: Realism and Resistance." *The Art Bulletin* LXX, no. 1 (March 1988), 25–48.

————. "On Criticism Handling History." *History of the Human Sciences* 2, no. 1 (1989), 63–87.

Silver, Larry. "The State of Research in Northern European Art of the Renaissance Era." *The Art Bulletin* LXVIII, no. 4 (Dec. 1986), 518–35.

Spector, Jack. "The State of Psychoanalytic Research in Art History." *The Art Bulletin* LXX, no. 1 (March 1988), 50–76.

Spitz, Ellen Handler. *Art and Psyche: A Study in Psychoanalysis and Aesthetics.* New Haven, 1985.

Stafford, Barbara. "The Eighteenth Century: Towards an Interdisciplinary Model." *The Art Bulletin* LXX, no. 1 (March, 1988), 6–24.

Steer, John. "Art History and Direct Perception: A General View." *Art History* 12, no. 1 (March 1988), 93–108.

Summers, David. "Conventions in the History of Art." *New Literary History* 13 (Autumn 1981), 103–25.

Tickner, Lisa. "Feminism and Art History." *Genders* 3 (Fall 1988), 92–117.

Trachtenberg, Marvin. "Some Observations on Recent Architectural History." *The Art Bulletin* LXX, no. 2 (June 1988), 208–41.

Zerner, Henri, ed. "The Crisis in the Discipline." *The Art Journal* 42, no. 4 (Winter 1982).

ILLUSTRATIONS

1. Edouard Manet, *A Bar at the Folies-Bergère*, c.1881. Private Collection.

2. Edouard Manet, *The Asparagus*, 1880. Musée d'Orsay, Paris.

3. Edouard Manet, *The Lemon*, c. 1880. Musée d'Orsay, Paris.

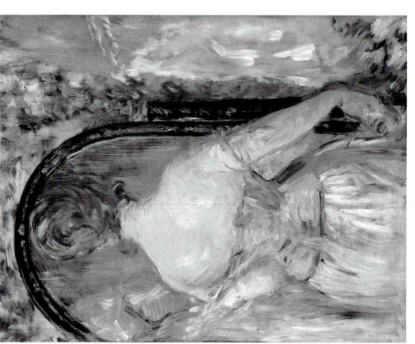

5. Edouard Manet, *Woman Reading*, 1878–79. The Art Institute of Chicago.

4. Edouard Manet, *Before the Mirror*, 1876–77. Solomon R. Guggenheim Museum, New York.

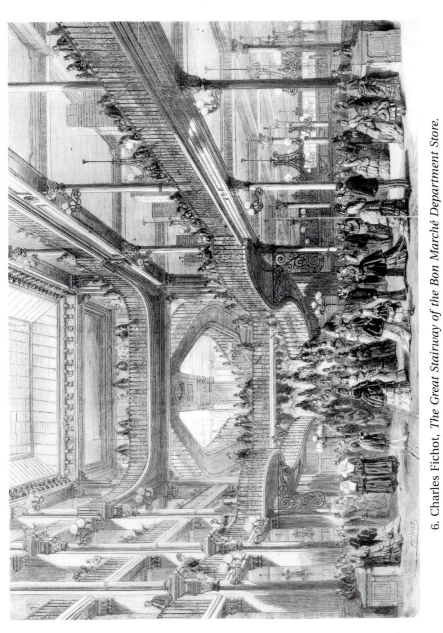

6. Charles Fichot, *The Great Stairway of the Bon Marché Department Store.* Wood engraving. *L'Illustration,* 30 March 1872.

9. Anonymous, *At the Anglo-American Bar.*
Wood engraving. Published in G.A. Sala,
Paris Herself Again in 1878–79
(London, 1882).

UNE MARCHANDE DE CONSOLATION AUX FOLIES-BERGÈRE. — (Son dos se reflète
dans une glace; mais, sans doute par suite d'une distraction du peintre, un
monsieur avec lequel elle cause et dont on voit l'image dans la glace, n'existe
pas dans le tableau. — Nous croyons devoir réparer cette omission.)

8. Stop, *A Merchant of Consolation at the
Folies-Bergère.* Wood engraving.
Le Journal Amusant,
27 May 1882.

7. Louis-Henry Dupray,
Self Portrait, n.d. Wash drawing.
Published in A.M. de Belina,
*Nos peintres dessinés par
eux-mêmes* (Paris, 1883).

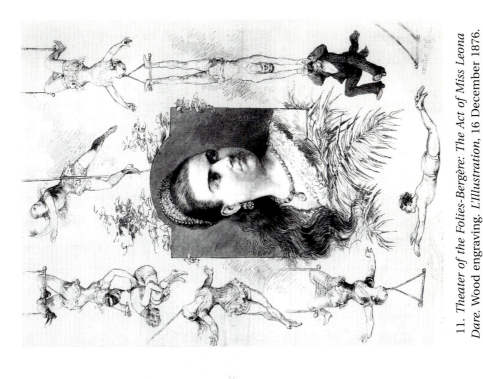

11. *Theater of the Folies-Bergère: The Act of Miss Leona Dare*. Wood engraving. *L'Illustration*, 16 December 1876.

10. Jules Chéret, *At the Folies-Bergère*, 1875. Color lithograph. Private Collection.

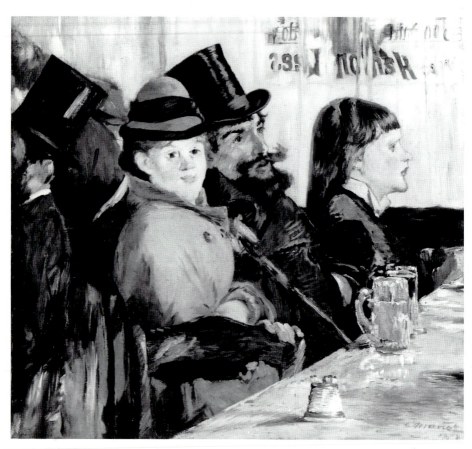

12. Edouard Manet, *At the Cafe,* 1878. 78 × 84. Oskar Reinhart Collection
"Am Romerholz," Winterthur.

13. Edouard Manet, *At the Folies-Bergère,* c. 1881.
Wash over hard pencil. Collection unknown.

14. Edouard Manet, *Study for A Bar at the Folies-Bergère,* c.1881.
Wash drawing. Collection unknown.

15. X-Ray photograph of Édouard Manet, *A Bar at the Folies-Bergère*, 1881–82.

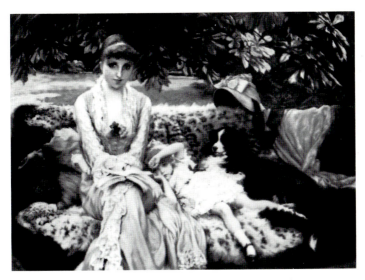

16. James Tissot, *Quiet*, c.1881. Private Collection.

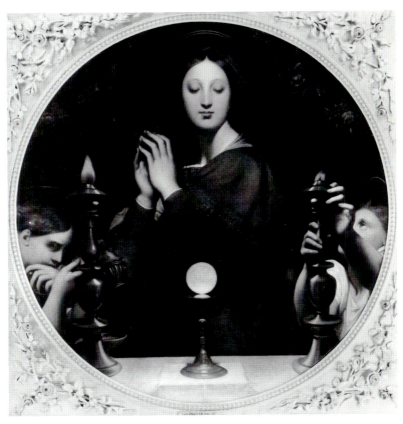

17. Jean Auguste Dominique Ingres, *The Virgin with the Host*, 1854.
Musée du Louvre, Paris.

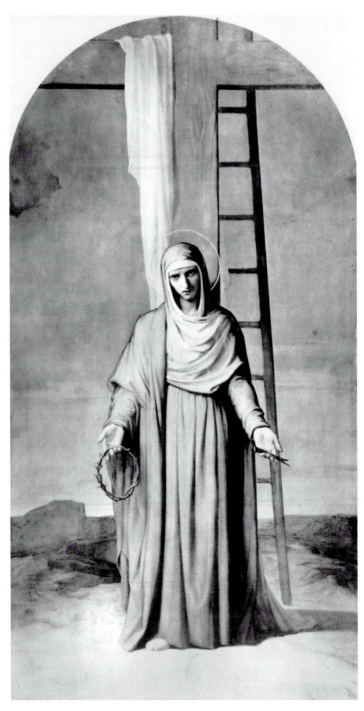

18. Hippolyte Flandrin, *Mother of Sorrow*, 1845.
Lithograph after the painting by Jules Laurens.

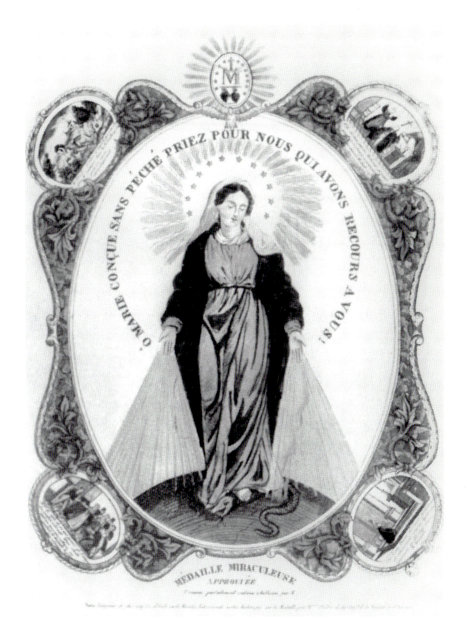

19. Anonymous, *The Miraculous Medal*, c.1838. Engraving.

20. Jean-Paul Laurens, *Studio Visits, Le Philosophe*, 26 Oct. 1867. Lithograph.

21. Pepin, cover for Léo Taxil, *Vie de
Veuillot immaculé* (Paris, 1884).

22. Frid'rick, *The New Virgin*.
Published in Léo Taxil,
Calotte et Calotins,
volume 2 (Paris, 1879).

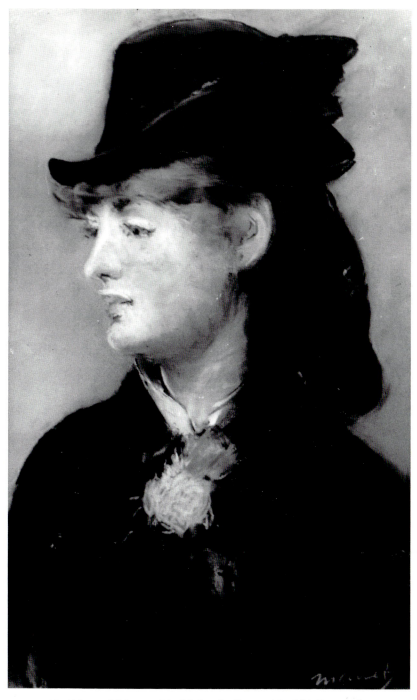

23. Edouard Manet, *Model for the Barmaid of "A Bar at the Folies-Bergère,"* 1881. Pastel. Musée des Beaux-Arts, Dijon.

24. G. Lafosse, *At the Folies-Bergère.* Lithograph.
Le Journal Amusant, 14 Dec. 1878.

25. G. Lafosse, *At the Folies-Bergère.* Lithograph.
Le Journal Amusant, 24 Nov. 1877.

26. Diagramatic reconstruction of Edouard Manet's *Reichshoffen* project prepared from *At the Cafe*, 1878 (Oskar Reinhardt Collection, Winterthur), an X-ray of *Corner in a Cafe-Concert*, 1878–79 (National Gallery, London), and the first drawing for the project (Musée du Louvre, Paris).

27. Anonymous, *Les Hanlon-Volta, Aerial Gymnasts.* Published in
G. Strehly, *L'Acrobatie et les Acrobates* (Paris, 1904).

28. Anonymous, *Les Alex, Trapeze Artists.* Published in G. Strehly,
L'Acrobatie et les Acrobates (Paris, 1904).

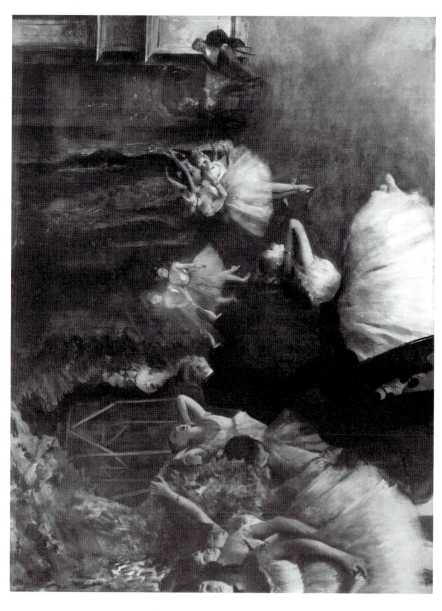

29. Edgar Degas, *The Rehearsal of the Ballet on the Stage*, 1874. Metropolitan Museum of Art, New York.

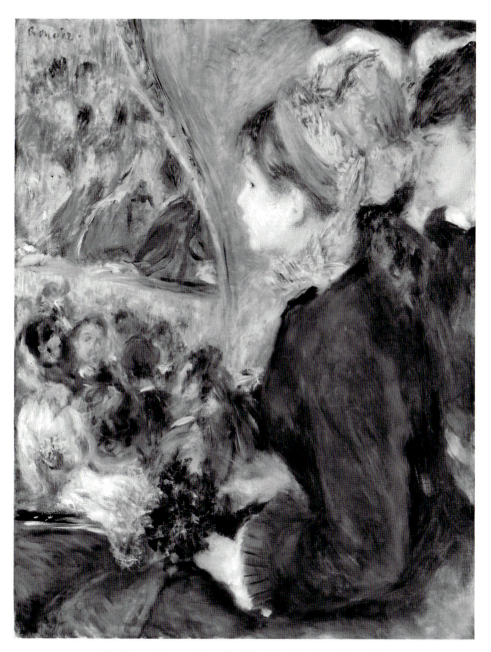

30. Pierre August Renoir, *The First Outing*, 1875–76.
The National Gallery, London.

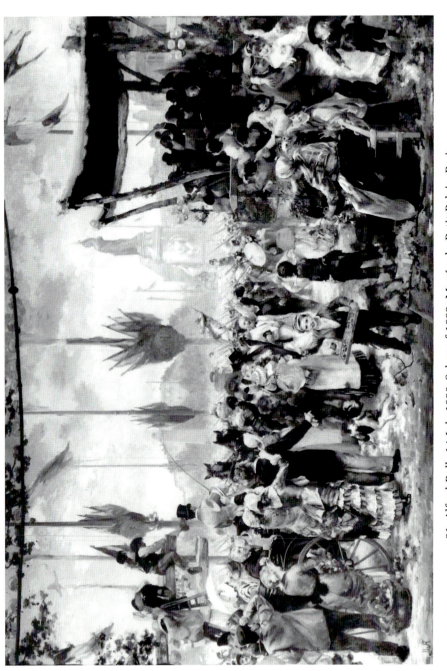

31. Alfred Roll, *14 July 1880*, Salon of 1882. Musée du Petit Palais, Paris.

32. Ernest Duez, *In the Restaurant Le Doyen*, 1878. Collection unknown.

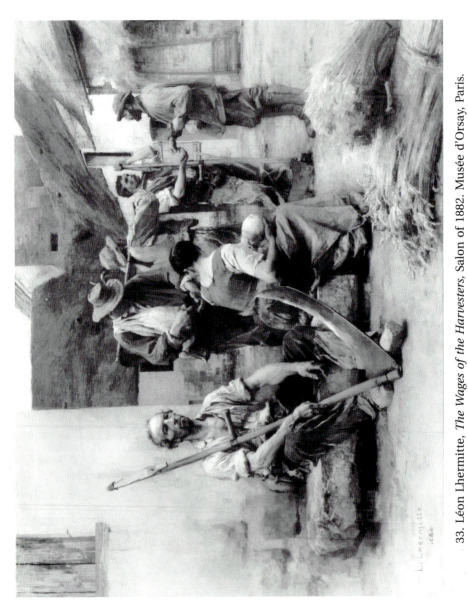

33. Léon Lhermitte, *The Wages of the Harvesters*, Salon of 1882. Musée d'Orsay, Paris.

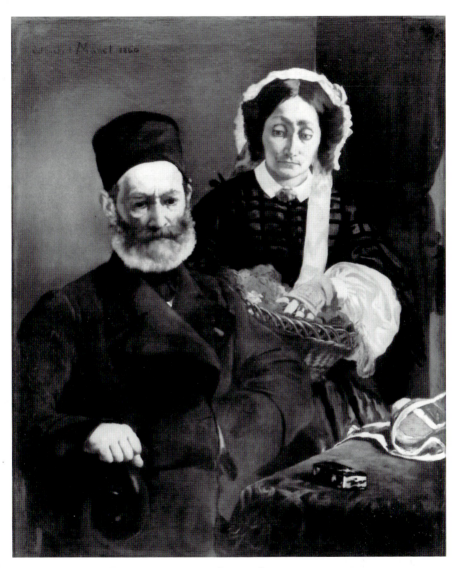

34. Edouard Manet, *Portraits of M. and Mme Auguste Manet*, 1860.
Musée d'Orsay, Paris.

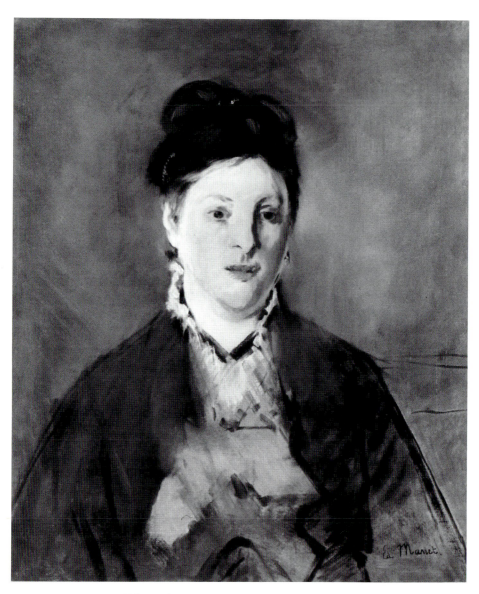

35. Edouard Manet, *Portrait of Mme Manet*, 1866.
Norton Simon Art Foundation, Pasadena.

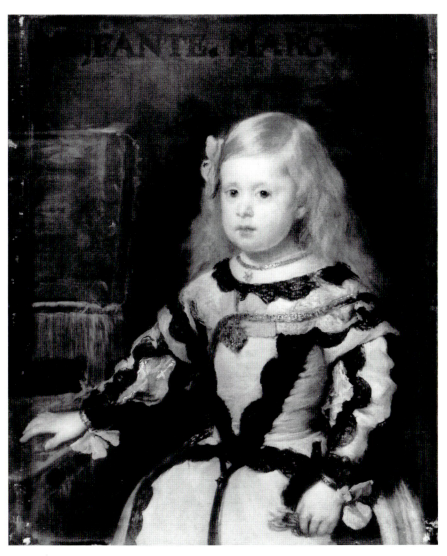

36. Diego Velázquez, *Portrait of the Infanta Maria Margarita,* 1654.
Musée du Louvre, Paris.

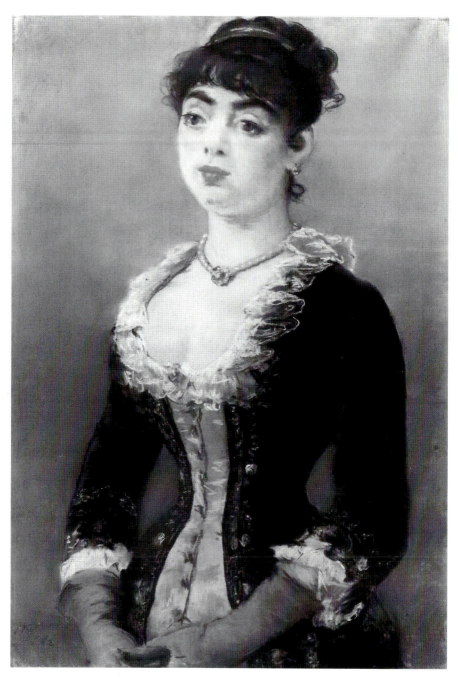

37. Edouard Manet, *Portrait of Mme Michel-Lévy,* 1882.
Pastel and oil. National Gallery of Art, Washington.

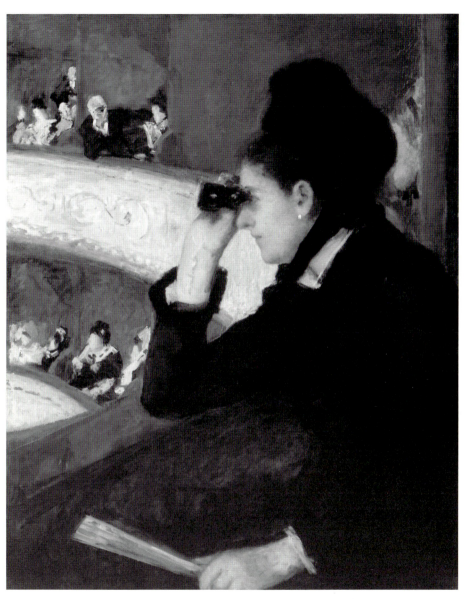

38. Mary Cassatt, *At the Opera,* 1879. Museum of Fine Arts, Boston.

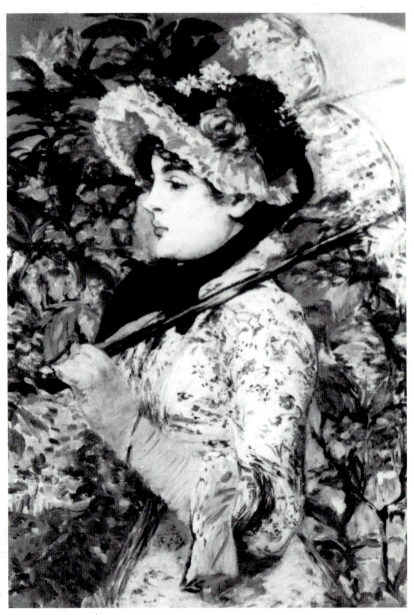

39. Edouard Manet, *Spring: Jeanne,* 1881. Private Collection.

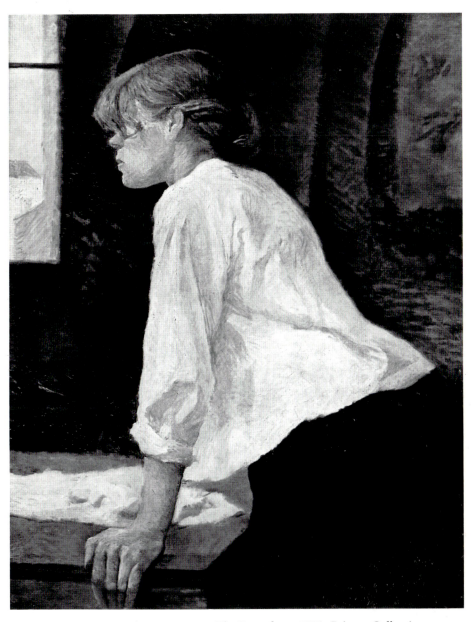

40. Henri de Toulouse-Lautrec, *The Laundress*, 1889. Private Collection.

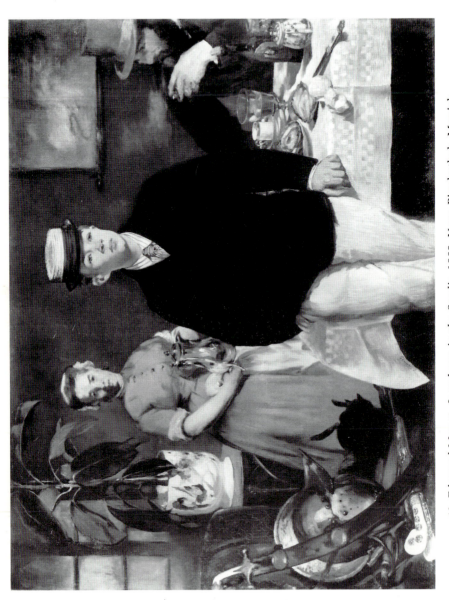

41. Edouard Manet, *Luncheon in the Studio*, 1868. Neue Pinakothek, Munich.